CHILDREN IN THE VISUAL ARTS OF IMPERIAL ROME

Modern approaches to Roman imperialism have often characterized Romanization as a benign or neutral process of cultural exchange between Roman and non-Roman, conqueror and conquered. Although supported by certain types of literary and archaeological evidence, this characterization is not reflected in the visual imagery of the Roman ruling elite. In official imperial art, Roman children are most often shown in depictions of peaceful public gatherings before the emperor, whereas non-Roman children appear only in scenes of submission, triumph, or violent military activity. Images of children, those images most fraught with potential in Roman art, underscore the contrast between Roman and non-Roman and as a group present a narrative of Roman identity. As Jeannine Diddle Uzzi argues in this study, the stark contrast between images of Roman and non-Roman children conveys the ruling elite's notions of what it meant to be Roman.

Jeannine Diddle Uzzi is assistant professor of classics at the University of Southern Maine.

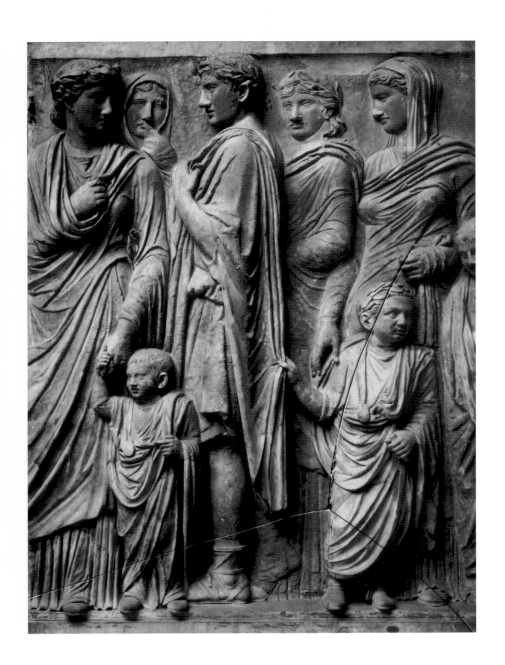

CHILDREN IN THE VISUAL ARTS OF IMPERIAL ROME

JEANNINE DIDDLE UZZI
University of Southern Maine

CAMBRIDGE
UNIVERSITY PRESS

CAMBRIDGE UNIVERSITY PRESS
Cambridge, New York, Melbourne, Madrid, Cape Town, Singapore, São Paulo

Cambridge University Press
40 West 20th Street, New York, NY 10011-4211, USA

www.cambridge.org
Information on this title: www.cambridge.org/9780521820264

First published 2005

Printed in Hong Kong by Golden Cup

A catalog record for this publication is available from the British Library.

Library of Congress Cataloging in Publication Data
Uzzi, Jeannine Diddle, 1971–
Children in the visual arts of imperial Rome / Jeannine Diddle Uzzi.
 p. cm.
Includes bibliographical references and index.
ISBN 0-521-82026-X (hardback : alk. paper)
1. Art, Roman. 2. Children in art. 3. Identity (Psychology) in art.
4. Art and state – Rome. I. Title.
N5763.U98 2004
704.9′425′0937 – dc22 2004055081

ISBN-13 978-0-521-82026-4 hardback
ISBN-10 0-521-82026-X hardback

For Chris

CONTENTS

LIST OF ILLUSTRATIONS

ABBREVIATIONS

AA	*Archäologische Anzeiger*
ADA	Regia Academia Italica. *Acta Divi Augusti*, Pars Prior. Rome, 1945.
AJA	*American Journal of Archaeology*
ANRW	*Aufstieg und Niedergang der römischen Welt*
BJb	*Bonner Jahrbücher*
BMC I–IV	Mattingly, H. et al. *Coins of the Roman Empire in the British Museum.* London, British Museum Press, 1923–1962.
Brilliant	Brilliant, Richard. *Gesture and Rank in Roman Art.* New Haven: Connecticut Academy of Arts and Sciences, 1963.
BullComm	*Bullettino della commissione archeologica comunale di Roma*
CIL	*Corpus Inscriptionum Latinarum*
DA	Suetonius' *Divus Augustus*
HA	*Scriptores Historiae Augustae*
ILS	Dessau, H. *Inscriptiones Latinae Selectae.* Berlin, 1892–1916.
JdI	*Jahrbuch des (k.) deutschen archäologischen Instituts*
JRA	*Journal of Roman Archaeology*
JRS	*Journal of Roman Studies*
Kleiner	Kleiner, Diana, E. E. *Roman Sculpture.* New Haven: Yale University Press, 1992.
L&F	Lepper, Frank and Sheppard Frere. *Trajan's Column.* Gloucester: Alan Sutton Publishing, 1988.
MAAR	*Memoirs of the American Academy in Rome*
Mél. Ec. Tr. Rome	*Mélanges d'archéologie et d'histoire de l'Ecole Française de Rome*
P&M	Pugliese Caratelli, Giovanni. *Pompei: Pitturi e Mosaici*, 5 vols. Rome, 1990–1994.
PBSR	*Papers of the British School at Rome*
PECS	*Princeton Encyclopedia of Classical Sites*

ProcBritAc	*Proceedings of the British Academy*
RE	Pauly-Wissowa *Real-Encyclopädie der klassischen Altertumswissenschart*
REA	*Revue des études anciennes*
RIC	Mattingly, H. and Syndenham, E. A. *The Roman Imperial Coinage.* London, 1923–1981.
RM	*Mitteilungen des deutschen archäologischen Instituts, Römische Abteilung*
RPC	Burnett, Andrew et al. *Roman Provincial Coinage.* Vol. 1, London: British Museum Press, 1992.
RRC	Crawford, M. *Roman Republican Coinage.* 1974.
Strack I	Strack, P. L. *Untersuchungen sur römischen Reichsprägung des zweiten Jahrhunderts. I: Die Reichsprägung zur Zeit des Traian.* Stuttgart 1931.
Strack II	Strack, P. L. *Untersuchungen sur römischen Reichsprägung des zweiten Jahrhunderts. II: Die Reichsprägung zur Zeit des Hadrian.* Stuttgart 1933.
ZPE	*Zeitschrift für Papyrologie und Epigraphik*

ACKNOWLEDGMENTS

Thanks is owed first and best to Tolly Boatwright, my dissertation advisor, mentor, and now dear colleague, who witnessed every inch of this work, from seminar paper in 1995 to dissertation in 1998 and finally to manuscript. Her thoughtful insight provided me both foundation and inspiration and is evident to me on nearly every page of this text. Thanks is also owed to my Duke University dissertation committee, Micaela Janan, Larry Richardson, Kent Rigsby, and John Younger, and to my honorary committee member, the late Paul Rehak, all of whose comments set me on the track to this book, as well as to my Hamilton College faculty, Barbara Gold, Shelley Haley, and Carl Rubino.

I would also like to thank Dana Burgess of Whitman College, a friend and colleague without equal, who not only read my entire manuscript and offered me invaluable questions and suggestions but also provided the opportunity for some of the most stimulating and enjoyable discussions I've had to date on this and a seemingly endless variety of topics. I must also thank Pat Keef, dean of the faculty of Whitman College and, indeed, Whitman College itself, for the generous and early sabbatical that allowed me to complete the bulk of this work, as well as Columbia and New York Universities, where I completed much of the research for the book as a visiting scholar.

Although I made the acquaintance of Beryl Rawson late in the process of writing, her encouragement and the thoughts and images she generously shared with me were helpful and much appreciated. It has been my pleasure and honor to work with Ms. Rawson.

Thanks also goes to my new colleagues at the University of Southern Maine, Peter Aicher and Lois Hinkley, whose support I never doubt and whose

company I always enjoy, and to the USM Classics Fund, which provided me assistance in obtaining photographs and permissions for my illustrations.

In addition, I would like to thank Beatrice Rehl of Cambridge University Press for her promptness, patience, and tireless support, and my three readers whose suggestions and criticisms were not only well founded but who gave me that last bit of direction and motivation I needed.

Finally, years of thanks are due my parents, family, and friends who never doubted I could complete such a task, strange though they may have found it, and who never discouraged me from a career in classics. And, last and certainly not least, to Chris, my husband and best friend, and to Mary Jane, who may read and enjoy this some day, thank you with all my heart.

INTRODUCTION

There has always been a symbiosis between
the will to power and monumental display
Jas Elsner[1]

On the Arch of Septimius Severus at Lepcis Magna a non-Roman child is dragged through the streets by a Roman soldier (see Fig. 45). A frontal figure in non-Roman costume, he flails across the triumphal scene with arms spread, disrupting the movement of the procession and attracting the eye of the viewer. A solitary figure, he has no explicit connection to non-Roman adults who might serve as his *familia*. He is the victim of violence and humiliation, apparently powerless at the hands of the Roman soldier, and his pathetic situation is emphasized by his gesture and position in the scene.

This image contrasts starkly with images of Roman children from similar public monuments. The Arch of Trajan at Beneventum, for instance, presents children in Roman costume among Roman family members in an orderly and peaceful scene of imperial largesse (see Fig. 9). The contrast, briefly illustrated here, between the official artistic contexts in which Roman and non-Roman children appear opens up a narrative of Roman identity in which Roman children act as the future Roman citizenry, and non-Roman children appear as captive or submissive figures.

In official imperial art, Roman children are regularly shown in depictions of public gatherings before the emperor. Non-Roman children, on the other hand, appear in scenes of submission, triumph, or violent military activity. All children have a certain potential in Roman art as symbols of the future. Non-Roman children represent the future of their particular ethnos, territory, or province just as Roman children are the *futurus populus* of Rome.[2] It is in the nature of this potential and the way in which the Roman state manipulates it that we may identify fundamental aspects of a Roman imperial ideology, an idea of *Romanitas*.

Renan's historic nineteenth-century essay, "What Is a Nation?"[3] denies that Rome was a nation in the modern sense of the word. "Nations," according to Renan, "are something fairly new in history. Antiquity was unfamiliar with them" (Eley and Suny 1996, 43). Renan identifies the Roman Empire as "a huge association, and a synonym for order, peace, and civilization," but he claims that "an empire twelve times larger than present-day France cannot be said to be a state in the modern sense of the term" (ibid.).

Renan defines a nation rather as "a soul, a spiritual principle" composed of two basic elements: a past, a "rich legacy of memories," and a present, a desire to live together (p. 52). Renan's definition of nation is grounded in the concepts of remembrance and forgetting. For an entity to be called "nation," its constituents must both remember a common past and forget enough of that past to retain their desire to live together. As "unity is always effected by means of brutality . . . forgetting . . . is a crucial factor in the creation of a nation" (p. 45).

Anderson (1991) builds on and problematizes Renan's definition of nation in *Imagined Communities*. He defines a nation as "an imagined political community – and imagined as both inherently limited and sovereign" (p. 6). In Anderson's view, the "nation is always conceived as a deep, horizontal comradeship . . . [a] fraternity that makes it possible for so many millions of people, not so much to kill, as willingly to die for such limited imaginings" (p. 7). Although he does not reject the significance of Renan's remembrance and forgetting, Anderson rejects the simplicity with which Renan employs those terms. Anderson believes that for most citizens, remembrance and forgetting occur in the same conceptual space, and he provides an instructive example: "A vast pedagogical industry works ceaselessly to oblige young Americans to remember/forget the hostilities of 1861–65 as a great 'civil' war between 'brothers' rather than between – as they briefly were – two sovereign nation-states" (p. 201).

Anderson likens the formation of nations to puberty: "After experiencing the physiological and emotional changes produced by puberty, it is impossible to 'remember' the consciousness of childhood. . . . Out of this estrangement comes a conception of personhood, *identity* . . . which, because it can not be 'remembered,' must be narrated" (p. 204). With nations, "awareness of being imbedded in secular, serial time, with all its implications of continuity, yet of 'forgetting' the experience of this continuity – product of the ruptures of the late eighteenth century – engenders the need for a narrative of 'identity'"

(p. 205).[4] Like Renan, Anderson identifies the concept of the nation as modern, a phenomenon of the past two centuries.

Similar disavowals of Rome's unity as a nation or state can be found in classical scholarship. In a thoughtful chapter on "Romanization," Woolf argues against the validity of the term as Haverfield and Mommsen used it. "[T]here was no standard Roman civilization against which provincial cultures might be measured. The city of Rome was a cultural melting pot. . . . Nor did Romanization culminate in cultural uniformity throughout the empire" (1998, 7). Moreover, according to Woolf, "Roman culture was not static and its composition was never a matter of consensus. Over the centuries in which the identity 'Roman' was felt to be important, ways of eating, ways of dealing with the dead, styles of education and so forth underwent many transformations. . . . Becoming Roman was not a matter of acquiring a ready-made cultural package, then, so much as joining the 'insiders'' debate about what that package did or ought to consist of at that particular time" (p. 11). For Woolf, "Romanization has no explanatory potential because it was not an active force" (p. 7).

Hingley makes a similar assessment: "Although local folk memory can be long-lived, the concept of what was Roman and what was native will have varied throughout society at the time of the conquest" (1996, 43). "The dominant approaches [to studies of Romanization] . . . create a reification of the concept 'Roman.' They suggest that the idea of 'Rome' (and those of Roman material culture and Romanization) have some actual objective existence" (p. 42).[5]

What have the claims of Woolf and Hingley, let alone those of theorists like Renan and Anderson, to do with art, children, and Roman imperial ideology? In denying the possibility that "the idea of 'Rome' ha[d] some actual objective existence," that there was any "standard Roman civilization," or that Rome might be understood as a nation or an empire in the modern sense of the terms, scholars of both classics and political theory have limited the ways in which we in the modern world can approach the Romans and their empire. How did Romans understand themselves if not as a nation or state? If nothing can be identified clearly as "Roman," how are we to talk about the empire? If Rome was not a nation, not a "soul, a spiritual principle" with a commonly understood and accepted past and present, not a limited and sovereign community in which members felt a fraternity for which they were willing to kill and, more importantly, die, how can we talk about a sense of Roman identity?

Woolf and Hingley, in particular, are responding to a very specific type of arrogance in nineteenth-century scholarship on Romanization, but their

conclusions are at times too relativistic to be useful for the study of the effects of Roman expansion on either Romans or non-Romans. Is any political entity ever culturally static? Does any nation possess what Woolf terms "cultural uniformity"? Is there any nation, ancient or modern, whose cultural composition has not been, at some time, a matter of debate? Any nation whose traditions do not change over time? The fact that Rome was a "melting pot," influenced culturally by those it conquered militarily, does not negate the possibility of a Roman identity. Nor does the fact that provinces uniquely experienced Roman conquest and influence negate the possibility (or, in fact, the likelihood) that an "idea of 'Rome'" existed.

Žižek (1993) addresses the issue of nationalism elegantly in *Tarrying with the Negative*. He describes national identity as a "mode of being proper to ideological causes" in which a nation "'is' only insofar as subjects believe (in the other's belief) in its existence" (p. 202). "[T]he normal order of causality is here inverted, since it is the Cause itself which is produced by its effects" (ibid.):

> National identification is by definition sustained by a relationship toward the Nation qua Thing. This Nation-Thing is determined by a series of contradictory properties. It appears to us as "our Thing" (perhaps we could say *cosa nostra*), as something accessible only to us, as something "they," the others, cannot grasp; nonetheless it is something constantly menaced by "them". . . . It would, however, be erroneous simply to reduce the national Thing to the features of a specific "way of life." The Thing is not directly a collection of these features; there is "something more" in it, something that *is present* in these features, that *appears* through them. Members of a community who partake in a given "way of life" *believe in their Thing*, where this belief has a reflexive structure proper to the intersubjective space: "I believe in the (national) Thing" equals "I believe that others (members of my community) believe in the Thing." The tautological character of the Thing to "It is the real Thing," etc. – is founded precisely in this paradoxical reflexive structure. The national Thing exists as long as members of the community believe in it; it is literally an effect of this belief in itself. (201–2)

Žižek's definition of nationhood is surprisingly close to those of Renan and Anderson – a nation exists only in as much as it is imagined to exist – but Žižek does not limit his definition temporally, nor does his definition fall into relativism. "To emphasize in a 'deconstructionist' mode that Nation is not a biological or transhistorical fact but a contingent discursive construction, an overdetermined result of textual practices, is thus misleading; such

an emphasis overlooks the remainder of some *real*, nondiscursive kernel of enjoyment which must be present for a Nation qua discursive entity-effect to achieve its ontological consistency" (p. 202).[6]

This is not to argue for Roman nation- or statehood or to refute any of the theories presented here per se. This is to argue that modern definitions of nation and state can be helpful for understanding the phenomenon that was Rome, particularly in light of Žižek's assessment of nationhood. In fact, latent in modern denials of Rome's political and cultural unity, consistency, and knowability are invaluable tools, concepts, and terminology that, although purportedly off-limits to students of the Roman Empire, are indeed useful for excavating a Roman identity. This is also to argue that the frequent omission of such things as art, architecture, and numismatics from the studies just discussed has left us with an incomplete, and perhaps skewed, view of Roman identity.[7] Perhaps we *can* uncover a narrative of Roman identity, a narrative that might explain why ethnic non-Romans were willing to kill and, more importantly, die for the entity that was Rome.

Let us return to Žižek. "The national Thing," writes Žižek, "exists as long as members of the community believe in it; it is literally an effect of this belief in itself" (p. 202). The question, therefore, is not whether the 'Roman' exists, but how we can locate it and understand it given its inherent contradictions and "paradoxical reflexive structure" (ibid.). Roman historians have uncovered evidence consistent with Žižek's assessment of nationhood. Braund notes that, beginning in the second century B.C., foreign kings sent their sons to Rome to be educated, and this education was much more than academic.[8] Livy's account of the education of King Ariarathes' son at Rome provides the Roman perspective: "The message of the envoys was that the king sent his son to be educated at Rome so that he might, from very boyhood, become accustomed to Roman people and Roman culture (*mores*); the king asked that they might receive him not only as a guest under the supervision of private citizens but also as a charge and student of the state."[9] Princes sent to Rome were to be immersed in public and private Roman life and instructed in Roman mores. As Braund points out, although the education of princes in countries other than their own was not unusual in this period, "Athens' dominance [as an educational center] was purely cultural: a better precedent for the education gained by kings-to-be at Rome is the education of Massinissa at Carthage, for it too had a major political aspect ... there was an intimate connection between education at Rome and succession at home" (p. 11).

Similarly, although Woolf problematizes the term *Romanization*, he also notes that for the Gauls, "learning to be Roman . . . meant learning the virtues and mores appropriate to their place in the empire of cities and the empire of friends" (1998, 104). He invites us to imagine Roman influence in Gaul "as the expansion of Roman society through the recruitment of Gauls to various roles and positions in the social order. That society reproduced itself through rituals and customs, the traces of many of which are to be found in Latin inscriptions" (p. 105). "In Gaul men literally came down from the hills, shaved their beards, and learned to bathe themselves. Nor did these changes affect only the richest and most prominent. The humblest altars and the cheapest pottery vessels testify to the creation of a new civilization" (pp. ix–x).

Although Rome may not have created "a culture of imperial uniformity" (Woolf 1998, x), it seems to have effected sweeping cultural change based on a generally identifiable set of norms and traditions. Livy's passage, like Braund's and Woolf's analyses of Roman influence on non-Romans, implies not only that one could indeed be educated in Roman culture, mores, and politics – what one might call "Roman identity" – but also that education at Rome may have lent a prince or local official a certain something, Žižek's "something more," that would have given him a political or social advantage (or both). In their use of the untranslated mores, which I understand as something deeper than simply "way of life," Braund and Woolf express themselves in terms of Žižek's intangible "something more"; they reveal their belief in Rome's "National Thing."

Tacitus' *Agricola* reveals a similar understanding of Roman identity. In fact, Tacitus uses the figure of Calcagus, who denies the possibility of Roman military cohesion, to highlight the unity of the Roman troops. Let us examine the claims of Calcagus and the subsequent response of the Roman army to British aggression:

> Or do you all believe that the Romans have as much excellence in war as they have excess in peace? They are famous on account of our dissentions and disagreements; the failings of their enemies turn into the glory of their army, an army which, composed of the most dissimilar peoples, only favorable conditions cement and which will disintegrate when the tide of war turns: unless you think that Gauls and Germans and (it is shameful to admit) many Britons, granted that they serve with their blood an alien despot, although much longer her enemies than her slaves, are held together by trust and good will. Dread and terror are unstable bonds of alliance, bonds which, when removed, will allow those who no longer fear to begin to hate.[10]

Such sentiments may inform those of Renan as he denies Rome's status as nation. Calcagus claims that Rome is a vast, imperial entity comprising diverse populations, recently conquered, likely to be resentful, and supposedly without common memories, consent, or fraternity. How could such a group of people ever form a cohesive military unit, let alone agree to kill, or more importantly die, for Rome? Calcagus imagines that the rebellious Britons will find help within the Roman army as Gauls, Germans, and Britons fighting for Rome remember their past: "In the very battle-lines of the enemy will we find our strength. The Britons will recognize their own cause; the Gauls will recall their earlier freedom; the rest of the Germans will desert them, just as lately the Usipi left."[11]

The outcome of the battle, however, is not as Calcagus imagines. Tacitus relates that Agricola's troops, his *commilitones*, or comrades-in-arms, as he calls them,[12] are brave and loyal. "Then, when the Batavi began to fire blows and to strike with their shields and to break heads and, having laid low those who defended the flats, to march the battle-line uphill, the other cohorts, striving to emulate them, cut down those nearest to them."[13] And Agricola's troops are not loyal to him alone; his battalions are even reported to have followed one another's examples, in this case, that of the Batavi. Finally, the behavior of the Romans is presented in stark contrast to that of the Britons, who fail to remain in formation and instead beat a hasty and disorganized retreat. "But when they saw our troops composed in orderly lines to strike again, they turned in flight, not in orderly groups, as before, nor looking after one another, but scattered and avoiding one another equally, they sought their remote retreats."[14]

In Tacitus' presentation, the Britons behave exactly as Calcagus thought the Romans should. Despite the diverse ethnic composition of the Roman army, the Roman troops do not break ranks, do not succumb to any mythical resentment or lack of loyalty. Apparently, they have forgotten the violence, the "brutality" by which Roman unity was created, and they act accordingly, willing to kill, and even die, for Rome. Tacitus provides evidence here of something akin to a national narrative, a narrative that recognizes and participates in the presentation of a Roman identity. In the voice of Calcagus, Tacitus acknowledges the charge of disunity within the Roman army. He then refutes that charge in the battle scene that follows, showing that the Roman soldiers (and Tacitus himself) believe in an idea of Rome.

Finally, as Lintott observes, by the second century A.D. Aelius Aristides "perceived Rome as a world state" (p. 186).[15] Oliver's 1953 edition of Aristides

records that Aristides saw Rome as a "common emporium of the world," a "common town" for the civilized world (p. 889). In fact, Oliver identifies the word "Roman" as "the label, not of membership in a city, but of some common nationality" (ibid.). As Oliver notes, the word *koinon* recurs again and again in Aristides' text with respect to Rome and the Empire (ibid.). According to Oliver's translation, Aristides goes so far as to call the Roman Empire "a World League based on democratic equality with an impartial court of law over and above that of the constituent cities" (p. 890).[16]

That Aristides' view of contemporary Rome existed, or was at least comprehensible to him, is enough to argue that Žižek's "belief" existed for Rome, that Rome had significance as something akin to a modern nation, national identity, narrative, and all. Add to Aristides' assessment the passages of Livy and Tacitus discussed earlier and the analyses of Braund and Woolf, and it becomes clear that an identifiable narrative of *Romanitas* must exist. In fact, prior to his 1998 publication, Woolf (1992, 352) asked the following:

> If the Romans had no unitary policy of Romanisation, and if local experiences were so different, how are we to explain the recognizable common features of Romano-British, Gallo-Roman and Hispano-Roman material culture, or the widespread expansion of urbanism in the west under Roman rule? Most importantly, why did all, or at least most, local elites succumb to the lure of Roman culture? The adoption of the conquerors' culture has been a common but not invariable feature of pre-industrial, as of more recent, empires. It may be that the answer lies in something *particularly Roman* about the Roman Empire, some trait or cluster of traits that will only emerge from studies of what distinguished Romans among ancient conquerors. The specificity of *romanitas* (ideologies, as well as structures, of domination) may be as important in understanding the unity of Romanisation, as the specificity of iron-age societies is crucial if we are to understand its diversity.

It is that *particularly Roman* something with which I am concerned here.

PRIMARY SOURCES

<div style="float:right;border:3px solid black;background:black;color:white;padding:10px 18px;">2</div>

The sources in which one might locate a narrative of Roman identity are copious and rich, and there are a number of reasons I have chosen imperial images of children as my body of evidence. This work stems from my 1998 dissertation in which I compiled a corpus of representations of children from the official art of the Roman Empire. The images, many of which come from Rome and its immediate surroundings, span the beginning and height of the empire, from the reign of Augustus through the Severan dynasty.[1] Few children were depicted in Roman republican art, and the political chaos following the Severan period disrupted the development of children as artistic subjects. Although never before examined comprehensively, many images of children appear on works officially sponsored or made public by the central Roman government or its ruling elite. As Gregory (1994) has noted, "scholars in other historical fields have already begun to examine how images as well as other symbols, gestures, spectacles, pageants and ceremonials – in short, the 'theatre' of political life – all interact to support, reinforce, or question political regimes. . . . [S]uch approaches have only lately made themselves felt in the study of ancient political life" (p. 81). By identifying relationships among images of children within the context of the visual language of the empire one may draw conclusions beyond those that apply to a single child, monument, or artistic genre – conclusions that relate to questions of Roman identity and Roman political ideology.

Representations of children in official imperial art are an excellent place from which to approach one of the most fundamental questions of Roman history ("What did it mean to be Roman?"), and children play an important and identifiable role in official art from the reign of Augustus at least through

the reign of Septimius Severus, yet studies of ancient children have been placed almost exclusively within larger studies of the Roman or Greek family, nearly all of which rely on evidence from literary or written sources. Gardener and Wiedemann's (1991) volume of sources in translation addresses a wide range of domestic topics from the composition of the *familia* to the education and socialization of Roman children. Rawson's *The Family in Ancient Rome: New Perspectives* (1986) and *Marriage, Divorce, and Children in Ancient Rome* (1991) include chapters covering topics from wet-nursing to inheritance. Similar studies have been undertaken by Dixon in *Childhood, Class, and Kin in the Roman World* (2001), Rawson and Weaver in *The Roman Family in Italy: Status, Sentiment, Space* (1997), Saller in *Patriarchy, Property and Death in the Roman Family* (1994), Evans in *War, Women, and Children in Ancient Rome* (1991), and Wiedemann in *Adults and Children in the Roman Empire* (1989). Other studies focus on single aspects of familial relations. Dixon examines the role of the Roman mother in her 1988 volume,[2] and Hallett explores the bond between fathers and daughters in *Fathers and Daughters in Roman Society: Women and the Elite Family* (1984).

Although these scholars and their respective, often pioneering, works have been invaluable to the study of children in the ancient world, there are two major gaps in the field of Roman family history. First, most studies do not focus on children. Rather, they address children either as one element of the family or as one aspect of a specific familial issue such as slavery, inheritance, or marriage and divorce law. The larger picture of the ancient family, while providing a context for children's history, tends to obscure the details of child life and the significance of children in their own right.

This first gap may reflect the bias of ancient literary sources, the primary type of evidence used by social historians. Roman authors occasionally address the topic of children or mention children in passing, but children are not often the focus of their attention. Most references to children in literature either refer to education or are sentimental or anecdotal rather than documentary.[3] That is, Roman authors tend not to document children and childhood consciously, as they might imperial policy or political and military events. Even in descriptions of education, where we might expect children to be the focus, it is usually the process of education rather than the children themselves, either individually or as a group, with which authors are concerned.

One of our most fruitful literary accounts of children in the public sphere comes from Pliny's *Panegyricus*, but even this passage presents children incidentally; one cannot identify children as the focus of the scene:

> On the day for giving the distribution (*congiarii*), it was usual for crowds of children, the future populace [of Rome], to observe the entrance of the emperor into public and to gather along his route. It was the job of the parents to display their little ones, seated on their shoulders, and to teach them obsequious words and flattering sayings.

> *Adventante congiarii die observare principis egressum in publicum, insidere vias examina infantium futurusque populus solebat. Labor parentibus erat ostentare parvulos impositosque cervicibus adulantia verba blandasque voces edocere.* (Pliny, *Pan.* 26.1)

Although this passage provides evidence for the presence of children at official public events and even identifies children as the future of Rome, the primary purpose of the text is to praise Trajan. Pliny is not concerned here with children per se; he does not mention the genders or ages of the children present; he does not make explicit the significance (if any) of the donative to children, nor does he indicate whether the presence of children in this case is unusual. In fact, he gives no details at all regarding the children he mentions. It is the event, the *congiarium*, that Pliny highlights in order to demonstrate Trajan's generosity. As Pliny says, *super omnia est tamen quod talis es, ut sub te liberos tollere libeat expediat* [*Pan.* 27].

While this first gap may be, in part, ancient, it has exacerbated the second gap – the neglect of archaeological and visual sources. The exclusive use of written sources by many scholars has influenced the way in which we approach and conceive of family studies. Literature, inscriptions, papyri, and legal records are plentiful and fruitful sources for children and the ancient family, but few scholars have balanced the conclusions they have drawn from written sources with detailed examinations of archaeological or visual sources, in which the evidence for children is rich.[4] In contrast to written sources, children are often the focus, or at least a crucial aspect, of images found in the official art of the Roman Empire. In fact, visual evidence suggests that children were much more visible in the public realm than has previously been thought.[5] One has only to study the Columns of Trajan or Marcus Aurelius, for instance, to note the impressive presence of both Roman and non-Roman children in official Roman art. The Column of Trajan alone contains representations of roughly fifty children.

In 2003 Oxford University Press published Beryl Rawson's latest volume, *Children and Childhood in Roman Italy*, which has helped combat both of the problems I identify here. A comprehensive look at Roman child life, the book addresses all stages of childhood from birth to death, including education and

public life, and begins with an excellent introductory section on representa-
tions of children from both public and private art. Rawson's interest in children
is unusual and her attention to material culture excellent; her focus on children
in the private, domestic, and funerary sphere provides a fitting and necessary
complement to this study.

Visual evidence is a particularly important source for the study of children
in the Roman Empire as there is clearly greater attention to children in the
art of the Empire than in that of any previous period in the Mediterranean.
A significant number of representations of children survive from both official
and private Roman imperial art, whereas the great majority of extant repre-
sentations of nonmythological children (children who do not resemble putti)
from pre-Hellenistic Greece come from funerary, miniature, or domestic art.
In pre-Hellenistic Greek art, the viewers of most art forms on which children
were represented were limited to one family or kin group.[6] While funerary
monuments were certainly visible to a wider audience than were the miniature
or domestic arts, they were funded privately.

Depictions of children from classical Greece occur most often in domestic
scenes painted on vases or sculpted in relief on funerary monuments, and a
"notable" body of child images exists on Attic *choes*, small jugs given to children
of three years of age at the *Anthesteria* (Currie 1996, 154).[7] The most famous
exception is the Parthenon frieze,[8] on which at least five children, all called
acolytes by Stewart (1990), are shown participating in the Panathenaic festival
procession.[9] Attendant boys accompany some of the horsemen on the frieze,
and a child on the east frieze, whose gender is disputed, participates in the
peplos ceremony beside the *archon basileus*.[10] In much of pre-Hellenistic Greek
art, children are shown simply as small adults. Little care is taken to explore
the child as artistic subject in his or her own right.[11]

During the Hellenistic period, the child becomes a more common subject
in both private and public or official art.[12] This trend may have resulted from
the increased sense of individualism characteristic of the Hellenistic period.
"As life became less intensely identified with, and less controlled by, small
ancestral communities," Pollitt (1986) states, "men and women began to look
elsewhere for a sense of belonging...Their search went [in part] into the
private recesses of the human mind and personality" (p. 7). The individualism
of the Hellenistic age is reflected in its art: "Much of the distinct character of
Hellenistic art stemmed from an interest among Hellenistic sculptors, painters,
and even architects in exploring the inner experience and inner nature of the

individual" (p. 8). Hellenistic artists' new interest in the human experience and individuality may have inspired them to explore the realm of children and childhood in their art.

The increased artistic attention to children in the Hellenistic age, however, was not simply the result of individualism, realism, or experimentalism. It also stemmed from what has been termed the Hellenistic "rococo," an artistic interest in the light-hearted or playful (p. 127). As Pollitt points out, "playfulness and light-heartedness are qualities generally ascribed, whether rightly or wrongly, to children, and it is quite natural that Hellenistic artists' particular fascination with children should be seen as one aspect of a desire to capture these qualities in art" (p. 128). The popularity of putti, or cherubic winged figures, in Hellenistic art reveals the ideological connection between the child and the ethereal. Currie claims that the putto was the perfect child, for "it was divine . . . the most purely aestheticized type of child, occupying a perfect and unchanging realm of art" (p. 154). Putti were often used in sculptures of mythological scenes or as decorative features in architectural sculpture, and many freestanding examples of Hellenistic putti are known from Roman copies, many of which functioned as garden ornaments or fountain figures.

While the Hellenistic period saw an increase in the number of children and childlike figures being portrayed in public or official art, it was not until the Roman Empire that realistic children of all ages and status groups began to be portrayed widely in public and official art. Manson (1983) argues that the young child, between the ages of three and seven, "emerged" in Rome during the late republic and early empire as a factor in literature and, in particular, as a person to be educated. While Manson views this emergence primarily within the context of education and literature, he points to art as a medium in which young children also became more prominent during the empire. He contrasts the emergence of the young child during the empire with the dearth of references to the young child in the literature and art of the republic. While Manson claims that the young child takes a new place in Augustan ideology, he mentions the visual arts only briefly.

Currie supports Manson's assertion with her claim that "Roman art in the imperial period placed the child at the centre of its public visual culture" (p. 154). Roman artists may have borrowed the Greek method and style of depicting children, but she holds that "the politicisation of the child's body was a [Roman] innovation" (ibid.). She attributes this new interest in the child's body to what she terms the "process of Empire," a process that relied in part

on the analogy between "Italy's relationship with the provinces and adults' relationship with children . . . in which both citizenship and adulthood are of necessity penetrable and unfixed categories" (p. 181). Currie sees in the art of the Roman Empire a tendency to incorporate children into the visual messages sent by the Roman ruling elite to the Roman people. As Currie points out, children often represent the disempowered in those visual messages.[13]

In her study of freedmen's funerary art, Kleiner provides additional evidence that the awareness of children as individuals increased during the first century A.D., when children began to be depicted outside the context of family groups. "In the late Republican and Augustan periods," she writes, "a dead child was generally depicted in a group portrait with parents who were still alive, but from the Tiberian period on, children were commonly honored with monuments of their own" (1987, 74). She suggests that this "new emphasis" on the individual, including the child as individual, reflects an increasing wealth and independence among freedmen and their descendants, as well as a new interpretation of the spirits of the dead, the *manes*, as souls of individual people (ibid.).

Augustan family legislation, combined with Julius Caesar's earlier emphasis on the Roman family, must have contributed to the growing popularity of children in public imperial art as well. In an agrarian law of 59 B.C., Caesar offered allotments of land to fathers of three or more children.[14] Augustus brought the private life of Roman citizens into public view with the Julian Laws on adultery and classes permitted to marry and the Papian-Poppaean Law. Although the efficacy of these laws is debated, it is clear that they opened family institutions and reproduction to new public scrutiny; we might say that family issues became less private during the reign of Augustus. A century later, alimentary programs may have influenced the number of child images that appear in public art, although, as I show in Chapter 3, scholars have become overly focused on Trajan's *alimenta*.

The reasons for increased interest in children as artistic subjects during the Roman Empire are numerous and complex, but the best way to approach the resulting imagery is quite simple. One must examine and compare as many child images as possible. Naturally, the numbers of children depicted in public art fluctuate during the course of the empire, but children have a consistent presence in official art from the reign of Augustus at least through the reign of Septimius Severus. This conclusion itself is important for the fields of classics and art history. We must, however, move beyond simply noting the impressive

presence of children in Roman art to assess the significance and meaning of child images. A detailed examination of the artistic contexts in which children are depicted and of the roles children play in those contexts will allow us to identify the role of children in the visual presentation of a Roman imperial ideology and a narrative of Roman identify.

I have encountered no study with aims similar to mine, although Currie and Rawson both use images of children as their primary evidence.[15] In her chapter titled "The Empire of Adults: The Representation of Children on Trajan's Arch at Beneventum" in Elsner's *Art and Text in Roman Culture* (1996), Currie "explore[s] the range of uses to which the child's body could be put in Roman monumental art" (p. 153). Currie limits her study to the arch itself, the Column of Trajan, and the Ara Pacis in an attempt to demonstrate that Rome's "dominion over its empire found a parallel in the dominion of adults over children" (ibid.). Rawson's "The Iconography of Childhood" is published in Rawson and Weaver's (1997) *The Roman Family: Status, Sentiment, and Space*, and her "Children as Cultural Symbols: Imperial Ideology in the Second Century" appears in Dixon's (2001) *Childhood, Class, and Kin in the Roman World*. In the earlier chapter Rawson claims that "[c]hildren are highly visible not only in the art of ancient Rome but also in its law and, to some extent, its literature. This reflects an active consciousness and high valuation of children and childhood in Roman society" (p. 206). She examines a small group of images from public and private art, following her belief that "an analysis of representations of children in all these media may illuminate further the role of children and attitudes to them in that society" (ibid.). In the later chapter Rawson explores the visual evidence for imperial ideology in the second century, arguing that "children were an important element in the promotion of the ideology of imperial generosity and care for the population. That ideology was promoted through many activities and diverse media, but nothing was more persuasive than the display of concern for children. This concern was conveyed not only through specific programmes but also through the visual impact of sculpture in prominent public places, and coinage of wide circulation" (pp. 37–8). As noted earlier, Rawson's most recent volume, *Children and Childhood in Roman Italy*, contains an introductory chapter on the representation of children in Roman art.

Each of the works mentioned makes a valuable contribution to the study of children in official art, but much remains to be done. While I have found the work of Currie and Rawson helpful for my research, their studies of official images are brief and, for the most part, preliminary; they serve as excellent

introductory forays into a virtually untapped field of evidence, but they do not address the question of children in official art comprehensively or in much detail, nor do they aim to view such images over time. Furthermore, no study has approached the wide range of child images comparatively and within the context of the artistic language of the empire. Most important, while Currie makes a move in this direction, no study has sought to illuminate imperial ideology by examining images of children in official art. Images of children in official Roman art have much to tell us about the attitude of the Roman ruling elite toward its own people and those still on the margins. Through its comparison of child images with particular attention to status and ethnicity, this study forces a reevaluation of modern notions of *Romanitas*. The study of children in Roman official art is a void that needs to be filled, and I have set to work on that task here. In official imperial images of children we may begin to understand what it means to be Roman.

METHODOLOGY

In her anthropological study, *Art as Culture* (1985), Hatcher notes that while art is generally assumed to help hold society together, there are three theories as to how this is accomplished. According to Hatcher, art helps hold society together (1) "because of its psychological functions – essentially it acts as a safety valve, channeling discontent, disruption, and excess energy"; (2) "by the aesthetic pleasure it provides, especially when people are gathered in large groups"; and (3) "because it reflects and reinforces the relationships deemed proper in that society; art symbols are collective representations which by their form and content are shaped by and help shape the social order" (p. 113). Although Hatcher claims that art functions in all of these ways simultaneously, it is the third modality that is most applicable to official Roman art. This third modality can be used in industrial society to help promote social change (pp. 120–1), but this was probably not the case in Rome, where images were regulated by the Roman state. Official imperial imagery was certainly intended to reinforce the political and social order.[16]

Zanker's definition of visual imagery provides insight into the purpose of public art at Rome, specifically. Zanker claims that "through visual imagery a new mythology of Rome and, for the emperor, a new ritual of power were created" (1988, 4). Zanker's observations are meant to apply only to the Augustan period, but he provides an excellent working definition of political imagery or

propaganda. Zanker, however, is careful to avoid the term "propaganda." He does not believe that Rome had an intentional or self-conscious "propaganda machine" (p. 3) at work but that visual imagery at Rome arose with relative spontaneity.

Evans is somewhat less circumspect. In *The Art of Persuasion* (1992) she examines propaganda in ancient Rome, defining propaganda as "the educational efforts or information used by an organized group that is made available to a selected audience, for the specific purpose of making the audience take a particular course of action or conform to a certain attitude desired by the organized group" (p. 1). Evans follows Ellul, who first divided propaganda into "overlapping categories of agitation versus integration, horizontal versus vertical, and rational versus irrational" (ibid.).[17] Whereas Ellul claimed that the propaganda of integration did not exist before the twentieth century, just as modern political theorists see the concept of "nation" as modern, Evans believes that it could apply to Rome (p. 2). The propaganda of integration is "a propaganda of conformity," designed to make "the individual participate in his society in every way" (Ellul, 74–5). Evans finds, as we might expect, that in addition to its integrative function, Rome's propaganda was largely vertical: that is, it was produced by "the leader [in order] to influence the audience" (Evans, 2).

Evans notes that the use of art as visual propaganda at Rome was a useful way to overcome the illiteracy rate, which would have prevented many from accessing written forms of propaganda, and Gregory (1994) supports her theory. "In a world in which literacy was to a large extent limited to the intellectual and social elite, this kind of visual communication was of paramount importance" (p. 83). Ancient authors recognized this fact as well. In the *Ars Poetica*, Horace, as translated by Gregory, says, "what the mind takes in through the ears stimulate it less vigorously than those things which are set before the eyes and which the spectator can see and believe for himself" (ibid.).[18]

I have used three basic criteria in defining a work of art as official: (1) the patron, (2) the viewer, and (3) the message or function of the work. Because official art is often commissioned by the Roman state, the patron may be the emperor himself or a member or members of the Roman ruling elite. Official art is usually displayed in public space and accessible to a wide audience. Finally, official art participates in a narrative of Roman identity, and one may identify a certain number of themes, motifs, and stock elements as "official." Although my corpus focuses on works of art from Rome and its immediate surroundings, I also include a number of images from the provinces, because

the official art of the provinces parallels official art of Roman provenance in
its patron, viewer, and message or function.

We cannot always determine the patron of a particular piece of art, making
the first criterion problematic. Augustus' *Res Gestae* reports that the Senate
commissioned the Ara Pacis Augustae to be consecrated upon the return
of Augustus from Spain and Gaul.[19] An inscription on the Arch of Trajan
at Beneventum identifies the arch as a dedication to the emperor from the
Senate and People of Rome.[20] It is nearly impossible to determine the patron
of a work of art without such an explicit literary reference or inscription, but
scholars do speculate. Lepper and Frere hold that "in the case of the Column
[of Trajan], it [is] expedient to speak of Patrons and Artists in the plural: the
ostensible dedicators were the Senate and the People of Rome, and we do
not know how many artists were involved. It remains plausible to maintain,
however, that on each side there was a single 'protagonist', – Trajan and
Apollodorus" (p. 16). We may assume that in the majority of cases, triumphal
arches and other monuments that recorded an emperor's political activities
or the details of historic or military events were commissioned either by the
Senate and People of Rome or by the emperor himself.[21] As Kleiner notes, "In
the Roman milieu, it was the patron who had the most significant impact on
the appearance of a work of art" (p. 4).

Determining the audience of a piece is much easier. We can assume a wide
audience for monumental works of art erected in public spaces. While official
art is often considered synonymous with monumental art, official art necessar-
ily includes all works of art commissioned, funded, or distributed by the state,
including coins. In his *Art in Coinage*, Sutherland (1956) claims that while the
first purpose of coins is to serve as an economic commodity, "the hard cash
designed for the practical business of hand-to-hand exchange," coinage is a
"pre-eminently social art" (p. 15). As he notes, while the small scale of coins
has confined them largely to the realm of the miniature arts, causing the art
history of coinage to be neglected, the scale of coins is a matter of practical
convenience and should not have bearing on their art-historical value (p. 16).
Hill (1989) also acknowledges the value of coins to students of Roman art,
architecture, and topography,[22] and Foss (1990) has compiled a catalogue
of Roman coin types to "make correlation between Roman history and nu-
mismatics easier by identifying and listing coin types which refer to history"
(p. ix). "Coins," Foss writes, "provide a survey of a kind of late Republican
and imperial propaganda, designed to be seen and widely circulated. They

should therefore reflect the image which the government of the day wanted to present to its subjects" (ibid.). Likewise, Brilliant acknowledges the importance of coins to imperial propaganda, noting that even Otho, emperor for less than one year, took advantage of coins as a medium through which he might present his ideology to a wide audience (p. 88).

The third criterion, the message of a work of art, is a slippery one. As Gregory (1994) has shown, we cannot assume political images had the desired effect on their audience even if we can determine that original desire.[23] Gregory uses literary evidence to document responses to political images. In particular, he cites the case of Sextus Titius, who was convicted of treason in 99 B.C. in part because he had an *imago* of the "radical" tribune Saturninus in his house (p. 90). Cicero reports that the judges regarded a person possessing images of seditious men to be a citizen of questionable value (ibid.). Cicero also states that such an image could incite the ignorant masses to pity and imitate the radical tribune [*Rab. perd.* 24]. As Gregory concludes, "in Cicero's observation we have an obvious reference to the so-called 'affective' and the 'cognitive' components in responses to symbols. . . . The masses, Cicero points out, responded emotionally, while the educated man draws upon his accumulated knowledge about the figure represented to respond with a mixture of sentiment and cognitive appreciation" (p. 91).[24]

Gregory demonstrates well the range of responses that could exist for one image. Unfortunately, with few exceptions, we cannot know how an ancient audience received specific works of art. Fortunately, for my purposes, just as it does not matter that the top of the Column of Marcus Aurelius would have been a virtual blur to those on the ground or that coins are too small or too susceptible to wear to have had the same visual effect as the Arch of Trajan, it does not matter that the responses of ancient audiences are lost to us. Artistic intention exists independently from accessibility and reader response.

Of course, it can be just as difficult to reconstruct artistic intention as it is to reconstruct reader response. This fact stems from the primary difficulty classicists face: Our own cultural biases and radical distance from the societies we study limit our ability to reconstruct those societies with certainty. Just as we cannot assume political images had the desired effect on their audience, we cannot claim to have a direct line to the intention of Roman artists and their patrons. We can (and should), however, strive to determine what the desired effect of an ancient work of art might have been. It is the intended message of the image that is most important for uncovering a narrative of Roman identity.

The images that the emperor and his ruling elite chose to display in public were certainly meant to convey messages. Arguably, these messages were related to the goals of the ruling elite at the time, goals that may have included such things as the glorification of traditional Roman culture, the family, and the emperor, and the advertisement of the conquest of new territory and the prosperous future of Rome. Whether we call them propaganda, cultural symbols, or part of a national narrative, it is clear that, regardless of their actual effect on ancient viewers, official images were intended to influence the attitudes or the actions of their audience in a manner deemed appropriate by the Roman ruling elite.

The existence of recurring themes, motifs, and other artistic elements in official imperial art supports this claim. In fact, certain elements recur so frequently that scholars have felt confident identifying the messages those elements send. These recurring elements provide not only a framework within which to view official images but also general tools with which to identify the messages of official images. Hannestad (1988) documents the use of such elements in reference to representations of processions, in particular. He cites a triumphal painting from the Esquiline, now in the Palazzo dei Conservatori in Rome, claiming that the representation contains "a typical feature, which often recurs . . . in Roman historical representations like state reliefs or coins, the hierarchic depiction of persons, who vary in size according to their importance" (p. 37). Similarly, Kampen, who examines Roman historical reliefs, defines her body of evidence as "sculptures whose subject matter focuses on official events and personages. These reliefs were usually made for public rather than private consumption and often had the patronage of government or state officials" (1995, 46). Kampen's definition of "historical reliefs" is reminiscent of Kleiner's assertion that in Roman art, the finished artistic product could be traced back to its patron.

Although the work of Kampen, Kleiner, and Hannestad provide excellent parameters for defining images as "historical" or "official," they do not go far enough toward illuminating the purpose and power of such images. Certainly official images could celebrate or document official events and personages, as Kampen implies. We may also assume that such images were intended to glorify their patrons. It is in its creation of an official memory, however, that the real power of official art lies. Official images make tangible for a diverse public audience an official version of events and personages. Moreover, official images were not necessarily intended as realistic depictions of specific

events or people. As Andreae says of the friezes on the Arch of Septimius Severus, "[u]nlike pictorial reportage . . . [the friezes] do not depict historical events but instead follow earlier public monuments in presenting certain general principles as embodied in the traditional guise of a public act or ceremony" (1977, 274). Thus, whether they seem to depict historical events realistically or are based rather on some traditional composite of such events, official images create a finite, monumental, and nearly indestructible memory of events and personages for their viewers from the perspective of those in power. In their creation of official memories, particularly in a world in which other forms of literacy were severely limited, official images hold the power, as Ellul put it, to "provoke . . . conformity and stability and . . . to make 'the individual participate in his society in every way'" (pp. 74–5).[25]

My primary methodological goal in compiling a corpus of images and organizing this study was to let the representations of children divide themselves into categories. I have tried to approach each child image individually, often separately, at first, from other images on the same monument, and then in comparison with those and other child images, asking, "What is the function or role of *each child?*" I allow for the possibility that on one monument the role of children can change from scene to scene, as I believe is the case on the Ara Pacis and on the Columns of Trajan and Marcus Aurelius. As Gregory (1994) states, "*individual* images could convey meaning or evoke recognition and response by the way in which the subject was rendered, through attributes, costume, posture, and so on" (p. 84).[26] I look first at the child's costume to identify the status of the child. I also examine the artistic context in which the child appears to identify the role or function of that child.[27] The settings and scenes in which children appear, the media in which they are rendered, and the monuments on which those scenes are depicted all help to determine how images of children function within each artistic context. I note the composition of the scene in which the child appears and the gestures and gazes of the figures within that composition. Finally, I use similar gestures and parallel compositions to create coherent groups of images.

As Brilliant says in his examination of gesture and rank in the imperial period, "art depended heavily on gestures as a ready device of visual distinction" (p. 103). He continues:

> The symbolic gesture was used in works of art as a principal instrument of status identification because gestures were familiar social acts and their

significance was accessible to all. . . . The denotation of status through ges-
tures is an iconological problem which is intimately connected with the
aesthetic purposes of the Roman monuments . . . [Gestures'] deliberate and
intensive use by Roman artists . . . arises from the congruence of two pe-
culiarly Roman traditions. The first of these is an aspect of the rhetorical
training which conditioned the form and character of education, especially
for the future personages of the state. . . . As gesture was an intrinsic part
of public speaking, its telling use by the speaker . . . encouraged the growth
of formal conventions. . . . In addition to their rhetorical training, Roman
taste in the theater heightened their appreciation of the expressive power of
gestures. . . . The profound reliance on the power of visual communication
through gesture is the foundation of the mimetic art, the gesticulate sub-
tleties of oratory, and of the aggressive force of the politician's uplifted arm,
thrown out like some elocutionary missile. (pp. 9–10)

Whereas Brilliant is optimistic about the potential of gesture both to hold
meaning and to convey that meaning to a modern audience, Beard's (2000)
work on the Column of Marcus Aurelius has illuminated thoughtfully the
difficulty of deriving meaning from gesture. She claims that the "'language' of
gesture is *our* language, written and spoken . . . the language into which it is
translated by those who describe, read, or claim to interpret it" (pp. 267–8).
Using a child image from the Column of Marcus Aurelius interpreted by
Petersen and colleagues (1896) as a joke but by others, including Zanker
(2000), as an image of striking violence, Beard demonstrates the slippery
nature of the language of gesture, claiming bluntly, in fact, that "gesture *is*
no language" (p. 278). She suggests that the problem of gesture might be
mitigated, for this image in particular, by placing the image within the context
of the surrounding scenes on the column. This would certainly help. I suggest
that the problem of gesture is further mitigated by addressing comprehensively
and comparatively the images from which those gestures come, placing them
within the context of a larger visual language. When one treats the image in
question not only within the context of those images that surround it on the
column but also within the context of all other images of children in official
imperial art, a language of gesture, however tenuous or preliminary, does begin
to emerge.

In her defense, Beard's paper does not descend into nihilism – quite the
opposite. In fact, her conclusion states that her "paper has *not* been about
our repeated *failure* to read gesture; it has *not* been about the impossibility of
understanding gestural representations. Paradoxically, quite the reverse. It has
been about the fleeting, fragile, enticing *possibilities* of reading and interpreting

the (represented) body in action. The repeated fragility of our interpretations, the constant denial of certainty, the prompts to *re*-narrativise and *re*-interpret, to look again, and to *look harder*, are all part of this hermeneutic game" (p. 278). I have made my attempt to *look hard*, and I present here *my* reading, *my* interpretation.

WHAT IS A CHILD?

It remains, finally, to clarify our definition of child. Any society's concept of childhood must be understood as a complex combination of biological, social, practical, and legal criteria unique to that society's limited cultural and temporal space.[28] Carp (1980) holds that two factors put scholars of ancient history at a particular disadvantage for studying children. First, as noted, there exists an ancient literary bias that favors depicting adults and adult activity over children and their activities; second, ancient authors confuse the issue by recording age imprecisely. Carp finds that terms such as "child and children, depending on context and literary convention, were used to describe persons ranging in age from birth to senility" (p. 736). Carp boldly holds that "it was almost as if infancy and childhood were of no interest to the ancients" (ibid.). Plecket (1979) goes so far as to claim that the Romans had no concept of youth.[29]

Eyben (1981) doesn't see the issue as bleakly, although he is primarily interested in the nebulous period between childhood and adulthood known as "youth." He attempts to refute Plecket's claim, arguing that at least as early as 200 B.C., a period of youth existed as a "bridge between childhood . . . and adulthood" (p. 349). Eyben implies that the Romans not only acknowledged multiple stages of preadulthood but that some definition of childhood, generally accepted if not tangible, must have existed for the Romans.

Although Carp, Plecket, and Eyben illuminate myriad issues concerning the Roman concept of childhood, they address only literary and legal sources. What is more, Eyben and Plecket are concerned only with wealthy males aged fifteen to thirty during the republic and fifteen to twenty-five during the empire.[30] Even if Romans agreed on a clear definition of child or childhood at some point in Roman history, definitions no doubt changed over time. Eyben claims that "at an early period it was perhaps the case that a young Roman, having put on the *toga virilis*, was considered a full-fledged member of society and acted as an adult . . . [but] around 200 B.C., laws were passed whereby a young man had to be well into his twenties before he was

fully accepted by society legally, politically, and undoubtedly also militarily"
(p. 349).[31] Eyben demonstrates that the ambiguities surrounding the tran-
sition from childhood to adulthood caused what he terms the "transitional"
status of "youth" to become a "constant" in the Roman world (ibid.).

Some have explored the theory that the term "child" simply indicates one
deprived of knowledge or (or, thereby) power. Such theories may follow
explicitly the work of John Locke or Michel Foucault. In *The Second Trea-
tise of Government*, Locke, after Hooker, makes the following observations on
childhood:

> (Though I have said above (Chap. II) that all men by nature are created
> equal.) Age or virtue may give men a just precedence. . . . Children, I confess,
> are not born in this state of equality, though they are born to it. . . . The bonds
> of this subjection are like the swaddling clothes they are wrapped up in and
> supported by in the weakness of their infancy; age and reason, as they grow
> up, loosen them, till at length they drop quite off and leave a man at his own
> free disposal. . . . But if, through defects that may happen out of the ordinary
> course of nature, anyone comes not to such a degree of reason wherein he
> might be supposed capable of knowing the law and so living within the rules
> of it, he is never capable of being a free man. . . . And so lunatics and idiots
> are never set free from the government of their parents.[32] (pp. 31–2)

In Locke's model, various stages of childhood might be marked by the dis-
closure of previously taboo knowledge. When a child is told the truth about
human reproduction, for example, he or she moves to a more advanced stage
of childhood. Locke, however, also acknowledges a category of people ("lu-
natics and idiots") who never reach the age of reason and therefore never
move beyond the legal status of child.

In *The Use of Pleasure*, volume 2 of *The History of Sexuality*, Foucault creates a
similar model in which sexual ethics "define the man":

> From this viewpoint, and in this ethics (always bearing in mind that it was a
> male ethics, made by and for men), it can be said that the dividing line fell
> mainly between men and women. . . . But more generally, it fell between what
> might be called the "active actors" in the drama of pleasures, and the "passive
> actors": on one side, those who were the subjects of sexual activity . . . and
> on the other, those who were the object-partners, the supporting players. . . .
> The first were . . . adult free men; the second included women of course, but
> women made up only one element of a much larger group that was sometimes
> referred to as a way of designating the objects of possible pleasure: women,
> boys, slaves. (p. 47)

Foucault's criterion is not reason but sexuality: the only fully legal adult actors in his model are "adult free men." All other sexual actors, "women, boys, slaves," have limited power in the world of sexuality (and the legal world). If we accept Foucault's analysis, there is a level on which all women, boys, and slaves in the ancient world might be considered children.

The theories of Locke and Foucault find specific support in the Roman period with the literary topos of the *puer senex*, a figure in whom old age and childhood are "telescoped" because of perceived similarities in intellectual innocence and physical features (Carp, 737). The *puer senex* figure transcends the accepted physical, psychological, and sociological boundaries of age. These theories also find support in the fact that during the classical period, the term *puer* could apply to all "junior members of the Roman household," including both the freeborn children of the *paterfamilias* and the household slaves, regardless of age (Wiedemann 1989, 33).

The preceding discussion notwithstanding, there is some evidence for an- cient interest in the practicalities of childhood preceding even the Roman period. Aristotle's *Politics* outlines a method by which human life is divided into seven-year periods.[33] He prescribes that children in the first division (zero to seven) must be reared at home, further subdividing that division into ages zero to two and two to seven (sections vii–xv). Aristotle also prescribes two periods of education, the first from age seven to puberty, and the second from puberty to age twenty-one (ibid.).[34]

The Romans separated childhood into similar stages marked by a system of rites of passage. After the father accepted the newborn child by lifting him or her from the ground (*tollere*),[35] the first rite of childhood occurred on the *dies lustricus*, the day on which a child was named, the ninth day after birth for boys, the eighth for girls.[36] Quintilian asserts that the education of a child should begin *ab infantia* (*Inst. Orat.*, I, *Prooemium*, 5), opposing others, like Aristotle, who claim that education should not begin before age seven and demonstrating an awareness of, if not an interest in, stages of childhood and activities appropriate to those stages.[37] For boys, the donning of the *toga virilis* was an important rite of passage as well.

With these issues in mind, we must arrive at a working definition of "child." I have attempted to limit this study to prepubescent children, thus eliminating the necessity for debates on "youth." I am not concerned with the transitional stage from childhood to adulthood but rather the period from infancy to puberty, approximately the first two seven-year periods, and I include only

those children who are too young to be marriageable. As my primary sources
are visual, I define puberty for both boys and girls via physical attributes. I
exclude from this investigation boys with any trace of facial hair or chest
musculature and girls with breast development. I also generally exclude boys
wearing the *toga virilis*, although, as we shall see, artistic conventions allow pre-
pubescent children to wear the costumes of Roman adults in certain contexts.
I consider height, body frame size, face shape, and body fat as well, but lack
of detail occasionally requires me to estimate a child's age from size or height
alone. As a result, I favor representations of small children with round faces
and bodies, such as the controversial child from the north side of the Ara Pacis
(Fig. 62).

Withee (1992, 336) has used modern medical texts to extrapolate the ages
of children in the late Bronze Age fresco fragments from Thera on the basis
of their physical characteristics and hair growth, cutting, and regrowth. She
argues that modern medical criteria can be applied to the children in the
frescos. Pollini (1987) has estimated the ages of the children on the Ara Pacis
using both modern and nineteenth-century growth charts to counteract the
effects of modern nutrition on children's bodies. His findings indicate that
there is a consistent ratio between the sizes of children at various ages and the
sizes of adults of the same time period (p. 22). For instance, a two- to three-
year-old boy is normally half the size of an adult male, a ratio consistent with
Pliny's findings in his *Natural History* (p. 23).[38] Although Pollini's and Withee's
findings support my methodology, I remain cautious. While I do not assume a
Roman child would necessarily correspond in physical size and development
to a child of the same age raised in a developed country during the twentieth
century, I make rough estimates of children's ages based in part on Pollini's
and Withee's conclusions.

Gender inequities during the Roman Empire make impossible a comprehen-
sive definition of childhood based on age. Generally, boys were considered
adults when they donned the *toga virilis* and girls when they married.[39] Both
distinctions correspond roughly to puberty, but whereas boys assumed the
toga virilis around age fifteen, there was no corresponding aspect of costume
that marked a girl's age.[40] According to the Julian and Papian-Poppaean Laws,
boys were expected to marry and produce children by age twenty-five. Girls,
by the same legislation, were expected to marry and have children by age
twenty, but girls could be married much earlier.[41] Moreover, while the head
of a family could appoint guardians for male children only up to the time of
puberty, a guardian could be appointed for a female at any time, regardless of

marital status, and even married women could remain under the *ius* of their fathers.[42] Was a male child a "child" during the duration of his bachelorhood, despite the fact that he did not have a guardian? Was a female child a "child" when she married? Was she a "child" when she had her own children if she was still under the guardianship of another? Did the concept of "youth" exist only for male children? As has become obvious, a female's status as "child" was much more problematic than a male's. Female children were not defined by costume or age during the Roman Empire as much as by marital status, and even marriage could not necessarily prevent a *paterfamilias* from appointing a guardian for his daughter.[43]

Gender presents myriad philosophical issues to the student of Roman history, and it brings an immediate difficulty to this study in particular. Just as it is sometimes difficult to determine the age of children in official representations, it is also sometimes difficult to determine a child's gender, especially because both male and female children are shown wearing the toga. An early-second-century A.D. marble portrait of a child from Wales, now in the Museum of Fine Arts in Boston, provides an excellent example of a child whose gender cannot be determined despite its excellent state of preservation.[44] As Kleiner and Matheson (1996) note, "the gender [of the child] remains ambiguous since many of its characteristics can support either a male or a female identification" (p. 143). The child wears the long hair usually associated with girls, yet it is unbound, a feature common to boys' hair. In addition, the child has Trajanic bangs and the longer hair often worn by young boys in the Trajanic period. On the other hand, the child seems to wear the stola and palla, the costume of married, Roman women. The child's gender remains mysterious, as does the purpose of the representation.

Although they will not be addressed specifically in this study, *camilli* and *camillae* also illustrate well the ambiguities surrounding children and gender. Beginning with the Flavian period, *camilli/ae* have typically female hairstyles, often wearing long, flowing curls, yet scholars consistently identify them as male. The debate is apparently fueled by the agendas of those who participate in it. Judging from the hairstyles of *camilli/ae*, I see female children participating in an important ritual, whereas other scholars, for other reasons, see *camilli/ae* as unquestionably male.[45] The possibility exists that the gender of these children may simply be impossible to determine.

The gender of these children, however, may just as likely be indeterminate. That is, the distinction between a male and a female child may not always have been important to Roman artists. Currie notes the frustration with which

scholars have approached anonymous children in Roman art, preferring to attach a specific name and identity to artistic subjects. She concludes that "such ambiguities reinforce the impression of the child's body as poised between centrality and marginality and between past and present" (p. 157). Perhaps, but it may be simpler than that. It may be that the ambiguity surrounding some children's identities is related to the ambiguous gender of other children. In these cases, just as we may not always be viewing a little *Julia* or a little *Ahenobarbus*, specifically, we may not always be viewing a *female* child or *male* child, either; we may simply be viewing a *child*. As de Beauvoir says, "one is not born, but rather becomes, a woman . . . it is through the eyes, the hands, that children apprehend the universe, and not through sexual parts" (p. 267).

Language supports the possibility that the gender of children in visual images could be ambiguous, perhaps even intentionally so. The most common Latin word for freeborn children is *liberi*, a masculine plural that included children of both genders. Slave children are called *servi*, again a non-gender-specific term. The next most commonly used word for child is *puer*, now commonly translated "boy," but which could apply to household slaves of all ages and genders.[46] This usage expresses the power relationship between the *paterfamilias* and those under his control rather than an age difference, illustrating the preference of the Roman language of childhood for status over gender distinctions.[47] Whereas male and female children are both known as *liberi*, free children are never called *servi*.

Wiedemann points out that grammarians argued into the first century B.C. over the correct way to express "child" in the feminine, using both *puera* and *puella*.[48] Eventually, *puella* became the accepted term, but "there is no conclusive evidence that *puer/puella* replaced *liberi*" as the commonly used term for freeborn children (1989, 32–3). Moreover, the term *puella* came to mean both "girl" and "woman." When Catullus calls Lesbia his *puella* (3.3), we do not imagine that he is addressing a child; he is calling her "babe." Finally, although Latin uses other gendered terms such as *natus/nata* and *filius/filia* to describe children, it uses equally as many, if not more, nongendered terms. Words like *propago*, *stirps*, and *fetus* are taken from agricultural terminology, while *progenies* and *posteritas* refer to a collective group of descendants (Wiedemann 1989, 33–4). Gender was certainly not the focus of Latin terminology for children. Therefore, it seems likely that some representations of children in official Roman art are intentionally indeterminate with respect to gender.

Physical markers of ethnicity and status provide additional layers to the complex definition of "child" during the empire. The best indication of a child's ethnic status in Roman art is his or her costume and hairstyle.[49] Citizens were careful to display their own status through their costume and jewelry, and there were restrictions placed on the garb of non-Romans, as well as on the garb of Roman citizens of low status. Just as Roman citizens and their children had the exclusive right to wear the *toga pura*, the *toga praetexta* was originally reserved for the sons of noble families.[50] Macrobius reports that during the Second Punic War, the right to wear the *toga praetexta* was granted to the sons of freedmen, but it is not clear whether this policy was continued after the war.[51] Roman citizen children of higher status wore gold *bullae*, while Roman citizen children of lower status wore *bullae* of leather,[52] and a certain type of shoe, the *mulleus*, was reserved for patricians.[53] In addition, Romans never wore leggings, considering such to be the costume of barbarians and foreigners.[54]

In Roman art, non-Roman children often wear tight caps or diadems, distinctive boots, and short tunics with leggings or capes, clothing that is easily distinguishable from the *togae*, *bullae*, and sandals of Roman and imperial children.[55] In addition, both male and female non-Roman children, like non-Roman adults, often have long, unbound, curly hair, whereas Roman boys are depicted with neatly styled, often close-cropped hair, and Roman girls wear hairstyles similar to those of adult Roman women. I classify as non-Roman all children whose costumes identify them as barbarian (non-Romans hostile to Rome), alien (non-Romans living in Rome or Italy), or peregrine (non-Romans living outside of Rome).[56] While alien and peregrine non-Romans may appear "Romanized" and nonhostile and may, in some cases, even have been granted Roman citizenship, I judge them to be non-Roman if they wear non-Roman costumes and hairstyles. Whatever their true legal status, children depicted in non-Roman costume in Roman art are presented as foreigners.[57]

Likewise, I consider Roman costume to be an indication of Roman status. A child's "Romanness," his or her status as a future Roman citizen, is indicated in art by that child's appearance, which tended to mimic that of Roman adults.[58] All Roman children could wear the toga, regardless of gender.[59] As noted, Roman children often wear the *bulla*, a round, hollow pendant attached to a gold necklace (Sebesta 1994, 77). Slave children were prohibited from wearing the *bulla*, so if a child is shown with a *bulla*, he or she must be a Roman citizen.[60] The inverse, however, is not true: not all citizen children wore, or were depicted wearing, the *bulla*. Toynbee holds that it was acceptable for

Roman children of imperial or patrician rank to wear a collar around their necks,[61] although I have not found an example of this in extant Roman art aside from the torque, which in my estimation indicates non-Roman status.[62] Although the *bulla* could indicate Romanness, it was not a required element of a Roman child's costume. The *bulla* functions much like the torque worn by non-Roman children in that its presence implies the ethnicity or status of its wearer.

The distinction in costume and hairstyle between Roman and non-Roman children stands out clearly on the Ara Pacis. I argue in Chapter 9 for the non-Roman status of the two boys who wear torques and short tunics on the north and south sides of the Ara Pacis frieze. In contrast, the three Roman children from the south side of the frieze, for example, wear *bullae* and togas. The boys have short hair, styled like that of Augustus and the other men on the Ara Pacis, and the girl wears her hair in a bun similar to those of the Roman women on the monument. An equally striking contrast occurs over a century later in scene XCI from the Column of Trajan, addressed in Chapter 4. Roman children, in togas, with togate adults, stand at the front of the crowd. Non-Roman children accompany non-Roman adults at the rear of the group. The boy wears a short, belted tunic, leggings, and a cape, and the non-Roman girl wears long drapery, gathered in a knot at the waist like those of the non-Roman women near her. The costumes of both sets of children on the Column of Trajan mimic those of the adults with whom they are shown.

For the purposes of this study, therefore, a child may be Roman or non-Roman as assessed by costume and hairstyle. A child may be either male or female or of indeterminate gender. Finally, I consider as children those figures who are approximately one-half to two-thirds the size of adults of the same gender (if known), with round faces and bodies (again, if possible to determine), and without secondary sex characteristics or other indications of marriageability.

I exclude from this study mythological children in favor of nonmythological, veristic, children who could have lived in Rome, Italy, or the provinces during the empire.[63] One of the most important distinctions to be made for understanding the artistic innovations taking place during the Roman Empire is the distinction between mythological and nonmythological children. Currie states that "there was a tension between real children, whose distinguishing features were flux and mortality, and the putto" (p. 155). This tension exists between all real children and all mythological children, whether they appear

in the form of putti or as the children of Medea, for example. As Currie states, "the putto and child were part of the same continuum," but the putto was "divine" and "perfect" (ibid.). The putto might be understood as the paradigm of a child rather than a mortal child (pp. 154–5). Although mythological children are sometimes depicted with gestures similar to those of real children and in compositions similar to those in which real children appear, their relationship to real children is limited. Moreover, mythological and nonmythological children often serve very different purposes in Roman art. Thus, I do not include here representations of the children of Alcestis sometimes found on sarcophagi or representations of Romulus, Remus, or Ascanius as young boys. I also exclude the naked children from the Tellus/Terra Mater panel of the Ara Pacis.

I must also exclude slave children from my study because it is almost impossible to identify this group unequivocally. Roman artists employed what Kleiner and others call the "hierarchy of scale," a technique that equates the status of a figure with his or her scale (p. 227). Kleiner notes that this technique first appears in state art on the Arch of Trajan, but that "the device was already developed on earlier coins and in the reliefs of freedmen since the Augustan period" (ibid.). That is, the most important figure in Roman art is usually shown larger than the others, making slaves the smallest figures. Because height is one of the most important criteria with which to identify children, as has been shown, the hierarchy of scale makes determining the ages of slaves nearly impossible. For example, the small figures in the foreground of a banqueting scene from Pompeii are identified as slaves by their function in the scene.[64] One helps a banqueter with his shoe, one holds out a cup to another banqueter, and another helps a third banqueter vomit. While these figures are presumably adult slaves, they seem childlike because of their height.[65]

As noted, I also exclude from this study depictions of *camilli/ae*, the young acolytes of Roman state religion. *Camilli/ae* are a common component of the *suovetaurilia* and similar sacrificial scenes, and their function is illustrated by their gestures and positions in such scenes. In sacrificial scenes *camilli/ae* stand near or behind the altar; they act as attendants, often pouring libations or presenting incense to a priest. Because *camilli/ae* perform a specific set of narrowly defined duties as official participants in the imperial cult, are represented in nearly identical contexts in at least forty works of art, and present gender difficulties unique to their religious office because of their costumes and hairstyles, I do not address them here. I find the problem of *camilli/ae* too

broad to address in a study intended to explore questions of Roman imperial identity and ideology using child images.[66]

Finally, just as I exclude children who can be identified as mythological, I also exclude children who can be identified clearly as members of the imperial family. Although imperial children were included in my dissertation, I have decided that they are a unique category and must be considered separately from the children addressed here. My current interest is in the anonymous, mortal child who stands for the future in a general way and participates as a symbol in the visual narrative of Rome's identity. Imperial children are specific heirs to specific offices, with specific duties and responsibilities, and I believe that their images are intended to produce specific responses; they are not anonymous and therefore not meant to be generalizing. Included within my category of imperial children are many of the young figures portrayed on coins with Venus Genetrix, Pietas, Felicitas, and similar personifications. Thus, the corpus of images compiled here includes only representations of nonslave and nonmythological children who do not function as *camilli/ae* or similar religious attendants and cannot be identified with certainty as members of the imperial family.

IMPERIAL LARGESSE

<div style="float:right; border:2px solid black; padding:8px;">3</div>

R oman children are depicted in much of the extant official art of the
Roman Empire, and with a few notable exceptions they always appear
in public gatherings before the emperor.[1] These gatherings may be divided
into two general categories: scenes of imperial largesse and scenes of other
official events. The depictions of Roman children addressed in this and the
following chapter adumbrate the type and magnitude of the role Roman chil-
dren played in public life, providing evidence for an imperial definition of
Romanitas.

Compiled in this study are representations of approximately sixty-five
Roman children in scenes of public gathering. The sheer number of child
images demonstrates the visibility of Roman children in public, and the visual
evidence shows that children played an active role in public life. Children
were present at public gatherings not only as observers within the family unit
but also as active participants in their own right, illustrating the attitude of
Roman citizens toward their children as well as the attitude of the Roman
ruling elite toward the future Roman populace.

In this chapter I consider images of more than thirty children who appear in
scenes of imperial largesse. In such scenes, Roman children are often depicted
among figures who appear to be their family members. They stand before or
around the emperor, directing their attention toward him. Scenes of largesse
take place in open, public spaces, usually outdoors, and the emperor either
sits on the *sella curulis* or stands before the children. As Brilliant notes, the
sella curulis lends a "triumphal" and "magisterial" tone to the scenes in which
it appears (p. 75).[2] In scenes of largesse the emperor often interacts with the
assembly from a raised platform; when he does not, he is portrayed as the
tallest or largest figure in the scene. He may hold out a hand to the recipients,

although he does not always perform the distribution himself. Children may accompany their parents as observers of the ceremony or receive donatives themselves, holding out a hand toward the person distributing the donative. Sometimes children create a cradle from the folds of their drapery as if about to receive something.[3] In official Roman art, imperial largesse is presented as an investment in the future, symbolized by Roman children, from the reign of Nero through the reign of Marcus Aurelius.[4]

Visual imagery is not our only evidence for the importance of largesse to imperial culture. Augustus' *Res Gestae* alone lists seven donatives, often called *congiaria*, given by the emperor to people living both in Rome and in the colonies.[5] Likewise, Pliny records that Trajan gave *congiaria* to the people, and he documents specifically the presence of children at those *congiaria*.[6] Official largesse, however, was not an imperial innovation. From a reference in Livy, van Berchem holds that the first known *congiarium* was sponsored in the second century B.C. by the aediles P. Cornelius Scipio and M. Cornelius Cethegus, who distributed oil on the day after their election to the aedileship (1939, 119).[7] Cassius Dio records that *congiaria* were distributed by Julius Caesar.[8] Although it is clear that Augustus' distributions were given in the form of cash, as are most of the distributions depicted in images with children, Hands claims that imperial *congiaria* were "the continuation through the emperor . . . of distributions of corn or oil which had once been offered, especially by the aediles, to the people under the Republic" (1968, 105). Whatever form individual distributions took during the empire, the tradition of largesse had been established at least a century before the transition from republic to empire.

During the empire largesse not only continued a republican tradition but also advertised the generosity, compassion, and foresight of the emperor as well as ostensibly assisting those in need.[9] Hands believes, moreover, that imperial *congiaria* may have had affinities with distributions made to the public during triumphal processions (p. 121). That is, imperial distributions may have functioned as a type of propagandistic performance akin to those that took place during triumphs. Although the topic of imperial largesse has previously been addressed almost exclusively in reference to adults,[10] the images I have compiled show that children were an important component of the visual language of largesse. These images suggest not only that children were present at imperial distributions but also that children could be recipients of such largesse.

MOTIFS OF LARGESSE: NUMISMATIC EVIDENCE

Coinage provides ample evidence for the importance of imperial largesse to the workings of empire and the visual messages being sent by the ruling elite. Coin motifs, including primarily the *congiarium, alimenta,* and *liberalitas,* identified and named from coin legends[11] ostensibly commemorating specific distributions, can be used to identify many scenes of largesse.[12] As coin motifs provide a framework for studying scenes of imperial largesse in general, they are likewise helpful for clarifying the role of children, specifically, in such scenes, and they are an excellent place to begin our investigation.

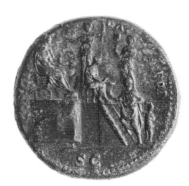

1. *Congiarium* AE of Nero: BMC 138. Photo: © Copyright The British Museum.

As we might expect from the literary evidence of its appearance, the earliest of these motifs is the *congiarium.* We know that donatives were given during the Roman Republic and that Augustus gave *congiaria,* but the *congiarium* motif as such first appears on bronze coins of Nero, where it existed in at least two standard forms. In one, a child appears with the recipient at the far right of the scene. The emperor, seated on the *sella curulis,* faces the recipients from a high platform at left (Fig. 1).[13] While the emperor extends his hand in a gesture of largesse, an official performs the actual distribution. The child and togate adult approach his platform by means of a ladder, and the adult holds out his right hand toward the emperor. The child makes no gesture, although he appears to grasp the bent left elbow of the adult, probably his father. The gender of the child is impossible to determine unequivocally. Observing the *congiarium* are Minerva and Liberalitas.

In the second type, children are absent (Fig. 2).[14] The emperor, again on the *sella curulis,* sits on a platform, this time facing a single recipient on the left who holds out a hand to receive the donation. Again, a magistrate makes the distribution, but this time the central figure holds a tablet with four round indentations in his right hand. This tablet has been variously identified by scholars, but van Berchem and Hamberg have argued most convincingly that it is a type of coin-calculator used to hold the correct number of coins for each individual distribution.[15] Again, Nero extends a hand toward the

2. *Congiarium* AE of Nero: BMC 139. Photo: © Copyright The British Museum.

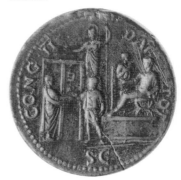

3. *Congiarium* AE of Nerva: BMC 87. Photo: © Copyright The British Museum.

recipients in a gesture of largesse from the raised platform on which he is seated. Finally, as in the first type, Minerva observes the scene from behind.

The compositions of these two contemporary types are so closely related that their purposes and messages must be similar, a conclusion confirmed by their legends. The existence of two such coins, moreover, one with a child and one without, may evidence the existence of a general motif of giving into which a child could be inserted. This can be seen even more clearly from the similarity of the Neronian type with child to bronze *congiarium* coins of Nerva (Fig. 3). The later coins reproduce the composition of the Neronian type almost exactly, both with and without a child.[16] In all types the emperor is seated high on the left on the *sella curulis*. A seated official makes the distribution to the recipient(s) who approach the platform from a ladder on the right. The adult recipients place their right legs on the second rung of the ladder and extend their right hands toward the official. All adults bend their left elbows, to which a child clings when present. Finally, in both Neronian and Nervan types, Minerva and Liberalitas observe from behind.[17]

Perhaps a child could be inserted into the *congiarium* motif if the donative commemorated had specific implications for children. Alternatively, the presence of the child may simply announce the emperor's support of the Roman family or his symbolic interest in the future Roman populace. Although the child does not hold out a hand or make a cradle of his or her drapery in this context, the insertion of a child into a motif that also existed in childless form certainly demonstrates the significance of the child when present.

4. *Alimenta* AU of Trajan: BMC 378. Photo: © Copyright The British Museum.

The *alimenta* motif that occurs in the coinage of Trajan between 104 and 111 always includes children, usually one male and one female. Trajanic coins with the *alimenta* motif are generally assumed to commemorate a specific program begun between A.D. 96 and 104 that is argued to have provided "subsistence allowances" to children living in Italy (Woolf 1990, 197).[18] In contrast to the *congiarium* motif, in which the emperor is somewhat removed from the distribution itself, *alimenta*

coins emphasize the proximity of the emperor to the young recipients. Three distinct types bear the legend *ALIM*(enta) *ITAL*(iae). One, on a gold coin, includes on its reverse two children, identified as male and female by their different attire, who hold up their hands as if to receive a donation from the emperor (Fig. 4).[19] One child is taller (and therefore perhaps older) than the other. The emperor extends his right hand, with palm visible, toward the children in a gesture of giving. His hand, shown overly large, nearly touches their small ones.[20]

5. *Alimenta* AE of Trajan: BMC 872. Photo: © Copyright The British Museum.

A similar *sestertius* of Trajan from a Roman mint, dated 108–110, shows Trajan seated on the *sella curulis* greeting a woman, identified as either Italia or Abundantia,[21] with two children, the younger of whom she holds in her arms while the other stands beside her (Fig. 5).[22] Again, Trajan extends his right hand toward the group. Although the emperor appears larger than the recipients, he does not sit on a high platform. The genders of the children are impossible to determine, but it is likely that one is a boy and one a girl as on the coin in Figure 4. Kuttner calls them the *puer* and *puella* of the *alimenta*.[23] Both children gesture toward the emperor.

The third *alimenta* type shows a woman standing in the center of the flan with one small child on her right. The woman, variously identified as Abundantia and Annona, holds an attribute such as the cornucopia or stalks of wheat in her left hand. Trajan appears on the obverses of such coins but is absent from the scene with the child on the reverse. Neither child nor woman makes any gesture.[24]

Contemporary coins similar in composition to *alimenta* types but with the legend *REST*(ituta) *ITAL*(ia), *REST*(ituta) *ITALIA*, or *ITALIA REST*(ituta) depict one kneeling woman with two standing children lifting up their hands toward Trajan (Fig. 6).[25] The children wear slightly different attire, probably indicating again that they are male and female, and one is noticeably taller than the other. Trajan, who may stand right or left, extends one hand toward the woman, identified as a goddess by her turreted crown; she may grasp the emperor's hand. As the legend indicates, the adult woman is most probably Italia or Roma. In one example Italia hands

6. *Restituta Italia* AU of Trajan: BMC 404. Photo: © Copyright The British Museum.

a globe to Trajan, and in another Trajan holds a scepter. As in *alimenta* types, the emperor is shown in close proximity to the women and children. He does not greet them from a stool or tribunal but stands on their level, often making physical contact with them.

Although these coins carry images similar to those of *alimenta* coins, the presence of Italia/Roma and their legends problematize their classification. Using such coins, Brilliant has identified a "restoration" motif, generally commemorating the "relief work" of Trajan in Italy (p. 107). He holds that such coins depict Trajan restoring the kneeling figure of Italia/Roma without explicit reference to the *alimenta*. Strack, however, sees an inherent connection between these coins and the *alimenta* motif because they were produced nearly simultaneously and with such similar compositions. He holds that the *REST*(ituta) *ITAL*(ia) legend, in particular, celebrated the specific success of the *alimenta*, or its end result, rather than serving as a simple advertisement for the program as do *alimenta* coins.[26]

Similar types from the reigns of Galba and Nerva may shed light on such issues. Sestertii of Galba with the legend *ROMA REST*(ituta) show the cuirassed emperor holding a spear in his left hand and raising a kneeling Roma with his right.[27] Roma, in military attire, holds an infant in her right arm. The infant stretches forth his arms toward the emperor. The infant does not touch the emperor but is almost close enough to do so. Some scholars have apparently missed the child; Brilliant claims that the coin's "reduction of the restoration motif to two figures intensifies the iconic character of the design." (p. 87), but Mattingly and Sydenham identify a child in the composition.[28] This coin sets a precedent for Trajan's presentation of a female personification with children before the emperor in the context of the *RESTITUTA* legend (or restoration motif). Nerva's issue of A.D. 97 bearing the legend *TUTELA ITALIAE* provides another salient example.[29] On the coin, Nerva stands at the left, extending his right hand toward the goddess Italia. A boy and girl stand between them, quite close to the emperor.

These issues are not identified with the *alimenta* because of their legends and their pre-Trajanic dates, but their compositions are unmistakably similar to Trajan's *alimenta* coins as well as his restoration motifs, which Strack holds commemorate the success of the *alimenta* program. I find Brilliant's analysis most convincing here. The children on such coins without specific legends of largesse function in a general sense as symbols of Italy's future, commemorating programs like the *alimenta*; they advertise the successful result of the emperor's

largesse. Trajan's restoration coins, Galba's *ROMA RESTI*(tuta), and Nerva's *TUTELA* types most probably advertise not specific donatives, but the success of imperial policies that may have included such programs.

The final motif of imperial largesse, *liberalitas*, first appears in the coinage of Hadrian and completely replaces the *congiarium* motif (Hamberg 1945, 33).[30] Legends of Hadrianic coins no longer praise *congiarium populo Romano datum* but rather simply *liberalitas Aug(usti)*; that *liberalitas* coins commemorated *congiaria*, however, is likely, according to Strack.[31] The *liberalitas* motif, like the *congiarium*, usually shows the emperor seated on the *sella curulis* facing left on a high platform (Fig. 7). The recipient approaches from the left, holding out his drapery before him, but the ladder of the *congiarium* motif is absent. As in the earlier motif, the emperor does not perform the distribution himself; personifications or imperial officials accompany him.[32] Although children do not appear on any extant *liberalitas* coins, I include the motif for comparison with other coins that do include children. Just as coins of Galba, Vespasian, and Nerva bear compositions and messages related to Trajan's *alimenta* types, children appear on coins similar in composition to Hadrian's *liberalitas* coinage.

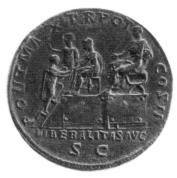

7. *Liberalitas* AE of Hadrian: BMC 1137. Photo: © Copyright The British Museum.

A *sestertius* of Hadrian from A.D. 119 with the legend *LIBERTAS RESTITUTA* shows a Roman woman with two children, one of whom stands beside her and one of whom she holds in her arms (Fig. 8).[33] Although the children's genders are impossible to determine with certainty, it is likely that one is male and the other female, as was the case in the *alimenta* motif. In fact, the composition of Hadrian's issue is clearly reminiscent of one of Trajan's *alimenta* types (Fig. 5). The only difference between the two is that Hadrian distributes the donative from a high platform on which his *sella curulis* is located, as on contemporary *liberalitas* coins. Otherwise, he is shown in close proximity to the woman and children, and he makes the distribution himself. His closed hand faces the ground, as if he is about to release something from it. The infant in the woman's arms appears to hold out a hand to receive the distribution from Hadrian, as does the child beside her.

8. *Libertas Restituta* AE of Hadrian: BMC 1160. Photo: © Copyright The British Museum.

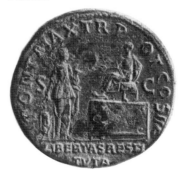

Strack holds that the female figure accompanying the children on the coin does not represent Libertas in general but rather Italia. He suggests that the *LIBERTAS RESTITUTA* coin type commemorates the success of Hadrianic programs like the *alimenta* just as earlier *ITALIA REST*(ituta) coins commemorated the success of Trajanic donatives.[34]

Hadrian's use of the *LIBERTAS RESTITUTA* legend was not unique. The legend had been used at least as early as A.D. 68–69 on coins of Galba that Foss calls the "realisation of war propaganda by restoration of freedom and of Rome" (1990, 75). On such coins, the emperor stands at the right, raising the kneeling figure of Libertas with his right hand; Roma stands behind the pair. Children do not appear on Galba's *LIBERTAS RESTITUTA* coins, but they do appear on his contemporaneous *ROMA RESTI*(tuta) type, as we have seen. Against this backdrop, Strack's analysis is even more attractive. Roma is present explicitly on Galba's *LIBERTAS* issue, making possible the jump from Libertas to Italia, or Roma, on the Hadrianic issue. Consider, in addition, the fact that the Trajanic precursor of the composition of Hadrian's coin had an *alimenta* legend, and the meaning of Hadrian's *LIBERTAS RESTITUTA* type becomes clear. The coin tells the viewer that *libertas* is safe throughout Rome and Italy because of the success of imperial largesse symbolized by the two children with the goddess.

Coin motifs evidence the existence of a visual language in which children are used to demonstrate the emperor's investment in the future. The preceding discussion shows that while it is crucial to acknowledge the specific motifs of largesse identified on imperial coinage to understand the complex visual language of largesse, imperial coin motifs continually referenced and cross-referenced one another, sending consistent messages over dynastic rifts through visual imagery. The coins presented here display a number of legends and slightly different compositions, but the strings that connect them are obvious. The presence of one boy and one girl of different ages in many such scenes is particularly effective shorthand for all Roman children. The benevolent figure of the emperor with hand outstretched advertises the generosity, compassion, and foresight of the emperor and his empire; the emperor always acknowledges explicitly the recipients of largesse. Moreover, the fact that those recipients are sometimes maternal or paternal figures evidences the commitment of the empire to the Roman family, specifically.

These images of imperial largesse belong to Hamberg's "illustrative mode" of representation in which a concept is represented by "a symbolic act whose

purpose is to illustrate directly the abstract content" (p. 42). Such motifs depict either the symbolic moment of largesse or the result of that largesse, perhaps the restoration of Roma or Italia. Coins with motifs of largesse advertise the emperor's investment in the future by focusing on the role of children in the imperial donative and the role of the emperor in providing for those children. The proximity of the emperor to the future of the empire, shown especially on *alimenta* coins, underscores this message explicitly. Finally, the connection between Roman children and the personifications Roma, Italia, and Libertas exemplifies the importance of children to all three concepts. Motifs of largesse and coins with compositions similar to them declare the necessity for imperial investment in Rome's future for the ideas of Rome, Italy, and Liberty to remain intact.[35] It is no coincidence (and certainly no mistake) that the standard motifs of largesse, *congiarium*, *alimenta*, and *liberalitas*, are closely tied in composition to restoration motifs. Children appear in scenes commemorating the success of imperial largesse to trigger a sense of confidence in imperial programs. Children appear in motifs expressing the restoration of Rome, Italy, and Liberty to signal that such programs have indeed been successful.[36]

MONUMENTAL IMAGES OF LARGESSE

Roman children also play a role in scenes of largesse depicted on official imperial monuments, and coin types provide a lens through which to view such scenes. The Arch of Trajan at Beneventum, dated A.D. 114–118, is the earliest monument on which children appear in a scene of largesse (Fig. 9).[37] The scene, from a relief panel inside the passageway of the arch, includes five children, three male and two female. The male children are togate, and the female children wear the *stola* with breast belt. The two tallest children, both male, stand in the foreground of the scene, while adults carry the younger children either in their arms or on their shoulders as they approach the emperor from the right side of the relief. Although the spatial focus of the scene is a large tray from which the distribution is made, central in the relief is the child standing near the tray, holding out his toga to receive the donation. In addition, the two children who sit on their fathers' shoulders appear at a level higher than even the emperor, drawing the eye toward them.

Among the adults in the scene are four women dressed as Roman matrons in *stolae* and mantles but identified as personified cities by their crenellated crowns.[38] The personified city at the far right holds the youngest of the

female children in her arms and reaches toward a standing male child, although her hand is not extant. Another personified city places her hand gently and protectively on the head of a male child standing in the foreground near the center of the scene.[39] The adult men wear short tunics, identifying them as plebeian. The only gestures they make connect them to particular children. Other male figures are depicted in low relief in the background, and the group at the far right turns as if to leave the scene. A tree on the right indicates that the donative takes place outdoors.

Trajan stands at the left side of the panel on the same level as the recipients. Like the recipients, he wears a short tunic. The emperor, of course, is not being shown as plebeian; his short tunic suggests that he is traveling outside of Rome, perhaps through Beneventum.[40] The similarity of his dress to that of the recipients, however, may send the visual message that he is one of them, as does his proximity to them. Trajan extends his left hand, and perhaps also his right, now missing, toward the children and adults before him in a gesture of benevolence and largesse like that seen on the coins discussed earlier. In front of him, a Roman official performs the distribution.

Scholars inevitably identify this scene as a representation of Trajan's *alimenta*. They base this conclusion on three factors: the presence of children in the scene, the status of the recipients, and the inclusion of the personified cities.[41] The proximity of the emperor to the recipients of the distribution could also be used to support such an interpretation because *alimenta* coins show the emperor near the recipients of the donative. The parallels between this scene and a representation of an *alimenta* distribution are indeed attractive, but the evidence will be shown to be inconclusive.

Although the inclusion of Roman children in this scene may imply that the donative was intended specifically for children, children are depicted in scenes of largesse from the reigns of Nero and Nerva unrelated to Trajan's *alimenta*.[42] Similarly, although the costume of the male adults in the relief may imply that the donative was distributed only to plebeians, this implication does not identify the distribution unequivocally as the *alimenta*. Woolf has demonstrated that there is no conclusive evidence that recipients of the *alimenta* were chosen according to financial need. In fact, he suggests that recipients of the *alimenta* were actually privileged inhabitants of Italy.[43] Although Duncan-Jones (1974) holds that "[the] immediate purpose [of the *alimenta*] was clearly the support of children in the small inland towns of Italy" (pp. 123–4), and although many other scholars identify the *alimenta* as a type of support for "impoverished"

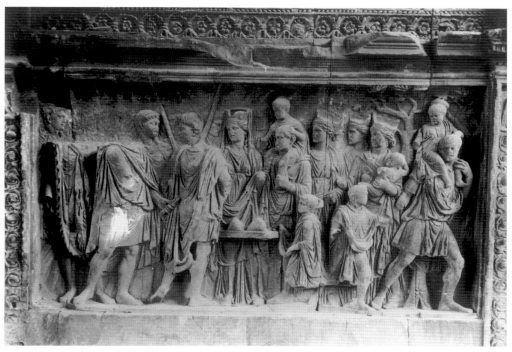

9. *"Alimenta"* relief panel, Arch of Trajan at Beneventum, A.D. 114–118. Photo: DAI 29.479, Deutsches Archäologisches Institut.

children,[44] no literary source indicates that *alimenta* distributions were given to children on the basis of need. In fact, no literary or epigraphic source provides information as to the motivation for or the success of alimentary programs. Woolf asserts that alimentary programs were not, as is commonly assumed, the response of the imperial government to poverty in Italy. He holds that if we look at alimentary schemes in terms of the custom of patronage, we shall find that the *alimenta* were "drama played by the emperors to the people with the imperial and local aristocracies taking bit parts" (1990, 227). As Hands intimated in his discussion of imperial largesse, discussed earlier, the *alimenta* were primarily a form of imperial publicity.

Finally, although the presence of the personified cities of Italy in the scene may imply that the donative was given specifically to Italian recipients, as the inscriptions imply, there are no parallels for such a representation on *alimenta* coins. One *alimenta* type includes the personification of Italia with children, but in Trajan's other *alimenta* type, children approach the emperor alone. This panel may indeed depict an *alimenta* distribution, but there is no

conclusive evidence for the identification. Even the proximity of the emperor to the recipients of the distribution, which, to my mind, is our best evidence that this scene depicts the *alimenta*, is not conclusive. Trajan does not present the donative himself as he does on *alimenta* coins; his attendant stands between him and the Roman throng.[45] We simply do not know enough about the *alimenta* to identify this scene as a representation of the program. Moreover, the contrast between this scene and *alimenta* coins of the period may suggest that it, in fact, does not depict the *alimenta*. On the Beneventan panel, multiple children and multiple adults of both genders approach the emperor, whereas on coins, a maximum of two children approach the emperor alone or in the company of one woman. Distribution trays, such as that seen in the center of this panel, do not appear on *alimenta* coins, and *alimenta* coins do not include an imperial attendant.

The conclusion that the panel may not represent the *alimenta* is an important one. Scholars tend to label all Trajanic and Hadrianic images of Roman children *alimenta* scenes, marginalizing such scenes and ignoring the larger role Roman children play in imperial iconography. I believe it is this tendency that led Torelli (1997) to argue that the entire Arch of Trajan at Beneventum commemorates the *alimenta*. Although Kleiner also labels the panel in question an *alimenta* scene, she holds that the Arch of Trajan at Beneventum is neither a monument to the *alimenta* nor an accurate historical documentation of Trajan's principate but rather a symbolic depiction of Trajan's foreign and domestic policies. She points out that the general social policies of Trajan were "generous and far-reaching" (p. 224), citing *congiaria* of 99 and 102, nonalimentary donatives, as evidence that Trajan performed other acts worthy of commemoration during his principate.[46] Analogously, Ryberg interprets the other reliefs on the pylon of the Arch of Trajan as representations of various aspects of Trajan's "good government" at home and in the provinces (1955, 154). She notes that allusions on the arch are military as well as civilian, and she suggests that the panel opposite that discussed here may represent a sacrifice to Jupiter on the occasion of the Dacian triumph.[47]

These interpretations are crucial for understanding the Beneventan panel and other representations of largesse because they take into account the larger picture of imperial rule and the visual language of empire. The Trajanic panel, like our coin motifs, clearly shows that children were used within the language of largesse. Even if we cannot identify this scene as a depiction of a specific imperial program, we can certainly conclude that it participates in the visual

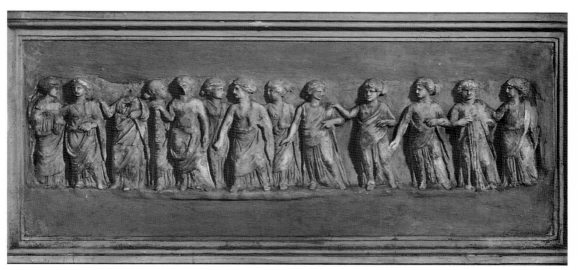

10. Procession of Women, Museo di Villa Albani, Rome, A.D. 161–180. Photo: Alinari/Art Resource, NY.

language of largesse. In fact, relegating the scene to the category of *alimenta* both marginalizes it and clouds the larger picture. This relief participates in a motif of giving that was well established in the minds of Roman viewers from the coinage of Nero, Galba, and Nerva long before the problematic *alimenta* was established. Most important, this scene confirms that children were present at public distributions and may themselves have been recipients of largesse.

A pair of little-known reliefs from the reign of Marcus Aurelius, now in the collection of the Villa Albani, also commemorate imperial largesse.[48] These reliefs are most unusual in that men are entirely absent from them. Women distribute the donative, and girls receive it. The left panel depicts thirteen girls in two lines moving in opposite directions (Fig. 10). The right shows a group of thirteen girls standing near a raised platform.[49] On the right side of the platform stand two women, identified by both Helbig and Rawson as Faustina the Younger and her daughter, Lucilla.[50] Helbig suggests that the women may be shown as the goddesses Ceres and Proserpina, but Hammond holds that one of the women may be the personification of Liberalitas or Annona, as seen on coins commemorating imperial largesse, rather than Faustina or Lucilla.[51] The woman who may be Faustina the Younger pours a distribution (grain, in Helbig's estimation) from a round vessel, and the girl at the front of the line holds out her garment in the typical gesture of a recipient. Because the panels are a pair, we may assume that some of the girls on the left panel are

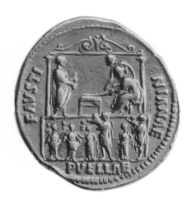

11. *Puellae Faustinianae* AU of Antoninus Pius: BMC 324. Photo: © Copyright The British Museum.

waiting in line, approaching the panel on the right, while the others have received their distribution and are moving away from the right-hand panel. This composition parallels that of the Beneventan relief, in which the figures on the right appear to be leaving the scene.

Just as the Trajanic relief may have commemorated an alimentary scheme instituted or championed by Trajan, the Villa Albani reliefs may commemorate funds established by Antoninus Pius to honor Faustina the Elder after her death in 141, the recipients of which are known as the *puellae Faustinianae*.[52] Marcus Aurelius, however, established funds to commemorate both Lucilla's marriage to Lucius Verus in 164 and the death of Faustina the Younger in 175.[53] Helbig claims that the donatives in question provided assistance to girls of poor parents in particular, but he does not identify the reliefs unequivocally with any one specific fund.

As noted by Rawson, multiple coins of Antoninus Pius contain scenes that appear to parallel those of the Villa Albani reliefs. Bearing the legend *PUELLAE FAUSTINIANAE*, the reverses of these coins show the emperor standing on a platform before a group of what appear to be parents and daughters to whom a distribution is made (Fig. 11).[54] Children, some of whom are held up to the platform by adults, stretch out their hands toward the officials on the platform. Sometimes the figures approach the emperor in what appear to be family groups, as in Figure 12, but on one such coin the recipients are women and girls exclusively. The emperor may either stand or sit on the *sella curulis* at right or left, but he always extends a hand toward the crowd. Faustina may accompany Antoninus Pius. From a low table in the middle of the scenes imperial attendants make the distribution, sometimes from a coin counter similar to that in the *congiarium* coins of Nero discussed earlier. One *PUELLAE FAUSTINIANAE* type parallels Hadrianic *liberalitas* coins nicely (Fig. 12). The emperor is seated at right on a high podium, holding his arms toward the crowd. On the left, a citizen holds a child toward the emperor. The child holds out her arms as if to receive something. In the foreground of the scene a second parent-child pair approaches the podium. The adult appears to urge the child along from behind, as if they are next in line. In this scene the emperor appears with one assistant; although he does not make the distribution himself, he is shown near the recipients.

There are a few important differences between the reliefs and the coins. First, the emperor is absent from the Villa Albani reliefs. Second, men are absent from the reliefs but may appear among the recipients on *PUELLAE FAUSTINIANAE* coins. Whether the Villa Albani reliefs commemorate the same fund or distribution immortalized on the coins, and whether the reliefs commemorate funds established by Antoninus Pius or Marcus Aurelius, the coins and the reliefs together allow us to conclude that children were just as important to the language of largesse at the end of the Antonine dynasty as they had been during the reigns of Nerva, Trajan, and Hadrian.

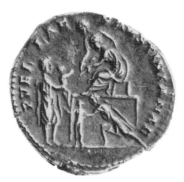

12. *Puellae Faustinianae* AR of Antoninus Pius: BMC 325. Photo: © Copyright The British Museum.

As I noted of the Beneventan relief, the attempt to identify such scenes with specific historical programs has obscured the larger picture of the language of largesse in which children played a crucial role. What these images add to that picture is proof that female children appeared in public to receive distributions intended specifically for them. Even young female children, presumably too young to walk, are present on their parents' shoulders and in their parents' arms. Moreover, it appears that mothers accompanied their female children at the distributions to the *puellae Faustinianae* and at the distribution depicted on the reliefs, whereas no mortal woman is present among recipients in any previous image of largesse extant.

The Arch of Constantine includes two scenes of imperial largesse: a reused panel relief of Marcus Aurelius[55] and a relief carved during Constantine's reign. The panel of Marcus Aurelius is divided into two registers by the top of the platform on which the emperor sits (Fig. 13).[56] The recipients before the emperor are divided by status, with the *togati*, the senatorial and equestrian orders, at the front of the line and plebeians at the rear. Two children appear among the recipients in the lower register. The first child, a male who wears a belted tunic, is shown frontally. The bearded, togate man with whom he is depicted holds him by the ear, a gesture that may indicate parental responsibility.[57] The second child sits on the shoulders of the man at the end of the line. The head of the child is lost, and most of his or her body is hidden by the man's head, making the gender of the child impossible to determine.[58] The father, however, wears a tunic, which, along with their position at the rear of the line, makes their status clear. The children are clearly different ages, as are the children in most scenes of largesse. The man at the front of the line places

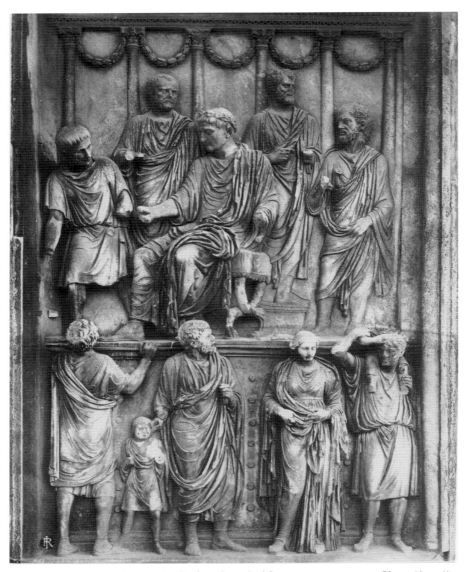

13. Largesse panel relief of Marcus Aurelius from the Arch of Constantine, A.D. 176–180. Photo: Alinari/Art Resource, NY.

his right hand on the edge of the platform, gazing up at the emperor and turning his back to the viewer. Between the adult-child pairs stands a woman wearing the costume of a Roman matron. She connects herself neither by gesture nor gaze with any man or child but seems to be a recipient in her own right. In fact, she appears to begin to grasp her garment as if to receive and carry away her portion of the distribution. With the exception of the

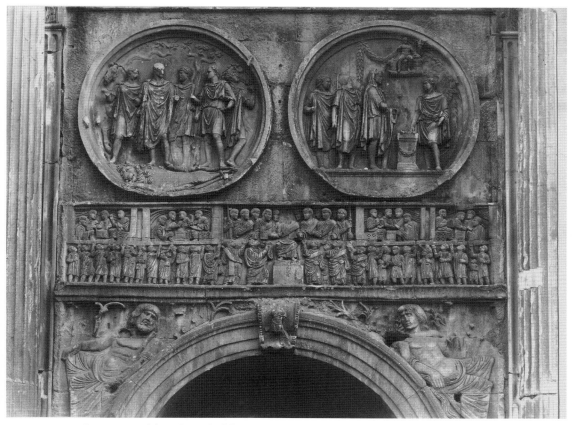

14. *Congiarium* panel from the Arch of Constantine, A.D. 312–315. Photo: Alinari/Art Resource, NY.

women in the Villa Albani reliefs and the *PUELLAE FAUSTINIANAE* coins discussed earlier, she is the only mortal woman shown in a scene of largesse.

Marcus Aurelius is depicted in near-frontal view, a novelty in the depiction of the emperor in scenes of imperial largesse[59] but a depiction similar to that of the child below him. More predictably, the emperor sits on the *sella curulis*. He extends his right hand and directs his gaze toward the figure nearest him in the lower register. Four attendants or magistrates accompany the emperor, one of whom leans toward the lower register to make the distribution, and Angelicoussis has argued convincingly that a young Commodus originally sat to the right of the emperor.[60] The scene takes place in front of a garlanded portico. As in earlier *congiarium-liberalitas* scenes and the scene from the Arch of Trajan at Beneventum, Marcus Aurelius participates in the donative indirectly. While he makes a gesture of giving, he does not come into contact with the Romans gathered before him but rather works through a magistrate.

Although a century too late for the parameters of this study, I include here for comparison the largesse panel from the Arch of Constantine carved during that emperor's reign (see Fig. 14). The scene comes from the north side of the arch and is located below the Marcus Aurelius panel on the same side. Constantine sits in the center of the scene, and senators stand on either side of him to receive the first coins that drop from his plate. Behind the senators stand plebeian men and children, distinguished from the senators by their tunics, waiting to receive their portion of the distribution. Four children walk alongside the adults, and two more are carried on the shoulders of adults, probably their fathers. Unfortunately, the gender of the children is impossible to discern. All the senators and plebeians in the lower register lift up their hands toward the emperor. With the exception of four figures, three men and a child, who turn to receive their distribution from the Roman officials in one of the four gallery scenes in the second register, all the plebeians face the emperor. The officials in the upper four galleries assist the emperor by distributing and documenting the donative. Like Marcus Aurelius in the earlier panel from the same arch, Constantine is shown frontally. He sits on a platform in the center of the scene, surrounded by senators and attendants. The small, indented plate he holds in his right hand identifies the scene as a *congiarium*.

CONCLUSION

As Brilliant says of the largesse panel of Marcus Aurelius, "the emphatic character of this public ceremony arises from the ambivalent poses of Emperor and citizens which involve them not only in a reciprocal relationship within the frame of the relief but also encourage the direct participation of the Roman spectator who is not precluded by any formal barrier from stepping up metaphorically to get his share" (p. 152). Brilliant is concerned here only with the relief of Marcus Aurelius, but his analysis reveals what makes images of imperial largesse effective. The symbolic nature, or "illustrative mode," to use Hamberg's terminology, of images of imperial largesse speaks to every Roman citizen as a potential recipient.

More specifically, images of imperial largesse highlight the symbolic meaning attached to the Roman child in official Roman art. In scenes of largesse, Roman children, whether alone or in family groups, direct their attention toward the emperor. The appearance of children of different ages and genders in such scenes may be shorthand for Roman children as a whole. In scenes

of largesse, children and emperor acknowledge one another with reciprocal gestures. Children either stretch forth their hands toward the emperor or fold their drapery into a cradle as if to receive something. Likewise, although the emperor may not perform the distribution himself, he always acknowledges the children before him with a welcoming gesture. Roman children appear in scenes of largesse to advertise the charitable social policies of the Roman ruling elite and to make explicit the investment of the ruling elite in the future of Rome. Consequently, Roman children also appear in images that illustrate the positive effects of those policies for the future of the Roman people. In scenes like those found on *restituta* coins, children represent the prosperity that is to come as a result of imperial policies and programs. In imperial visual imagery, Roman children are not simply potential recipients of the emperor's largesse; they are proof of it as well.

Images of imperial largesse acquire yet another level of meaning when viewed within the context of evidence from epigraphic and literary sources. Such sources imply that scenes of imperial largesse should be seen as a type of pro-child, pro-family propaganda as well as advertisements of imperial policies and their success. Even before the reign of Augustus, families with three or more children received benefits from the Roman government. In an agrarian law of 59 B.C passed during his consulship, Caesar offered allotments of land to fathers of three or more children.[61] Cicero expresses his approval of Caesar's policy to increase the birth rate in his *Pro Marcello*.[62] In fact, Yavetz (1983) notes that "there was already an awareness of the [birth rate] problem . . . in 131 B.C. [when] the censor Q. Metellus proposed that every unmarried man be obliged to take a wife and produce children" (p. 151).[63]

Of course, Augustus' Julian and Papian-Poppaean Laws rewarded childbearing by giving priority in assuming the *fasces* to the consul with more children and by exempting people with three or more children from certain public duties. In addition, under the Papian-Poppaean Law, people without children lost half of all inheritances or legacies.[64] Suetonius reports that under Augustus, although *congiaria* continued to be distributed to all adult citizens without restriction, they also began to be distributed to boys under the age of eleven. Before Augustus, apparently, *congiaria* had only been given to adults and boys older than that age.[65]

Evidence for distributions to or for children continues after the reign of Augustus. An inscription from the second half of the first century A.D., which Duncan-Jones holds cannot be later than the reign of Nero,[66] commemorates

a donation of 400,000 sesterces to the people of Atina, in southern Italy, from Titus Helvius Basila, an aedile, praetor, proconsul, and legate of Caesar Augustus, to help supply grain for their children until they were grown.[67] In addition, we have already noted that Pliny records a *congiarium* given to children, or at least to families with children, during the reign of Trajan,[68] not to mention the *alimenta* program supposedly instituted during the reign of Nerva or Trajan.

Such legal precedents and imperial programs provide a context in which to view imperial images of largesse. Although our earliest visual evidence for largesse comes from a *congiarium* coin minted during the reign of Nero, it is clear that before and during the reign of Augustus, as well as before and after the Trajanic period (on which so many scholars of children have focused), children were viewed as legitimate recipients of largesse, both through their parents and perhaps even individually. Moreover, the presence of children may have been especially important at such events because their existence seems to have been required for certain types of public benefits.[69] The number of representations of imperial largesse with children demonstrates the desire of the Roman ruling elite to advertise its generosity toward children, its investment in the future of Rome, and the success of imperial policies and programs, as well as to encourage the growth of the Roman family.

PUBLIC GATHERINGS

Roman children appear in depictions of many types of official public gatherings in addition to scenes of largesse. These gatherings include imperial speeches, sacrifices, games, and processions. This chapter addresses eleven scenes of public gathering in which Roman children appear. In contrast to those depicted in scenes of largesse, Roman children in scenes of public gathering make no specific gesture or group of gestures; they function as observers. Scenes of public gathering are identified, therefore, by their settings and compositions, as well as by the gestures and postures of the adults who appear in them. Roman adults always accompany Roman children in scenes of public gathering.

Although the primary function of Roman children in scenes of public gathering is simply to observe official activity, such scenes give us insight into the socialization of Roman children. In scenes of public gathering, Roman children witness the activities of Roman citizens; they are indoctrinated into adult Roman life and taught what it means to be Roman. The children wear Roman clothing, appear as part of the Roman *familia*, and participate in the official duties and responsibilities of citizens of the Roman Empire. As Ellul said, in images of public gathering Roman children "participate in their society in every way" (1973, 75).

A number of scenes of public speeches in which children appear have been labeled *adlocutiones* after legends or motifs from coins, and, as was the case with scenes of imperial largesse, coin motifs have been helpful for identifying such scenes. After examining the *adlocutiones* in which Roman children appear, I address the extant representations of children at sacrifices, games, and processions.[1] Coin motifs are not as useful for identifying these other types of public gatherings as they are for *adlocutiones*.

ADLOCUTIONES: THE EMPEROR SPEAKS

The *adlocutio* first appears as a complete motif, with audience and legend, on coinage of Caligula (Hamberg, 136).[2] In the motif the emperor appears in *contrapposto*, resting his weight on one hip, causing his opposite knee to bend. The emperor usually makes his speech from a platform, holding out one hand in a lateral gesture of address. This gesture is related, as Brilliant notes, to that of the republican "Arringatore" from Florence.[3] Before the emperor stands a representative group of three or more Roman adults who gaze up at the emperor and may lift their hands toward him, acknowledging his speech.

At this early date the *adlocutio* is a simple military motif relying solely on the emperor's speaking gesture. In Caligula's *adlocutio* coinage the emperor stands on a platform in front of the *sella castrensis* addressing a crowd of Roman soldiers (Fig. 15).[4] He extends his right hand and arm forward and parallel to the ground in a gesture of address. The emperor stands in *contrapposto* with his left knee slightly bent and his weight resting on his right hip. The *sella castrensis* functions here as did *the sella curulis* in scenes of largesse, lending an official, and perhaps even triumphal, tone to the scene. The five soldiers in the audience stand in processional composition gazing toward the emperor, but they make no gesture.

After the reign of Caligula the *adlocutio* motif becomes a stock numismatic image. Coins depicting *adlocutiones* of Trajan in the Circus Maximus[5] and Hadrian before the Temple of Divus Julius (Fig. 16)[6] demonstrate the consistent nature of the motif.[7] On Trajanic *adlocutio* coins the emperor extends his right arm in the lateral gesture, again with his left knee bent and his weight supported by his right hip. He addresses his audience from a platform, but the *sella castrensis* is here replaced by an imperial attendant behind the emperor. Audience members now acknowledge the emperor's speech with a gesture of their own. Three out of four raise their right hands over their heads, and all look toward the emperor.

On Hadrianic issues the emperor stands alone on a platform before a temple Brilliant, Strack, and Aldrete identify as the Temple of Divus Julius.[8] Again, the emperor stands in *contrapposto* with his weight on his right hip and his left knee bent, and he extends his right hand in the lateral gesture of address. He appears to hold a scroll in his left hand. As on the Trajanic coin, audience members raise their hands and faces in acknowledgment of the emperor's speech. As many as eleven audience members may appear on such Hadrianic

issues. Although children are absent from these *adlocutiones*, the compositions discussed exemplify the motif and parallel those in which children appear.[9]

The only extant *adlocutio* coin on which children appear comes from the reign of Hadrian in A.D. 126.[10] Foss includes the coin in a series he dubs "Hadrian's return to Rome."[11] The coin is nearly identical to the Hadrianic issues discussed earlier. On the coin Hadrian is shown addressing three citizens before what appears to be the Temple of Divus Julius. The emperor makes the requisite gesture of address. On either side of Hadrian stands one child, for a total of six figures on the coin.

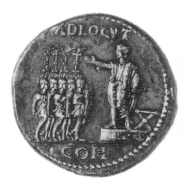

15. *Adlocutio* of Caligula: BMC 68. Photo: © Copyright The British Museum.

The legend reads simply *COS III*. The children's purpose on the coin is unclear; they make no gesture, have no distinguishing characteristics, and cannot be identified by legend or portrait type. The similarity of the composition of this type, however, to *adlocutio* scenes without children indicates that children could be inserted into the composition of the *adlocutio* motif just as they could be into the *congiarium* motif.

The presence of children on this coin may simply indicate that children could attend speeches of the emperor, although the position of the children on the podium near the emperor suggests that they are more than simple audience members. Foss posits a symbolic meaning for the children, holding that their inclusion on the coin may advertise Hadrian's connection with the charities of Trajan (p. 116). Alternatively, the inclusion of children may advertise Hadrian's largesse in its own right. Contemporary *liberalitas* coins, which Foss includes in the same series as the *adlocutio* coin, record a donative of Hadrian associated with his return from Greece and Sicily to Rome (ibid.).[12]

16. *Adlocutio* of Hadrian: BMC 827. Photo: © Copyright The British Museum.

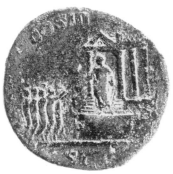

The Hadrianic coin, however, does not bear a motif of imperial largesse; it bears the *adlocutio* motif intended to document the speech of the emperor. Although it is possible that the speech documented here was germane to imperial largesse, and perhaps even children specifically, nothing on the coin itself suggests this. On the other hand, considering their position on the coin, as well as the symbolic nature of images of similar pairs of

Roman children addressed in the previous chapter, it is likely that the children pictured here are symbolic of the future Roman populace. Most important is the simple fact that children are included in the *adlocutio* motif. The Roman ruling elite saw the stock motif of imperial speech as an appropriate artistic context in which to include Roman children.

Adlocutiones also appear in monumental imagery. A problematic relief panel from the Arco di Portogallo, perhaps originally from an arch or altar and dated between A.D. 136 and 138, has been variously identified as an *adlocutio* scene, an *alimenta* scene, and a depiction of Hadrian's funeral oration in honor of Sabina.[13] The relief, however, has not been the focus of much scholarly attention, perhaps in part because it is so heavily restored (Fig. 17).[14] The panel shows Hadrian addressing three figures from a platform. The emperor reads from a document in his left hand. He stands in *contrapposto* with his weight on his left hip and his right knee slightly bent; his right arm and hand are extended. Behind him stand three male figures, two bearded and one beardless. Kleiner identifies the bearded figure directly behind Hadrian as the Genius Senatus and the bearded figure with the spear as the emperor's bodyguard.[15] The half-nude man behind the child, identified as the Genius Populi Romani by Kleiner, also lifts up his right hand toward Hadrian, nearly grasping the emperor's toga.

One of the figures whom the emperor addresses is a togate male child. The child wears shoes and has close-cropped hair. He lifts his right hand toward Hadrian in a gesture like those performed by audience members on Trajanic and Hadrianic *adlocutio* coins. In addition, he stands closer to the emperor than do other members of the audience. The proximity of the child to the emperor is typical of Trajanic and Hadrianic imagery, as we have seen. The scene appears to take place near a temple in the Forum Romanum, perhaps even the Temple of Divus Julius.

Although some have identified the child in this relief as Lucius Verus, then six years old, Kleiner points out that the depiction does not conform to portraits of Lucius Verus.[16] She identifies the child instead as a representative of "the impoverished Roman children who were recipients of the emperor's largesse" (p. 253). She holds that the panel "underscores the likelihood that Hadrian continued Trajan's policy of the *institutio alimentaria*" (ibid.). Not only is this reasoning circular, but, as we have noted, there is no evidence that the *alimenta* was intended to combat poverty in Italy. Even if the purpose of the *alimenta* were to support needy children, Kleiner's statement attributes

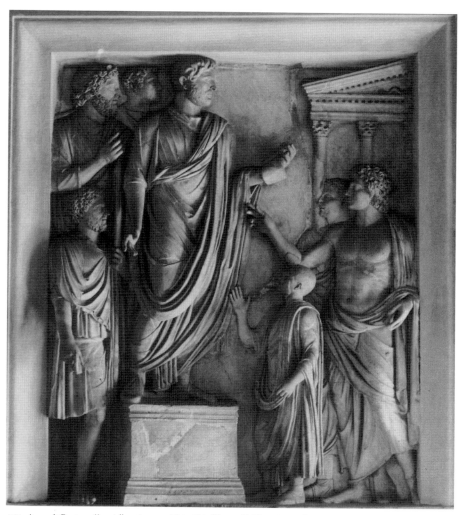

17. Arco di Portogallo, *Adlocutio*, A.D. 136–138. Photo: DAI 68.1262, Deutsches Archäologisches Institut.

characteristics to the child that the representation does not support. This child is not impoverished. He wears shoes and the toga of the senatorial or equestrian orders, unlike the tunic-clad figures present in a number of the scenes discussed in the previous chapter. Plebeians are entirely absent from this scene.

Moreover, in contrast to most scenes of imperial largesse, no adult makes a gesture of responsibility toward the child on the Arco di Portogallo panel.[17] Gestures of largesse are also absent from this scene. The emperor does not hold out his hand toward the child, nor is the child about to receive something. In

addition, in this relief the emperor stands, reading from a document, and the *sella curulis* is absent, again in contrast to most scenes of largesse.[18] Finally, no adult ever appears bare-chested in an extant scene of imperial largesse. As we have seen, mythological figures in scenes of imperial largesse tend to be female.

Overzealous interest in the *alimenta* of Trajan has led scholars both to misidentify representations of Roman children as *alimenta* scenes and to discount or ignore representations of children that seem not to depict the *alimenta*. This scene is clearly an *adlocutio*, an imperial speech. Although it lacks the specific lateral gesture found on many *adlocutio* coins, it conforms to the general composition of *adlocutiones* from contemporaneous and earlier coins, replacing the gesture of speech with a document from which the emperor reads.[19] An *adlocutio* panel relief of Marcus Aurelius shows that emperor similarly, in the typical *contrapposto* stance but with his right arm bent rather than extended.[20] Most important is not the specific gesture itself but the composition of the scene and the spirit of the depiction.[21] On the Arco di Portogallo panel Hadrian addresses his audience in a public space, and his audience acknowledges his speech through gesture. His stance and posture is similar to that of emperors in the *adloctiones* discussed earlier, and the temple in the relief may be identical to that found on two Hadrianic *adlocutio* coins, one of which includes children.

The specifics of the Arco di Portogallo *adlocutio*, such as the presence of a togate, male child along with personifications of the Senate and Roman people, are unparalleled in extant Roman art and therefore somewhat mysterious; however, the companion panel from the Arco di Portogallo may shed some light on the *adlocutio*. The companion relief has been identified as the depiction of the apotheosis of the Empress Sabina (Fig. 18).[22] As Hadrian looks on from his seat, Sabina is carried from what appears to be a flaming funeral pyre by a winged goddess or personification, perhaps Aeternitas. As Kleiner notes, the fire may be a modern addition and is therefore suspect, as is the heavily restored youth seated at Hadrian's feet.[23] Because the panels are companionate, scholars such as Hannestad and F. Kleiner have identified the *adlocutio* scene as the depiction of Hadrian's funeral oration for Sabina before the Roman people. Kleiner (1990, 512) even speculates that the panel decorated a funerary arch dedicated to Diva Sabina in A.D. 136–137.

Strack uses evidence from one of the Hadrianic coins discussed earlier (Fig. 16) to confirm the identification of the Arco di Portogallo *adlocutio* as a depiction of a funeral oration.[24] As noted, Strack identifies the temple on the

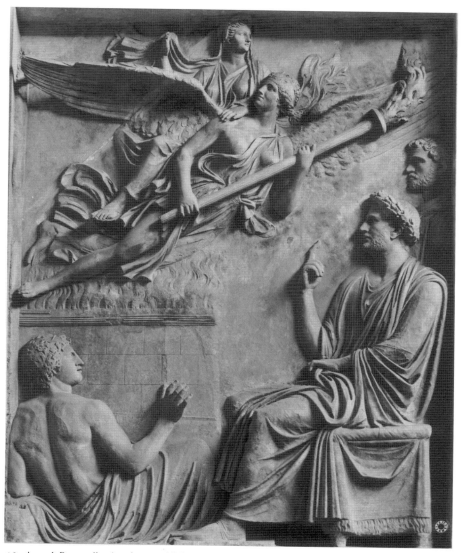

18. Arco di Portogallo, Apotheosis of Sabina, A.D. 136–138. Photo: Alinari/Art Resource.

coin as the Temple of Divus Julius, the temple at which funeral orations were often given during and after the reign of Augustus. Because the coin gives no specific reason for the *adlocutio* and because Hadrian learned of the death of Plotina in 121, Strack holds that such coins, minted in A.D. 121–122, depict Hadrian's funeral oration for Plotina.[25] Both coin and panel show Hadrian addressing audience members before the temple. Based on the similarity of the compositions of the coin and the panel, particularly the presence of the

Temple of Divus Julius, Strack argues that the *adlocutio* panel from the Arco di Portogallo depicts a funeral oration, this time given by Hadrian in honor of Sabina, perhaps providing evidence that Roman children could have been present in the audience at such ceremonies.

Strack here presents an intriguing possibility, but it remains just that – a possibility. The subject of the *adlocutio* on the Arco di Portogallo panel must remain a mystery. What does not remain mysterious is the subject of the panel itself. It is certainly an *adlocutio*, a depiction of an imperial speech, and while the presence of a child in the crowd may have no bearing on the subject of that *adlocutio*, it provides evidence as to the attitude of Roman citizens toward children. An emperor's address, perhaps even a funeral oration, was seen as an occurrence at which children were welcome and present.[26]

Although technically too late for my study, an *adlocutio* panel similar in style and spirit to the *congiarium* panel addressed in the previous chapter appears on the north side of the Arch of Constantine. Kleiner calls the scene "the most interesting and significant on the arch because it is through its details that the arch's political program can be deciphered" (p. 450). Equally important is the fact that this panel includes children. Constantine, who is shown frontally, stands in the center of the relief in the typical stance and gesture of address. The weight of his body rests on one hip, and he extends his right hand toward his audience. Surrounding the emperor are senators, but the entire audience consists of *paenulati*, plebeians. There are three children in the audience, whom Kleiner identifies as boys, but whose gender I cannot confidently identify. None of the children sits on an adult's shoulders, as do children in scenes of imperial largesse; all stand beside the adults. Some of the audience members gaze at the emperor and hold up their hands toward him, but others turn away, apparently talking with other members of the audience. Unlike scenes of largesse, in which *togati* and *paenulati* stand in an orderly line waiting to receive the donative, the audience of this scene behaves as if at a social event. They do not perform a single, unified gesture, nor do they share the same posture or stance. The composition of the crowd is much more haphazard, as may have been the case at a public event like a speech. This same, somewhat haphazard composition can be seen on the Parthenon frieze, in which members of the procession appear to be chatting informally with one another, oblivious to the movement of the procession. The children, however, all gaze toward the emperor. The details of the relief allow us to identify the setting positively as the Rostra in the Forum Romanum (ibid.).

SCENES OF SACRIFICE: OBSERVING STATE RELIGION ON
THE COLUMN OF TRAJAN

The Column of Trajan contains three scenes in which Roman children attend public sacrifices.[27] Two of these occur in what Lepper and Frere identify, after Cichorius, as a traveling series, scenes LXXX–LXXXVI.[28] These children appear in settings outside Rome, and often outside Italy, but their costumes and hairstyles mimic those of the Roman adults with whom they appear. In many cases scholars have hesitated to call these children Roman, identifying them rather as non-Romans or as Romanized "barbarians" because of the locales in which they appear. Lepper and Frere call these children simply "inhabitants" or "civilians," thereby avoiding questions of status and ethnicity (p. 135). Settis calls the children in the six relevant scenes *provinciales* rather than Romans or Dacians (p. 149), and Currie identifies as Dacian all fifty children depicted on the Column of Trajan, despite discrepancies in their costumes and the artistic contexts in which they appear. While she acknowledges the Roman costume of some of the children with the term "Romanized," Currie insists that all children from the Column of Trajan are ethnically non-Roman.[29]

The representations themselves do not support her assumption, as I shall show. Although many of the children depicted on the Column of Trajan can be identified unequivocally as non-Roman by their costumes, gestures, and the contexts of the scenes in which they appear, the costumes and hairstyles of the children in each of the following scenes indicate that these particular children are Roman. And like all Roman children depicted in official imperial art, they are shown in scenes of public gathering.

Scene LXXX depicts a group of men, women, and one child at a sacrifice (Fig. 19). As Ryberg notes, during the floruit of Roman imperial relief, the emperor's arrival or departure was the occasion most often selected for depictions of public sacrifices. In fact, imperial arrivals and departures account for five of the eight sacrificial scenes on the Column of Trajan.[30] Imperial arrivals sparked sacrifices of thanksgiving and welcome, while imperial departures required sacrifices to ensure the emperor's safety. In scene LXXX Trajan's arrival occasions the sacrifice. At the front of the Roman throng stands a child whose presence is emphasized by his central position in the scene. His hair is cropped short, and he wears what appears to be a tunic or cape. He stands conspicuously near the sacrificial victim and garlanded altar, on which a fire burns. Although the composition may evoke those in which *camilli/ae* appear,

this child does not act as such; he has no cult paraphernalia and appears only to observe the scene. The child's arms are bent at the elbows, and he extends his open right hand toward the ox, as do the women behind him. All figures direct their attention toward the altar. The men behind the boy have short hair and wear either the tunic of the Roman plebs or what may be traveling garb. The women are Roman matrons; they wear the *stola*, long drapery that falls to their feet, and the *palla*, or mantle.[31] In addition, their hair is piled in buns high on their heads in a style similar to that worn by Marciana, Matidia, and Sabina on coins minted at Rome between 114 and 136.[32] Although this scene takes place outside Rome, it clearly depicts Romans. In sacrificing on Trajan's behalf, the townspeople announce their loyalty to Rome.

Scene LXXXVI is the culmination of the traveling series. Here Trajan performs a sacrifice while men, women, and children observe.[33] The final scene in the series, scene LXXXVI shows Trajan being welcomed by people in Roman dress, presumably a group of local inhabitants.[34] Trajan himself performs the sacrifice. He is flanked by lictors, and a *camillus/a* is visible near the altar. Among the observers of the sacrifice are four children, two boys and two girls, one of whom is noticeably taller than the others. The older girl places her left arm on the head of the younger. All stand clustered near adults in the scene, and although none performs any gesture, all observe attentively, directing their gazes toward the altar. The men in the audience wear short hair and togas, and the women are dressed as Roman matrons in *stolae* and *pallae* with their hair twisted and rolled back from their faces into low buns like the hairstyle worn by Messalina and Antonia the Younger in coins minted at Nicaea and Rome, respectively.[35] The costumes and hairstyles of the children mimic those of the Roman adults.

Scholars do not agree as to the location of the so-called harbor town shown in scene LXXX, but most do agree that it depends on the identification of the town in scene LXXXVI. Cichorius identifies the town in scene LXXX as Zara (modern Iader), the nearest harbor across from Ancona and part of the Roman province of Dalmatia. Froehner and Stucchi, who interpret the scene as "western," generally hold that it is Ravenna, a Roman city. Still others identify the city as a Roman colony, either Corinth or Patrae.[36] This leaves the city in scene LXXXVI to be identified by Cichorius as Salona, the administrative capital of the Roman province of Dalmatia, by Domaszewski as Piraeus, and by still others as Byzantium, Dyrrhachium, or the Roman colonies Trieste, Sirmium, or Poetovio.[37] Poetovio was granted colonial status under Trajan, but

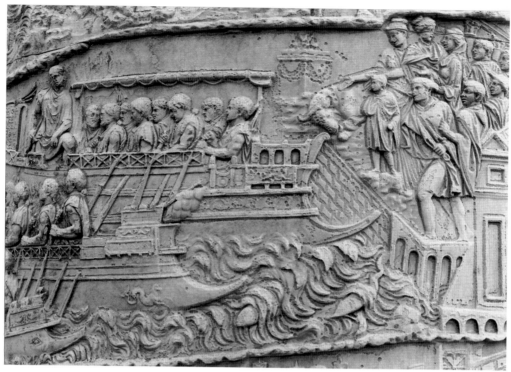

19. Column of Trajan scene LXXX, A.D. 113. Photo: DAI 89.755, Deutsches Archäologisches Institut.

all other cities proposed were colonies before his reign.[38] All identifications are based either on architectural similarities between those cities and the monuments that appear in the background of the respective scenes, or on the proposed route of Trajan's journey. As Lepper and Frere point out, none of these identifications can be proved with any certainty.[39]

Most important for my purposes is that the majority of towns proposed for scene LXXX are neither Dacian nor "barbarian"; rather, they are almost certainly in Italy or the Roman provinces, and therefore certainly home to Romans. Ryberg identifies the city in scenes LXXXIII and LXXXIV, for example, simply as a seaport on the Adriatic.[40] In all scenes in question the people depicted receive Trajan gladly, the towns display aspects of Roman architecture, and the people are dressed as Romans. The quay in scene LXXX appears to be constructed of brick and supported by arches (Fig. 19), and a city with amphitheater, temple, and porticoes forms the background of scene LXXXVI. In all scenes Roman women wear hairstyles similar to those of Roman imperial women, in contrast with those worn by Dacian women on the column. For

instance, as in scene XCI, discussed later, non-Roman women wear a bun at the base of the neck, often bound by a loose kerchief.

The third scene of sacrifice with children from the Column of Trajan, scene XCI, includes both Roman and non-Roman children, a unique occurrence that affords us the opportunity to compare Roman and non-Roman costumes side by side (Fig. 20). The scene depicts a sacrifice made upon the emperor's arrival. Here Trajan himself performs the sacrifice, holding his *patera* over a garlanded altar at the left side of the scene. *Camilli/ae* are visible behind the altar. There are a total of six altars in the scene, each identified with one of the six deified Caesars, Julius Caesar, Augustus, Claudius, Vespasian, Titus, and Domitian, indicating imperial cult activity.[41] Among those who observe the sacrifice are six children, one of whom is carried in the arms of a woman at the back of the audience. A male and a female child stand near her, the male wearing a short, belted tunic and cape, and the girl floor-length drapery and a kerchief, like the women around her. The boy turns back as if to say something to the girl, who faces the altar, but the woman behind him places a hand near his mouth, perhaps to shush him.[42] Both children hold their right hands open, as does the woman holding the infant. The women's garments are tied at the high waist in a twisted knot. They wear loose kerchiefs draped over their hair. Two non-Roman men with long hair and beards are visible in low relief behind the children. They wear a garment belted at the waist. The women direct their attention toward the altar, while the men appear to converse. This group clearly comprises non-Romans, as Ryberg observes.[43]

Three Roman children stand among a group of Roman men near the front of the crowd. Two appear to be male, with togas and short hair. The child in the middle may be female because her drapery falls to the ground, but it is impossible to say for sure. All three stand near togate men, and all acknowledge Trajan's sacrifice with a gesture that mimics those of the adults around them. The children nearest the altar hold out their hands in Trajan's direction, while the third child points toward the emperor and looks back at his father as if to say *ecce!* The left hands of the three men nearest the children fall near the heads of those children, perhaps indicating responsibility for them.

Members of both Roman and non-Roman groups appear relaxed. In both groups adults make gestures of responsibility for their children, although the children are not shown in complete family units. Roman children appear exclusively with men. Non-Roman men are visible in low relief behind the group, but it is women who take primary responsibility for the non-Roman children.

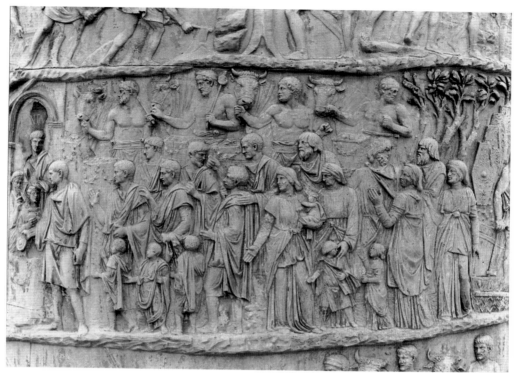

20. Column of Trajan scene XCI, A.D. 113. Photo: DAI 89.560, Deutsches Archäologisches Institut.

The men in the background make no visible contact with the children, while the women acknowledge the children through gesture and gaze. The association of Roman children with male family members in this scene is consistent with many other scenes of public gathering in which Roman children appear, including scenes of imperial largesse, as we have seen. Even in scenes in which Roman women appear, Roman men are often shown in closer proximity to the children; women stand at the back of the group, while men and children appear in the foreground. As shown in the following chapters, the association of non-Roman children with women in this scene is likewise consistent with other images in which non-Roman children appear.

Scene XCI is unique in Roman art in that it includes within the same artistic context both Roman and non-Roman children.[44] Otherwise, Roman and non-Roman children appear in separate and distinct artistic contexts, which my chapter divisions follow. In scene XCI the audience is divided by status, a familiar artistic tool; however, while in depictions of imperial largesse the senatorial and equestrian orders stand before the plebeians, here Roman parents

and children stand before figures in non-Roman dress. It seems likely that the figures at the front of the group are members of the town's Roman ruling elite, depicted with their children, while those at the rear are native inhabitants of the Roman colony or province, perhaps the *provinciales* or the "Romanized barbarians" of which Settis and Currie, respectively, speak. Whatever their specific legal or political status, their costumes are clearly non-Roman. This is the only depiction I have encountered in which non-Roman adults and children are included in a peaceful, public gathering with Romans, participating in Roman public life and presenting the possibility of a benign sort of Romanization through figures akin neither to the hostile or subjected non-Roman nor to the full Roman citizen.

Images from the Column of Trajan include Roman children as prominent figures in depictions of public sacrifices. While Roman children in the scenes addressed earlier do not participate actively in such sacrifices, they accompany family members and observe sacrificial ceremonies along with Roman adults, often at the front or in the foreground of such scenes. Roman children are shown to take the same role as Roman adults in imperial sacrifices, directing their attention toward the emperor and learning the ritual of Roman state religion firsthand. In this way Roman children are taught to participate in Roman public life and to observe state religion, as are the Romanized children in scene XCI.

CHILDREN AT GAMES AND PROCESSIONS

Roman children appear in three depictions of Roman games, usually in what appear to be processions. Suetonius reports that Augustus revived the *ludi saeculares*,[45] which were celebrated six times during the empire. In the same passage Suetonius also records that Augustus banned both male and female children from the evening activities of the festival unless they were accompanied by an adult relative, making it clear that children of both genders participated in the daytime activities of the games. After Augustus' games, Domitian and Septimius Severus celebrated the *ludi saeculares* according to the 110-year cycle adopted by Augustus. The other three celebrations, those of Claudius, Antoninus Pius, and Philip the Arab, followed the more traditional hundred-year cycle.[46]

The first two representations come from commemorative coin types from the reign of Domitian celebrating the *ludi saeculares* of A.D. 88.[47] Both types

bear the legend *COS XIIII LVD SAEC (FEC)*, and the first
adds *SVF P D*. The first type shows a togate adult man
and a Roman child greeting the emperor (Fig. 21).[48]
The child's gender is impossible to determine because
children of both genders could wear the toga and par-
ticipate in the *ludi*. The emperor sits in front of a temple
on a platform, handing *suffimenta* (incense) to the adult.
His hand touches that of the citizen, making explicit
the exchange. Domitian is shown near the child, who
stands between the two adults, lifting up his or her hands
toward the emperor. Brilliant claims that the gesture of
the child seems to "honor Domitian among the gods"

21. *Ludi Saeculares* AE of Domitian: BMC
428. Photo: © Copyright The British
Museum.

(p. 100). He suggests that the child and his or her position on the coin pri-
marily emphasize Domitian's status. The child, however, may have been a
participant in the activities of the *ludi* as well.

The second coin type depicts what is likely a procession of the *ludi saeculares*
(Fig. 22).[49] Domitian and a togate adult walk behind three children who carry
small branches in uplifted hands. Dennison identifies the children as two boys
and a girl and speculates that the group is intended to represent a moving
procession.[50] All figures face right, and the postures and stances of the two
children at the rear of the procession are nearly identical, both with bent right
knees. The drapery of all three children is also nearly identical, emphasizing
the rhythm of the processional movement. The first child in the procession,
however, may have stopped, for his knees are not bent.

In 1891, after the discovery of an inscription commemorating the *ludi saec-
ulares* held by Augustus in 17 B.C.,[51] Mommsen proffered the theory that the

carmen saeculare of the games was a processional, sung by
a chorus.[52] He speculated that the procession moved
from the Temple of Apollo on the Palatine to the Temple
of Jupiter Optimus Maximus on the Capitoline and back
again.[53] As we have seen, the first of Domitian's *ludi*
coins discussed earlier locates the emperor's distribu-
tion of incense before a temple. Furthermore, in his de-
scription of the secular games celebrated by Augustus,
Zosimus reports that fifty-four children performed
songs and hymns in the Temple of Apollo on the
Palatine on the third day of the festival. Equal numbers

22. *Ludi Saeculares* AE of Domitian: BMC
426. Photo: © Copyright The British
Museum.

of boys and girls took part, although only children with both parents living could participate. The songs of the children were intended to protect the cities of the Roman Empire.[54] Seven verses of the Sibylline books quoted by Zosimus confirm his description, as do two scholia on the *Carmen Saeculare* of Horace.[55]

While none of these accounts includes a procession exactly like that proposed by Mommsen, Dennison (1903) points out that the procession was a "common and characteristic feature of ancient religious celebrations, both Greek and Roman – a fact so familiar that no citing of specific instances is necessary" (p. 55). Dennison does go on, however, to cite a number of religious processions similar to that proposed for the *ludi saeculares*. Among his examples is Livy's account of a procession that took place at Rome in 207 B.C. after *pontifices* received negative portents throughout Italy. Livy records that at the behest of the *pontifices*, twenty-seven maidens (*virgines*) walked in procession through Rome singing a hymn (*carmen*).[56] Dionysius and Appian record that dancers and musicians were a common component of the Roman *pompa*.[57] Dennison concludes that Mommsen's theory is correct and that the *ludi saeculares* of 17 B.C. most probably included a hymnal procession that began at the Temple of Apollo on the Palatine.[58] These accounts help to explain depictions of Roman children at *ludi*. Although it is nearly impossible to determine the exact function of Roman children in such depictions, it is likely that they play a role similar to that described by Zosimus and suggested by Mommsen.

A poorly preserved medallion from the reign of Antoninus Pius commemorates public games identified by Ryberg and Gnecchi as the *ludi decennales* or *decennalia*.[59] Gnecchi records the legend *LVD DEC* on the reverse of the medallion, but if such legend once appeared it is no longer visible. Cassius Dio records that because Julius Caesar was originally awarded power in increments of ten and five years, and later in increments of ten years, ruling for the span of his life through the succession of ten-year increments, Augustus and subsequent emperors celebrated the anniversary of their rise to power every ten years with a *decennalia*, despite the fact that they held power for life.[60]

The medallion shows Antoninus Pius and another adult with three small figures. The adult at the far left of the flan is barely visible. Gnecchi calls him a flute player, an identification that may be supported by the angle at which he holds his arms.[61] The emperor stands as the central figure in the scene, and again he is shown near the children. On his right stand two children, both of whom hold shields, now barely visible. On his left, behind a table, stands a figure who is probably a servant.[62] Antoninus Pius places his right hand

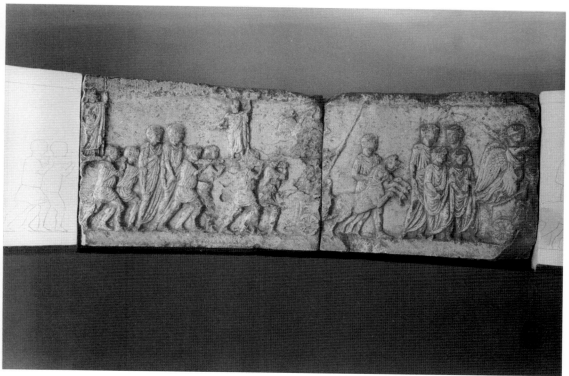

23. Limestone Ludi Relief. Photo: DAI 60.398, Deutsches Archäologisches Institut.

around the child at his immediate right. The child's left leg may be bent at the knee as if to imply motion. His left hand is raised such that it nearly touches the head of the child on his left. All figures direct their gazes toward the child behind the table, who looks out toward the viewer. Gnecchi identifies the figures as members of a *corteo agonistico*, a procession of the *ludi decennales*, calling the table before the servant *la tavola agonistica*. He even identifies prizes on the table before the servant.[63] Ryberg speculates that these figures are the children who marched in the procession at the *decennalia* and took part in exercises or dances such as the *lusus Troiae* or those proposed by Mommsen and others,[64] but Gnecchi's analysis leads me to believe that the children were participants in some sort of athletic or military contest.

Games and processions are intimately related, and an imperial limestone relief provides an excellent segue between the two categories. On this relief, two of whose four total parts will be discussed here, two Roman children appear in what Ryberg calls a "procession before the *ludi* of a *sevir*" (Fig. 23).[65] The procession is certainly affiliated with games, but the relief itself depicts the

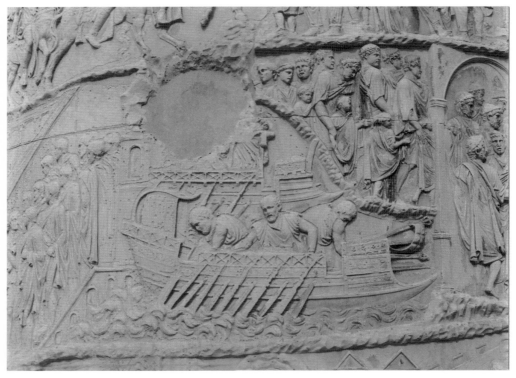

24. Column of Trajan scene LXXXIII, A.D. 113. Photo: DAI 89.757, Deutsches Archäologisches Institut.

moment before the games. From the entablature of an exedra in Amiternum, now in the Museo Nazionale in Rome, the relief shows, from left to right, two togate men flanked by *fercula* holding divine images, then two togate men with two children flanked by *bigae*. The *biga* on the left carries the sponsor of the games, identified by his scepter, while the second, at the far right of the relief, carries Victoria.[66]

The children, both male, simply walk in procession; both face right, contrasting with the adults behind who gaze toward one another. Their clothing mimics that of the Roman adults in the scene. The function of the children is unclear, as they make no specific gesture, but they may have been young participants in the exercises or procession of the games. There is no sacrifice shown on the relief. As Ryberg notes, the emphasis here is placed on the honorific procession that took place before the performance. She identifies the scene as a *pompa* of the *ludi* rather than a triumphal procession because the participants in it are gladiators rather than soldiers and captives.[67] Thus, the children are Roman, not foreign, and they are singers or dancers, not captives.[68]

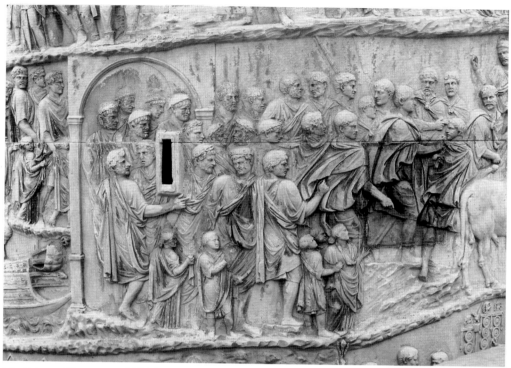

25. Column of Trajan scenes LXXXIII–LXXXIV, A.D. 113. Photo: DAI 89.569, Deutsches Archäologisches Institut.

Adjacent scenes LXXXIII and LXXXIV from the Column of Trajan include representations of nine children who accompany adults in procession as they escort the emperor on his departure from their town (L&F, 133).[69] Four children appear in the procession on one side of the arch, and five in the procession on the other side (Figs. 24 and 25). As in *adlocutio* scenes from the Column of Trajan, women are absent; Roman children of both genders are shown in scenes LXXXIII and LXXXIV exclusively with Roman men.[70] The adults in these scenes wear togas and fillets or wreaths over their close-cropped hair. They make loving gestures toward the children, helping them down the stairs and through the arch, holding their hands, and generally guiding their movement. The gestures of the men show clear responsibility for the children. The children, at least three of whom appear to be girls, follow where the men lead. Like the men, they direct their attention toward the emperor; with the exception of the girl at the very front of the group who holds out her open left hand, all children bend their right arms at the elbow, holding their hands in the emperor's direction. Their gestures mimic those of the adults around

them, as does their clothing. These children are not Dacian. They wear Roman clothing, they appear among Roman adults in a scene of public gathering, in this case a procession escorting the emperor upon his departure, and their actions mimic those of the Roman adults around them. The scene, part of the traveling series discussed earlier, probably takes place in a Roman province or colony, perhaps a port on the Adriatic, as has been suggested.

CONCLUSION

As we have seen, on the Column of Trajan there are approximately twenty children in Roman dress in contexts that are obviously outside the city of Rome. Because of the geographic settings in which they appear, scholars have been hesitant to identify these children as Roman, and Currie goes so far as to identify them as Dacian. These children, however, all wear Roman costume and are accompanied by men in the toga and by women, if present, in the *stola* and *palla*, the costume of Roman matrons. Roman citizens were careful to display their own status through their attire, and restrictions were placed on the garb of non-Romans.[71] Furthermore, the only reliable evidence available as to the status and ethnicity of children in Roman art is their appearance. We must conclude, therefore, that children shown in Roman dress on the Column of Trajan would have been viewed as Roman by ancient audiences, regardless of whether this identification is problematic for modern viewers.

This methodology and the conclusions it engenders are confirmed by the fact that the contexts in which the disputed children on the column appear correspond precisely to the contexts in which Roman children appear on the monuments and coins discussed in this and the preceding chapter. Roman children appear consistently in scenes of official, public events like the processions and sacrifices found on the column, as well as in scenes of imperial largesse. As shown in the following chapters, non-Roman children, in contrast, appear only in scenes of submission, triumph, and violent military activity. The only exception to this rule is scene XCI, in which Roman and non-Roman children appear in the same artistic context, the public sacrifice. In this unique case, the message is clear: although non-Roman children are not recipients of imperial largesse and do not participate in *adlocutiones* or Roman games, it is appropriate for Romanized non-Romans (that is, non-Romans friendly to Rome) to observe (and to embrace) imperial cult activity. What better exemplifies the Romanization of non-Roman people than their acknowledgment of the

religion of the emperor and empire? Unfortunately, this is the only extant image of which I know that includes Roman and non-Roman children and adults in such a peaceful context.

It remains, finally, to tie this chapter to the last, for the two are intimately related. Why do Roman children appear in the context of the public gathering? After all, the role of children in such scenes is not always clear. Whereas Roman children in scenes of imperial largesse are often, ostensibly, recipients of that largesse, Roman children in other scenes of public gathering appear only to observe. Occasionally we may identify a procession in which they take part, but they seem primarily to accompany family members, having no active role in the events they attend. Moreover, there are some images, such as those from Hadrianic *adlocutio* coins, and perhaps even the Arco di Portogallo relief, in which we might see Roman children as symbolic, that is, as representative of the general commitment of the emperor to children and the family rather than as taking part in a public gathering in an historical sense.

These observations do not preclude significant conclusions. While the primary function of Roman children in scenes of public gathering appears to be to accompany their parents and family members as observers, such scenes give us insight into the socialization of Roman children – the way children learned to become Roman citizens. In scenes of public gathering, including scenes of imperial largesse, Roman children are indoctrinated into Roman public life by observing it firsthand. To be Roman in such scenes is to look and to behave like a Roman. To be Roman is to wear Roman clothing, to be a part of a Roman family unit, to show loyalty to and respect for the emperor through attentive behavior, and to attend imperial speeches, sacrifices, and games.

The visual evidence is supported by references to the presence of children at public gatherings occasioned specifically by the *adventus* or *adlocutio* of an emperor. Even before the reign of Augustus, Caesar documented the presence of children at both *adlocutiones* and *adventus*. His *Bellum Civile* records the following *adlocutio*: "When it was light, Caesar ordered that all senators and children of senators, the military tribunes, and the Roman equestrian class be brought before him."[72] Caesar's *Bellum Gallicum* describes similarly the arrival of Caesar at various towns and colonies:

> Caesar's arrival was received by all the towns and colonies with extraordinary honor and love, for that was the first time he came after the war against all of Gaul. Nothing thinkable was omitted from the decoration of the gates, the roads, and all the places through which Caesar was about to pass. Along

with their children, the whole multitude went forth along his route, sacrificial victims were slaughtered at all locales, and temples and fora were outfitted with heavily-laden tables so that the joy of the long-awaited triumph might be anticipated.[73]

Tacitus records the presence of children at an *adventus*, this time in honor of Nero: "And they found matters more prepared than they had promised, with the tribes lining the road, the Senate in festal attire, lines of wives and children positioned according to gender and age, bleachers set up for viewing where he would pass, in the way that triumphs are observed."[74] Finally, as noted earlier, literary sources document the presence of children at funerals.[75]

Visual and literary evidence show that to be a future Roman citizen is to be engaged in all aspects of Roman public life, from politics and governance in *adlocutiones*, to social life and recreation in Roman processions and *ludi*, to state religion in public sacrifices. Roman children are included in these scenes because of their potential; they will someday take responsibility for the events depicted in them. In scenes of public gathering Roman children are shown learning to act as Roman citizens, guaranteeing the continuation of Roman traditions. As with scenes of imperial largesse, the inclusion of Roman children, historical or symbolic, in scenes of public gathering underscores the commitment of the emperor to children and family.

It may seem unexceptional that Roman children represent the future Roman populace, especially considering modern political rhetoric in the United States. Yet whereas modern political rhetoric seems to stem primarily from the simple reality of the human life cycle, the importance of children to visual imagery in the Roman period stems, in part, from the nature of the imperial political system. The value of Roman children in official Roman art does not become completely clear until one considers the dynastic nature of the empire. Emperors were continually concerned with the smooth transfer of power within their dynasty, a phenomenon that often required much or-chestration. Succession was a matter of grave importance within the imperial family if the dynasty was to be preserved.

Van Bremen (1983) considers the emergence of women into the public sphere during the Hellenistic period. She identifies the system of euergetism as the primary mechanism through which this emergence took place: "The possession of wealth and the apparent freedom to use that wealth inside a sufficiently flexible and tolerant legal system were clearly essential precondi-tions for independence. . . . But they were not in themselves sufficient factors

to bring about the prominent position of these women. The wealth factor has to be seen in a wider political context" (p. 237). I believe the wider political context to which van Bremen refers is, at least in part, the context of monarchy or dynasty, the context in which the smooth transfer of power from generation to generation depends on women to produce viable heirs. It is this type of political system, again in part, that caused "the disappearance of a clear distinction between private and public life" (ibid., 236).

This same phenomenon influences the art of the Roman Empire. Because succession was of crucial importance to maintain the imperial dynasty, the location of women and children completely within the private sphere was not possible. In a dynastic system, women and children necessarily become public figures as either producers of heirs, or as potential heirs or producers of heirs. Against this backdrop, images of Roman children in scenes of public life become even more meaningful. The dynastic nature of the imperial government relied on the production of heirs for its stability. Although this necessity was presumably felt most urgently within the imperial family, the reality of dynastic succession forms part of the cultural context in which we must view all images of children in Roman art. In Roman art, children represent not only the future Roman populace; they also represent the stability of the imperial government.

Finally, the Roman family unit is defined in images of public gathering by the primacy of the father (or adult male figure). In scenes of imperial largesse, mortal women appear only in depictions of the *puellae Faustinianae* and on one panel relief of Marcus Aurelius. Moreover, the woman on the panel relief does not connect herself through gesture or gaze with either of the children on that panel; she appears, rather, as an independent figure. While women are present in two scenes of sacrifice from the Column of Trajan, they appear at the rear of the crowd. It is men who appear with children in the foreground of such scenes, men who take primary responsibility for Roman children in scenes of public gathering, and men with whom Roman children are most often depicted.

5 ANAGLYPHA TRAIANI/HADRIANI

The so-called Anaglypha Traiani/Hadriani has caused scholars enormous grief, with no end in sight. In her *Hadrian and the City of Rome*, Tolly Boatwright sums up the situation:

> Two marble reliefs, the so-called Anaglypha, have been assigned to both Trajan and Hadrian since their discovery in 1872 between the Column of Phocas and the Rostra on the west side of the Forum Romanum. The original purpose and location of the reliefs is as uncertain as their date. . . . The slabs that make up the two Anaglypha were reused in the foundations of the medieval Torre del Campanero in the Forum; reassembled, they show on one face apparently historical scenes and on the other a parade of the three victims of a *suovetaurilia*. . . . Before their reuse in the tower, almost every human head in high relief they carried was destroyed, with the result that the identification of the original figures is not possible and we are thrown back on stylistic considerations that lend themselves to dating as both Trajanic and Hadrianic. Finally, and most important, the interpretation of the historical scenes remains controversial: within the past few years U. Rüdiger has identified them with known Hadrianic events, and M. Torelli with Trajanic ones. Without new evidence, the questions of the original location, purpose, and date of the Anaglypha must remain unanswered.[1]

Scholars have been hacking away at the Anaglypha since their discovery before the turn of the century, making convincing and creative arguments regarding questions of both subject and date but little progress toward unequivocal answers to either. I do not propose here to solve the mystery of the Anaglypha Traiani/Hadriani. I do propose, however, to shed light on one of the Anaglypha's historical reliefs by addressing it within the context of a larger visual field, specifically the images of Roman children compiled and examined in the two previous chapters.

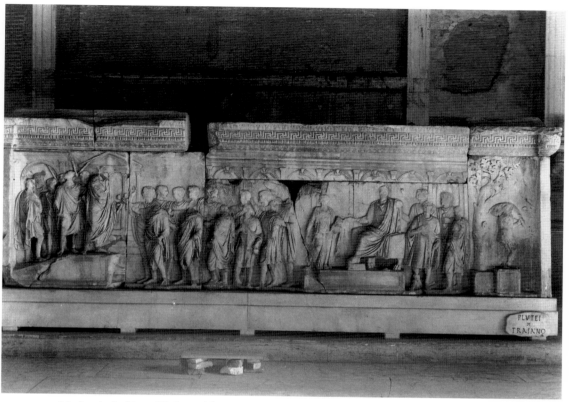

26. Anaglypha Traiani/Hadriani, *Adlocutio*. Photo: DAI 68.2783, Deutsches Archäologisches Institut.

The scene with which I am concerned has been variously identified as an *adlocutio* and an *alimenta* depiction, both motifs in which children appear (Fig. 26). Although apparently distinct in subject from its counterpart, the so-called debt-burning relief (Fig. 27), the *adlocutio/alimenta* scene forms one-half of what appears to be a contiguous group. The background of both scenes is now widely acknowledged to be the southern end of the Roman Forum; there is even overlap between the scenes as shown by the statue of Marsyas near the fig tree at the far right of the *adlocutio/alimenta* panel and far left of the debt-burning panel.[2]

The *adlocutio/alimenta* panel is divided into two compositional groups, one of which includes children. On the far right of the scene sits a figure identified either as an emperor or a magistrate. I identify him as an emperor because of the similarity of his position in the composition with that of emperors in analogous scenes from coins. The emperor's *sella curulis* is elevated on a

platform, he rests his feet on a stool, extending his right hand and his gaze toward a woman with two children, and his left arm, now lost, may have been raised to hold a scepter.[3] A woman with two children stands on the platform in close proximity to the emperor, although he appears much larger than they. The woman, dressed as a Roman matron, places her hand on the head of the older child, now barely visible, and holds the younger child in her arms. The younger child reaches out toward the emperor, perhaps originally touching his arm or hand. The children are too poorly preserved to determine their genders, but parallels on coins and from *alimenta* scenes suggest that one is male and the other female. Kuttner (1995) calls these children the *puer alimentarius* and the *puella alimentaria* (p. 49). Behind the emperor stand four plebeians.

At the left side of the relief an imperial figure stands on a platform, apparently addressing citizens from the rostra in front of the Temple of Divus Julius, as in a number of the *adlocutio* images discussed in Chapter 4. The audience, which is divided into *togati*, senators and equestrians, and *paenulati*, plebeians, directs its gaze toward the emperor, turning its collective back on the scene at the right. The *togati* at the front of the crowd raise their open right hands toward the emperor, acknowledging his speech as he reads from a scroll in his left hand; his left elbow is slightly bent, and he appears in the familiar *contrapposto* stance. Behind the emperor stand six figures, some of whom appear to be lictors.

As is perfectly apparent, and as Boatwright, Hammond, and others have observed, the group on the right side of the Anaglypha Traiani/Hadriani conforms to one type of *alimenta* motif. It is nearly an exact parallel of Trajanic *ALIM*(enta) *ITAL*(iae) coins on which the seated emperor greets a Roman woman with two children (Fig. 5). Even the stools on which the emperors sit and rest their feet match one another precisely. The position of the children in the composition of the scenes is also the same, as are the gestures of the figures. The children hold out their arms toward the emperor, and he extends his right arm toward them in return. In addition, the emperor's right arm is raised in the relief as if to hold the scepter extant on the coin. Finally, in neither medium is the emperor raised on a platform above the recipients as on earlier *congiarium* and later *liberalitas* issues. In Trajan's relevant *alimenta* coinage and on the *adlocutio/alimenta* panel from the Anaglypha Traiani/Hadriani, all figures appear on the same level, emphasizing the connection between the emperor and the figures before him.

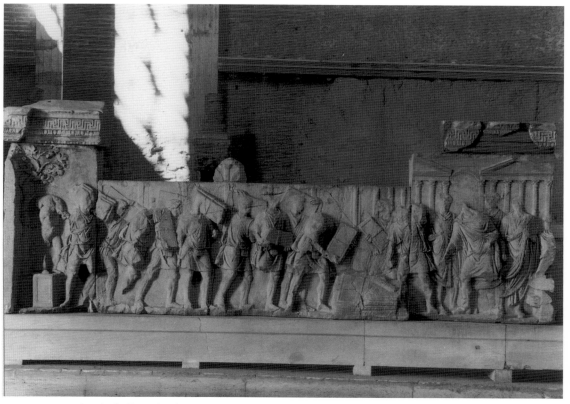

27. Anaglypha Traiani/Hadriani, Debt Burning. Photo: DAI 68.2785, Deutsches Archäologisches Institut.

The similarity between Trajanic *alimenta* coins and the group on the far right of the Anaglypha panel in question has led scholars to propose the existence of a statue group, now lost, commemorating Trajan's tradition of largesse. The composition of the group clearly identifies it as an image of largesse. In his 1953 study, Hammond held that "since statues seem to have served as prototypes for coin types of the emperors in superhuman guise, the coin type of Trajan which commemorates the *alimenta* and which closely resembles the group on the relief [Fig. 5] supports the view that the model for both was a statue group" (p. 180).[4] Henzen had earlier proposed the existence of a statue group depicting Italia with children before Trajan in the area of the Forum Romanum usually assigned to the *Equus Domitiani*.[5]

These suggestions are attractive because they account for the apparent inclusion of two emperors in the relief. The panel does not seem to be a documentary narrative; thus, the inclusion of two representations of the same

emperor would be odd.[6] Consequently, we must assign a Hadrianic date to the relief. The group at the right is probably a statue group of the deified Trajan with Italia and the representative children of Italy, as seen on Trajanic coins. The group at the left of the relief, however, is certainly an *adlocutio*, most probably given by Hadrian. The composition of the scene conforms to the *adlocutio* motif. The emperor stands on the rostra near the Temple of Divus Julius before a crowd of Roman men, apparently addressing them from a scroll in his left hand. He stands in *contrapposto*, and he is accompanied by lictors. The crowd, divided by status as in many scenes of public gathering, acknowledges the emperor's speech through an open-handed gesture.[7]

The similarity between Trajanic *alimenta* coins and the group on the far right of the Anaglypha panel has led scholars to connect the *adlocutio* shown on the left side of the relief with Trajan's *alimenta*. Henzen claimed as early as 1897 that the entire Anaglypha relief commemorated Trajan's institution of the *alimenta*. Even those who propose a Hadrianic date for the relief suggest that the *adlocutio* could depict the announcement of the extension of Trajan's *alimenta* by Hadrian in 118.[8] Hammond, for instance, while acknowledging the mysterious nature of the Anaglypha Traiani/Hadriani, concludes that the relief in question may represent Hadrian's extension of Trajan's alimentary funds.[9]

If the *adlocutio* depicted on the Anaglypha Traiani/Hadriani announced Hadrian's extension of the *alimenta* in 118, it seems likely that children would have been present in the audience: children are a constant in *alimenta* coinage. Taken as a whole, the panel in question does not conform to Trajan's *alimenta* coinage, and whereas Roman children could be depicted in *adlocutiones* as well as in scenes of imperial largesse, children are entirely absent from the *adlocutio* on the left side of the Anaglypha panel. As Torelli observes, the relief "does not show any understandable sign of the actual performing of the *alimenta* institution" (1982, 90).

Moreover, the crowd is organized according to status with *togati* at the front, nearest the emperor, and figures wearing the *paenula* at the back, as in scenes of imperial largesse unrelated to the *alimenta* (see Figs. 13 and 14) and other scenes of public gathering.[10] In addition, the first plebeian in line carries a *sportula*, and others carry *rotuli*, two types of documents used to prove tribal assignments and therefore possibly indicative of a *congiarium*.[11] As Torelli contends, it is likely that "(the statue) group . . . appears in our relief as just one of the monuments of the Forum, certainly of some relevance to the general propaganda of the reliefs . . . but not as the sign of the theme of the imperial

adlocutio" (p. 91). The compositional and thematic divide between the two halves of the *adlocutio/alimenta* relief is apparent in the posture of audience members at the *adlocutio*. *Togati* and *paenulati* alike turn their backs on the group at the right. Therefore, although the statue group in the *adlocutio/alimenta* panel may play an important symbolic role in the relief, the participants in the action of the *adlocutio* do not acknowledge it directly, signaling its separation from that action.

Torelli claims, therefore, that the subject of the emperor's speech must be simple *liberalitas*, holding that the scene in question depicts not Hadrian's extension of Trajan's *alimenta* but an *adlocutio* at which Trajan announced a *congiarium*.[12] In support of his theory Torelli observes that while the *alimenta* affected all of Italy, the location of the scene in the Forum Romanum "emphasizes a direct relationship with the people of Rome," implying that this particular *congiarium* may have applied only to those living at Rome (p. 90–1). *Congiaria* were indeed given by Trajan in 99 and 102 as well as in 103 and 108.[13] While I take issue with the Trajanic date proposed by Torelli, his analysis is otherwise sound.[14] The *adlocutio* panel from the Anaglypha Traiani/Hadriani may indeed have some connection to Trajan's *alimenta*, but there is no evidence in clear support of this conclusion.

There exists, however, another close parallel for the scene in question: a Hadrianic bronze coin type treated in Chapter 3 with the legend *LIBERTAS RESTITUTA* (Fig. 8).[15] On such coins, Hadrian is seated on a platform on the *sella curulis*. He extends his hand to a Roman woman who holds an infant in her left arm and places her right hand on the head of a togate child. With the exception of Hadrian's position on the platform, the composition of the three groups is exactly the same, and despite Hadrian's position he is still depicted near the woman and children on the *LIBERTAS* coin. Again we shall find Strack's explanation of Hadrian's *LIBERTAS RESTITUTA* coin useful here. Strack claims that the coin is a document celebrating the general success of Hadrian's fiscal policies (and perhaps Trajan's as well) with no explicit reference or necessary connection to the *alimenta*.

I believe the historical panels from the Anaglypha Traiani/Hadriani serve a function similar to Hadrian's contemporary *LIBERTAS RESTITUTA* coinage. Considering the artistic unity imposed on the two historical panels by their contiguous backgrounds, it is likely that the *adlocutio/alimenta* panel is linked thematically with the debt-burning relief. Hammond (1953) holds that "the realism of the style, the coherence of their composition, and the continuity

of the background in the historical reliefs demand that the two scenes be both actual and related" (p. 179). Whether the subject of the *adlocutio* is Hadrian's extension of Trajan's *alimenta*, specifically, the announcement of a simple *congiarium*, or the announcement of the debt relief depicted in the companion panel, paired with the debt-burning relief, the panels together announce and celebrate Hadrian's generosity and investment in the future of Rome. As Hammond says, "[a]s far as the events themselves go, the artist might have meant to show how two different emperors contributed through acts of generosity to reestablishing security and liberty for the Roman citizens. The connection between the two scenes would thus be given mainly by the statue of Marsyas, which would have come to stand not for the ancient liberty of the Republic but simply for freedom from want" (p. 177).[16] Kleiner draws similar conclusions, claiming that the Anaglypha is an "early example of Hadrian's piety toward the divine Trajan" (p. 248). Of the two panels in question she says:

> There is no better summation of the beneficent attitude that both Trajan and Hadrian had toward the Roman people, whether the senatorial elite or the Roman poor. It is for this reason that the Anaglypha is a visual document of the utmost importance. What it records about the social programs of the Trajanic/Hadrianic period is more important than its precise date.... Hadrian wanted to erect a monument in Rome that would extol Trajan's social policies, both the *institutio alimentaria* and possibly also his *congiaria*, and that would indicate to the Roman populace that those policies would be continued by his rightful heir.... The Anaglypha, therefore, seems to be one of those monuments commissioned early in the principate of a new emperor eager to associate himself with both the person and the policies of his immediate predecessor. (p. 250)

This is not to say that the children in the scene are unimportant. On the contrary, the *adlocutio/alimenta* image is anchored by the group at the right that certainly recalls Trajan's *alimenta* issues, is nearly contemporary with Hadrian's *LIBERTAS RESTITUTA* coins, and may document the presence of such a statue group in the Forum Romanum. As shown in Chapter 3, this type of group, in which an emperor greets representative children of Italy in the context of imperial largesse, can celebrate not only the specific policies of that emperor but also the general success of such policies. Roman children appear in scenes of imperial largesse to advertise the charitable social policies of the Roman ruling elite and to make explicit the successful investment of the ruling elite

in the future of Rome. As I have argued, Roman children in scenes of imperial largesse are not simply recipients of that largesse; they are proof of imperial commitment to the future of the Empire.

This group in particular, in which Trajan appears, most probably as a deified emperor, advertises the restoration of *libertas* to Italy by referencing familiar images that incorporate children as symbolic of Italy's future. Viewed within the context of the images of the previous two chapters, the *adlocutio/alimenta* panel from the Anaglypha Traiani/Hadriani appears consistent, readable, and perhaps less mysterious. It is not an anomaly but rather a thoughtful combination of two imperial motifs, an *adlocutio* and a scene of imperial largesse, both of which could include children, and one of which does here.[17] The combination of the two motifs sends a layered and yet accessible message to the Roman viewer, a message that highlights the generosity, consistency, and success of Trajanic and Hadrianic imperial policies, with specific reference to children as the future of Rome.

6 | SUBMISSION

I mages of non-Roman children are found in three distinct artistic contexts: scenes of submission, scenes of triumph, and scenes of military activity. The monuments on which non-Roman children appear often celebrate and commemorate Roman conquests or victories. Just as Roman children represent the future of the Roman populace in a general sense, non-Roman children represent the future of their particular region or *ethnos*. They are rarely depicted singly but usually appear in family or kin groups, and they are often shown in the company of the emperor or other Roman officials. Although all non-Roman children in official Roman art represent the foreigner or the other on some level, they function in a number of specific ways as well. In scenes of submission they highlight the political impotence of the non-Roman, representing conquered ethnic groups in a submissive and paternalistic relationship with the emperor. They may also symbolize the future of these groups or provinces under Roman rule. In triumphal scenes non-Roman children function both as actors in a type of dramatic military production and as *spolia* on display for the viewer. Finally, in military contexts non-Roman children document the heat of battle and, through their fear and subjugation, illustrate the weakness and vulnerability of conquered territories in the face of Rome's power.

I consider here fifteen images in which non-Roman children either submit or are offered as tokens of submission or supplication to the emperor or other Roman official. Children do not usually appear as individual suppliants in this context. Non-Roman adults, identified by costume, gesture, and posture as members of the child's family or ethnic group, offer the children. Attributes such as bound hands sometimes mark the non-Roman adults as prisoners of war. The children, often young males between infancy and six or seven years

of age, function as offerings to the emperor and Rome. An implicit symbol of the future of their territory or *ethnos*, they are handed over to the Roman ruling elite by a representative of that territory or group. This exchange symbolizes the submission of the vanquished to their new ruler and exemplifies the relationship between the vanquished and the *pater patriae*, that of child and father, respectively.

In this context non-Roman children perform a gesture of submission toward the emperor or other Roman official. The gestures of the children, their parents, and the Roman officials who receive them are the glue that holds this category together, although the consistency of the compositions also helps define the category. The gesture, identified by Brilliant, may be related to *proskynesis* in Greek art, and it appears in republican as well as imperial art.[1] The suppliant kneels either with hands outstretched or with hands at the knees or feet of the imperial official, and face is always upturned (Brilliant, 70–6).[2] If bearded, the angle of the suppliant's beard emphasizes the position of his head. If the suppliant does not kneel, he or she often bends at the knees or waist (or both), placing one leg in front of the other.[3] In addition, the suppliant may turn one palm up.

Adults were the first to perform the gesture of submission in Roman art, as on a coin of Faustus Cornelius Sulla from 62 B.C. on which Bocchus, king of Mauretania, kneels, offering an olive branch to Sulla seated in a curule chair.[4] An Augustan coin with the submission of an Armenian also shows the gesture clearly.[5] A panel relief from the Arch of Marcus Aurelius approximately two hundred years later shows a bearded, non-Roman man making the same basic gesture toward the emperor (Fig. 28). He kneels with hands outstretched, one palm up, and his gaze is turned toward the emperor. This gesture of submission is clearly distinct from the *dextrarum iunctio*, in which a subject of the emperor kneels and shakes his hand.[6]

It is not the gesture alone, however, that defines such scenes as submissions. In scenes of submission, the emperor or other official who receives the non-Romans is shown on a platform or tribunal, giving him an imposing presence and distinguishing him from the suppliants around him. He always appears taller, and sometimes in larger scale, than those who submit to him. In addition, the official may make a gesture to acknowledge the suppliants, although he may not interact with them directly. While the emperor receives Romans from the *sella curulis*, he often receives non-Romans from the *sella castrensis*, signaling a military setting. In most cases, the recipient of the submission is accompanied

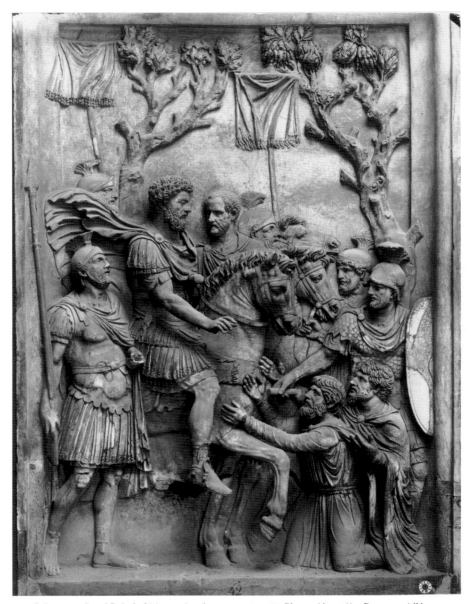

28. Submission Panel Relief of Marcus Aurelius, A.D. 161–180. Photo: Alinari/Art Resource, NY.

by other Roman figures, usually soldiers in military dress, as well as military paraphernalia. Note, for instance, the *vexilla* in Figure 28.

My study includes a number of Brilliant's images, and I often follow his lead in defining specific gestures as submissions, but I examine here a number

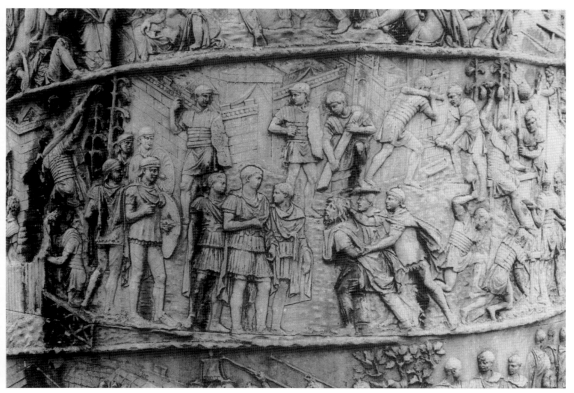

29. Column of Trajan scene LVIII, A.D. 113. Photo: DAI 91.93, Deutsches Archäologisches Institut.

of child images without an explicit gesture of submission. Gesture alone cannot determine the purpose of a figure in art and therefore does not exclusively define its function. Although these images lack the gesture of submission, their compositions are similar and often nearly identical to those in which the gesture occurs. An excellent example of such an image comes from scene LVIII from the Column of Trajan (Fig. 29). In this scene, a non-Roman man with long, shaggy hair wearing leggings and a cape, obviously a prisoner of war, is forced to submit before the emperor and a group of Roman soldiers. A Roman soldier behind the captive restrains his hands, preventing the man from making any gesture, and he forces the prisoner's head upward. The position of the prisoner's upturned face and the angle of the beard, as well as his posture, thrust forward with bent knees and one foot in front of the other, echo standard submission scenes. The emperor, while not on a tribunal, appears taller than those around him, including, of course, the non-Roman hostage, giving him an imposing presence in the scene.[7]

The earliest official work of art in which a non-Roman child makes the gesture of submission is an Augustan coin of 8 B.C. from the mint at Lugdunum (Fig. 30).[8] According to Foss, the coin commemorates the "defeat and submission of German tribes" (p. 53). The reverse depicts a cloaked adult figure offering an infant of indeterminate gender to Augustus. The adult may be a member of the child's family or ethnic group, perhaps a Celt.[9] Augustus, wearing a toga, sits on a stool on a low tribunal; although seated, he is depicted as the tallest figure in the scene. He extends his right hand toward

30. *Denarius* of Augustus, 8 B.C.: BMC 494. Photo: © Copyright The British Museum.

the infant. The gesture of the child mimics that of the submissions documented earlier, with arms and face outstretched toward the emperor, although his or her legs dangle below.

Another early imperial scene of submission comes from a silver cup from Boscoreale produced during the reign of Tiberius (Figs. 31 and 32).[10] According to Zanker (1988) the cup depicts the submission of defeated non-Romans from the north.[11] Although the Boscoreale cups are not, strictly speaking, public or monumental works of art, Kuttner has argued for their official significance based on their iconography and style. She notes that the cups "document one of only two cycles of Roman imperial state reliefs to survive from the entire Julio-Claudian period" (p. 2),[12] and she argues that the prototypes or patterns

31. Boscoreale Cup, Tiberian. Photo: From A. Kuttner, *Dynasty and Empire in the Age of Augustus: The Case of the Boscoreale Cups* (Berkeley: University of California Press, 1995), fig. 5, after P. Héron de Villefosse, *Monuments Eugène Piot* 5 (1899).

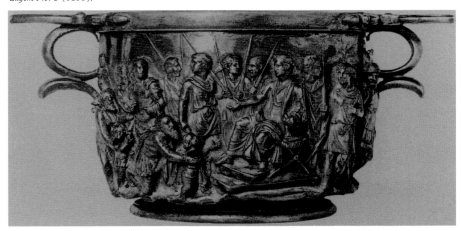

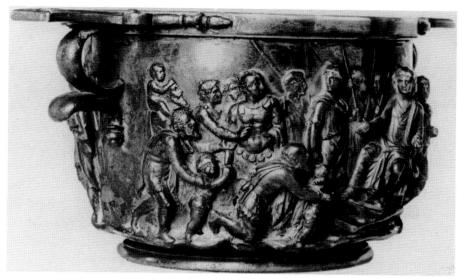

32. Boscoreale Cup, Tiberian. Photo: From A. Kuttner, *Dynasty and Empire in the Age of Augustus: The Case of the Boscoreale Cups* (Berkeley: University of California Press, 1995), fig. 4, after P. Héron de Villefosse, *Monuments Eugène Piot* 5 (1899).

that inspired the cups probably came from a narrative panel relief on a temple or in an imperial forum.[13] I am comfortable, therefore, considering the cups among official works of art.

Children appear on only one side of one cup, Kuttner's BRI:2 (Figs. 31, 32). In the scene, two bearded non-Roman men kneel and bend at the knees, respectively, to grasp young boys, presumably their sons, at their waists, holding them out as if to offer them to Augustus. A third man stands behind them with a young child on his shoulders. These figures form a sequence of three non-Roman adult-child pairs before Augustus. The two standing children stretch out their arms and turn up their faces toward the emperor in the typical gesture of submission. (The first non-Roman adult in the group may hold his child's arms in the submissive position.) The child on his father's shoulders appears to grasp his father's hair, creating an angle with his arms that parallels that of the other two children. The first child also appears to bend his knees slightly. All children wear short tunics, the adults with them wear short tunics and capes, and both standing children have exposed buttocks. Although I cannot assess their gender with certainty, I assume that the children in this scene are male. All have short hair, and all wear costumes like those of the adult men; adult women are entirely absent from the scene. A beardless non-Roman man,

whom Kuttner calls a youth, stands behind the second adult-child pair, and a fifth non-Roman man stands behind him in low relief.

Augustus is seated in this scene, although his position on the dais presents him at an imposing height. The togate emperor extends his right hand as he receives the non-Romans from the *sella castrensis*.[14] Augustus' open-handed gesture has been identified as one of clemency, but it is from a position of absolute power and a context of military conquest that Augustus proffers that clemency. As Brilliant (1963) says, "his gesture is . . . the visual conclusion of the design and the ensign of his superiority" (p. 74). Accompanying the emperor are lictors wearing tunics and military *paludamenta* and holding *fasces* with axes. In addition, two soldiers in full military dress stand behind the emperor. Finally, a cuirassed military figure, identified by Kuttner as Drusus the Elder and by Brilliant as Tiberius, stands among the non-Romans, leading one of the children by the hand.

The Column of Trajan contains a number of representations of non-Roman children in scenes of submission. Scene XXX shows a group of five captured women and four children before the emperor. The women all wear the same coiffure, with long hair gathered in a bun at the nape of the neck, and the gender of one of the children can be determined from her similar hairstyle. The gender of the other three children is difficult to discern, but they may be male because their hair is depicted differently. The women, many of whom hold children, extend their arms in the familiar gesture of submission. The woman in the center of the group holds a male child above her head, extending him toward the emperor as an offering. The child performs the gesture of submission, creating the focal point of the scene midway between the ground line and the boat. His gesture emphasizes his position. The group is surrounded by Roman soldiers who use their shields to herd the group toward the emperor and boat in the background.

A lone woman and infant are depicted at the front of the group near the emperor, apparently about to board a ship. The child is very small and poorly preserved; only his or her head is visible. This woman has been called noble because of her position in the scene, but her identity and the meaning of the entire panel remain uncertain. Lepper and Frere speculate that she is Decebalus' sister, who was captured by Laberius Maximus and "would have been sent by him to Trajan for 'disposal' " (p. 77).[15] They speculate further that she is being sent to Italy, where she will be displayed in Trajan's triumph (ibid.). Although we cannot know whether this woman and her child were

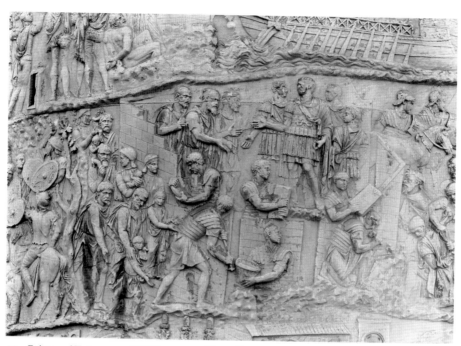

33. Column of Trajan scene XXXIX, A.D. 113. Photo: DAI 90.255, Deutsches Archäologisches Institut.

displayed in a triumph, it is certainly an intriguing possibility in light of extant representations of non-Roman women and children in imperial triumphs.[16] What is certain is the submissive gestures of the women and children. Moreover, the composition of the scene is consistent with other submissions. The emperor is shown cuirassed and taller than all other figures in the scene. In addition, he makes a gesture both toward the woman near him and toward the captives behind them. In fact, based on scenes in which similar gestures occur, Settis suggests that Trajan is either indicating to the woman that others around her have surrendered or reminding her that while she holds one son, her other son will remain as a hostage with the Romans (p. 221).[17]

Scene XXXIX shows two groups of Dacians submitting to the emperor (Fig. 33). In this scene, dubbed "Subjugation of a Dacian Tribe" by Lepper and Frere, Dacians of all ages and genders perform gestures of submission.[18] Settis (1988) holds that it is the intention of the artist in this case to present the submission as the consequence of the battle in the previous scene (p. 161). In the scene outside the fort, two men at the front of the group present a boy to the emperor, while a woman behind them presents a girl. Children and men alike extend their hands, one palm up, and stride forward on one bent knee.

The gesture of the children seems to be emphasized by the disproportionate size of their arms. The woman in the center of the group holds an infant and turns to look at the man behind her with a child on his shoulders; he is probably her husband. The man at the rear of the group holds a child on his shoulders, and the woman behind him grasps the same child around the waist. These three form another family group.[19] As on the Boscoreale cup, the figures at the rear do not yet perform the submissive gesture; they are waiting their turn to supplicate. A Roman soldier at the front of the group receives the submission, apparently reading from a scroll.

While the submissive Dacian throng stands outside the fort, the emperor stands within, receiving a group of bearded, non-Roman men, identified as *tarabostes*, wealthy Dacian officials, by their headdress, the *pileus*.[20] The *tarabostes* make the gesture of submission to the emperor, with arms out and palms up, while the emperor, cuirassed and accompanied by Roman soldiers, holds out his right hand to receive them. The composition of this scene is different from other submissions in its separation of the non-Romans into two groups; most unusual is the fact that the emperor cannot see the group outside the fort.[21] Moreover, the Roman soldier nearest the group before the fort turns his back on the non-Roman throng, as do two other soldiers working nearby. Only the soldier with the tablet acknowledges their presence.

There are two possible reasons for the apparent indifference of the soldiers in the foreground. First, they may belong to the adjacent scene. Their gazes connect them with the fort and the activities in and around it rather than with the group of Dacians outside. While their apparent indifference may simply be the result of the division of scenes on the column, there are many other ways to articulate divisions between scenes. A ground line is used to separate a submission scene (XXX) from a violent scene (XXIX), and trees often separate distinct scenes, as in scenes LXVII and LXVIII. The absence of the emperor, as well as the stance of the soldiers and their indifference toward, and possibly even their rejection of, the Dacians' submission is therefore particularly pointed. Even if the soldiers' orientation performs a practical artistic function, the effect remains. The rejection of the supplication of non-Romans by Romans illustrates the futility of the non-Romans' situation.

The rejection of submission here is not unique. The emperor treats a group of suppliants similarly in scene CXXIII from the column (Fig. 34). As Brilliant notes of this and similar scenes, while Trajan may occasionally acknowledge the submission of Dacian groups, "in most instances the Emperor makes little

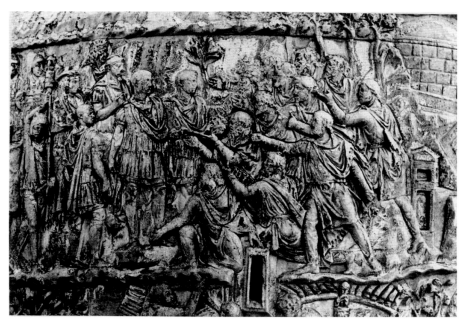

34. Column of Trajan scene CXXIII, A.D. 113. Photo: DAI 89.618.

or no response no matter how pressing or extravagant may be the gesticulate pleas of the captives" (p. 124).[22]

Scene XC from the column of Trajan depicts a group of Dacians similar to that in scene XXXIX.[23] The group, composed entirely of men and children, greets the emperor, who arrives on horseback wearing the *paludamentum*. The equestrian presence of the emperor differentiates this scene from most in which children appear; however, in one of the panels discussed earlier (Fig. 28), Marcus Aurelius receives submissive non-Roman adults from horseback. In both scenes the horse stands in place of the tribunal, lending the emperor an imposing presence and separating him from the non-Romans. In fact, of a similar, although much earlier, stele from Cumae, Brilliant says that the mounted position enhances both the "distance" and "nobility" of the equestrian figure (p. 17).[24] Moreover, Brilliant claims that the equestrian figure is evocative of victory and *imperium*. "[T]he rampant, thrusting cavalier was an icon of victory" (p. 56).

All non-Romans in scene XC hold out their hands toward the emperor, some in the gesture of submission and others with a single finger extended in a gesture that may indicate a specific appeal or request.[25] Lepper and Frere suggest that some of the figures in scene XC wished to speak with Trajan about

a particular matter or to inform him of recent events in their town (p. 138). The figure closest to the emperor is a very young child whose posture indicates the nature of the situation. The child, who seems about to be trampled by Trajan's horse, gazes up at the horse as he grasps at his father's tunic; his posture is certainly submissive and possibly fearful. The two men at the top of the scene appear particularly submissive as well, as are the children in the foreground. All non-Romans look awed in the presence of the emperor, and the three men in the foreground hold their children before them in a composition reminiscent of those in which children are offered to the emperor.

Although this scene may indeed be one of peaceful greeting, as Lepper and Frere imply, the child's place in the composition, threatened by the emperor's horse, references scenes of submission as well as scenes in which non-Roman children fall victim to violence at the hands of the Romans.[26] Consider, for example, a Trajanic coin on which a Dacian is about to be trampled by Trajan's horse.[27] The Dacian's arms are raised in a manner similar to that of the arms of the child in scene XC. Whatever the intended meaning of the scene on the column, the pose and gesture of the non-Roman child at the front of the group as well as others around him participate in the language of submission. The scene confirms the power structure to which non-Romans are subject and the threat of violence behind that power structure.

Three Antonine reliefs provide excellent parallels for the scenes described already. The first, a general's sarcophagus from the Uffizi, includes a group in which a non-Roman woman and child supplicate a victorious general (Fig. 35).[28] In this and other scenes like it, a Roman general takes the place of the emperor. In this case, the Roman general receives the submission from a rock, wearing the *paludamentum* over his cuirass. A female personification, perhaps Victory, and two figures on horseback appear behind him. The general's left hand is partially obscured by the woman's head, but he makes no noticeable gesture toward the submissive pair, and his gaze does not appear to rest on them but rather on the sacrifice taking place behind them. The child is offered by a woman, presumably his mother, who pushes him forward with her left hand while extending her right, palm up, toward the general. The woman's garment slides from her shoulder as she submits, bending her knees. The child, nude, looks up at the general, lifting both hands toward him. He (the child is probably male) stands with his back to the viewer, his left leg in front of his right, and his knees slightly bent. A male figure stands behind the non-Roman suppliants.

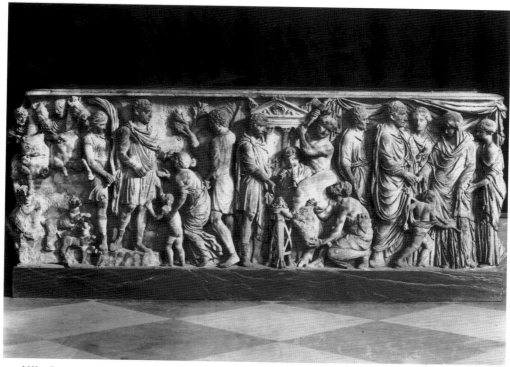

35. Uffizi Sarcophagus, A.D. 160–180. Photo: Alinari/Art Resource, NY.

A nearly identical group comes from a sarcophagus from the Palazzo Ducale in Mantua.[29] The woman, whose garment also slides from her shoulder as she bends down, holds up her right palm and offers a child, this time clothed in a short, belted tunic and leggings, who likewise holds his hands and face toward the general, turning his back toward the viewer. Again, the general makes no obvious gesture toward the mother-child pair; his right hand remains at his side. This group, however, is somewhat more overt in its military imagery. The general, this time wearing a more visible cuirass, is accompanied by two female personifications, Virtus and Victory, according to Kleiner (p. 303), one of whom carries a *vexillum*. In addition, the tree of Figure 35 is replaced here by two (presumably conquered) non-Roman men in pointed caps behind the mother-child pair, one bent at the waist; the Roman figure behind the men is still present.[30]

The third relief, from the Camposanto in Pisa (Fig. 36), also portrays a general receiving submissive non-Romans.[31] Again, the general stands on a low platform with other military personnel. Holding a spear in his left hand,

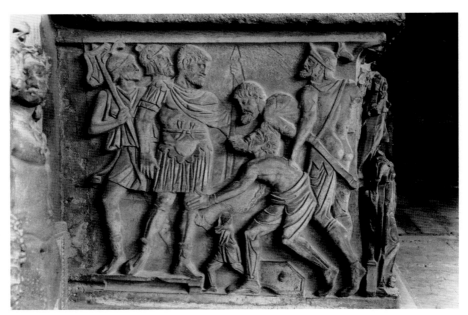

36. Camposanto Sarcophagus, A.D. 160–180. Photo: DAI 34.238.

the general gazes down at the group of non-Romans before him but makes no gesture toward them. His right hand remains at his side. Both father and child at the front of the group perform the gesture of submission with upturned faces and outstretched hands. Both stand with bent knees and place one leg in front of the other. In fact, their gestures and postures are nearly identical. The non-Roman man in the foreground is bare-chested and may have bound hands. The child's gender is impossible to determine unequivocally, in part because his or her head is no longer extant, but his leggings and tunic mimic that of the man behind him. The non-Roman children man behind the father-child pair does not perform the gesture of submission; he appears to be supported by a Roman soldier and may be injured.

Finally, two scenes from the Column of Marcus Aurelius show the submission of non-Roman children to the emperor.[32] Both scenes are divided into two levels, probably in part to suggest depth but with the additional effect of presenting the emperor above the submissive figures. Scene XVII depicts a group of non-Roman adults and children in a scene of submission before the emperor (Fig. 37). In the upper register a non-Roman man, now almost entirely lost, kneels in submission to Marcus Aurelius. He extends his right hand toward the man, but nearby appear three Roman soldiers, *signa*, and a *vexillum*. The

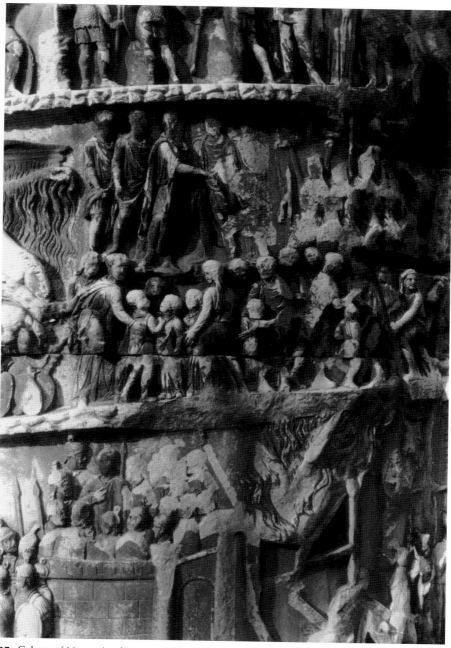

37. Column of Marcus Aurelius scene XVII, A.D. 180–192. Photo: DAI 55.799.

emperor looks down from his platform upon the chaotic throng huddled before him, with children herded together at the front. Adults place their arms around nearby children, pushing them in the direction of the emperor, but the children do not necessarily obey. Instead they look in all directions, perhaps scared, perhaps about to be separated from their parents, as Zanker implies.[33] Only one of the children holds out his or her hands in submission, but the meaning of the scene is clear, especially in light of the submission in the upper register. The children, who do not seem to understand what is happening, are being pushed forward by their adult family members as tokens of submission. One child appears ready either to flee or to climb into the arms of the adult to his right, as shown by the cape flying out behind him.[34]

In scene LVI three bearded, non-Roman men, *con testa inchinata e volto ostile* (Caprino 1955, 101), approach the emperor in the upper register.[35] Marcus Aurelius stands on a platform from which he receives the non-Romans, and he is shown taller even than those in the upper register. He wears the military *paludamentum*, as do the lictors on the Boscoreale cup, and Roman soldiers accompany him. In addition, there are *vexilla* visible in the background. This scene may be intended as a narrative coda to the victory that precedes it. On the ground far below stands a non-Roman family group. The mother stands behind the child, thrusting him forward by his left hand, which she grasps. The child extends his gaze and his right hand toward the soldier in front and the emperor high above him, but the Roman soldier nearest the child rejects his submission, as in scene XXXIX from the Column of Trajan.

The theme of child as offering is poignantly reversed in the composition of a relief panel from the Arch of Marcus Aurelius reused on the Arch of Constantine (Fig. 38). The relief depicts a non-Roman boy in leggings and tunic presenting a similarly clad, bearded man, presumably his father, to Marcus Aurelius.[36] The boy hovers protectively behind his father, who appears to have been wounded in battle. The boy is hunched over with bent knees but makes no gesture of submission as he supports his father with his hands. The man drapes his left arm over the boy's shoulder but extends his right hand and his gaze toward the emperor in the gesture of submission; his knees are slightly bent. Roman soldiers surround the pair, watching their submission. Marcus Aurelius receives the submission from a high tribunal on which he is seated; his distance from the suppliants is striking. While the emperor is togate, a cuirassed military figure, identified as Pompeianus by Ryberg (1967, 61), stands stiffly behind him; standards and a victory-crowned *vexillum* fill the

38. Child Submission Panel Relief of Marcus Aurelius, A.D. 176–180. Photo: Alinari/Art Resource.

background. The emperor is markedly detached from the assembly before him. He does not gaze at the submissive non-Romans, and although his arms are outstretched, their position suggests that he originally held a scroll with both hands.[37] Again, although seated, the emperor is depicted so that he appears much larger than the non-Romans and nearly as tall as the man standing near him.

A similar scene comes from an Antonine relief panel on the arch in the Via di Pietra in Rome (Fig. 39).[38] In the scene a non-Roman male child stands behind a non-Roman adult, presumably his father, who kneels and performs the gesture of submission. The child extends his right hand. Behind the pair stand two non-Roman men making similar gestures. All non-Roman figures whose hands are visible hold one palm up. This time the emperor extends his right hand toward the assembly. Although the emperor is not depicted on a tribunal, he is shown as the tallest figure in the scene, and the Roman figures are all shown taller than the non-Roman.[39]

Although the children who offer their fathers are slightly older than most of the children in scenes of submission, they can be compared effectively with other submissive father-son groups. The composition of these scenes is nearly identical to the father-son groups seen earlier, although reversed. Adults and children alike look at the emperor and stretch forth their arms, if able. Whether non-Roman figures kneel or stand, the emperor always appears larger and taller than they. In both reliefs the children perform the function of suppliant, apparently offering their submissive fathers to the emperor. Ryberg identifies the panel relief of Marcus Aurelius, in particular (Fig. 38), as a scene of submission. She also observes the basic similarity between the panel and the submission scene on the Boscoreale cup, which, she holds, shows non-Roman adults offering their children to Augustus (1967, 61). These groups are clearly reminiscent of groups in which children are offered to the emperor by defeated non-Roman adults.

The child-offering-father composition may have developed from a father-offering-child motif in use during the Augustan or Julio-Claudian periods. Such scenes may have held increased poignancy for the viewer because of the reversal of the motif. There are countless descriptions, in both art and literature, of Aeneas carrying Anchises out of Troy, and scenes of sons caring for fathers may have recalled the Aeneas-Anchises pair. When a father offers a child, the power structure of the family as Rome defines it is preserved; the father holds the power. When a child offers a father, however, Roman social norms have been disrupted. Scenes in which children offer their fathers stress the distorted nature and the urgency of the situation in which non-Romans find themselves.[40]

As I suggested earlier, although they may appear in compositional contexts that seem to require them, not all non-Roman children in submissive scenes perform explicit gestures of submission. A scene from a sarcophagus in the

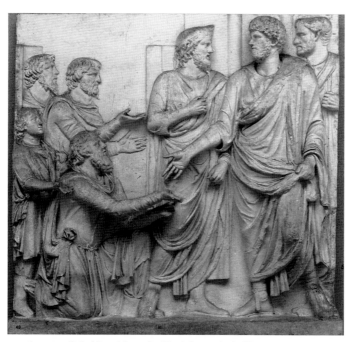

39. Antonine Relief Panel from the Via di Pietra Arch. Photo: DAI 71.301.

Vatican contains a submissive non-Roman child who does not perform the familiar gesture. The sarcophagus, dated A.D. 170–180, contains two parallel submissions (Fig. 40).[41] At right, the general, seated on a stool on a low tribunal, extends a hand toward a kneeling, non-Roman man who performs a gesture of submission before him. The man kneels, turning his face toward the general, his hands at the general's feet. While the general extends his right hand and appears to meet the suppliant's gaze, he is being crowned from behind by Victory, and he places his left hand on his sword in what could be perceived as a threatening gesture. In addition, the skirt of his cuirass is visible beneath his *paludamentum*.

At left, in parallel composition, a non-Roman woman thrusts forth a weeping child as an offering of submission to a Roman soldier. A round shield behind the group draws the eye toward the soldier's hand and his suppliants, at the same time lending the scene a military flavor. The child is shown frontally and does not perform a specific gesture, but his role in the scene as a pathetic offering of submission is manifested by his reaction; the child weeps, one hand at his eyes. As on contemporary sarcophagi (Figs. 35 and 36) the woman's garments slide from her shoulder as she kneels to submit. Again, while the

40. Vatican Sarcophagus, A.D. 170–180. Photo: DAI 93.VAT.13.

Roman soldier holds out a hand and gazes down at the woman and child, his left hand remains on his sword.

A biographical sarcophagus now in the Los Angeles County Museum of Art, dated A.D. 160–180, presents a similar scene (Fig. 41).[42] A non-Roman family submits to a cuirassed Roman general who stands on a low platform. The non-Roman man bends his left knee slightly and holds out his right hand toward the general, while the woman looks up and bends forward in a posture of submission. The woman and child, who is very difficult to see, do not perform any gesture but rather cling to one another in terror. The child's gender is impossible to determine. While the general holds forth his left hand as if to touch the head of the woman or the hand of the man, in the scene directly behind him Roman horsemen trample non-Romans underfoot, providing both a threatening context for the submission here as well as a possible artistic context for the galloping horsemen behind the victorious general in Figure 35. Noteworthy here is the similarity of the overall compositions of Figures 35 and 41, despite the lack of an overt gesture of

41. Biographical LACMA Sarcophagus, A.D. 160–180. Photo: Los Angeles County Museum of Art 47.8.9a–c.

submission in Figure 41. One wonders, in particular, if a second, younger child originally cowered at the feet of the emperor on the LACMA sarcophagus.

Finally, although a few years too late for this study, I include for comparison the lid of the Ludovisi Sarcophagus, now in Mainz.[43] Dated circa A.D. 260, the sarcophagus follows in the tradition of earlier battle sarcophagi and generals' sarcophagi in vogue during the reign of Marcus Aurelius.[44] In the relief six adult non-Roman men, four of whom are bearded, offer non-Roman children to a Roman general as a symbol of submission.[45] A Roman soldier presents the non-Romans to the general, separating and perhaps protecting him from the throng as he places his left hand on his sword. The general, depicted in a scale larger than the non-Romans, sits on a stool on a raised platform, raising his hand toward the assembly. He wears the *paludamentum* and is surrounded by military personnel. Although the children do not perform explicit gestures of submission, their gazes, one looking pensively back at his father and the other looking toward the general, evidence the exchange. These children are being transferred from the power of their non-Roman families into the power of the Romans. While a non-Roman man places his hand on the child who gazes back, a Roman soldier places his hand on the head of the taller child in a familiar gesture of responsibility. The eagle standard in the background as well as the *vexillum* set the tone of the scene. In addition, the general's left hand is raised as if to hold a spear or scepter.[46] Furthermore, the rest of the sarcophagus provides a context for this scene. There is a small panel of captive non-Romans seated around a trophy under the epitaph plate adjacent to this scene, and the main relief of the sarcophagus depicts a violent battle between Romans and non-Romans.

CONCLUSION

The similarity among the compositions of the scenes discussed here is striking. With the exception of the scene from the arch in Via di Pietra, the emperor or Roman official receiving the submission always sits or stands on a raised platform or horse. He is always shown taller, at a higher level, or in a larger scale than those whom he receives, giving him an imposing presence and preserving a sensibility akin to the hierarchy of scale.[47] With the exception of the Augustan coin and, again, the Via di Pietra arch, in all scenes in which the emperor appears he is accompanied by soldiers or imperial officials in military attire, if not cuirassed himself. Generals who receive suppliant non-Romans are usually cuirassed. In addition, military paraphernalia such as *aquilae, vexilla*, or spears and standards are usually visible near the assembly, and noncuirassed Roman figures wear the *paludamentum*, a military cloak. In some cases, the recipients of non-Roman submissions even place hands on their weapons. A soldier may present submissive non-Romans to the emperor or general, who may or may not acknowledge the assembly.

In all scenes non-Romans exhibit submissive posture. With few exceptions, the figures before the emperor perform a gesture of submission with out-stretched arms, upward gazes, and bent knees, often with one leg in front of the other. If the gesture is not performed in its entirety, the overall composi-tion of the scene, as well as the posture of the non-Romans, identifies it as a submission. In such scenes, non-Roman children usually appear between the emperor or general and adult members of their ethnic groups or territories, ap-parently offered to the emperor or general as tokens of submission, although, as we have seen, this arrangement may be reversed. In addition, adult-child pairs tend to be accompanied by other submissive non-Romans.

While similarity of gesture and composition is substantial evidence for similarity of function, some scholars are hesitant to label these scenes "sub-missions." Despite the similarity of these scenes to one another and the simi-larity of the gestures of figures in these scenes to Brilliant's gesture of submis-sion, particularly with respect to children, Kuttner (1995) has suggested that the children on the Boscoreale cup, as well as the children on the Ludovisi Sarcophagus, in particular, are not shown in scenes of submission. She claims that if these children were to be seen as offerings of submission, they would be found in military settings in which "disheveled, cowering, anguished bar-barians" are surrounded by Roman soldiers (p. 100). Kuttner holds that on the

cup in particular, the emperor, in part because he is dressed in a toga, is performing a task of "peaceful, civil administration" rather than receiving newly conquered people; she even calls the submissive children on the Boscoreale cup "joyful" (ibid.).

Kuttner points to what she considers dissimilar scenes in which she finds the non-Romans somehow more distraught than those depicted on the Boscoreale cup.[48] Kuttner suggests that on the cup and the sarcophagus, the foreigners are "sponsored by a Roman officer who physically cherishes their children, a motif not seen in submission scenes" (p. 99). She concludes that in the scene on the Boscoreale cup non-Romans are petitioning to have their children educated under Augustus' authority in his court:

> [The cup] shows aliens friendly to Rome (the *primores* of Gaul) offering their children to be raised by Augustus; it does *not* show the leaders of a just-defeated people offering their children unwillingly as hostages . . . this representation is unique . . . Republican instances of submission scenes and all later imperial depictions that show foreigners with or without children approaching a Roman official in a military setting portray groveling, beaten savages abasing themselves before a general to beg his clemency . . . I think that the very resemblance of the [Boscoreale] composition to canonical submission scenes, among which modern scholarship has summarily placed the cup, testifies to the fact that it is a variant on an established (lost) genre of crowded triumphal representations; for if the artist had never seen such a submission scene, I do not think that it is likely that he would have composed such an initially misleading rendering. (122, 164)[49]

Kuttner's argument comes in part from the practice adopted by foreign kings in the second century B.C. of sending their sons to Rome to be educated. As Braund (1984) points out, there was a clear connection between "education at Rome and succession at home" (p. 11). That is, foreign kings saw a good relationship with Rome as a near guarantee of continued power in their own territory. The practice continued into the empire. Augustus received a number of children from foreign ruling families whom he educated along with his own children. As Suetonius documents, [*Augustus*] *plurimorum* [*regum*] *liberos et educavit simul cum suis et instituit.* "Augustus raised and educated the children of many kings along with his own" (Suet. *Aug.* 48). Josephus reports that Herod sent a total of eight sons to Rome, beginning in 23 B.C.[50]

Although this practice may appear to explain the submission scene on the Boscoreale cup and other similar images, kings such as Herod sent their sons

to Rome voluntarily and for their own benefit. Augustus never requested that these children be sent to him, nor did he offer to educate them (Braund, 12). Evidence suggests, rather, that the practice originated with foreign kings who saw a potential benefit to themselves and their dynasties in obtaining a Roman education for their sons. Furthermore, kings did not regularly accompany their children to Rome, as do the fathers of children depicted in scenes of submission. Braund records that foreign kings "sent their sons to Rome" (p. 10), as Augustus says in *Res Gestae* 32: *ad me rex Parthorum . . . filios suos . . . misit.* Strabo tells us that two of Phraates' wives accompanied his sons to Rome; his account is the closest we come to an entire family coming to Rome as a gesture of loyalty.[51] Moroever, education at Rome was the norm; children of foreign rulers were sent to Rome regularly. The scene depicted on the Boscoreale cup, however, takes place in a military installation outside of Rome. In fact, there are no extant, peaceful scenes from Roman art in which non-Roman children do not either perform the submissive gesture identified by Brilliant or appear as suppliants or captives.[52] In addition, there are no extant scenes in which the education of non-Roman children is implied in any way, and many of the children in the scenes I have dubbed "submissive" are too young even for elementary education.[53]

As I have shown, Kuttner contrasts with the Boscoreale cup scenes that have compositions and functions similar to it. In fact, there is no contrast. With two exceptions each submission scene I have encountered contains an explicit military element, emphasizing the reality of the relationship between Rome and non-Romans. If they are not "groveling, beaten savages," to use Kuttner's terminology, non-Romans in scenes of submission *are* subject to humiliation as well as a visible and consistent military presence. Of submission scenes in general, Kuttner writes, "[p]erhaps the children in these groups are to be handed over to the custody of the conquerors as hostages; more likely, they are brought by their fathers to try to stir Roman pity for the vanquished, as symbols of the total subjection of their race" (p. 144). Although non-Roman children do not experience violence explicitly in such scenes, if their ethnic group has experienced *total subjection*, are they not implicitly hostages?

Whatever the exact practical situation of the non-Romans depicted, images of non-Roman children in scenes of submission highlight the political impotence of the non-Roman. Viewed within the context of Rome's dynastic political system, images produced or funded by the Roman ruling elite in which non-Romans hand over their children to the imperial government

make explicit the surrender of political power by non-Romans into the hands of Rome. Such images embody the subjection of non-Roman people with respect to the Roman emperor and the empire, and their presence characterizes the relationship between non-Roman peoples and the Roman Empire, that of child and father, respectively. It is most useful, then, to approach images of submissive non-Roman children against the backdrop of *patria potestas*. The emperor, after all, is not simply shown with submissive non-Romans; he is shown with submissive *children*.

In his 1994 examination of *pietas* and *patria potestas*, Saller notes that the "most striking aspect of paternal power, *patria potestas*, was the power of life and death (*vitae necisque potestas*) that a father possessed over his descendants *in potestate*" (p. 115).[54] Under Roman law, few people were independent (*sui iuris*). Most, including most notably children and slaves, were subject to the power of another individual (*alieno iuri . . . subiectae*), usually their *paterfamilias* (Gaius *Inst.* 1.48).[55] The most telling aspect of the absolute legal power of a father over his offspring was his ability to expose or abandon unwanted or unviable children.[56] Even if the *paterfamilias* did not often exercise his power to the utmost extent, as has been argued, *patria potestas* exists as an ideological context for all images of children in Roman art.[57] What better way, then, for the Roman state to illustrate its power over its provinces and territories than through the analogy of *paterfamilias* to child?[58] The image would have been well-established in the minds of the Roman people, who called the emperor *pater patriae* just as their own fathers were *patres familias*. Most important, although few fathers may have exercised their ultimate power, the potential violence of *patria potestas* parallels the explicity military presence and subtle threat of violence inherent in scenes of submission. Recall, for example, scene XC from the Column of Trajan, in which Trajan's horse appears about to trample a non-Roman child, or Figure 40, in which the recipient of non-Roman submission holds one hand out to submissive figures while keeping the other firmly on his sword.

Finally, Romans in scenes of submission are not always attentive to the submissions they receive. Surprisingly often the official to whom non-Roman children submit or are offered appears not to notice the children, or at least not to acknowledge them. This is particularly striking in Figure 33, where Roman backs are turned toward submissive non-Romans, although there are a number of scenes in which the Roman recipient simply makes no gesture. Against the backdrop of *patria potestas* and the focus on the children of conquered or subjugated non-Romans in scenes of submission, the inattention of

Roman recipients in such scenes underscores their message: the impotence of non-Romans and the futility of their situation. The indifference with which Roman rulers sometimes received the submission of non-Romans suggests their attitude toward non-Romans only slightly more subtly than the explicit images of violence acted out against non-Romans in Chapter 8.

The distance between the emperor and non-Romans in these scenes is also meaningful. Even if the emperor acknowledges non-Roman submission with an explicit gesture, he is always separated from the non-Romans by a cuirassed soldier, the height of his horse or tribunal, or the scale in which he is depicted. In scenes of submission, the Roman ruling elite does not cherish the non-Romans who submit to them. They do not appear to feel obligation or responsibility toward the people Rome has conquered. The emperor or general rarely interacts intimately with the non-Roman assembly; he does not often appear connected to or interested in the non-Roman children before him, and in some cases his gesture may be read as a threat. Despite the attitude of the Roman ruling elite, however, non-Romans must offer the very future of their ethnic groups or regions to it. The futility and finality of the situation of the non-Roman and the humiliation experienced by the non-Roman in scenes of submission, emphasized by the presence of non-Roman children, challenges modern notions of imperial clemency and the notion that Romanization can be understood as a neutral, forgiving, or benign process.[59]

TRIUMPH

The scenes addressed in this chapter may represent a later conceptual stage of the conquests implied in scenes of submission. I consider here three scenes in which six non-Roman children participate in imperial triumphs. Triumphal processions served two basic aims during the empire. First, they represented the battle for spectators, most of whom would have had no direct knowledge of events that had taken place in foreign territories. Second, they celebrated the military feats of the emperor and his generals, thereby glorifying Rome and advertising the strength of the empire.

"In its 'classical' Republican form," according to McCormick (1986), "the prestigious ceremony of victory, the triumph, was carefully netted in the archaic formalism of Roman religion. . . . By the days of the waning Republic, however, its religious significance had come to be eclipsed by its political value" (pp. 11–12). That is, as the republic became an empire, what had originally been a religious ceremony of purification for the "bloodguilt" incurred in battle became "a purely honorific ceremony, whose chief purpose lay in the *auctoritas*, or authority, and consequent political power it bestowed on the victorious general" (Holliday 1997, 132). McCormick claims that by the time of the empire, "[a]bove all . . . triumphal ceremonial, propaganda and public display celebrated and confirmed the victorious rulership of the emperor" (p. 5). Imperial triumphs would have instilled confidence in the emperor and empire while providing a diversion for the people in the form of a holiday.

Depictions of triumphs are likely to have served aims similar to those of the processions themselves. They documented both battle and triumphal procession for viewers, and, of course, they celebrated and advertised imperial strength. Moreover, depictions of triumphs could have an effect even more powerful and lasting than the triumph itself. Such depictions immortalized one

version of the imperial triumph in stone, imbuing that triumph with permanence unknown to the procession itself. In their permanence, depictions of imperial triumphs could be more efficient mechanisms of propaganda than the processions themselves.[1]

Visual and literary evidence indicates that non-Roman children accompanied adult prisoners of war and were displayed along with the traditional triumphal quadriga and spoils of war in triumphal processions.[2] In his *Life of Aemilius Paulus*, Plutarch describes Aemilius' triumphal procession after his capture of Perseus in 167 B.C., stating that "the children of the king were led as slaves, and with them a group of nurses and attendants and teachers, weeping and entreating those watching, and teaching the children to supplicate and beg for mercy. There were two boys and one girl" (Plut. *Aem.* 33). Appian tells us that the infant Juba II was displayed similarly in Caesar's triumph in North Africa (*BCiv.* 2.101). Of course, Plutarch and Appian describe pre-Augustan triumphs, but we may assume that the form of the imperial triumph remained similar to that of Aemilius Paulus, which was considered one of the most lavish triumphal processions ever celebrated. In her examination of the literary evidence Kuttner (1995) finds that the *pompa triumphalis* was "standardized" by the mid-republic with few substantive changes made during the empire (p. 144). The primary difference between the triumphal processions of the republic and those of the empire was that imperial triumphs were reserved exclusively for members of the imperial *familia*.[3]

Non-Roman children depicted in triumphs do not perform a consistent gesture or group of gestures as do children in scenes of submission. Rather, they are categorized by the processional compositions and triumphal settings of the scenes in which they appear. In depictions of triumphs non-Roman children stand among non-Roman adults and are surrounded by Roman soldiers. Although they may appear to move in the direction of the procession, in such scenes non-Roman children perform no other action; they appear simply as items of display. In triumphal scenes non-Roman children serve one of two functions. First, they may be important to the imperial government because of their specific individual identities, as in the case of the children of Perseus or Juba II. Second, and more commonly, non-Roman children may function as a type of military or political currency, serving in a general sense as *spolia* and glorifying the emperor by advertising Rome's military power. As Currie (1996) observes, "captured children constituted part of the spoils of war" (p. 172). Non-Roman children whose identities are not immediately obvious to the

42. Julio-Claudian architectural frieze fragment, Museo Nazionale 6722, first century A.D. Photo: From
I. S. Ryberg, *Rites of the State Religion in Roman Art* (American Academy at Rome, 1955), fig. 81c.

viewer probably represent their region or *ethnos* on a general level, standing
for the future of that group or territory as a whole.

A small Julio-Claudian architectural frieze fragment from Rome, now in
Naples, includes the depiction of an anonymous, poorly preserved non-Roman
child of indeterminate gender (Fig. 42).[4] Preserved from an unknown build-
ing presumably in Rome, the frieze depicts a triumphal procession in which
Roman soldiers carry *spolia* and lead non-Roman captives, one child among
them, all of whom Kuttner identifies as Celtic.[5] The figures may represent a
captive family, but the specific identity of that family cannot be determined.
As Kuttner concludes, these are most probably stock figures of conquered
non-Romans (p. 166).

The child stands between two adult captives, one male and one female,
who connect themselves to the child by gesture. Although nearly all the
men in the scene avoid true frontality, including the non-Roman man, who
looks away from the child in the direction of processional movement, the
child is shown frontally.[6] We cannot determine where the child's gaze orig-
inally fell, but his or her frontality evidences his or her function within the
frieze – he or she is a body on display, meant to receive the gaze of all
viewers like the surrounding *spolia*. Of course, the child is not the only fig-
ure depicted frontally. The woman beside him, presumably his mother, is
also depicted in complete frontality. The child and woman are intimately
connected and on display in a manner in which the non-Roman man is
not. Moreover, their frontality appears to disrupt the movement of the

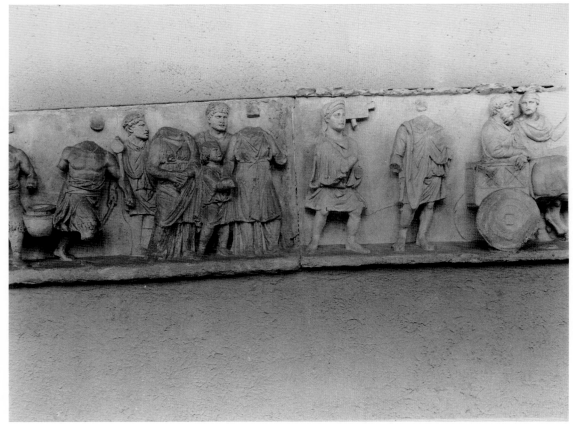

43. Arch of Trajan at Beneventum, frieze, A.D. 114–118. Photo: DAI 72.2644, Deutsches Archäologisches Institut.

procession in way that the man's gaze does not, making a further spectacle of them.

A frieze on the Arch of Trajan at Beneventum probably commemorates the triumph celebrated by Trajan in 107 after his defeat of Dacia. Included among the participants in the triumph are three non-Roman children in two distinct family groups (Figs. 43 and 44). We may assume that the children in the procession are Dacian on the basis of their costumes and their role in the scene, but it is impossible to identify them as members of a specific Dacian family. Like the child on the Julio-Claudian fragment, they are probably generic Dacian children, stock figures of the conquered non-Roman.

The two older children wear leggings beneath short tunics with capes draped over their backs, and at least one of the children has what appears

to be long, curly hair. It is impossible to determine their genders unequivo-
cally, but their hair and clothing leads me to believe that they are male. Both
children follow a non-Roman woman. In fact, both children are flanked by
non-Roman women. Both compositional groups also include a man in lower
relief behind the child. In Figure 44, a Roman figure grasps one of the female
figures by the arm as though she is a prisoner or hostage.

 The similarity between these two compositional groups is striking. In both
groups the woman on the child's right stands with her right foot pointed away
from the direction in which the procession moves. The women to the childern's
left exhibit the opposite stance, with left legs and feet pointed forward. The
position of the women's legs on either side of each group frames it as a unit
within the procession. Both children look toward their left, in the direction of
processional movement, but their legs and feet are nearly frontal. Both stand
with bent right knees, and both cling with both arms to the right arm of
woman in front of them. Finally, the women behind the childern both cradle

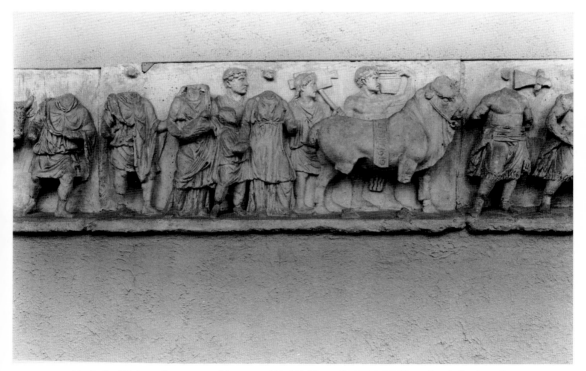

44. Arch of Trajan at Beneventum, frieze, A.D. 114–118. Photo: DAI 72.2638, Deutsches Archäologisches
Institut.

their arms in front of them as if they carry infants, but an infant appears only in Figure 44.

The similarities between these groups may indicate that they were based on the same pattern. Art historians have suggested that in repetitive friezes of this nature, artists may have worked from patterns or set compositional types and then filled in details in accordance with the requirements of the individual work of art. This artist or group of artists probably worked from a pattern of a non-Roman child, perhaps even a pattern of this particular group, and inserted it into the processional frieze as needed. The right feet of the women shown at the rear of the each group appear to be tabbed into the left feet of the male figures behind them, connecting their group to the group behind, as is common in the composition of processional scenes.[7]

The possibility of the existence of such a pattern is crucial to our understanding of the function of non-Roman children in this context. If sketches of non-Roman children in triumphal scenes were available for use by sculptors, non-Roman children must have been a common element in such scenes and therefore an important part of the visual imagery of triumph employed by the Roman elite. The existence of a stock character necessarily demonstrates the frequency with which it was employed and its significance in the visual language of the period.

These groups from the Arch of Trajan frieze are strikingly similar to the group on the Julio-Claudian fragment as well. Although the non-Roman children in the Trajanic scenes are not frontal, the women who flank them are nearly so and appear to interrupt the movement of the procession. As on the Julio-Claudian fragment, the men in the scene look in the direction of the procession's movement. Finally, it is women and children who are connected most clearly by gesture, and in each of the three groups, artistic emphasis is placed on the women and children, who are grouped together.

The Arch of Septimius Severus at Lepcis Magna, erected in A.D. 203, contains a similar triumphal procession frieze in its attic.[8] The arch, like the Arch of Septimius Severus at Rome, is thought to commemorate the emperor's victory over Parthia. The fragment with which I am concerned has been dubbed the *gloria Augustorum* by Andreae (Fig. 45).[9] It depicts the triumphal quadriga and attendants of the emperor as he enters Lepcis Magna. Displayed in the procession on a bier or *ferculum* are a non-Roman man and woman, presumably a former political leader and his wife,[10] who hold a small child between them. The child, whose head is no longer extant, reaches for his mother. The

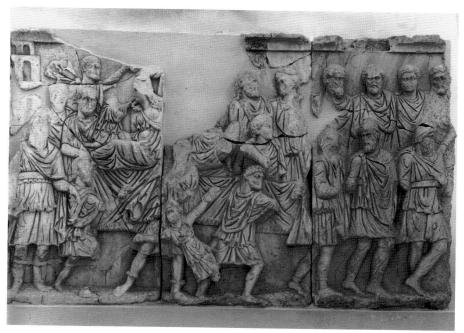

45. Arch of Septimius Severus at Lepcis Magna, frieze, A.D. 203. Photo: DAI 61.1696, Deutsches Archäologisches Institut.

man and woman face one another, and the three clearly form a family group. Before the quadriga walk non-Roman captives and another non-Roman child who is apparently dragged along, protesting. The child wears a pointed cap and belted tunic but is otherwise poorly preserved. His facial features, in particular, do not survive. While the gender of the child cannot be determined unequivocally, the similarity of his costume to that of the non-Roman adult may indicate that he is male.

The most violent scene of its type, this frieze is particularly important because of the emphasis it places on the older child. In contrast to the Julio-Claudian fragment and the frieze from the Arch of Trajan, in which non-Roman children fit neatly into their compositional groups, surrounded by adults who appear to be their family members, this child is completely alone. While a non-Roman couple is carried on the bier behind him, no non-Roman adult takes responsibility for him through gesture or gaze.[11] Moreover, the child's position, both frontal and diagonal, disrupts the composition of the scene. With the exception of the child, all other figures in the procession stand upright and parallel to one another. From left to right we see a centurion, two

Romans holding the bier, and the captive child in front of the bier with a Roman soldier. Even the horses (not pictured here) align in a linear, processional composition. The child, in contrast, flails across the procession, breaking the continuity of the scene and drawing the viewer's attention.

Like the children from the Julio-Claudian fragment and the Arch of Trajan, this is probably not a specific child from an identifiable non-Roman family. In his discussion of the Arch of Septimius Severus, Andreae notes that "[the friezes] do not depict historical events but instead follow earlier public monuments in presenting certain general principles as embodied in the traditional guise of a public act or ceremony" (1977, 274). If Andreae is correct, figures in triumphal friezes are not intended as specific historical figures. The generic nature of this child as well as his position in the composition make clear his function – he is the subjugated non-Roman foreigner, the "other," on display. As a child, he heightens the pathos of the scene, forcing the viewer to notice him as he gazes out, dragged through the streets of Lepcis Magna.

The frieze from the Arch of Septimius Severus makes explicit the futility and violence implicit in earlier triumphal scenes, and although the number of images addressed in this chapter is small, the similarities among the contexts in which these six non-Roman children appear are not insignificant. All children appear with non-Roman adults, and in most cases non-Roman adults take responsibility for them through gesture or gaze. Non-Roman women play a role more visible than non-Roman men in these scenes. The children either disrupt the composition of the triumphal scene or the movement of the procession, or they appear with a group of figures who do so. If the children themselves are not consistently depicted frontally, they are always shown with other figures clearly on display. Finally, as confirmed in the following chapter, there is no apparent artistic interest here in depicting the merciful treatment of captive non-Roman women and children – non-Roman women and children are handled with the same violence as non-Roman men. This is particularly apparent in the Severan frieze, but I believe it is implicit in the grasp of the Roman soldiers on the Trajanic frieze as well.

CONCLUSION

Why do non-Roman children appear in the context of the imperial triumph? I believe the answer lies first in the dual purpose of triumphal processions and second in the dynastic nature of the imperial government. As noted,

triumphal processions serve two aims: they illustrate the battle for civilians, and they celebrate the power of the empire. Depictions of such processions immortalize the triumphal celebration and instill confidence in the empire by reinforcing imperial activity with visual imagery. Evans (1992) holds that triumphal paintings, in particular, which she dubs the "essence of propaganda," were intended to inform the people at home of the deeds of the Roman general and his army (p. 8). She claims that such paintings provided "a non-verbal form of campaign news that was readily understandable to the common man" (ibid.). Likewise, Coleman (1990) holds that staged battles, "fatal charades," which occurred frequently during the first two centuries of the empire, were an extension of the triumphal procession (70–1).[12] In a sense, then, non-Roman children depicted in triumphal processions may be understood as actors, albeit unwilling ones, in the reenactment of foreign battles or events, representing their ethnic groups or territories for those living in Rome.

Edwards (1997) notes that "[a]ctors, gladiators, and prostitutes in ancient Rome were symbols of the shameful. Their signal lack of reputation was reflected and reinforced in the law, which, in the late Republic and early Principate, classified them as *infames*. . . . Even those among them who were Roman citizens (as opposed to free non-citizens or slaves) were subject to a range of legal disabilities" (p. 67). Although Edwards admits that *infames* may not have "constituted an entirely coherent legal category until the second or third century C.E." she claims that "those who followed professions associated with public performance and prostitution were utterly devoid of honor" (ibid.). The reason for the dishonor of these professions lies in their association with the body: "In the theaters, arenas, and brothels of Rome, the infamous sold their own flesh" (ibid.). In selling their flesh, *infames* apparently gave up some right to that flesh. "Protection from corporal punishment," writes Edwards, "was one of the hallmarks of Roman citizenship" (p. 73). Thus, "[o]ne of the most striking aspects of the legal situation of those labeled *infames* . . . is their liability to corporal punishment" (ibid.).

What becomes clear from Edward's analysis is that in their function as actors, as bodies on display for an audience, non-Roman children in triumphal scenes are limited with respect to their right to control their own bodies. As Currie claims of representations such as those discussed here, "the child's body would have been manipulated as part of a spectacular display of Roman domination" (p. 172). The key to this manipulation is that in Roman art, as we have seen, the body of the Roman child represents hope for the future, the future body public,

and the future ruling elite. The display of the bodies of non-Roman children in depictions of triumphal processions as actors or items of display, therefore, is a powerful inversion of the artistic norm in which children function generally as symbols of hope. The manipulation by the Roman ruling elite of the bodies of non-Roman children in triumphal processions evidences the message of that ruling elite: non-Roman children, the future of the non-Roman populace, are socially stigmatized as *infames*.

Furthermore, because non-Roman children in triumphal scenes are presumably prisoners of war, and because such scenes are intended to illustrate the power of the imperial government and the subjugation of the non-Roman, non-Roman children in scenes of triumph may be seen not only as actors and items of display, but even as slaves. Plutarch states as much explicitly.[13] Of course, a slave does not have any right to his or her own body; it is his or her body that is by definition the property of another. Non-Roman children shown as slaves, therefore, are clearly the physical property of another; in triumphal scenes they can be seen as property of the emperor or imperial government and therefore even *infamior* than *infames*.

Thus, just as scenes of submission were shown to highlight the political impotence of the non-Roman, depictions of non-Roman children in imperial triumphs highlight the social and legal impotence of the non-Roman. Political impotence is implicit in these scenes; as Kuttner (1995) has concluded, based in part on the Julio-Claudian frieze fragment (Fig. 42), the "stock figure of a barbarian with his little child is used in a purely triumphal context as an emblem of a beaten enemy" (p. 166). The scene of triumph adds social and legal impotence to political impotence. As items of display, non-Roman children in triumphal processions bear a social and legal stigma akin to that of *infames* or even slaves.

The significance of non-Roman children in triumphal images does not become completely clear, however, until we consider the dynastic nature of the imperial government.[14] Within a dynastic system of government the importance of viable and appropriate heirs is paramount. Depictions of non-Roman children in triumphal processions, however, announce the subjugation of conquered territories either by showing a once-powerful non-Roman ruling family completely disempowered, stripped even of its hope for the future with its heirs portrayed as actors and slaves, or by showing the symbolic future generation of a conquered territory or ethnic group as stripped of its dignity.

Because the children addressed in this chapter cannot be identified with any certainty as members of specific families, or even as male or female, in some cases, their value is symbolic rather than specific. In the context of the triumph, non-Roman children are displayed in ways that might be appropriate to a gladiator, actor, or prostitute, but never to a future member of a ruling family, at least in the eyes of the Roman ruling elite.

8 | THE BATTLEGROUND

T he final artistic context I consider is the scene of military activity. Such scenes usually depict the attack and conquest of non-Roman towns or territories by Roman soldiers. Scenes of this type are common, comprising nearly half of all official representations in which non-Roman children appear. They are also perhaps the most disturbing to the modern eye. The images are often cold and violent, demonstrating the brutality of which imperial art is capable at its height.

The following images expose the harsh reality faced by non-Romans of all ages at the hands of Roman soldiers.[1] They show explicitly the effect of Roman conquest on the native family group by illustrating its destruction. In scenes of military activity non-Roman women and children may be depicted among Roman soldiers rather than in the company of their husbands and fathers. Non-Roman children may be physically separated from maternal or paternal figures or other family members; often they either witness violence visited on their families or fall victim to violence themselves. In such scenes non-Roman children are bound as captives, taken hostage, and treated as spoils of war in the heat of battle. The very inclusion of children in battle scenes illustrates a breach of social norms, and the explicit nature of these scenes highlights both the brutality of the Romans and the disruption of civic life in regions conquered by Rome.[2]

Images of non-Roman children in violent contexts do not appear until A.D. 113 and come from a relatively small number of monuments. Nearly all such images appear in narrative scenes from the Columns of Trajan and Marcus Aurelius, although four relevant scenes survive from the Victory Monument at Adamklissi, also known as the Tropaeum Traiani. One-quarter of the total space on the Column of Trajan is devoted to battle scenes (Kleiner, 216),

and the majority of the space on the Column of Marcus Aurelius is taken up with depictions of violent military activity. I examine an additional three scenes from so-called battle sarcophagi. Scenes of violent military activity may derive from the triumphal procession, which is likely to have included representations of battle.[3]

Non-Roman children in scenes of military activity serve a purpose similar to that of non-Roman children in triumphal processions. Like triumphal scenes, scenes of military activity advertise Roman conquest. In both contexts images of non-Roman children underscore the dominance of Rome by equating conquered non-Romans with children. The inclusion of children also increases the pathos of such scenes.[4] Moreover, in both contexts non-Roman children appear to be on display as trophies or spoils of war. Like children in representations of triumphs, non-Roman children in violent contexts do not consistently perform a single gesture. They are categorized rather by the violence or chaos of the settings and the compositions of the scenes in which they appear. Roman soldiers are nearly a constant in scenes of military activity. Although no one gesture is common to all such scenes, certain gestures and postures do predominate. Non-Roman women often raise an open hand in what may be a gesture of surrender. Fleeing, non-Roman adults often grasp the arms of their children, dragging them away from the Romans. Non-Roman children often rush in one direction but turn to look back at the scene behind them. This posture highlights the confusion of non-Roman children at the events taking place around them, and the backward glance,[5] in particular, symbolizes the loss experienced by the child, who looks back either at the familiar surroundings he or she must leave or at violence being acted out against his or her kin group.

THE COLUMN OF TRAJAN AND THE TROPAEUM TRAIANI AT ADAMKLISSI

I treat the Column of Trajan and the metopes from the Tropaeum Traiani under the same heading for a number of reasons, not the least of which is chronology. The subjects, too, are compatible, for both monuments depict moments from Trajan's Dacian campaigns. In the face of Florescu's (1965) groundbreaking work on the Tropaeum, which seems to deny the value of studying the Column and Tropaeum in tandem, Rossi has recently worked toward "providing a parallel treatment of 'twin' monuments in [an] icono-historiographic

setting of their own" (1997, 472). Indeed, as he says of the monuments, "as diverse as they [are]...both of them pertain, contemporarily, to the same feats and, as such, do call for a timely coordinate investigation throughout" (ibid.). Most important, despite the obvious differences between the Column of Trajan and the Tropaeum Traiani in terms of style (the Tropaeum Traiani is the work of a provincial artist, perhaps even a veteran of the Dacian wars[6]) and form (the Tropaeum is not a column but a monumental drum similar to the Tomb of Augustus[7]), both monuments are clearly official, and iconographic similarities in the portrayal of non-Roman children on the two monuments are striking.

Metope XLIII[8] of the Tropaeum Traiani (Fig. 46) shows a non-Roman[9] family in a wagon being attacked by a Roman soldier. In the foreground of the scene a non-Roman man falls, impaled on the javelin of the soldier. As he falls he seems to perform a gesture of submission, with both knees bent and head tilted toward his aggressor. The woman is also submissive, with hands outstretched and head lifted.[10] Both parents turn their backs toward a small child in the right corner of the metope. The child, whose feet and bent knees suggest that he is running, flees the scene behind him. Above the child's head the weapon of the non-Roman man, presumably his father, appears menacing; it is twice the size of the child. Although we are most probably not meant to see a threat to this child from his dying father, the simple proximity of the large weapon to the child illustrates the danger of battle to the child. That danger, imminent and yet latent in this scene, will be realized in subsequent scenes.

A similar group appears in scene XXIX from the Column of Trajan in which Roman soldiers cut down Dacians.[11] In the lower register two Romans with shields menace a group of non-Romans, while additional Roman soldiers arrive on horseback in the upper register. Two bodies lie in the foreground, and at the right flee two non-Roman men, one of whom guides a child beside him. Probably the child's father, he shelters the child with his right arm in a gesture of responsibility. The cloak of the man with the child billows out behind him, indicating the direction of motion. The Dacians look back as a Roman soldier stands poised to kill a fellow Dacian. While the child in this setting is not subject to violence, he has witnessed the death of other Dacians and is now fleeing the battleground.[12] His backward glance both identifies him as witness and illustrates his loss.[13]

46. Tropaeum Traiani metope XLIII (inv. 35), A.D. 109. Photo: From F. B. Florescu, *Das Siegesdenkmal von Adamklissi, Tropaeum Traiani* (Bonn: Der Akademie der rumänischen Volksrepublic, Bukarest and Rudolf Habelt, 1965), Abb. 221.

Perhaps the most horrific scene from the Column of Trajan is scene XXXVIII (Fig. 47), in which the corpse of an infant is draped over a wagon wheel in the background of a battle scene. The scene before the wagon is chaotic: men cut one another down in the heat of battle, and the group seems to be a jumble of limbs, clubs, and shields. The triangular composition of the scene is clear, however, with the infant at its apex. The men's shields and the jumble of bodies draw the eye upward toward the focal point, the lifeless child.[14] Although difficult to see at first, the body of the child, naked and hanging limply across a wagon wheel, stands as a sobering reminder of the result of such battles. This is the only scene on the column in which a dead child is depicted. The child is a lonely figure, shown outside the context of a family

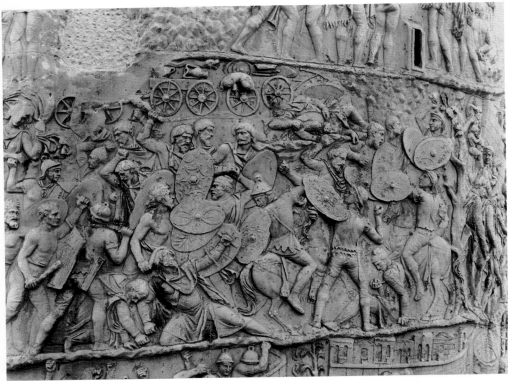

47. Column of Trajan scene XXXVIII, A.D. 113. Photo: DAI 90.254, Deutsches Archäologisches Institut.

group. He or she functions as a lifeless trophy or flag hanging above the battle, out of place and yet on display.[15]

A child appears in nearly the same posture on metope XL[16] from the Tropaeum Traiani (Fig. 48). Simpler and less chaotic in composition, this scene depicts the aftermath of battle. A four-wheeled wagon fills the bulk of the metope. On the wagon lies a non-Roman man, who must be dead. In front of the wagon at the right a second non-Roman man leans on his shield, his left hand at his forehead. He turns his back toward a child whose lifeless body is draped over a rock or small hill in the foreground of the scene. Like the child on the column, this child appears outside the context of a family group. If his father appears on the metope, he does not connect himself to the child through gesture or gaze. Instead, the child's lonely and pathetic face stares out at the viewer, as on the column.

Scene LXXVI from the Column of Trajan shows a group of Dacian refugees in flight (Fig. 49). This is not an explicitly violent scene; Roman soldiers are

48. Tropaeum Traiani, Restoration of metope XL. Photo: From F. B. Florescu, *Das Siegesdenkmal von Adamklissi, Tropaeum Traiani* (Bonn: Der Akademie der rumänischen Volksrepublic, Bukarest and Rudolf Habelt, 1965), Abb. 218b.

absent, but the composition parallels other scenes with more violent content, and the spirit of the scene is clear. Scholars disagree as to whether this scene depicts Dacians forced to evacuate lands claimed by Rome or fugitives from the battleground.[17] Whatever the case, the non-Romans are clearly experiencing the effects of Roman conquest. The force with which the bearded man at the right drags his child betrays the urgency of the scene. This gesture occurs in a number of explicitly violent scenes, as we shall see, in which parents drag children as they flee Roman soldiers.[18] Scene LXXVI contains three men, three women, and six children, three of whom are babes-in-arms. At least one of the children is female – she wears drapery and head covering similar to that of the woman next to her, while male figures in the scene wear knee-length tunics, leggings, and waist-length capes. As is the general rule, children who are old

enough to walk follow adults; women carry infants at their breasts, and men carry toddlers on their shoulders. With the exception of the woman at the front of the group who looks down at the children beside her, and the man at the rear, who looks back at a male child, all non-Romans face the direction in which they flee. It is not clear whether the group shown is meant to represent an entire town or simply a group of families, but the meaning of the scene is clear as the non-Romans hurry forth, the suggestion of a town behind them.[19]

Scene CXLVI includes two Dacian boys who attempt to flee but are captured by Romans.[20] A Roman soldier holds one of the boys by his right arm, which is raised as he tries to twist away. The other boy tries to run, his arms flailing out at his sides, but he, too, is captured. A soldier places his arm on the boy's shoulder. Both boys wear leggings, long tunics belted at the waist, and cloaks like the non-Roman adults in the scene. The boys have been called Decebalus' sons (L&F, 177), but it is impossible to confirm their identification. Lepper and Frere hold that these must be Decebalus' sons to "merit a scene" (ibid.), but as we have seen, there are a number of similar scenes in which the individual identity of the non-Roman child or children is not crucial to the message.

As they run, the children look back at two violent events. In the lower scene, a Dacian man is about to be killed. He kneels while a Roman soldier holds him from behind, reaching for his sword with his right hand. Before the pair are another soldier and a fallen Dacian. A third Dacian at the top of the scene may be Decebalus, about to be decapitated.[21] A Roman cavalryman holds the figure in question by his hair; the captive's hands are obviously bound behind his back. Because the figures are shown only from the chest up and the remainder of the scene is obscured behind a mountainous ground line, the identification of this figure as Decebalus is impossible to prove. As Lepper and Frere note, if the artists had intended to portray Decebalus here, they could have made his identity more obvious. This scene is important for my purposes not because of the possible identification of Decebalus but because it conforms to other scenes in which non-Roman children flee, experience, or are witness to violent military activity. It also provides evidence that non-Roman children were taken hostage by Roman soldiers and that this fact was advertised by the Roman elite in its visual messages.[22]

Scenes CLIV–V, a poorly preserved group from the very top of the Column of Trajan, shows another group of fleeing Dacians.[23] One can make out at least two children, one in the arms of a parent and another being dragged along

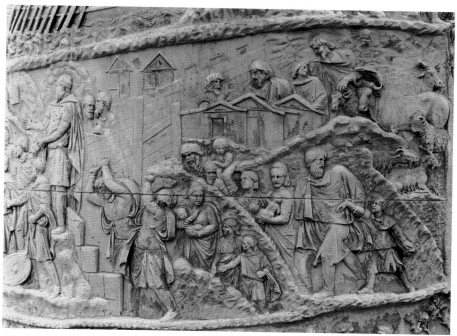

49. Column of Trajan scene LXXVI, A.D. 113. Photo: DAI 89.769.

by the arm in the typical manner of a parent and child in flight. The older child may be veiled, and he or she appears to wear a knee-length tunic over leggings. In this last scene of the column in which human beings are depicted, we see what appears to be the exodus of a final group of Dacians from their homeland.[24] The column winds to a close with a procession of animals being driven before the refugees. This is the final episode of the war, the capstone, so to speak, of the long narrative of the column. Although we cannot know whether these Dacians are being driven out forcibly from their homeland or resettled peacefully by the Romans, the inclusion of children in this ultimate scene increases the pathos of the image by illustrating the effect of Roman conquest on the native family group. The harsh future that lies ahead for these Dacians is certainly implied here.[25]

Again, the Tropaeum Traiani offers a simpler version of scenes from the column. In metope XLII[26] (Fig. 50) a non-Roman family flees Roman aggression in a four-wheeled wagon pulled by an ox.[27] A man, woman, and child ride in the wagon, while an older man walks ahead, supporting himself on a staff. There are no overt signs of aggression in metope XLII, but surrounding metopes XL, XLI, and XLIII all show violence perpetrated against non-Romans

50. Tropaeum Traiani metope XLII (inv. 9), A.D. 109. Photo: From F. B. Florescu, *Das Siegesdenkmal von Adamklissi, Tropaeum Traiani* (Bonn: Der Akademie der rumänischen Volksrepublic, Bukarest and Rudolf Habelt, 1965), Abb. 220.

by Romans.[28] In fact, that same harsh future is implied in metope LIV[29] from the Tropaeum, which shows two captive women with an infant (Fig. 51). The infant stands naked in the arms of the non-Roman woman at the right, and, if Florescu's arrangement of the metopes is correct, the three figures in metope LIV follow a line of captives in metopes L–LIII.[30]

In all, there are approximately fifty extant depictions of children on the Column of Trajan. Over half of these children are non-Roman. Six *camilli* and seventeen other Roman children appear on the column, but the remaining twenty-seven children are non-Roman. Of these twenty-seven, all but three are shown in violent or submissive contexts.[31] Furthermore, of the approximately forty battle scenes depicted on the column, five include children, all of whom are non-Roman. The fact that non-Roman children appear in more

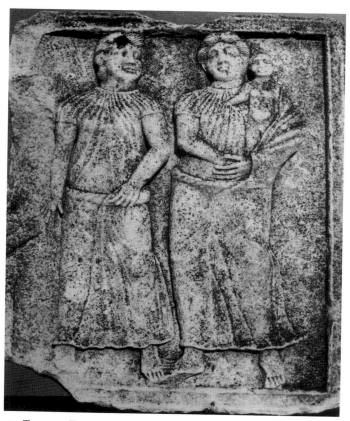

51. Tropaeum Traiani metope LIV (inv. 49), A.D. 109. Photo: From F. B. Florescu, *Das Siegesdenkmal von Adamklissi, Tropaeum Traiani* (Bonn: Der Akademie der rumänischen Volksrepublic, Bukarest and Rudolf Habelt, 1965), Abb. 232.

than 10 percent of the battle scenes on the Column of Trajan demonstrates the importance of non-Roman children to the imagery of conquest employed by Trajan and the Roman ruling elite. Currie notes that children have an impressive presence on the column.[32] In fact, it is non-Roman children who have the most impressive presence.

COLUMN OF MARCUS AURELIUS

Non-Roman children have a comparable presence and purpose on the Column of Marcus Aurelius. Although similar to the Column of Trajan in subject matter and narrative style, the Column of Marcus Aurelius presents more violent, chaotic, and often more disorganized images of battle than those found on Trajan's Column (or the Tropaeum Traiani). Kleiner, noting the differences

between the two columns, characterizes the majority of scenes from the Column of Trajan as "anecdotal" (p. 216). Observing stylistic differences between the two, she points out that while Trajan's Column depicts an "efficient war machine . . . which excelled in battle preparations – including the building of bridges, camps, and so on" the Column of Marcus Aurelius depicts an "insecure army, one that spends more of its time vanquishing its barbarian enemies" (p. 300). Kleiner cites, in particular, the frequency with which women and children are taken captive on the column.

While only one-quarter of the scenes on the Column of Trajan are devoted to battle, the majority of scenes on the Column of Marcus Aurelius illustrate the chaos of battle and show explicitly the violence of the wars with the Germans and Sarmatians that took place between A.D. 168 and 176. Erected between the years 180 and 192, only some seventy-five years after the Column of Trajan, the Column of Marcus Aurelius reflects "changing historical circumstances as well as a new view of imperial power" (ibid.). Hannestad equates images from the Column of Marcus Aurelius with the chaotic scenes found on battle sarcophagi. On such sarcophagi the emperor is shown in the midst of what he terms an "orgy of violence" (p. 244). This may sound like a far cry from the efficient war machine presented on the Column of Trajan, but as on the Column of Trajan, non-Roman children play an important role in scenes in which violence is carried out against non-Romans.

Scene XX[33] depicts a chaotic military encounter centered on the figure of the emperor (Fig. 52). All around the emperor Roman soldiers cut down non-Romans who either attempt to flee or apparently seek some sort of divine help. A bearded man in the upper register holds his hands to the sky as if in prayer, while a Roman soldier approaches him from behind. To the emperor's right, a Roman soldier tries to grab by the hair a fleeing non-Roman woman, who turns back to look at the soldier with wide eyes. The woman' wild demeanor and flowing drapery demonstrate her desperation; her hair is loose and flowing, her garment slides from her shoulder, exposing her right breast, and she lifts her left hand, perhaps in surrender.[34] She grasps her young child by the forearm, dragging him along as she tries to escape. The child, wearing leggings and tunic, appears dazed as he looks up at his mother. His progress is hindered by a second Roman soldier with whose leg his is intertwined. Behind the woman and child lies a fallen non-Roman man. The layered composition of the scene, with the soldier's leg overlapping the child's and the corpse lying behind the group, suggests the futility of the child's situation.

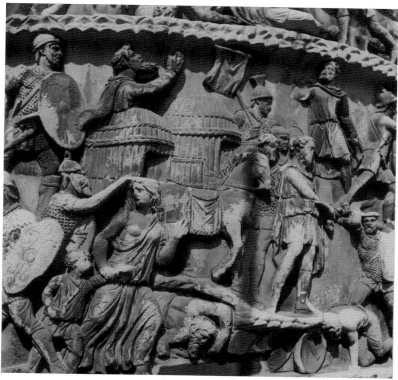

52. Column of Marcus Aurelius scene XX, A.D. 180–192. Photo: DAI 43.84.

A comparable scene is found in scene CII, in which a similarly disheveled woman tries to protect her young daughter from Roman soldiers (Fig. 53). Although the soldiers do not appear to notice her, she holds up a hand as if to stop them from taking her child. She shelters the child with her left hand, and both figures gaze back at the violent scene behind them in which Roman soldiers capture a non-Roman man and set fire to structures in the upper register. As in scene XX, the woman's drapery slides from her shoulder.

A third scene from the Column of Marcus Aurelius, scene CIV, shows the capture of non-Romans by Roman soldiers (Fig. 54). A familiar scene is depicted in the upper register: a woman grasps the forearm of a confused child, who tries to squirm away in fear. The woman's hair is unbound, and her drapery slides from her shoulder. Among the five women in the upper register is also a woman who holds a child too young to walk. In the lower register of the same scene an older male child clings to his mother as a Roman soldier seizes them both. The emotion of the scene is illustrated by the woman's

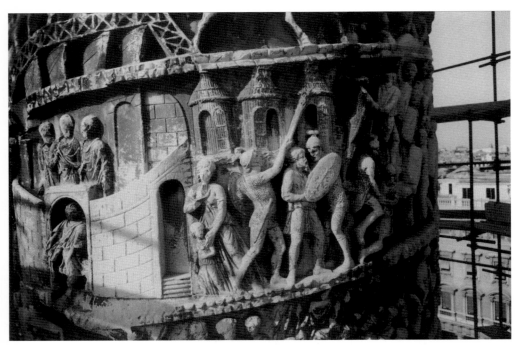

53. Column of Marcus Aurelius scene CII, A.D. 180–192. Photo: DAI 55.1143.

posture and horrified eyes and made more obvious by her frontal, deeply-chiseled face.[35] Her hair is unbound, and she holds up an open right hand in what should now be a familiar gesture. The child's cloak flies out behind him as he grasps his mother from the front as if to climb up into her arms, although he is obviously much too old to do so; he places a hand near her exposed breast. The pair is flanked by Roman soldiers, both of whom hold shields and one of whom tries to restrain the woman. Nearby a second woman resists capture by another Roman soldier.

Scene LXIX shows a group of captured non-Romans being led away by Roman soldiers, possibly for transfer into Pannonia.[36] Four non-Roman men in the lower register are prodded by a Roman soldier from behind. They move in the direction of a non-Roman corpse in the foreground of the scene. Four non-Roman women and three children are herded in the same direction in the upper register. The children are too poorly preserved to determine their genders. Behind the women a Roman soldier with shield and spear holds the smallest child rather roughly in his right arm. The child, kicking its legs, reaches for the woman at the end of the line who is probably his mother.

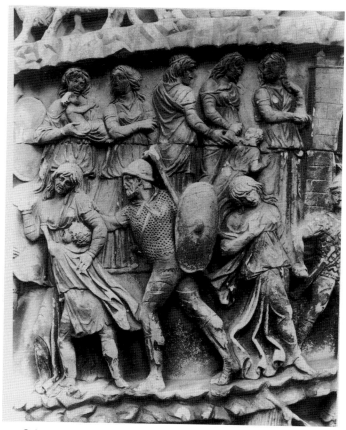

54. Column of Marcus Aurelius scene CIV, A.D. 180–192. Photo: DAI 80.2703.

She and the older child she grasps by the shoulder turn back to look at the younger child. The second woman from the rear, who also turns to observe the scene, places her right hand on her heart and her left on her own child's shoulder.[37] The faces of these figures are not preserved well enough to discern expressions of emotion, but to my mind the figures' gestures and the direction of their gazes, in addition to the artistic context in which they appear, make up for the loss.[38]

Scene LXXXV depicts the transport of a captive woman and child by Roman soldiers (Fig. 55). The pair is surrounded by military figures. One soldier places his right hand on the back of the woman, who turns to look at him, obviously frightened. Her drapery swirls about her legs as if she is attempting to flee, as in scene XX (Fig. 52), but she has nowhere to go. Barely visible is her open left palm. She places her right arm around a male child in a protective gesture,

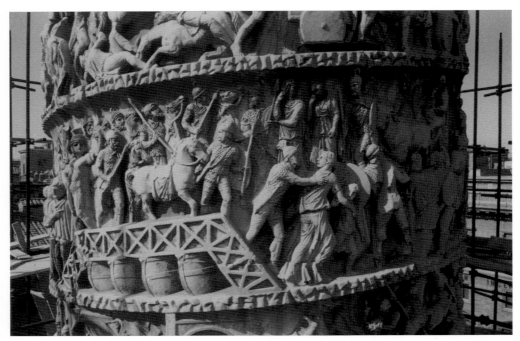

55. Column of Marcus Aurelius scene LXXXV, A.D. 180–192. Photo: DAI 55.1066.

while the child, who is depicted frontally, may cry out, his mouth open. The child appears about to flee, his legs spread and his knees bent, as emphasized by the motion of his tunic. In the scene above them, two non-Roman captives stand between soldiers.

A similar event is depicted in scene LXXXVIII.[39] Three Roman soldiers with shields lead captured non-Romans. Two lead bearded non-Roman men in capes, and the third soldier leads two male children wearing belted tunics and leggings. The soldiers separate the boys from the men and the men from one another. Both non-Roman men wear expressions of horror, mouths open, and both children walk toward the fortress as directed, but both appear frightened. They turn to look back at a chaotic battle scene in which Roman soldiers on horseback fight non-Romans. A corpse is visible in the foreground of the scene directly behind the children. The Romans have bound the hands of adults and children alike. This is one of the few violent scenes in which non-Roman children are shown exclusively with adult men.

Finally, the capture of non-Romans is depicted again in scene XCVIIb but with even more violent content (Fig. 56). In the lower register of this explicit

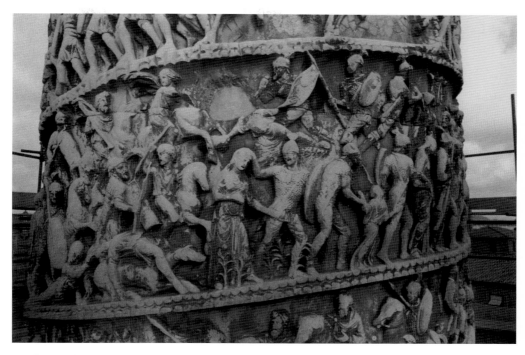

56. Column of Marcus Aurelius scene XCVIIb, A.D. 180–192. Photo: DAI 55.1111.

scene, two Roman soldiers manhandle two non-Roman women and one child. The non-Roman figures are flanked by Roman soldiers who prevent contact among them, although one of the women appears to connect herself by gesture and gaze with the child. She screams as a soldier grabs her unbound hair, her drapery slipping from her shoulders. She extends her left hand toward the second soldier, who grabs the fleeing child by the arm. The child, wearing long drapery like the women, twists, trying to escape. A soldier holds the second woman, who may be wounded, around the waist at the far right of Figure 56. The group is surrounded on all sides by bodies of fallen soldiers and horses, and the violence continues in the upper register. The poor preservation of the scene makes it difficult to say much more. Although the child's gaze is impossible to determine, she appears to look toward the woman behind her, and it is likely, based on the compositions of similar groups, that they are mother and daughter. This likelihood is important for understanding the message of such violent scenes, in which the conquest of non-Roman territories by Roman soldiers implies the separation of non-Roman family members from one another.[40]

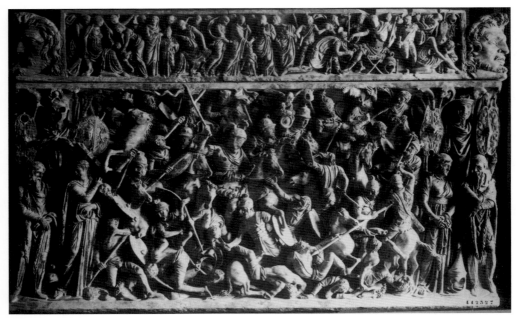

57. Via Tiburtina Sarcophagus, A.D. 170–180, Terme. Photo: DAI 38.1708.

SARCOPHAGI

Non-Roman children are also found in violent scenes on Antonine battle sarcophagi.[41] A sarcophagus from the Via Tiburtina in Rome, now in the Terme, carries a battle scene on its main relief and the aftermath of that battle in the frieze on its lid (Fig. 57).[42] The tumult of the battle, a chaotic jumble of limbs, shields, and weapons, on the main relief provides the violent context for the scene on the lid, and the lid itself shows the aftermath of battle as one part of the life of the victorious general. On the far right of the lid are depicted non-Romans. There a non-Roman man submits to the Roman general, kissing his hand. Behind the submission appear a woman and child. The woman sits hunched over, and the child kneels before her, hand to his or her chin. Both appear apprehensive, if not frightened. The woman's shoulder and arm are bare as in other violent scenes. Shields, helmets, and the materials of battle are visible in the background. While this scene may show a non-Roman family unit, that unit is impossible to reconstruct with certainty; the woman and child are separated from the non-Roman man by the general and the military implements. Furthermore, while the non-Roman man appears in a

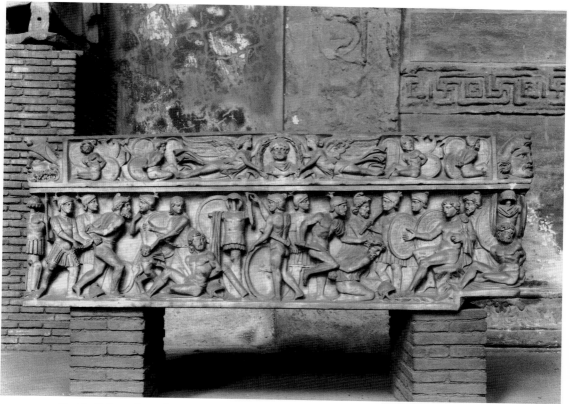

58. Via Collatina Sarcophagus, ca. A.D. 180. Photo: DAI 70.1596.

scene of submission, the woman and child are more clearly situated in the
violent aftermath of battle.

The Vigna Amendola Sarcophagus from the late second century A.D. again
depicts both a battle scene and its aftermath.[43] As on the Tiburtina sarcoph-
agus, children are absent from the main relief, which depicts a bloody battle
between Romans and Gauls, with three Gauls shown falling or fallen in the
foreground of the scene. The frieze on the lid of the sarcophagus shows what
is most probably the aftermath of the battle on the main panel. The narrow
band is decorated with a group of seated hostages. The men's hands are bound
behind their backs, and the women sit, hunched over and dejected. Children
reach toward the women with gestures similar to those performed by fright-
ened children on the Column of Marcus Aurelius. The central figure of the
frieze, a male child, reaches with both arms toward a woman whose back is

turned to him. Wearing leggings and a tunic belted at the waist, he turns to look over his shoulder at the man behind him in the manner typical of children in violent scenes; the man returns his gaze. The child can be read as a link between two adults who are probably his parents, but neither gestures toward him. The man is bound, and the woman's posture makes clear the futility of her situation. Neither parent is able to take responsibility for the child in such a context, evidencing the destruction of the non-Roman family as a result of Roman conquest. A second child, similar in costume and pose to the first, is paired with an adult woman on the far right of the frieze. This time the woman faces the child, who attempts to climb into her lap. Behind the woman sits a bound, non-Roman man, perhaps the child's father. He is distinct from the mother-child pair, however, in gaze, gesture, and posture. In fact, he appears to gaze at the trio behind him. Again, the family unit here is impossible to reconstruct with certainty. While Roman soldiers are absent from the frieze on the sarcophagus lid, they dominate the main panel, providing the violent context for the lid. Moreover, behind the captive non-Romans shields and other war paraphernalia are visible. The figures in the frieze are ostensibly the non-Romans captured in the battle depicted on the main relief, awaiting their fate. As in similar scenes from the Columns of Trajan and Marcus Aurelius, the non-Romans on this sarcophagus embody the result of Roman violence.

A sarcophagus from Via Collatina (Fig. 58) is a fitting place to close our investigation of images of non-Roman children.[44] Although I address it here among images of children in scenes of military activity, it contains elements of all three artistic contexts in which non-Roman children appear, the submission, the triumph, and the scene of violent military activity. Like the previous sarcophagi, the lid of the Via Collatina Sarcophagus depicts captive non-Romans. Children, however, are absent from this frieze. On the Sarcophagus itself we see a non-Roman man submitting to a general. At the left scene a group of non-Romans await their fate (and perhaps their turn to submit). The child, who appears in the guise of hero, nude and with cape flying behind him, looks out at the viewer as do children in triumphal scenes. He seems to be on display, shown frontally with legs and arms spread; the motion of his cape, unrealistic in comparison with the rest of the scene, emphasizes his position.[45] The child is shown near a non-Roman man and woman, perhaps his parents. The man's hands are bound, but the child places his left hand on the man's knee, and the woman appears to reach toward the child.

I include the sarcophagus in this chapter because the child on it is not depicted among explicitly submissive non-Romans, nor does the scene show a triumphal procession. The child appears in a group that closely parallels those addressed in this chapter. Non-Romans in his compositional group stand among Roman soldiers, shields, and war paraphernalia. At least one non-Roman man is physically restrained by a soldier, suggesting military violence. In fact, even the man who submits before the general at the right is held down by a soldier who grabs his hair and forces a knee into his back. The soldier's sword is unsheathed and poised for action, again suggesting violence. Although many scenes of submission include a military element and sometimes even a general who places one hand on a sheathed sword, in this scene the violent elements are explicit.[46]

CONCLUSION

This chapter presents the most disturbing and yet most telling images of non-Roman children extant in official imperial art. Explicitly challenging notions of benevolent imperium,[47] these images confront the viewer, ancient or modern, with the harsh realities of Roman conquest in which neither women nor children are spared the violence and horror of battle. Women are dragged by the hair, their children clinging to them. Children are separated from their families and taken hostage. Two children even hang lifeless as sobering reminders of the result of battle.

In scenes of violent military activity social norms are disrupted. Obvious from the images discussed here is the effect of Roman military activity on the non-Roman family group. Although a few such images show men, women, and children fleeing together, the majority of scenes addressed in this chapter show non-Roman adults of one gender with non-Roman children, and a number of the images discussed here make painfully explicit the division of the non-Roman family group. Scene XXXVIII from the Column of Trajan (Fig. 47) and metope XL from the Tropaeum Traiani (Fig. 48) show lonely corpses of children completely outside the context of family. Scene CXLVI shows the capture of two young boys; no adult is able to protect them. In scene LXIX from the Column of Marcus Aurelius a non-Roman child is held, kicking and screaming, by a Roman soldier. Scenes LXXXVIII and XCVIIb (Fig. 56), as well as images from battle sarcophagi (Figs. 57 and 58), show non-Romans physically separated from one another by Roman soldiers. The presence of

children in such scenes certainly heightens the pathos of those scenes, but it does much more than that. It strips the protection of the family unit from non-Roman children, creates an association between defeated non-Roman peoples and children, and implies that the future of conquered territories is utterly subject to Roman control, a control backed by explicit violence.

Non-Roman children appear most frequently with non-Roman women in images of violent military activity. This tendency can be contrasted with that of scenes of submission, in which men often offer their children to the emperor or victorious general. Of the nineteen scenes discussed in this chapter, only five show men, women, and children together.[48] Three show non-Roman children with men. Nine scenes depict non-Roman children with women, and the remaining two scenes show deceased children. A few of the nine scenes in which women play the primary role with non-Roman children show men nearby, but it is impossible to recreate the family group with certainty in those scenes, and it is non-Roman women who make gestures of responsibility toward the children.

It is likely that such images are intended to associate the non-Roman with the female, just as Roman children are associated primarily with male family members in scenes of public gathering. Images of violent military activity seek to associate non-Roman children, the future of non-Roman peoples, with the gender Roman society perceives as less powerful and, more important, treats as legally inferior to the male. These images must be viewed within the context of a legal system in which legitimate children followed the status of their father while illegitimate children followed the status of their mother. Moreover, the women with whom non-Roman children appear are often sexualized, shown frontally with their hair unbound and their clothing revealing their shoulders and breasts. The non-Roman is not only associated with the woman – he or she is associated with the loose woman, the object of sexual fantasy, a woman of much lower status than the Roman matron.[49]

Finally, as intimated earlier, images from this chapter provide something of a visual meta-language for images of non-Roman children, bringing together elements of all three artistic contexts in which non-Roman children appear. As in the triumphal scenes addressed in the previous chapter, non-Roman children in scenes of violent military activity may be seen as items of display, trophies of war, even unwilling actors, perhaps illustrating the battle and its aftermath for the Roman viewer as would the narrative paintings of battle scenes discussed in Chapter 7. Images of non-Roman children in violent contexts

are also intimately related to submissions, which, ostensibly, followed many Roman battles. Children captured in battle and depicted in scenes of violent military activity sometimes exhibit postures and gestures similar to those of submissive children, although the recipients of their gestures are usually their parents or members of their kin groups rather than the emperor or victorious general.

If images of non-Roman children in submissions may be seen primarily as depictions of the political situation of the non-Roman, and images of non-Roman children in triumphs as depictions of the social or legal position of the non-Roman, then images of non-Roman children in violent military contexts should be seen as an explicit combination and reinforcement of the two messages. Such images illustrate the political impotence of non-Romans by showing them subject to the physical control of Roman soldiers and the social impotence of non-Romans by portraying the explicit violation of the non-Roman body, the division and separation of members of the non-Roman family group, and the destruction of the primary unit of civic life, at least from the Roman point of view. In images of violent military activity, non-Roman children are made to witness violence enacted against their kin groups. They are sometimes even victims of violence themselves; they are forced from their homes; most important, images of violent military activity depict the destruction of the non-Roman family by separating parents from children, children from parents, and spouses from one another.

9 ARA PACIS

T he Ara Pacis is the earliest imperial monument on which children appear. It may seem odd, therefore, that a treatment of the Ara Pacis should form the capstone of my study. Although many have approached the Ara Pacis as a model for later images in Roman art or within the context of Augustan visual imagery, I have found the backward glance invaluable in thinking about images of children from the monument. In the case of the Ara Pacis, synchronic analysis serves us well; approaching the Ara Pacis within the larger visual language of the empire provides a fresh perspective on the overworked monument.[1]

The procession on the outside enclosure wall of the Ara Pacis has been variously identified as the inaugural ceremony of the monument itself or the *adventus* of the emperor on July 4, 13 B.C.[2] Kuttner (1995) maintains that the friezes depict "a particular ceremony...on a particular occasion" (p. 274, n.100) but does not venture a guess as to which particular ceremony. Torelli, on the other hand, claims that the meeting depicted on the Ara Pacis is "fictitious" but is represented as a meeting "that could have taken place" (1982, 54). He holds that although the representation is not historically specific, it shows how such a ceremony could have been performed at that time. Scholars generally agree that the friezes on the Ara Pacis represent some sort of sacrificial procession. The identification of the specific procession is not crucial for my purposes; the fact that it is official and public is sufficient here. The procession depicted on the Ara Pacis lacks the forceful display and excitement of a triumphal procession, but it, like a triumph, recounts and illustrates for its audience the activities of the emperor and his family, at the same time instilling confidence in the empire by reinforcing ritual activity with visual imagery.

While scholars disagree as to the exact nature of the procession depicted in the monument's processional friezes, none would deny that the Ara Pacis served in part as a dynastic monument.[3] At the time it was erected the Ara Pacis advertised the current strength and future power of the imperial family. Children are an important part of this message, and there are a total of ten children preserved on the Ara Pacis. Four appear in the procession on the north frieze and four in the procession on the south frieze. The two remaining children sit on the lap of the figure variously identified as Tellus, Terra Mater, or Roma/Italia who appears on the east frieze of the altar screen. Because they are represented with a goddess in what appears to be a mythological scene, I do not treat them here.

Six of the eight human children in the processional friezes wear Roman costumes and are almost certainly members of the imperial family. Half appear on the north side of the enclosure wall, and half appear on the south. The presence of imperial children on the Ara Pacis is crucial to its identification as a monument to the future power of a dynasty, but it is not the imperial children with whom I am most concerned here. I include the following brief discussion of imperial children primarily to provide the context in which we must view the problematic images of non-Roman children from the monument.

The imperial children on the north side of the frieze are not grouped closely in the composition; each child is separated from the others by at least one adult, suggesting that they may not be from the same immediate family group. The first child appears to be between six and ten years of age. He wears a belted tunic and a *ricinium*, the shawl of a *camillus*.[4] A drawing from the Dal Pozzo Albani Collection documents that he originally carried a basket, possibly full of laurel, in his right hand and that he was barefoot.[5] His hair is short. Behind the *camillus* stands a girl younger than he, probably between two and five years of age, with hair elaborately styled in a melon coiffure. She wears a beaded necklace and earrings and carries a sprig of laurel in her left hand. Behind her is a fragmentary, togate child wearing a *bulla* like those of the imperial children on the south side of the frieze. Only the torso of this child survives.[6]

The three children on the south side of the frieze are depicted in closer proximity to one another (Fig. 59). In fact, the two older children, a girl and a boy, stand next to and gaze at one another. The youngest of the three, a boy, stands two figures in front of them, grasping the hand of a woman. His separation from the older pair may suggest that he is not their sibling. All three children on the south side of the frieze wear togas, *bullae*,

and leather shoes. The girl wears a long, pleated *stola* beneath her toga, as do the older women on the friezes, and her hair is gathered in a bun at the base of her neck.[7] The older boy on the south frieze wears a laurel wreath on his head.

Although there is little doubt that these children are members of the imperial family, there is doubt as to their individual identities. To my mind, the arguments of Pollini and Rose are the most convincing here.[8] From the children's heights, their ages in 13 B.C., and known portrait types of Gaius and Lucius Caesar, Pollini identifies the *camillus*, the young girl, and the fragmentary torso from the north frieze as Gaius Caesar, Julia Minor (children of Agrippa and Julia), and Lucius Antonius (son of Marcella Maior and Julius Antonius), respectively (p. 23).[9] He identifies the three children on the south frieze, from oldest to youngest, as Domitia and Gnaeus Domitius Ahenobarbus, children of Antonia the Elder and L. Domitius Ahenobarbus, and Germanicus, son of Drusus the Elder and Antonia the Younger (ibid.). Rose also identifies the children on the north frieze as offspring of Agrippa and Julia, but he suggests that the girl could be Agrippina, born approximately four years after Julia (1997, 16).

Rose and Pollini disagree over Lucius Caesar's place in the procession. Rose identifies the fragmentary torso from the north frieze as Lucius Caesar, but Pollini believes, as do I, that a portrait of Lucius Caesar does not survive from the Ara Pacis. In 13 B.C. Lucius Caesar would have been at most four years old, too young to be the fragmentary torso child who appears to be between six and ten years of age, approximately the same age as the *camillus* from the same side of the frieze. In fact, considering both his age and his likely placement near Gaius, there is no child on the Ara Pacis who corresponds to Lucius Caesar.[10] Although Lucius was probably depicted in the original friezes, his portrait is not extant.

None of the children in Roman dress on the Ara Pacis performs any specific gesture or action; each appears on the monument presumably because of his potential to rule or her potential to produce rulers.[11] It is the identities and imperial status of these children, rather than their actions, that are important. In addition, these children appear among Roman adults, presumably in family groups. On the north side of the frieze a Roman man places his hand on the head of the young Julia/Agrippina. On the south side, the youngest child holds the hand of an adult woman, while the older boy is guided by the hand of the woman behind him. These gestures of intimacy make explicit the children's inclusion in the imperial family. Finally, Roman children often appear on the

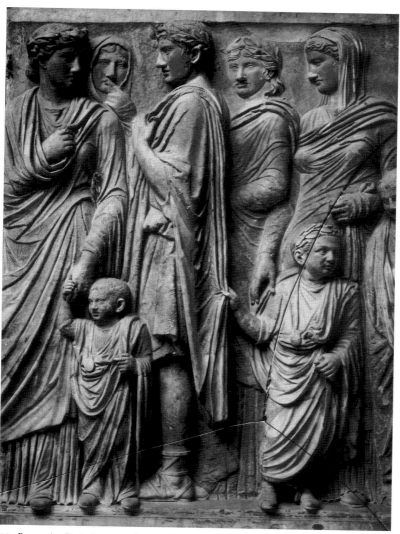

59. Rome, Ara Pacis Augustae, Roman Children, South Frieze, 13–9 B.C. Photo: DAI 32.1716, Deutsches Archäologisches Institut.

Ara Pacis in order of age, perhaps demonstrating visually the continuation of the family line like a family tree. Gaius may be followed by his younger sister, Julia (or Agrippina), and both children stand near a female figure whom I believe to be Julia, wife of Agrippa (Fig. 59). The young Germanicus appears with his parents, Drusus and Antonia the Younger. Likewise, the children of L. Domitius Ahenobarbus and Antonia the Elder stand with their parents. The younger Domitius grasps the toga of Drusus, his uncle, to demonstrate his connection with the Julio-Claudian family.[12]

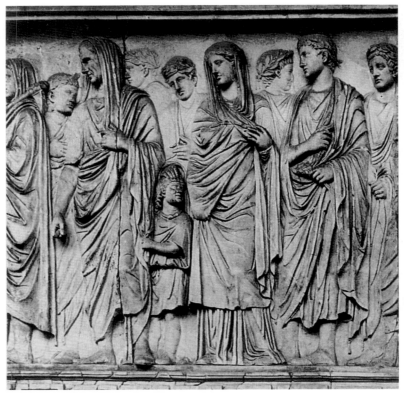

60. Rome, Ara Pacis Augustae, Non-Roman Child, South Frieze, 13–9 B.C. Photo: From D. Kleiner, *Roman Sculpture* (New Haven: Yale University Press, 1992), fig. 75.

The specific identities of these children remain debatable, but they are certainly members of the imperial family, and they are shown among family members in a processional scene. Like the children in scenes of public gathering addressed in Chapter 4, the Roman children in the processional friezes from the Ara Pacis function primarily as observers, and, as noted, it is their identity rather than their action that holds meaning for the viewer. Their depiction is consistent with other depictions of Roman children in imperial art, and they are not, on the whole, controversial.

Also included in the processional friezes, however, are two children in non-Roman costume.[13] The first, from the south side of the enclosure wall (Fig. 60), has been identified most often as Gaius Caesar, in part because of his proximity to the figures identified as Agrippa and Livia.[14] His costume, jewelry, and hairstyle, however, are unmistakably non-Roman. He wears a tight diadem over his long curly locks as well as a torque and a short tunic that slips from his

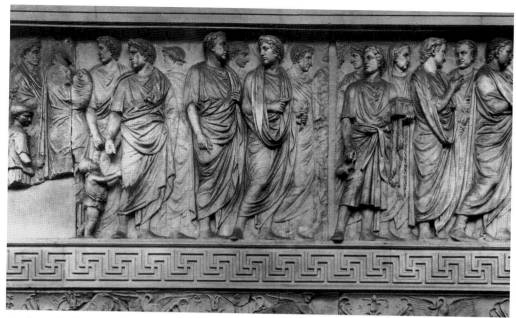

61. Rome, Ara Pacis Augustae, Non-Roman Child, North Frieze, 13–9, B.C. Photo: DAI 72.2402.

left shoulder. Rose notes that his shoes, in particular, are "distinctively eastern," with long laces and tongues pulled up over the front (1993, 55). Similarly, scholars have identified the child in non-Roman costume on the north frieze (Fig. 61) as young Lucius Caesar.[15] This north frieze child also wears a torque; he has unkempt, curly hair and wears a tunic too short to cover his buttocks. Most scholars have explained the unusual costumes and hairstyles of these children by claiming either that the torque was occasionally worn by imperial or patrician Roman children or that Lucius, in particular, was intentionally depicted on the Ara Pacis as a "little Trojan," reminding the viewer of Rome's roots and its mythical founder, Aeneas (Zanker 1988, 217).[16] As Rose notes, until fairly recently the problematic costumes of these children coupled with the scholarly assumption that they must be members of the imperial family had limited scholarly interest in them.

I believe that the children in non-Roman costume on the Ara Pacis are, indeed, non-Roman. First, costumes aside, the identification of these children as Gaius and Lucius Caesar is odd. The *camillus* on the north side of the frieze has been identified tentatively as Gaius Caesar. Moreover, one would expect Gaius and Lucius Caesar to be depicted near one another on a dynastic monument that shows family groups together; the children in non-Roman

costume appear on opposite sides of the enclosure wall of the altar.[17] Second, according to Pollini, who has studied the Ara Pacis and portraits of Gaius and Lucius Caesar at length, these children do not resemble traditional portraits of Gaius or Lucius.[18] Most important, however, the costumes of these two children contrast markedly with the garb of the other six children depicted in the processional friezes of the monument.[19] Considering the importance of Roman costume as an expression of legal status, I find it unlikely that children from the imperial family would be depicted in non-Roman costume on an official monument, particularly with bare buttocks. As we have seen, there is no other extant work of official imperial art in which Roman children are depicted partially nude or in the garb of foreigners.[20] Although they appear in an artistic context unique to the Ara Pacis, the gestures and poses of the children in question conform to those of the non-Roman children addressed in Chapters 6–8, confirming their identification as non-Roman.

I am not the first to argue the non-Roman status of these children. Both Rose and Pollini hold that the children in non-Roman dress on the Ara Pacis are non-Roman. Rose identifies the younger child on the north side of the frieze as a prince either from Gaul or another of the western Roman territories, and the older child on the south frieze as a prince from the East.[21] Pollini claims that the older child is Celtic.[22] I am the first, however, to consider these children within the context of a corpus of official images of Roman and non-Roman children. As will be shown, the images of the non-Roman children from the Ara Pacis are consistent in costume, composition, gesture, and posture with other non-Roman child images.

Let us address the older child from the south frieze first. Dressed in a belted tunic and torque, the child also wears boots with triangular ankle flaps and a tightly bound diadem from which his long curls protrude. While the majority of his body faces the movement of the procession, the child looks over his shoulder like non-Roman children in violent contexts. Moreover, the child's tunic slides from his shoulder as do the garments of so many captive non-Roman women in violent scenes and in some submissions. His body, with shoulder and legs exposed, contrasts sharply with those of the Roman adults around him who are wrapped and bound in seemingly endless drapery. In addition, the child's twisted posture gives him an air of frontality similar to the posture of non-Roman children in a number of triumphal processions and violent scenes. The child's feet do not face the direction of the procession but protrude out toward the viewer. This image may mimic (or anticipate) depictions of

triumphal processions in which non-Roman children appear. Finally, while the child makes no gesture, he grasps the toga of the Roman man in front of him with his left hand.

Behind the child in low relief stands a woman. Intimately connected to him by gesture and gaze, she looks down at the child, placing her entire hand gently on his head in a gesture that probably signals affection or responsibility.[23] She is the only adult who acknowledges the child's presence. The composition of this pair may be related to that of the Julio-Claudian frieze fragment (Fig. 42) in which a non-Roman adult connects herself by gesture with a child of similar ethnic background, while the child seems detached from her. In both scenes, the adults place open palms on the heads of the children.[24] A Roman man makes a similar gesture with respect to a Roman child on the north side of the frieze. As we have seen, however, the association of non-Roman children with women, in particular, is a common element of imperial imagery, especially when that imagery depicts the imperial triumph or the violent capture of non-Romans by Roman soldiers.[25]

Rose is one of the few scholars to take into account the woman standing behind the child. Because of her diadem he identifies her as an Eastern queen. Noting its unusual placement on her forehead rather than over her hair, he likens her to representations of Dionysus, Ariadne, and maenads, suggesting that the diadem may indicate a family connection between the woman and Dionysus.[26] Rose goes so far as to identify the mysterious pair as Queen Dynamis of Bosporus and her son.[27] If the procession is intended as an ideal representation of an event, however, such specific identifications are unnecessary.

Simon (1967) identifies the pair as eastern royalty and posits that the woman and child could have come to Rome as a sign of friendship and loyalty toward Augustus and the Roman government on the part of their territory, an occurrence documented in *Res Gestae* 32.[28] According to Simon, we need not view the pair as prisoners of war or captives but rather as ambassadors of peace from the conquered territory.[29] She suggests that a pair of this sort would have been exactly what the ruling elite at Rome would have wanted to include in a depiction of a procession in honor of the goddess Pax (p. 18). In her view, the young Eastern prince on the south frieze of the Ara Pacis symbolizes the integration of the rulers of conquered territories into the highest echelon of Roman society, suggesting that the message of the scene is the peaceful co-option of new territories and provinces into the

empire under the approving eye of the goddess Pax, to whom the altar is dedicated.[30]

Simon's argument makes sense in the context of an altar of peace, but as Weinstock observes, the Ara Pacis was named by scholars without support from ancient sources.[31] In 1879, after examining only six slabs from the monument, von Duhn identified the monument as the Ara Pacis primarily because some of its reliefs were found in the Campus Martius.[32] Weinstock argues not only that Pax was a late personification,[33] but also that the altar in question served the aims of the *gens Iulia* rather than the cult of Pax. He observes that Aeneas, Ascanius, and the Penates, all depicted on the Ara Pacis, have "nothing to do with the cult of Pax," but rather "occur whenever the Trojan past of the Romans was to be demonstrated" (p. 58). Furthermore, it is not the goddess Pax, whose principle attribute is the caduceus, who appears on the monument, but rather Terra Mater or Tellus.[34] Weinstock speculates that the altar served the aims of the dynasty rather than the cult of Pax per se, and he proposes that the so-called Ara Pacis may in fact be the *Ara gentis Iuliae*, a monument known to have stood on the capitol in the time of Vespasian.[35]

Whatever the original titulature of the monument, Weinstock's observations call into question all conclusions based on Pax as the theme of the altar. Therefore, we need not assume that the presence of a non-Roman child on the south side of the Ara Pacis frieze symbolizes the peaceful or willing co-option of foreign territories into the empire. To my mind, the key to the image in question is that the non-Roman figure is a child, powerless among the crowd of Roman adults. While he may be accompanied by his mother, she fades into the background. The absence of a non-Roman father figure in this scene strips away the power of the non-Roman family group, at least in the eyes of the Romans.[36] Read within the context of a Rome's dynastic political system, the child, if truly a member of a non-Roman ruling family, as Simon suggests, indicates that the future of that family is completely at the mercy of Rome. Even if the scene implies the eventual integration of the child into the Roman ruling elite, it isolates the child visually and emphasizes the impotence of the non-Roman in the face of that ruling elite; it should not be seen as a "willing or peaceful" event.

Pollini agrees: "The appearance of . . . barbarian children in the friezes signifies, in my opinion, not unqualified peace between Romans and barbarians, but Roman pacification of barbarian peoples and the Romanization of future barbarian chieftains and kings: the barbarian children appear as subordinates,

not equals" (1987, 27). The similarities between this child image and later images of non-Roman children from triumphal and violent contexts are clear. Viewed within the context of triumphal processions, this child appears to be on display for the viewer as a trophy, a symbol of the conquest of an eastern territory or perhaps the entire East.[37] He is nearly frontal, and his exposed shoulder contrasts with the modest attire of the Roman figures in the friezes, perhaps evoking the status of one with *infamia*. Viewed with the scene of violent military activity in mind, this child appears powerless and pathetic. He is completely surrounded by Roman adults, his only connection to his kin group a female figure depicted in low relief behind him. Moreover, the child turns to look behind him in a pose we have identified as significant of a loss, often the result of violent activity.

While the child's connection to the Eastern woman is passive, his connection to Agrippa is active. He grasps the toga of Agrippa in a gesture that may signal his dependency on the Roman ruling elite. Neither Agrippa nor any other Roman figure in the group, however, acknowledges the child through gesture or gaze.[38] Despite the gesture of the child, Agrippa continues to face the direction of the procession; he appears not to notice the child. Likewise, the Roman woman behind the child, who may be Livia, gazes out at the viewer, failing to meet the child's backward glance. The failure of Roman adults to acknowledge the non-Roman child can be contrasted effectively with the gestures of adults toward the imperial children in the frieze, discussed earlier. As in comparable scenes of submission, the presentation of the non-Roman child on the south frieze of the Ara Pacis exposes the reality faced by non-Romans; while the Roman may deign to acknowledge the non-Roman, it is the subordinate non-Roman with whom the responsibility of contact rests. It is the non-Roman who must take up the toga of the Roman.

Let us turn to the younger child from the north side of the Ara Pacis (Fig. 61). This child is clothed only in a short tunic. His buttocks and chest are exposed, and he looks upward, tugging on the toga of the Roman adult before him; both arms are outstretched, and he appears to hold the right hand of the Roman adult next to him. The child has long, curly hair and bare feet, and he wears a torque similar that of the south-side child. Rose recognizes the unusual costume of the boy, in particular his short tunic, as unlikely dress for the son of a Roman emperor. Like the non-Roman child from the south frieze, this child's body is on display in a way that contrasts with the Roman figures in the frieze; his dress is anything but modest. Rose also cites the

boy's hair and torque as evidence for his identification as a non-Roman prince, claiming that this type of depiction of a member of the imperial family would have been "unprecedented" (and presumably unsequelled) during the Roman Empire (1993, 59). As noted, if this child and his counterpart from the south side of the frieze are members of the imperial family, they are the only Roman children in all of Roman art to be depicted as non-Romans.

Although Rose does not discuss the restoration of the child's torque, he does note the subtle differences between the torque worn by the north frieze child and that worn by the older boy on the south frieze.[39] The torque of the south frieze child is flat and held together in the front by two large clasps, while the torque of the north-side child appears to be twisted, with a smaller clasp. Rose states that "it seems as if the designers wanted to indicate that these children were associated with two different regions in which torques formed part of the traditional costume" (1993, 59). Even without the torque the child's costume is clearly non-Roman.

Most important, the child on the north side of the Ara Pacis frieze performs a gesture of submission. His right hand is outstretched, reaching the knees of the Roman man before him. His right foot strides in front of his left, and his knees are slightly bent; his posture and the gesture of his right arm parallel those of submissive children precisely. Rose notes in particular the similarity among the gesture of this child and those of the children on the Boscoreale cup (Figs. 31 and 32) and on the Augustan *denarius* discussed earlier (Fig. 30). As he acknowledges, Rose takes this comparison partly from Héron de Villefosse, who first noticed the similarities among these images in 1899. The non-Roman children on the Boscoreale cup and the Augustan coin appear to be the same age as the child on the north frieze of the Ara Pacis, probably between one and four years of age. All children perform the same gesture and are dressed similarly. In fact, both standing children on the Boscoreale cup have exposed buttocks. As Kuttner states, "one has only to look at the . . . representations side by side to see that the Ara Pacis child belongs to the group of infants from the cup scene and that his figure is a conflation of the two toddling children in the foreground of the cup panel" (p. 101). One can easily add to these comparisons later representations of children from the Column of Trajan and Antonine sarcophagi. Scene XXXIX from the Column of Trajan, in particular, shows children performing similar gestures (Fig. 33), while the sarcophagi from the Palazzo Ducale in Mantua, the Uffizi (Fig. 35), and the Camposanto in Pisa (Fig. 36) depict submissive non-Roman children

in the same pose as the child in question from the north side of the Ara Pacis frieze.

Although non-Roman adults and military paraphernalia are absent from the Ara Pacis, the posture and gesture of the child on the north frieze clearly participate in the visual language of submission. Likewise, while the child on the north frieze holds the hand of a Roman adult, it is not unusual in scenes of submission for a soldier or Roman official to act as a liaison between submissive non-Romans and the emperor, guiding the non-Romans as they approach. On the submission from the Boscoreale cup, a cuirassed military figure stands among the non-Romans, leading one of the children by the hand. Similarly, a Roman soldier presents non-Roman children to the general on the Ludovisi Sarcophagus, separating and perhaps protecting him from the throng. In that case the soldier places his left hand on his sword.

While Rose uses these similarities to confirm his identification of the child from the north frieze as a Western prince, he sees the child's presence primarily as a reminder of the peace that Augustus had secured in the Western territories by his activities in Gaul between 16 and 13 B.C. Of the two non-Roman children from the Ara Pacis, Rose says, "these two foreign children were associated with regions and peoples who had caused significant military setbacks to the Romans throughout the Republic; their participation in the Roman *supplicatio* indicated that peace with these regions had finally been achieved through the efforts of Augustus and Agrippa" (1993, 61).

In light of the specific parallels between the north frieze child and non-Roman submissions, not to mention parallels between the south frieze child and later depictions of non-Roman children in triumphal and violent scenes, we can take the interpretation further. The child on the north frieze may serve as a reminder of Augustus' peace in the West, but he also functions as a token of submission from the Western territories to Rome. After all, Augustus achieved peace in the West through either conquest or intimidation. As Rose himself notes, the regions with which the non-Roman children on the Ara Pacis are associated succumbed to Roman control neither quickly nor peacefully. The north frieze child, therefore, should be seen as a subordinate figure; his image participates in the message of non-Roman submission and Roman domination.

The Roman official reacts strikingly to the gesture of the north-frieze child. As with the non-Roman child on the south frieze, the Roman official seems not to notice the small child who tugs at his toga, his gaze directed toward the procession behind him. The official-child pair symbolizes the relationship

between non-Roman territories, represented by the child, and the ruling elite of Rome, represented by the togate official. The emperor and his ruling elite deserve respect and supplication from their subordinate, childlike territories, but they may choose not to acknowledge those subordinates. As we have seen, the indifference of the Roman recipient of non-Roman submission is not unusual in such scenes.[40]

The preceding argument confirms that the children in non-Roman costume from the processional friezes of the Ara Pacis are indeed non-Roman. Although some of the monuments with which I compare the Ara Pacis were erected more than a century after the altar itself, the similarities among the non-Roman children on the Ara Pacis and those depicted on later monuments is striking. While I do not wish to suggest here any direct stylistic or thematic influence of the Ara Pacis on later monuments, I do propose that the Ara Pacis and the monuments that follow it can be read most effectively within the context of the larger visual language to which they all belong – a language that establishes a definition of *Romanitas* for those living in the Roman Empire.

Their specific costumes notwithstanding, the two non-Roman children from the Ara Pacis resemble significantly other non-Roman children in imperial imagery. Both the north and the south frieze children appear as if on display, one with an exposed shoulder and the other with exposed chest and buttocks. Neither costume conforms to the modest standard set by other figures in the friezes, and both presage other non-Roman figures in official art. The children on the Boscoreale cup have exposed buttocks, and non-Roman women are often shown with exposed shoulders or breasts in scenes of submission, triumph, and violent military activity. In addition, both children exhibit postures and gestures consistent with those of non-Roman children in scenes of submission, triumph, and violent military activity. The child from the south frieze, in particular, is nearly frontal, and he performs the backward glance, disrupting the movement of the procession and perhaps signaling a loss. The gesture of the child from the north frieze clearly participates in the language of submission. Most important, both children make gestures toward Roman men that go unacknowledged, illustrating the relationship between the Roman and the non-Roman.

The message sent by images of non-Roman children on the Ara Pacis is consistent with that sent by images of non-Roman children in scenes of submission, triumph, and battle from other official, imperial monuments. The Ara Pacis, like so many other monuments on which non-Roman children appear,

exposes the harsh reality of the non-Roman situation. The non-Roman, con-
quered, subordinate, impotent, childlike, and stripped of its supportive kin
group, looks to the Roman ruling elite for guidance and support, while the
Roman elite may choose to ignore his or her pleas. The obligation presented
in images of non-Roman children from the Ara Pacis is one-sided. Moreover,
just as images of children from the Ara Pacis advertise the plight of the non-
Roman, they also participate in the narrative of Roman identity, establishing
what it means to be Roman. While non-Romans, represented as children, must
look to Rome for guidance and control, *Romanitas* is synonymous with auton-
omy. The autonomous Roman need not look to any superior for guidance or
control.

10 CONCLUSION: A NARRATIVE OF IDENTITY

I have proposed that modern discussions of nation can be helpful for understanding the Roman Empire, and I have argued that modern denials of Rome's nationhood contain useful tools for unearthing and reconstructing Roman political ideology. If, as I claim, official art presents a narrative of Roman identity or an idea of *Romanitas*, what might that narrative be? How might we describe in concrete terms the idea, the message of imperial child images?

Perhaps the most obvious conclusion to be drawn from the representations collected here is that a child's ethnopolitical status was the primary factor determining the artistic contexts in which that child might appear. Representations of children do not transgress status boundaries, illustrating that status divisions among the inhabitants of the empire were felt just as strongly for children as they were for adults. If we move beyond this quite obvious conclusion to look comparatively at images of children of different status groups we shall recognize that the disparate contexts in which Roman and non-Roman children appear illuminate the ideology of the Roman ruling elite.

The consistency of the scenes addressed in Chapters 3–9 and the regularity with which they are employed signal the existence of an imperial visual language in which children played a significant role. I have identified a limited number of artistic contexts in which Roman and non-Roman children appear. Each context is defined by the following elements: composition, background or setting, and, most important, the gesture and posture of the figures in it. Roman children always appear in peaceful scenes of public gathering, usually before the emperor. They observe or receive imperial largesse, they are present at *adlocutiones*, they participate in public games and processions, and they observe sacrifices. That is, Roman children are shown in official contexts

that demonstrate their integration into Roman society and their participation in public imperial life; they perform activities similar to those performed by Roman adults. In Roman art, as in Pliny's *Panegyricus*, Roman children represent the future. Through their potential as the next generation of Roman citizens, soldiers, and rulers, Roman children in official imperial imagery illustrate the empire's investment in and commitment to the future of Rome.

Against this backdrop, images of non-Roman children in imperial art seem grotesque. In contrast to Roman children, who are shown among autonomous Roman adults, often in family groups and always in peaceful scenes, non-Roman children are shown almost exclusively in subservient roles, usually subject to violence and humiliation, and always submissive. Non-Roman children have an impressive presence in official Roman art, but their ethnopolitical status is carefully differentiated from that of Roman children through costume, gesture, and posture, as well as through the compositions in which they appear. The non-Roman child is used in official art to demonstrate the power of the empire over its enemies, provinces, and territories. As offerings of submission, objects of display in triumphs, or captives and fugitives in violent scenes, the overwhelming majority of non-Roman children depicted in Roman art herald their probable future of subservience or slavery.[1]

Images of children, the images most fraught with potential in Roman art, are images in which the distinction between Roman and non-Roman is painfully clear. Where children are concerned, Romanization is not a process; Romanization is either absent or complete. Children either "participate in Roman imperial society in every way," as Ellul put it,[2] or they are displayed, abused, and humiliated, on, at best, the margins of Roman society. To be Roman in Roman art is performative; it is to look and act like a Roman, to have a Roman family, most importantly a father, to wear Roman costumes and hairstyles, to participate in public imperial gatherings and functions, to receive imperial largesse, and to recognize Roman religion.

To be non-Roman, on the other hand, is to be submissive, to be subject to violence and to political and social degradation and humiliation, and to be sustained in a paternalistic relationship with Rome and its emperor. A non-Roman wears foreign garb and has parents who are rebellious, captive, submissive, and often sexualized; non-Romans are associated with the female, objectified, displayed, and enslaved.[3] Although Roman art could have employed the non-Roman child effectively as a symbol of peaceful future relations between Romans and non-Romans or as a symbol of the incorporation of non-Romans

into Roman society, it instead presents the non-Roman in conflict with, and in stark contrast to, the Roman.

As noted in Chapter 4, one scene from the Column of Trajan provides an exception to this rule.[4] In scene XCI (Fig. 20), both Romans and non-Romans observe the emperor's sacrifice. The non-Roman families seem loyal to Rome and may even be what some would call Romanized, although they do not wear Roman costumes. Presumably, the non-Romans in scene XCI have already submitted to Roman rule, but they are not submissive here. This is the only scene I have encountered in which figures in non-Roman costume are shown outside the three artistic contexts discussed earlier, the only one in which they participate in a peaceful public gathering along with Roman figures. Standing behind the Romans in this scene, the status of non-Romans here is to the Romans as *paenulati* are to *togati* in other scenes of public gathering. The non-Roman figures in scene XCI are clearly taking part in Roman public life. Moreover, if the six altars in scene XCI represent the six deified emperors of the imperial cult, the non-Romans in the scene may be acknowledging the legitimacy of imperial state religion. All other representations of non-Roman children in official imperial art depict those children in a transitional phase, showing either the moment of conquest or capture, which is usually violent, or the moment immediately following conquest or capture, when children either flee their homeland, appear in triumphs or submit to their conqueror.

Although scene XCI shows that official Roman art could present peaceful images of non-Roman children and their families being incorporated into Roman society, it is not the norm; it is the exception that proves the rule. Subtle variations among images within the same artistic context certainly exist, but the cohesiveness of the categories overall is strong, and the big picture is undeniable. The artistic contexts identified in this study are used again and again to send a message, a narrative of Roman identity. At the same time, and just as vehemently, Roman visual imagery evidences a narrative of non-Roman identity. One would not be clear without the other. As Žižek (1993) holds, the "nation-Thing" that is Rome *"appears* through" a "collection of . . . features," through "ways of life" (p. 201). "Members of a community," in this case Rome, "who partake in a given 'way of life' *believe in their Thing*" (ibid.). That is, members of a community who perform the rituals of public daily life, who "participate in their society in every way," are necessarily exhibiting a belief in the existence of that community. It is not the performances themselves, however, that engender the existence of the Roman; it is the belief in those

performances, demonstrated by their advertisement in imperial visual imagery, that creates a definition of *Romanitas*.

It has been suggested to me that in receiving largesse from the emperor, Roman children are placed in a position similar to that of non-Roman children with respect to the imperial ruling elite. Likewise, one might argue that the submissive gesture of the non-Roman child is akin to the gesture of a Roman child receiving largesse. That is, on one level all children in Roman art, indeed perhaps *everyone* portrayed in Roman art, must submit to the emperor and his ruling elite, and all are dependent on the emperor for mercy and subsistence. I acknowledge the apparent similarities between children's gestures as well as the paternalistic relationship between the emperor and all his subjects, but I do not find that the striking differences between images of Roman and non-Roman children and the artistic contexts in which they appear are mitigated either by such general artistic similarities or by the realities or practicalities of imperial rule. It is rather the specifics of the artistic conventions for portraying non-Roman children — the military presence and the division of the non-Roman family, for instance — that draw such a clear distinction between Roman and non-Roman, discouraging the viewer, at least to my mind, from assimilating the two.

Just as Kuttner did not want to label the submission scene from the Boscoreale cup "submissive," she and others have championed the view that Roman imperialism could be a morally benign or neutral process. While acknowledging that images of "pure dominance" existed as advertisements for the power of the empire, Kuttner feels that this is not the only interpretation of the submission found on the Boscoreale cup (p. 86). Admitting that there is "an element of such a tone" in the image from the cup, she interprets the scene as one of "benevolent *imperium*," claiming that all the identifiable people depicted on the cup come from provinces already incorporated into the empire and therefore necessarily friendly to Rome: "There . . . the little children being handed over to Augustus are joyful, emblems of a benevolent imperialism in which those ruled are delighted at Roman guidance and are valued by their rulers" (pp. 86–7).

Haverfield (1912) and Millett (1990) present similar views of Romanization. Haverfield writes of a Romanization that "in general extinguished the distinction between Roman and provincial . . . [but] did not everywhere and at once destroy all traces of tribal or national sentiments or fashions" (p. 18). Millett defines Romanization as a "two-way process of acculturation: it was

the interaction of two cultures, such that information and traits passed between them. As such its products were not simply a result of change initiated by the Romans" (p. 2). Millett points to the size of the Roman ruling elite as evidence for the importance of local non-Roman rulers in particular: "The net effect of this was an early imperial system of loosely decentralized administration which allowed overall control by Rome while leaving the low-level administration in the hands of the traditional aristocracies. This enabled most areas brought under Roman control to be run without a significant military presence" (p. 8).

Finally, as noted in Chapter 1, Woolf (1996) goes so far as to say that "there was no standard Roman civilization against which provincial cultures might be measured. The city of Rome was a cultural melting pot and Italy experienced similar changes to the provinces. . . . Romanization may have been 'the process by which the inhabitants come to be, and to think of themselves as, Romans,' but there was more than one kind of Roman, and studies of provincial culture need to account for the cultural diversity, as well as the unity, of the empire" (p. 7).

Such theories present Romanization as a relatively neutral, if not always benign, process of cultural exchange that accounts for the diverse nature of imperial culture. Indeed, such theories are supported by literary evidence and archaeological remains. Rome *was* a cultural melting pot, the Roman ruling elite *was* too small to rule without the help of local elites, and the effect of "Romanization" *was not* everywhere and always the same. Based on the evidence they employ, these studies present what appear to be responsible pictures of Roman imperialism, and I believe they may be, on the whole, correct in their assessment of their sources. On the other hand, their omission of evidence from visual sources prevents them from painting the whole picture.

Viewed within the context of the images addressed in this study, these assessments appear anachronistic. Kuttner presents a surprisingly positive view of Roman imperialism in which the emperor cherishes non-Romans and in which non-Romans are "joyful" and "delighted" at Roman rule. Millett's theory of a "two-way process of acculturation" in which Roman and non-Roman culture influence one another in a symbiotic relationship and in which non-Romans, willingly "identifying their interests with those of Rome," take responsibility for ruling locally also becomes problematic. Official imperial imagery allows very little middle ground between the full Roman citizen, portrayed as such, and the submissive, abject, humiliated, and even dangerous non-Roman.

Images of non-Roman children in Roman art force a reassessment of modern interpretations of Augustan and post-Augustan visions of *Romanitas*, including theories of Romanization such as those presented earlier. Whether the concept held any practical relevance for the Roman emperor and his administration, the Roman ruling elite was not presenting benevolent *imperium* in its imperial imagery. It was not presenting Romanization as a process in which Romans and non-Romans interacted culturally. It presented, rather, "snapshot" vignettes that expressed most visibly the basis of its power: images of pure dominance in which Roman and non-Roman were clearly defined, nearly opposite categories.

The narrative of Roman visual imagery, therefore, is a relatively simple one of inclusion and exclusion – to be Roman is to be a member of an inner circle, included and privileged. Becoming Roman indeed may be, as Woolf put it, akin to "joining an insiders' debate about what that package [Romanness] did or ought to consist of at that particular time" (1998, 11), but while scholars take pains to illuminate the inconsistency of Roman culture and the unique experience of provinces throughout the empire with respect to Roman conquest and influence, there is no debate depicted in official Roman art. Instead we find a simple narrative in which iconographic symbols make clear to the viewer the distinction between Roman and non-Roman.

Of course, this is not to say that all non-Roman children actually suffered a violent fate at the hands of the Romans. One may assume that many non-Roman children continued their lives under Roman rule without much disruption. Peasants on the soil may have maintained their lives; loyal local rulers and their children were certainly incorporated into the administration of Roman provinces and territories. And by A.D. 212, all freeborn children, together with their parents, were made Roman citizens by the *Constitutio Antoniniana*. Roman official art, however, does not illustrate these possibilities. It does not depict the peaceful incorporation of new territories into the empire or the continuance of normal daily life in the new territories and provinces. Rather, it uses non-Roman children to underscore the power of the Roman Empire over those not yet incorporated into the state, those not yet "Romanized."

FAMILY, GENDER, AND STATUS

Children rarely appear alone or unsupervised in official Roman art. They are most often shown with adults of similar status in what appear to be family

or kin groups. Roman children receive imperial largesse from the emperor in the company of Roman adults, and they appear with Roman adults at *adlocutiones*, processions, games, and sacrifices. Occasionally Roman children are depicted with the emperor alone. Analogously, non-Roman children are depicted among non-Roman adults in triumphal processions and in scenes of violent military activity, although, as we have seen, in some of these scenes family members are separated from one another. In scenes of submission non-Roman adults offer non-Roman children to the emperor or to another member of the ruling elite.

Comparison of Roman and non-Roman child images illuminates the official formulation of the Roman *familia*, arguably the most important private institution in the empire.[5] As Cicero says, "[t]here are several levels of human society. Starting from that which is universal, the next is that of a common race, nation, or language. . . . An even closer bond is that between relations: for it sets them apart from that limitless society of the human race into one that is narrow and closely defined. . . . Since it is a natural feature of all living beings that they have the desire to propagate, the first association is that of marriage itself; the next is that with one's children; then the household unit within which everything is shared" (Cic. *De off.* 1.53–54).[6] In official imagery, men/fathers play a pivotal public role with Roman children, whereas women/mothers are eclipsed by representations of female divinities. Such a definition of the Roman *familia* stands in stark contrast to that of the non-Roman family, in which women/mothers play the most visible role.

Roman children almost always appear in public with male adults, presumably their fathers. As noted in Chapter 3, with the exception of depictions of distributions intended exclusively for female children such as the *puellae Faustinianae*, there is only one Roman woman from all scenes of imperial largesse in which Roman children appear. This woman, from the panel relief of Marcus Aurelius on the Arch of Constantine (Fig. 13), does not attach herself by gesture or gaze with any child or child-father group; she appears to be a lone figure. At least one *puellae Faustinianae* depiction includes women among the recipients of the distribution, and the recipients shown on the Villa Albani reliefs are exclusively female. All other adult women in scenes of imperial largesse have been identified by costume or attribute as personified virtues, cities, or countries, most often Roma or Italia. Moreover, while women appear in two of the three sacrificial scenes from the Column of Trajan (discussed in Chapter 4) and in the procession on the Ara Pacis frieze, all other scenes of public gathering that include children lack Roman women entirely.[7]

Images of Roman children may simply represent the practical reality; that is, Roman fathers may have taken primary responsibility for Roman children in public. This would not be surprising considering the role of the Roman man in public life, the Roman law of *patria potestas*, and the legal restrictions to which women were subject during the imperial period.[8] Moreover, because registration may have been required to receive certain types of imperial largesse, and because legitimate children followed the status of their fathers, it is conceivable that a father's presence might have been required for the receipt of certain distributions intended for the support of children. Pliny refers to a registration or enrollment that took place at distributions and may have required the father's presence or other proof of status.[9] Similarly, the Tablet of Veleia lists the status of children supported by the alimentary schemes in that town, proving that records of such facts were kept. Listed are 263 legitimate boys and 35 legitimate girls, along with two illegitimate children, one of whom is female.[10] Although it is clear from Suetonius and the *Res Gestae* that Augustus distributed donations to people of all orders,[11] it is also clear that recipients were sometimes required to register for donatives and that such markers as status and legitimacy were thus, presumably, determinant for the largesse.[12] The need to demonstrate status and legitimacy does not preclude the presence of mothers from scenes of imperial largesse, but it may explain the presence of fathers.

Of course, the need to demonstrate status or legitimacy at imperial distributions has no bearing on other scenes of public gathering, from which Roman women are also largely absent. The eclipsing of the Roman mother or mortal woman by female divinities in official Roman art is symptomatic, I think, of a combination of fear and reverence for the mortal woman in mainstream Roman society. An unusual set of funerary portraits provides support for the phenomenon I suggest. These portraits depict Roman matrons nude, in the guise of Venus. While the bodies of the immortalized matrons are soft and youthful, bearing every resemblance to the goddess, the faces of the matrons are stern, aged portraits of the mortal women themselves. In her investigation of a number of such portraits D'Ambra (1996) has suggested that images of Roman women in the guise of Venus were mechanisms for conveying "Roman attitudes about the reproductive woman, her roles as bride, wife, and mother" (p. 223). The tension between the divine body and the mortal head of Roman matrons portrayed as Venus illustrates the conflict inherent in the male view of the Roman matron. As D'Ambra concludes, "the self-restraint conveyed by the portrait heads maintains the proper control of the sexually explicit

bodies. The eroticism of the statues is stabilized not only by the grave and modest expressions of the heads but also by the bodies' images of a pristine and productive sexuality, implicit in Venus' role as mother of the Julian line and, therefore, as guardian of fertility and generation of the state" (p. 229).[13] While statues of Roman matrons in the guise of Venus present the sexuality and reproductive power of the Roman woman as safely under control, eliminating the Roman woman from imperial visual imagery is perhaps the safest method of all. Images of Roman mothers with their children advertise the mysterious reproductive power of those women, but images of children with goddesses illustrate the connection between the mortal and the divine and allow the presence of women without the taint of mortal feminine sexuality. When Roman women are shown with Roman children, it is either at distributions intended specifically for female children or in religious contexts.

In contrast, non-Roman children of both genders are frequently shown with their mothers, and women figure prominently in the majority of scenes in which non-Roman children appear. For instance, as noted in Chapter 9, a non-Roman woman stands behind the non-Roman child on the south side of the Ara Pacis frieze, whereas non-Roman men are absent from the scene (Fig. 60). Non-Roman children on the triumphal frieze of the Arch of Trajan at Beneventum (Figs. 43 and 44) appear between non-Roman women. It is the non-Roman woman in the Julio-Claudian frieze fragment (Fig. 42) whose gesture and posture connect her with the child in that triumph. Non-Roman women also appear prominently with children in violent scenes from the Column of Marcus Aurelius, as noted in Chapter 8. In scenes XX and CIV (Figs. 52 and 54), notably, Roman women and children attempt to escape Roman soldiers without the help of non-Roman men. In addition, Roman artists separated adult non-Romans from one another in scenes of conquest. Scene LXIX from the Column of Marcus Aurelius employs a dual-level composition to illustrate the separation of non-Roman women and children from non-Roman men. When such segregation occurs, children are most often grouped with women.

This is not to say that non-Roman men are absent from scenes in which non-Roman children appear. As we have seen, non-Roman children may be shown in the presence of both parents, and there are three scenes of violent military activity in which only men and children appear. In addition, it is often an adult male who offers non-Roman children to the emperor or Roman general in scenes of submission. I suggest that non-Roman men appear most prominently in scenes of submission because men acted as agents of exchange

in Roman society. Roman women could neither vote nor hold public office. *Negotium* was primarily the realm of men. When a non-Roman child is handed over to the emperor or Roman general by a non-Roman man, the exchange symbolizes the transfer of power from the non-Roman man (and territory or ethnic group) to the Roman man (and empire).[14] When non-Roman children are shown in scenes of violent military activity or in triumphal processions, contexts in which no symbolic exchange occurs, non-Roman men do not figure prominently with non-Roman children. If present, they are usually part of a larger family or kin group that includes women as well; alternatively, they are separated from non-Roman women and children.

Other scholars have noted the difference between the portrayal of Roman and non-Roman family groups in official Roman art. Currie claims that on the Arch of Trajan at Beneventum, specifically, "mortal maternity was defeated by paternity. Barbarian children in the frieze were associated with the servile, the feminine, and the natural [while] Italian children in the passageway relief were associated with masculinity, freedom, and urban life" (p. 173). Kampen observes that "goddesses and female personifications in great number and variety appear in Roman historical reliefs . . . as for mortal women, there are few" (1991, 218). She sees the dearth of women in official art as symptomatic of the fact that women were symbols of the private world: "My hypothesis is that women's images were used on public historical reliefs because they were uniquely recognizable signs of the private world. Set into a public context and noticeable precisely because of their rarity, women's images carried special meaning about the ideal and idealized relationship between public and private. . . . Women's images . . . helped to define the nature of the Roman social and political universe" (ibid., 219). Kampen also notes the importance of non-Roman women on imperial monuments, suggesting that "the barbarian woman with babe in arms signals the depth of defeat suffered by her society just as Livia, beneath her divine spouse and next to her ruling son, is the crucial link in the chain of enduring dynastic power" (ibid., 235). More recently Zanker (2000) has explored the meaning of images of non-Roman women and children specifically on the Column of Marcus Aurelius.

Although the work of Currie, Kampen, and Zanker is valuable and well-founded, it does not take into account the visual language in which images of children appear, and it has little to say about the *familia* as an institution. On the whole, the images in my corpus show that while Roman children were consistently depicted with fathers or male figures and female divinities,

non-Roman children were, in contrast, associated with their mothers or female relatives. The difference between the portrayal of Roman and non-Roman family groups must stem in part from the legal and political structure of Roman society, as Currie intimates. Just as legitimate Roman children followed the status of their fathers under Roman law, illegitimate children followed the status of their mothers. This fact may account for the difference in representation. In Chapter 7 I explored the possibility that non-Roman children may have been seen as members of a status group similar to that in which illegitimate and slave children existed. Images of children derive symbolic meaning from Roman social structure, in which men held more power than women. As noted earlier, women could neither vote nor hold public office; women were often subject to the legal control (*manus*) of their husbands or fathers, and while women held certain forms of power in Roman imperial society, their power was more often practical than legal. Thus, the association of non-Roman children with women, the subordinate figures in Roman society, and of Roman children with men, the dominant figures, sends a clear message of Roman power to the inhabitants of the empire. With their fathers at their sides, Roman children are presented as those with the legitimate potential to rule the empire. With divided families or with mothers at their sides, non-Roman children are presented as those who will struggle for political, social, and legal legitimacy and power.

DIACHRONIC ANALYSIS

In official Roman art, children are always shown in public contexts, illuminating the role of children in public life. Domestic and private scenes with children are reserved for privately funded art. Included in this study are representations of approximately 130 children. Of these, half may be identified as non-Roman and half as Roman.[15] The sheer number of representations adumbrates the importance of children in the visual language employed by the Roman state, and the images themselves tell us much about the ideology of the Roman ruling elite. While there is a great deal of consistency in the use of children in visual imagery from the age of Augustus through the reign of Septimius Severus, as we have seen, as the empire grows older the ways in which images of children are employed does change. The synchronic approach has served us well thus far, but such changes cannot be assessed without a diachronic gaze.

Images of non-Roman children, in particular, become ever more violent and disturbing to the modern eye as the empire ages. The evolution is most obvious in the contrast between child images on the Column of Trajan and those on the Column of Marcus Aurelius because the medium and subject matter of the monuments are essentially the same. As noted in Chapter 8, whereas only one-quarter of the scenes from the Column of Trajan depict battle, more than half of the scenes on the Column of Marcus Aurelius are devoted to violent military scenes. Images of non-Roman children from the late Antonine battle sarcophagi addressed in Chapter 8 are comparable to contemporary images from the Column of Marcus Aurelius. While children are not included in the main friezes of the Vigna Amendola and Via Tiburtina (Fig. 57) sarcophagi, for instance, those friezes, which provide artistic contexts for the scenes in which children do appear, are extremely violent. I include the sarcophagus from Via Collatina (Fig. 58), which bears elements of earlier submission scenes, in Chapter 8 in part because of its explicit violence. The man submitting before the general is held down by a soldier who grabs his hair and forces his knee into his back, and the sword of the soldier nearby is unsheathed and ready for action.

The change can also be seen in a comparison of the non-Roman children depicted on the Ara Pacis (Figs. 60 and 61), the Boscoreale cup (Figs. 31 and 32) and the Julio-Claudian freize fragment (Fig. 42) to those on the Column of Trajan, and in turn in the comparison of the non-Roman children on the Column of Trajan and those on the frieze of the Arch of Trajan at Beneventum (Figs. 43 and 44) to those in the triumphal scene from the Arch of Septimius Severus at Lepcis Magna (Fig. 45). As noted in Chapter 7, the triumphal scene from the Arch of Septimius Severus is one of the most violent, with the non-Roman child dragged through the street. Even scenes of submission become more violent over time. Compare for example, the submission from the Boscoreale cup, in which the seated emperor receives non-Roman figures with an open hand, to the submissions depicted on sarcophagi from the Palazzo Ducale in Mantua and the Uffizi (Fig. 35). On both sarcophagi, disheveled women offer children to cuirassed generals who do not acknowledge their submission. The Vatican Sarcophagus (Fig. 40) also shows a disheveled woman offering her child to a Roman soldier. This time the weeping child is surrounded by military paraphernalia, and while the soldier holds one hand out toward the pair, the other remains on his sword. As the empire expanded, the necessity to demonstrate its power must have became more urgent. Because

non-Roman children were an integral part of this demonstration, the later images in which they appear are exaggerated from earlier images. In general, scenes become more explicitly violent, while the children themselves are every bit as submissive.

The frequency with which children of either status group are depicted fluctuates during the course of the empire. The majority of the images compiled here date to the Augustan and early Julio-Claudian periods and to the Antonine and early Severan dynasties. Few nonimperial child images survive from the reigns of Caligula, Claudius, Nero, Galba, Otho, Vitellius, Vespasian, or Titus. Although it is impossible to determine clear causality for the surviving visual evidence, there are certain historical circumstances that seem likely either to encourage or discourage the production of child images. The first is the practical situation within the imperial family. The families of Augustus and the early Julio-Claudians produced biological children, some of whom appear on the Ara Pacis, and imagery from those periods often includes children. Likewise, just as Marcus Aurelius and Antoninus Pius celebrated the fertility of Faustina the Younger, their wife and daughter, respectively, with images of children from the imperial family, they also incorporated nonimperial children into their monumental imagery and coinage.

The early Antonines provide something of a puzzle within this model. Nerva, Trajan, and Hadrian were childless emperors, in contrast to the early Julio-Claudians and the late Antonines, yet Trajan and Hadrian both sponsored numerous child images. Both emperors used children on imperial coinage to advertise imperial programs and their success, and the Column of Trajan, the Arch of Trajan at Beneventum, the Anaglypha Traiani/Hadriani, and the Arco di Portogallo reliefs all include children. It is possible that Trajan and Hadrian incorporated children into their visual imagery to align themselves with Augustus and the Julio-Claudians or simply to emulate earlier visual imagery. As Boatwright says of Hadrian, in particular, the emperor's first works "emphasized his *pietas* and his respect for the imperial tradition. . . . Even the most personal of Hadrian's monuments, his tomb, carefully alluded to Augustus' Mausoleum" (1987, 238). It is also possible, however, that the Antonines incorporated Roman children into their imagery precisely because they were childless emperors. Perhaps children were a subject of artistic interest to Trajan and Hadrian because they were considered a valuable commodity by those emperors.

The second historical circumstance is legislation. Augustan family legislation encouraged Roman citizens to marry and reproduce, bringing private issues into the public eye. Like the dynastic system itself, such laws may have blurred the boundaries between public and private, bringing children into the public sphere and sparking the production of child images. As noted, many scholars have argued that the bulk of child images from the reigns of Trajan and Hadrian commemorate Trajan's institution of an alimentary program for children and Hadrian's extension of that program. The specific conclusions of such scholars are often tenuous, but Trajan's *alimenta* coinage is unique and may reflect specific legislation on his part. Similarly, coins produced during the reign of Antoninus Pius commemorate distributions to the *puellae Faustinianae*.

Finally, the political situation of the empire may have influenced the production of child images. When the Roman Empire was expanding, as it was during the first and second centuries, triumphal images and images of Roman dominance or conquest would certainly have been in demand, and such images often included non-Roman children. If therefore also makes sense that these images would have been popular when the empire was at war, as during the reigns of Trajan and Marcus Aurelius.

It is impossible to pinpoint the precise reasons why some emperors employed children in their imperial imagery and others did not. On the whole, however, emperors did not discriminate in their production of child images. When images of children from one status group are common, images of children from the other status group are common as well. Moreover, the so-called Antonine dynasty takes as much interest in non-Roman and Roman children as had Augustus and his immediate successors, despite the fact that before Faustina the Elder the Antonine emperors had been childless. It seems, therefore, that the use of children in official visual imagery depended on the ideology of the emperor and the particular interest of that emperor in images of children rather than the historical circumstances surrounding that emperor.[16] To varying degrees, from the reign of Augustus at least through the Antonine dynasty, children were viewed as artistic subjects in their own right.

The apparent change in the use of children in Severan and post-Severan imperial imagery may simply be an accident of preservation. The decrease in the number of child images may follow from the political chaos of the post-Severan period; however, it may also stem, in part, from the appropriation of dynastic power to ever younger members of the imperial family.[17] Perhaps the

changing understanding of childhood in the imperial family effected the use of children in official imperial iconography. After the Antonine dynasty, imperial children are presented in official Roman art not only as heirs or potential rulers among powerful family members, but also as powerful political figures in their own right.

AVENUES FOR FURTHER STUDY

While my dissertation, the foundation for this study, included a corpus of images of imperial children in official Roman art, I decided to omit those images from this book. I define imperial children as those children who are members of the imperial family and therefore either heirs to imperial power or potential producers of heirs. There are myriad correlations among depictions of Roman, non-Roman, and imperial children, the bulk of which I was not able to include here. A complete study of depictions of imperial children would certainly lead to important conclusions regarding the manipulation of those children's potential as symbols of the future. One could also compare the presentation of the imperial family to the presentation of the Roman and non-Roman family in official Roman art. It seems to me that mortal women (members of the imperial family) are more visible in scenes with children from the imperial family than are Roman women in scenes with Roman children. To confirm these impressions, however, is beyond the scope of this study.

It would also be worthwhile to explore further the sexualization of non-Roman figures in Roman imperial imagery. Often non-Roman women are shown with drapery sliding from their shoulders, sometimes with one breast exposed. Non-Roman men are shown bare-chested, the non-Roman children from the Ara Pacis wear revealing clothing, and non-Roman figures of all ages and genders are shown frontally as if on display. Images of triumphal processions demonstrate this display most clearly, but violent military scenes also present non-Roman bodies as if on exhibition. The visibility and sexualization of the non-Roman woman could be contrasted effectively with the absence or deification of the Roman woman in official imagery. Because the study of homoeroticism in Roman imperial culture is relatively young, the sexualization of the non-Roman man for what was largely a male viewing audience at Rome is certainly intriguing as well, as are the possible implications of the sexualization of non-Roman children in imperial visual imagery.

APPENDIX

COMPARANDA: CHILDREN IN PRIVATE AND FUNERARY ART

The bulk of this study addresses official child imagery comprehensively and within the context of a larger visual language, but the images compiled here are intended as comparanda, and my treatment is intended to be neither comprehensive nor exhaustive. With this appendix I only begin to address the rich and varied issues surrounding images of children from the private[1] and domestic spheres, primarily so that readers might further contextualize official child images and identify avenues for further study. Rawson has recently published a volume for Oxford University Press titled *Children and Childhood in Roman Italy* (2003) that includes considerable work on domestic and funerary representations of children, and although Huskinson (1996) treats one artistic genre rather than images of children per se in her *Roman Children's Sarcophagi*, her volume is groundbreaking with respect to its attention to a large body of child images from the private sphere. The images I have included here fall into two general categories: images of domestic provenance and funerary images. The sarcophagi, unlike those addressed previously, are clearly not official. They bear no resemblance to art funded or sanctioned by the Roman ruling elite, and they usually commemorate the death of the children whose images they bear rather than the death of a Roman official or general.

From private and domestic art survive true portraits as well as nonveristic representations of specific children, scenes of the daily life of children, and decorative representations of children. In stark contrast to official representations of children, nonofficial images rarely show children in the context of public gatherings. Private and domestic art, as one might imagine, usually present children in private contexts, most often at home among what appear to be family members, or occasionally in scenes of hunting or gaming. Nonofficial

images never show children in official gatherings before the emperor; not surprisingly, nonofficial child images seem never to include the emperor at all. Of course, the bulk of child images from private and domestic art survive as fragments and without certain provenance, but those that survive in situ and those for which an ancient locus is reasonably certain conform to these parameters. In private and domestic art, children function, as do the images themselves, within the private sphere.

FUNERARY SCULPTURE: SARCOPHAGI

Our most plentiful sources for nonofficial images of children are funerary. In *Roman Children's Sarcophagi* Huskinson divides her catalogue into ten thematic categories, only one of which addresses children as I define them in Chapter 2. She calls that category "everyday life" (p. 9). Included under this heading are scenes of children hunting, playing games, working at adult professions or occupations, acting, racing chariots, and competing in games or cockfights. The category of "everyday life" includes traditional biographical sarcophagi as well as scenes of *conclamatio* and feasting (pp. 9–73).

I address here three typical sarcophagi, one biographical, one *conclamatio*, and one gaming sarcophagus. A late-second-century sarcophagus originally from Ostia and now in the Louvre commemorates the death of the young M. Cornelius Statius (Fig. 62).[2] The sarcophagus narrates the life of the child in four scenes moving from left to right. In the first episode a woman nurses an infant while a bearded man looks on. In the second episode that man, probably the boy's father, tenderly holds the infant, who reaches out to touch his beard. The third scene finds an older child riding alone in a little cart drawn by a ram, and the fourth shows a child of the same age receiving a lesson from a bearded, seated man, perhaps his father. In the fourth scene both figures hold scrolls, and the child appears to be speaking to his instructor. With the exception of a belt, the child is naked in all scenes. In comparison with representations of children from the official sphere, the costume of this child seems unusual; as we have seen, official images never present Roman children in the nude. Although art from the domestic sphere may certainly conform to a set of parameters different from those of official art, the nudity of this child is acceptable in part because he is deceased. In Huskinson's treatment of a nude youth reclining on a third-century sarcophagus, she claims that the boy's nudity is heroic.[3] The figures on this sarcophagus are probably not intended

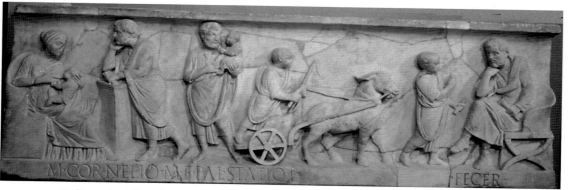

62. Biographical Sarcophagus of M. Cornelius Statius, second century A.D., Louvre. Photo: Réunion des Musées Nationaux Inv. MA 659/Art Resource, NY (Photographed by: Chuzeville).

as portraits, but the narrative form of the relief indicates that the figures represent the deceased and his family. Huskinson holds that the torches flanking the four episodes provide a funerary context, as may the cupid in the final scene (p. 10).

The *conclamatio*, literally the calling of the dead, provides a fitting subject for sarcophagus reliefs, but, as Huskinson notes, only a small number of sarcophagi actually bear that subject. Of those that do, many are child sarcophagi from the mid-second century A.D. (p. 13). On a sarcophagus from the British Museum, the deceased, a female child, lies on a couch in the center of the scene, hands clasped at her waist (Fig. 63).[4] Four child mourners stand around the couch, and seated figures, presumably the girl's parents, flank the couch. Her mother, on the left, sits in a high-backed chair, her father on a stool on the right. Both parents are veiled, and both rest their heads in their hands in a typical gesture of mourning (p. 14). Again, these figures are probably not portraits per se. Additional mourners stand behind the parents, and two dogs, most likely the girl's pets, keep watch beneath the couch. This composition is typical of *conclamatio* scenes.[5]

A number of extant sarcophagi show children at games, often nut games, which are attested in literary sources as well. A representative example from the Vigna Amendola on the Via Appia, now in the Museo Chiaramonti, dates to the second or third century A.D.[6] Girls appear on the far left of the sarcophagus, and boys are shown in the middle scenes and at the right. There are piles of nuts in the foreground of the frieze, and some of the boys resort to physical means to win the game. At least one boy holds a sack of nuts in his left hand. Huskinson identifies this game as *nuces castellatae* (p. 16).

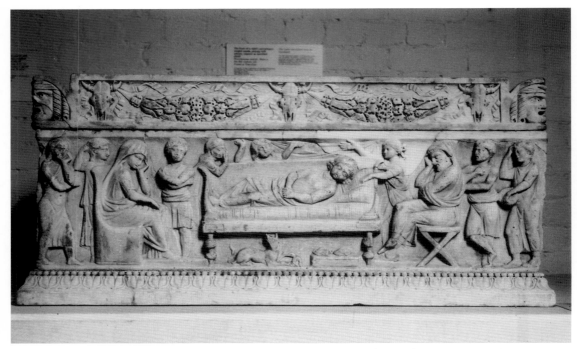

63. *Conclamatio* Sarcophagus, second century A.D. Photo: © Copyright The British Museum.

On children's sarcophagi parents accompany living children as they learn and play and deceased children as mourners. As Huskinson's label "everyday life" indicates, children's sarcophagi show children engaged in the activities of daily life – nursing, playing, education, and the like. What Huskinson does not claim, but what her catalogue of images clearly shows, is that the "everyday" activities in which children participate on Roman children's sarcophagi are activities associated almost exclusively with the private or domestic sphere. Certainly, attendance at a public gathering such as an imperial distribution or *adlocutio* would not have been an "everyday" occurrence for a Roman child, but the infrequency of an activity does not necessarily preclude its representation, particularly if that activity, while unusual, was extraordinary, as an audience with the emperor may well have been. Children's sarcophagi, however, portray children almost exclusively in private or domestic contexts.

FUNERARY SCULPTURE: STELAI AND ALTARS

The reliefs of Avita, Sextus Rufius Achilleus, and C. Nonius Pius exemplify the most basic sort of funerary relief, a simple representation of the deceased, nude

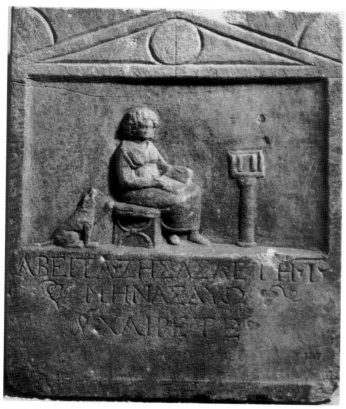

64. Relief of Avita, second century A.D. Photo: © Copyright The British Museum.

(if male), and with pets, playthings, or similar props. A marble funerary relief from the British Museum commemorates the death of Avita, a ten-year-old girl named in the Greek inscription (Fig. 64).[7] The girl, who has long curly hair and sits on a low stool with a cushion, reads from a scroll. Before her a lectern holds a second scroll. Sitting nearby, her pet dog, as Walker says, "implor[es] her to forget her learning and go out to play" (1985, 45). This relief provides an important companion to the following four examples, all of which either commemorate or portray male children.

The second-century A.D. relief of Sextus Rufius Achilleus in the Museo Nazionale, which identifies its subject by inscription, shows the boy standing entirely nude with the exception of a cloak.[8] He has short, curly hair and rolls of baby fat, and he holds a coin purse and caduceus and is shown with a rooster and turtle. While the inscription on the relief indicates that Sextus Rufius Achilleus died at age seven months, he appears much older on the relief.

A contemporary relief of C. Nonius Pius now in the Museo Civico in Bologna provides a close parallel for the relief of Achilleus.[9] Although carved more roughly, the relief shows Nonius nude and approximately the same age as Achilleus; he, too, holds a caduceus. Nonius holds his finger to his lips, requesting silence. While Nonius' features are no longer possible to discern, it seems unlikely that his was a veristic portrait. An inscription indicates that he died at age six; the relief was dedicated by his sister.[10] A third portrait of similar type from a first-century funerary altar from Ostia commemorates the death of a boy who is shown togate, standing with a small goat. An inscription identifies the child as *A. Ergilius A. f. Pal. Magnus*.[11] In all three cases it is clear that the child represents the deceased.

Children also appear in group compositions on funerary stelai. Typical of such monuments is a second-century relief from Ostia showing a couple in *dextrarum iunctio* (with right hands joined), the gesture of marriage (Fig. 65).[12] The woman gazes at the man, who is shown frontally. Between the two stands a small, male toddler, completely nude, touching his mother's leg with his left hand but looking back toward his father. The child connects the family through gaze and gesture. The woman holds a piece of fruit, perhaps a pomegranate, in her left hand, and the man holds a purse in his left. Above the couple hover cupids.

A similar group appears on a marble altar erected between 130 and 140 A.D. by Papias for Grania Faustina, his dearly departed *contubernalis*.[13] Between the adults, and, again, connected with them by gesture (Papias places his right hand on his child's shoulder), the child is the central figure in the scene. Wearing a tunic, he is probably male. The woman, who, from the inscription, is certainly intended to represent the deceased, holds a pomegranate in her left hand like the woman in the *dextrarum iunctio* relief from Ostia, perhaps indicating that it, too, commemorated only the death of the woman. This possibility is important because it implies quite a different function for children in group compositions than that which we have seen so far. In simple funerary portraits and on sarcophagi children themselves represent the deceased. Here, and on the *dextrarum iunctio* relief, however, children may perform a function more akin to that of children in official art. If living children appear on funerary monuments among both living and deceased family members, their function (in addition to representing realistically the family of the deceased) may be, at least in part, to trigger pathos, to induce sympathy from the viewer on their own behalf.

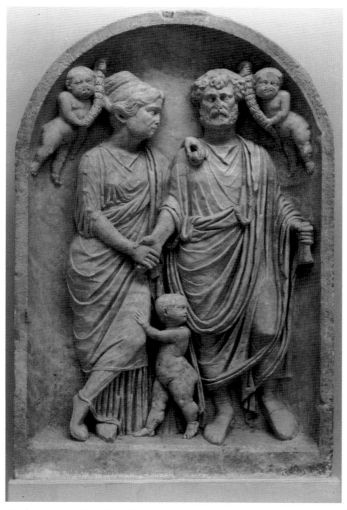

65. *Dextrarum Iunctio* relief, Ostia Museum 308–9, second century A.D. Photo: DAI 67.1071, Deutsches Archäologisches Institut.

DOMESTIC IMAGES: PORTRAITS

Although funerary art provides the greatest quantity of nonofficial child images, the eruption of Vesuvius left us with a rich and compelling record of images from the domestic sphere. Let us begin in Pompeii at the House of Puer Successus,[14] named for what appears to be a portrait painting of a child in a cubiculum near its atrium (Fig. 66).[15] Maiuri has noted the unusual interest of Pompeian portrait painters in figures other than the idealized adult, including

66. Puer Successus, first century A.D. Photo: From W. Jashemski, *The Gardens of Pompeii* I (New Rochelle, NY: Caratzas Bros. 1979), fig. 160.

people from a wide range of ages, physical types, and emotional states (1953, 99), and I consider this portrait a lucky consequence of that interest. Rendered on a large panel on the north wall of the room, its subject is identified by a graffito inscription, *puer Successus*, in the upper-right quadrant of the panel. The boy, who appears to be between one and three years of age, is entirely nude with the exception of a red cape that falls down his back. He has short, curly hair; a round, pudgy face and body; and large, expressive eyes. He is shown with a pigeon, a duck, and a pomegranate.

Jashemski suggests that the pomegranate many indicate that the boy had died (1979, 102), and the individuality and quality of the painting, its inscription, and, in particular, the child's nudity lead me to concur. This hypothesis is supported by the funerary reliefs of Sextus Rufius Achilleus and C. Nonius Pius treated earlier, both of which show a deceased male child in the nude. In fact, Achilleus wears a cape similar to that of *puer Successus*. In place of the pomegranate, duck, and dove Achilleus holds a coin purse[16] and caduceus and is shown with a rooster and turtle. While Achilleus' face is longer than that of *puer Successus*, both boys have short, curly locks and folds of baby fat, and they appear approximately the same age. Nonius is of similar age as well. Our

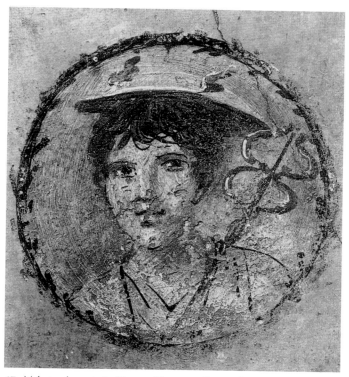

67. Male tondo portrait, House of Lucretius Fronto, first century A.D. Photo: From *P & M* III, p. 1001, fig. 70.

puer Successus, therefore, is almost certainly deceased, but it is unclear whether his is a veristic portrait. Parallels to the reliefs of Achilleus and Nonius lead me to believe that it is not. Nevertheless, there is no question that the painting of *puer Successus* commemorated a specific child.[17]

A fourth-style cubiculum in the House of M. Lucretius Fronto contains a pair of tondo portraits, one of a young boy and the other of a girl. The boy, dressed as Mercury with caduceus and *petasos*, has an oval face and pointed chin (Fig. 67). His hair is short and dark. The girl has round features; short, curly hair; large eyes; and prominent ears; she wears a dark tunic and is probably the younger of the two (Fig. 68). Neither child can be more than eight years of age. As Rawson says of the paintings, although the tondi "cannot be taken to identify a children's bedroom . . . they surely indicate awareness of children in the house" (1997, 219).[18] Preserved from the fourth-style tablinum of the Casa del Cenacolo is a similar pair of tondi that probably represent children who lived in the house. Both boys are wreathed, and each holds a scroll,

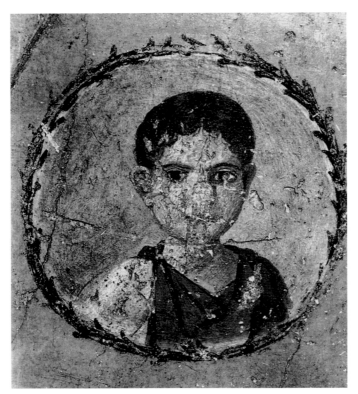

68. Female tondo portrait, House of Lucretius Fronto, first century A.D. Photo: From *P & M* III, p. 1001, fig. 69.

one of which is identified by a graffito inscription as "Plato," and the other of which reads "Homer."[19] The faces of the boys are individualized and yet similar, perhaps indicating that they are siblings; both have thin, oval heads with wide, deep-set eyes, long eyebrows, and sharply pointed chins. These portraits may commemorate the children's victories in recitation contests like that described on the Tomb of Sulpicius Maximus.[20]

The House of the Vettii contains eight paintings in its atrium that depict believably the bodies and hairstyles of very young children.[21] Each child, with one exception, holds some sort of vase or dish, perhaps representations of playthings or household implements. In addition, the children are distinct from one another. For instance, two are wreathed, and two have markedly round, cherublike features, while three have longer, thin faces. Hairstyles also differ from one child to the next. These paintings are important for three reasons. First, they present their subjects within square frames, unlike the tondo

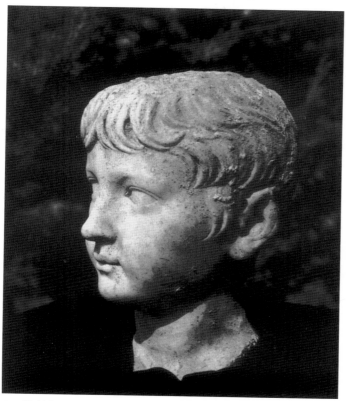

69. Child Portrait, Villa of Poppaea at Oplontis (inv. 2517), first century A.D. Photo: From W. Jashemski, *The Gardens of Pompeii* I (New Rochelle, NY: Caratzas Bros. 1979), fig. 460.

portraits discussed earlier. Second, they are individualized and therefore distinct from one another, indicating that they may indeed be veristic portraits. Third, and most intriguing, they are located at the base of the atrium wall in the dado band, at a young child's eye-level. While myriad explanations for the placement of these figures exist, it is certainly possible that the paintings were placed thus for the enjoyment of children in the household.

There are overwhelming numbers of unidentified and often fragmentary sculpted portraits of children from Roman Italy, only a handful of which I can address here. Jashemski records that the rear garden of the Villa of Poppaea at Oplontis (Torre Annunciata) yielded two sculpted heads of young boys, both of which seem be a portraits (1979, 301). The features of one, with a long, thin nose, full cheeks and lips, a slender neck, and wavy hair (Fig. 69), are clearly distinct from the other, found nearby, which has a fuller chin and neck, a mouth smiling and open to show the upper row of front teeth, and

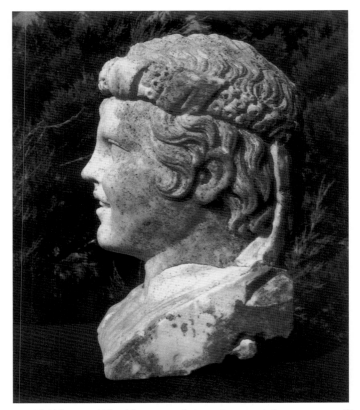

70. Child Portrait, Villa of Poppaea at Oplontis (inv. 2518), first century A.D. Photo: From W. Jashemski, *The Gardens of Pompeii* I (New Rochelle, NY: Caratzas Bros. 1979), fig. 461.

a shorter, slightly upturned nose (Fig. 70).[22] Both are carefully rendered and appear to be the work of an experienced sculptor. The first seems to have been influenced by Julio-Claudian portraiture but is not identifiable as any specific imperial child.[23] The second may originally have been treated as a herm.

A marble herm from the garden of the House of the Gilded Cupids bears a similar child's head that may be a portrait (Fig. 71). The boy smiles from beneath curly locks. His face is round and full, and his nose is upturned. He was originally accompanied in the garden by at least one other little boy treated similarly (Jashemski 1993, 162).[24] Found in the north section of the garden of the villa at Oplontis was another child's portrait head (Fig. 72).[25] The style and quality of the piece as well as the individuality of its physical features indicate that it is a portrait. The boy's nose is long and thin, his hair is

71. Child Herm, House of the Gilded Cupids (VI.xvi.7, inv. 20361), first century A.D. Photo: From W. Jashemski, *The Gardens of Pompeii* II (New Rochelle, NY: Caratzas Bros. 1993), fig. 186.

somewhat wavy but close-cropped, and his facial features are distinctive. In comparison with his three peers he seems quite serious.

DOMESTIC IMAGES: GENRE SCENES AND DECORATIVE WORKS

Of course, most extant paintings and sculptures of children of domestic provenance are probably not portraits. Some representations of children come from what Maiuri dubs genre scenes, scenes depicting activity in the palaestra, theater or home or which have as their subject erotic activity (p. 105). The genre scenes in which children appear, like many children's sarcophagi, depict scenes

of the daily life of children. Other representations of children from the domestic sphere function entirely as decorative elements. These come most often from gardens and fountains but are found in other areas of the home as well. The function of these decorative children is akin to that of putti, to which they bear a close resemblance.

The main third-style triclinium of the Villa Imperiale contains two small domestic or genre scenes that depict children's activities in the home.[26] Located high on the wall of the triclinium, they are enclosed by painted shutters on either side in the form of *pinakes*. The first shows a music lesson in which a young student stands between two adults. Maiuri identifies the adult on the left, who holds a lyre and wears the long robe typical of a pedagogue, as the personification of music, and the adult on the right, a tall woman in a *himation*, as the personification of singing (p. 107). The child, wreathed, watches the lyre player earnestly. The second scene depicts a female child with an instructor who holds a scroll. The instructor has bare feet but wears a white robe and wreath. A woman, probably the child's mother, sits to the right of the child; she observes the scene from a chair, her feet resting on a stool. This scene may show the instruction of a child actor since the child holds a *pedum* and comic mask. Because neither of these children appears to have individualized physical characteristics, these are probably not portrait paintings but stock or genre scenes into which any child might fit and with which any child might identify.[27]

The variously explained paintings[28] from the great triclinium in the Villa of the Mysteries contain a slightly different scene of education. The panel from the north wall depicts a nearly life-size boy holding an open scroll. He stands next to an adult woman, perhaps his mother, who points to lines on the papyrus with a stylus. The two are surrounded by a number of figures who seem either to perform domestic activities or to prepare for some sort of religious ritual. Maiuri describes the scene thus: "A richly-clad woman is standing erect and motionless on the threshold of the room, listening with the devout attention and reverent awe that befit a neophyte to the reading of a liturgy, which is being recited by a young naked boy in a quavering voice under the direction of a seated matron" (p. 58). How Maiuri knows the boy's voice is quavering is itself a mystery; however, the nudity of the boy is strange, suggesting that something more than a simple reading lesson is going on here. Moreover, the boy's nudity must be seen within the context of the nudity of other figures in the frieze, most notably the women

72. Portrait Head of a Boy, Villa of Poppaea at Oplontis, first century A.D. Photo: From W. Jashemski, *The Gardens of Pompeii* II (New Rochelle, NY: Caratzas Bros. 1993), fig. 342.

in the corner opposite the child, one of whom dances and one of whom appears to receive a ritual beating.[29] No matter what the interpretation of the cycle of paintings as a whole, the child shown within this particular context is certainly receiving some sort of instruction, perhaps relating to a particular religious ritual. While Maiuri believes that most of the women in the Mysteries cycle are true portraits, he says nothing of the status of the child.[30]

A painting of what appears to be a child officiant from the Temple of Isis at Pompeii, now in the Museo Nazionale, provides a unique example that I can only categorize as a genre painting.[31] The child, usually identified as boy priest, appears on red ground wearing sandals and long, white, fringed robes. She or he strides to the right, holding a white bag or purse in his or her right hand. The only visual clue as to the gender of this figure is the short hair, which may indicate a male figure.

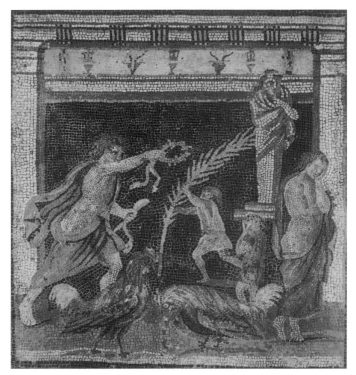

73. Cockfight Mosaic, House of the Labyrinth, first century A.D. Photo: From *P & M* V, p. 45, fig. 74.

With the possible exception of the child from the Villa of the Mysteries, it seems unlikely that any of the children depicted in these scenes was meant to represent a specific child as a portrait. None exhibits distinctive physical features, and no inscriptions identify them in any way. Rather, these paintings probably represent typical scenes of child life and education in Campania. This does not mean, however, that the children depicted in genre scenes cannot stand for child members of the households in which they appear. In fact, it seems likely that children in the household would identify with such paintings, assuming they portray accurately aspects of child life. In addition, the continuity of subject matter among the three triclinia paintings is striking. All portray a child receiving instruction in a domestic setting, and two out of three include a woman who could be the child's mother. In addition, the settings of all three conform generally to the rooms in which they were found, perhaps indicating that triclinia could serve as domestic classrooms.

A mosaic from room 44 of the House of the Labyrinth is related to genre paintings in both location and subject matter (Fig. 73). Variously identified

74. Fountain Figure, House of L. Caecilius Capella, first century A.D. Photo: From W. Jashemski, *The Gardens of Pompeii* II (New Rochelle, NY: Caratzas Bros. 1993), fig. 223.

by scholars–Strocka (1984, 48) calls it a *Nebentriclinium* – the function of room 44 remains "obscure" (Richardson 1988, 165). What is clear is that the room functioned as part of an entertainment complex, as evidenced by its proximity both to room 43, the Corinthian *oecus*, and room 39, the triclinium, and by scholars' instinct that it somehow functioned together with the triclinium. The mosaic itself depicts a cockfight. The child whose rooster is victorious dances in the background as he receives the crown and laurel branch, while the young owner of the defeated rooster, bleeding in the foreground, hides his face in his hands.[32] Again, although it is unlikely that the children shown in the mosaic are portrait types, they may stand for children in the household,

and the mosaic may have been placed in the room in part for the entertainment of the children. Might room 44 have served as the equivalent of the modern "children's table"?

In addition to these scenes of daily life Pompeii and its environs have yielded countless decorative works of art with children as their subjects. A fountain figure of a nude boy with dolphin is preserved from the House of L. Caecilius Capella (Fig. 74), and a similar figure of a boy with rabbit comes from the north niche of the garden in the House of Camillus.[33] Dwyer claims that the boy is striking the rabbit with a plectrum, but it is difficult to discern his intent from the plate Dwyer provides. A variation on these standard figures is the so-called sleeping fisherboy preserved from the House of the Small Fountain.[34] This figure originally seems to have been part of a fountain. The fisherboy wears a short tunic and a traveler's hood, and his lower half is nude. He sleeps on the ground, resting his head on a fishing basket as a mouse peers into his basket of provisions. As Warsher notes, he is like a Hellenistic caricature with overly round, rather exaggerated features. Finally, the House of Sextus Pompeius Axiochus preserved a terracotta statuette of a boy in a garden niche.[35] The niche is one of a group of six located high on the rear wall of the garden, and fragments of similar statuettes have been found in the other niches. As Jashemski notes, it has been suggested that each niche contained a similar terracotta, as in the House of Julia Felix (1993, 148).[36]

CONCLUSION

In light of the context in which this brief treatment of nonofficial child images is presented, the most important conclusion to be drawn is perhaps also the most obvious. In both form and function, images of children from the private and domestic spheres are very different from images of children from official imperial art. This conclusion may not be radical, but it is neither insignificant nor hackneyed. Whereas official images employ children as symbols of the future and ask individual or small groups of children to stand for their ethnic groups or geographic regions, images of children from the private and domestic spheres more often represent or speak to specific children. They commemorate the deaths of individual children, or they function in the home like modern portraits, perhaps marking a child's rites of passage or academic achievements. Although these images rarely take the form of veristic portraits, they do have intimate relationships with the individual children they represent

and therefore cannot be understood as symbolic of a future generation. In this way private and domestic images are quite like literary evidence – they are anecdotal, particular to one child or family, often making it difficult to draw conclusions about children and childhood from them.[37]

This is not to say that child images from the private and domestic spheres cannot be symbolic. On the contrary, in their depiction of scenes of daily life, genre paintings represent all children on some level. In fact, scenes of daily life in which children appear can be said to (re)present children to themselves like mirrors. All children of the appropriate status and age group would have been able to recognize their own experience in genre scenes. Decorative images of children can also be symbolic. Like genre paintings decorative images bear no specific or limited relationship to any particular child – they could be any child and therefore speak to all children about themselves and to all adults about children. This is a very different type of symbolism, however, from that employed by the Roman ruling elite in its official imagery. The symbolism employed in private and domestic art has much more to do with age and station in life than with politics; it arises out of human experience rather than political ideology. Although child images are never free from the politics of power (the distinction between adult and child always informs them), images from the private and domestic spheres have little to say about the difference between ruler and ruled or conqueror and conquered. I would argue that while private and domestic images speak to the viewer about life in general, life that happens to be Roman, official imperial images speak to the viewer about *Roman* life. Perhaps we could say that images from the private and domestic spheres are more descriptive than prescriptive and that for official images the inverse is true.

Audience has turned out to be less important than I had anticipated in distinguishing official and nonofficial imagery. On the surface audience seems of paramount importance – official art is necessarily public, and private and domestic art is just that, private and domestic. Nonofficial art is usually displayed in the home, and it is always funded privately. That private and domestic images were widely viewed, however, is not in doubt. The Roman home was a public place, a place of business for the *paterfamilias* and entertainment for the family, and although certain areas of the home were private and therefore off-limits to visitors, *atria, tablina,* gardens, *triclinia,* and even some bedrooms would have been viewed by those outside the *familia.*[38] Most of our extant domestic images of children come from the *atria, triclinia,* and gardens of luxurious

Pompeian homes, and funerary monuments were open to an even wider audience than domestic imagery. What has turned out to be more important than the *audience* of child images is the *intent* of those who fund and produce them. Private and domestic images are commissioned primarily for consumption by a specific, privileged group and often have specific relevance for a small number of viewers, no matter how many viewers they actually have. These images may have sentimental value and are subject to the whim and aesthetic sensibilities of a relatively small number of people. Official images, in contrast, are commissioned for public consumption by a diverse audience and cannot be divorced from their political function.

NOTES

ONE. INTRODUCTION

1 Elsner (1996), 32.
2 Pliny *Pan.* 26.1.
3 See Eley and Suny (1996, 42–55). The essay, "Qu'est ce qu'une nation?" (1882), was translated from the original French by Martin Thom in 1990.
4 According to Anderson (1991, 205), "Nations, however, have no clearly identifiable births. . . . Because there is no Originator, the nation's biography cannot be written evangelically, 'down-time,' through a long procreative chain of begettings. The only alternative is to fashion it 'up-time' – towards Peking Man, Java Man, King Arthur, wherever the lamp of archaeology casts its fitful gleam. This fashioning, however, is marked by deaths, which, in a curious inversion of conventional genealogy, start from an ordinary present."
5 Hingley (1996) is arguing primarily from the evidence of Roman Britain, but his logic could be applied to any province.
6 Here Žižek is using Lacanian terminology ("real," "enjoyment").
7 Of his own study Woolf says, "I am very conscious of the paths not trodden: there is little here on art and architecture, less on numismatics, and nothing on gender" (1998, x).
8 See Braund (1984, 9).
9 *Quorum oratio fuit regem educendum filium Romam misisse ut iam inde a puero adsuesceret moribus Romanis hominibusque, petere ut eum non sub hospitum modo privatorum custodia sed publicae etiam curae ac velut tutelae vellent esse* [xlii.19]. I must give credit here to Braund (1984) for putting this passage in the context of his volume on client kingship.
10 *An eandem Romanis in bello virtutem quam in pace lasciviam adesse creditis? Nostris illi dissensionibus ac discordiis clari vitia hostium in gloriam exercitus sui vertunt; quem contractum ex diversissimis gentibus ut secundae res tenent, ita adversae dissolvent: nisi si Gallos et Germanos et (pudet dictu) Britannorum plerosque, licet dominationi alienae sanguinem commodent, diutius tamen hostes quam servos, fide et adfectu teneri putatis. Metus ac terror sunt infirma vincla caritatis; quae ubi removeris, qui timere disierint, odisse incipient* [Agricola 32].
11 *In ipsa hostium acie inveniemus nostras manus. adgnoscent Britanni suam causam, recordabuntur Galli priorem libertatem: deserent illos ceteri Germani, tam quam nuper Usipi reliquerunt* [Agricola 32].

12 *Agricola* 33.

13 *Igitur ut Batavi miscere ictus, ferire umbonibus, ora foedere, et stratis qui in aequo adstiterant, erigere in colles aciem coepere, ceterae cohortes aemulatione et impetu conisae proximus quosque caedere* [*Agricola* 36].

14 *Ceterum ubi compositos firmis ordinibus sequi rursus videre, in fugam versi, non agminibus, ut prius, nec alius alium respectantes rari et vitabundi in vicem longinqua atque avia petiere* [*Agricola* 37].

15 Tacitus records that as early as the reign of Augustus, *mari Oceano aut amnibus longinquis saeptum imperium; legiones, provincias, classis, cuncta inter se conexa* [Tac. *Ann.* 1.9]. The Roman Empire is here presented as a "whole."

16 I must admit that Oliver and Lintott both call into question the legitimacy of Aristides' assessments. Oliver (1953, 892) takes a literary approach, acknowledging the generic conventions of Roman oration, the primary goal of which is not the truth. He warns that it is an orator's tendency to indulge in exaggeration and "to reflect his past reading rather than contemporary reality." Lintott (1993, 187) denies the claim of Aelius Aristides on political grounds, identifying the Roman Empire as a "conglomerate rather than a unified society." Although the views of Aristides cannot be proved unbiased, truthful, or correct, there is no doubt that they were conceivable to the author as he wrote, and this is the fact that is most crucial to the argument here.

TWO. PRIMARY SOURCES

1 I include a few monuments from the provinces, such as the Arch of Septimius Severus at Lepcis Magna, as well as coins, the circulation of which necessarily went beyond Rome itself. I also include reliefs from the Arch of Constantine and the Ludovisi Sarcophagus for purposes of comparison.

2 There are similar studies on the Greek family. See Lacey's (1968) comprehensive examination of the Greek family and Golden's (1990) study of Athenian childhoood.

3 In his letters Cicero refers to his children and those of others, but his references are almost always of a personal nature. For example, Cicero's letters to Atticus often include references to the education of his own children. In an early letter, Cicero urges Atticus to send to him the freedman M. Pomponius Dionysius so that he might teach Cicero and his son: *ut possit Ciceronem meum atque etiam me ipsum erudire* [Cic. *Att.* 4.15]. Later, Cicero tells us that Dionysius is, in fact, instructing at least two children in his household: *Dionysius mihi quidem in amoribus est; pueri autem aiunt eum furenter irasci; sed homo nec doctior nec sanctior fieri potest nec tui meique amantior* [Cic. *Att.* 6.1]. Similarly, in a letter to Fronto, Marcus Aurelius says of his daughter, *parvolam nuntio nostram melius valere et intra cubiculum discurrere* [Fronto, *DeFerAls.* 4]. In a letter to his son-in-law, Aufidius Victorinus, Fronto describes his grandson, also named Fronto: *Fronto iste nullum verbum prius neque frequentius congarrit quam hoc DA* [Fronto, *Ad Amicos* 1.12].

4 Huskinson (1996, 1) notes that "suprisingly little use has been made of visual material as a source of primary evidence." She criticizes two leading scholars of family history, Ariès (1960) and Néraudau (1984), among others, for their "poor selection of illustrations and superficial readings of iconography" and their "limited use of evidence from art," respectively (p. 1, n. 3).

5 For example, in describing the Arco di Portogallo reliefs, Kleiner (1992, 254) writes, "the presence of the child is of considerable interest since, as we have seen, children do not appear frequently in state relief sculpture." Wiedemann (1989, 25, 27) claims that children were "only partially [members] of citizen society" and that children were incapable of participating in the rational world of the adult male citizen. Wiedemann's dismissive approach stems from the legal status of children in the Roman world and their necessarily limited intellectual or philosophical sophistication; the implications of his assessments for the practical world, however, are contradicted by the overwhelming presence of children in the public art of the Roman Empire.

6 For additional collections of child images from Greek art, see Rühfel's studies (1984).

7 Currie (1996, 154) suggests that this "gift-giving" may have served as a rite of passage for children.

8 Two children also appear in the frieze from the Temple of Apollo at Bassae, now in the British Museum. They cling to their mothers as the violent battle goes on around them.

9 See Stewart (1990, vol. I 150–60; vol. II 342–3).

10 I return to the problem of children and gender later.

11 See Pollitt (1986, 128).

12 Currie (1996, 154) notes that "the discovery of the child's body as an aesthetic object . . . is usually attributed to Hellenistic art." Golden (1997, 176), however, questions the generally accepted assertion that the Hellenistic period was marked by a "change in the representation of children and childhood." He problematizes the idea that "the Hellenistic poets were the first to put children at the centre stage, as they actually are and for their own sakes . . . and the art of that period swims with true depictions of real children." Like Currie, he points to Attic *choes*, on which children were often depicted, and early so-called Hellenistic portrait types that actually belong to the mid–fourth century to demonstrate that the shift in attitudes often attributed to the Hellenistic age was not so striking. Golden also uses literary evidence from Homer, Herodotus, Thucydides, Xenophon, and Polybius to demonstrate that the use of children in literature did not change during the Hellenistic period. Although his study does succeed in pointing out the tendency of modern scholars to construct a narrative of change for each historical period and to draw conclusions without allowing for genre, it is not thorough enough to disprove art historians who have made a comprehensive study of the art of the period.

13 Although I agree with Currie's basic observations, I feel that her conclusions concerning the "process of Empire," or imperialism, apply primarily to representations of non-Roman children, who often stand for their province or ethnic group, illustrating its subservient relationship with the Roman Empire.

14 See Bolkstein (1939, 364) and Hands (1968, 104, n.122); for further details, see Chapter 3.

15 Ferris (1994, 1996) has published two articles and one book (*Enemies of Rome*, 2000) on images of barbarians in Greek and Roman art, but he does not focus on children, specifically.

16 Even republican art is recognized to have promoted political ideologies. Holliday (1997) and Gruen (1992) both hold that it was a well-established Roman tradition to use art to "promote Roman values" (Holliday, 145) and to advertise the achievements

of both state and individual. Of Roman paintings, in particular, Holliday says, "The Roman governing class commissioned historical paintings to inform a specifically Roman audience of its achievements, to educate that audience to adopt its views and follow a particular course of action. It used historical paintings to implement ideology" (ibid., 130).

17 See Ellul (1973, 71–86).

18 Hor. *Ars Poet.* 180–2: *segnius irritant animos demissa per aurem, quam quae sunt oculis subiecta fidelibus et quae ipse sibit tradit spectator.*

19 *Res Gestae* 12.

20 *CIL* 6.960.

21 At the very least such monuments would have required imperial approval. Rose (1997, 9) points out that all dedicators of imperial family groups had to secure the approval of the emperor before setting up those groups. Thus, even monuments dedicated by individual citizens in honor of the emperor or his family had to obtain imperial approval. Rose cites Millar (1967), Chatsworth (1939), and Oliver (1989).

22 See Hill (1989), 7.

23 Gregory provides here a supplement to Zanker's definition of visual imagery, claiming that Zanker "pays insufficient attention to the ways in which [this new visual] language could be 'communicated' to its audience" (1994, 81). On propaganda, see also Evans (1992).

24 According to Gregory (1994, 88–9), sociologists have identified two basic components of an individual's "orientation toward a symbol": the affective and the cognitive. The affective component indicates the "direction and intensity of a person's feelings toward an object." The cognitive component refers to the "meaning associated by that person with an object, drawing on previous knowledge about the object and what it represents." Gregory here follows Elder and Cobb (1983).

25 While the bulk of the images in my corpus come from official art, I include a few images from genres traditionally considered private. Such images contain themes, motifs, or stock elements consistent with those found in official imagery.

26 Emphasis is mine.

27 Cf. Gregory (1994, 85).

28 See Eyben (1981, 328–50), Huskinson (1996, 87–94), Plecket (1979, 173–92), and Wiedemann (1989, 5–48), for further discussion.

29 See Pleket (1979, 173–92) and Eyben (1981, 328).

30 See Eyben (1981, 328).

31 Eyben here cites the *Lex Plaetoria* and the *Lex Villia annalis*.

32 This is also true under Roman law.

33 See also Solon, fragment 27.

34 See Aristotle *Politics* vii.xv.

35 See Gardner and Wiedemann (1991, 107). Rawson (1991, 12) holds that this ceremony (*tollere*) took place "soon after birth" and did not necessarily indicate paternity but rather a willingness to raise the child.

36 Macrobius, *Saturnalia* 1.16.36. See also Wiedemann (1989, 17).

37 See Manson (1983, 149). There is no literary evidence for the beginning of education as a rite of passage per se. For more on the education of children, see Plutarch, *Cato the Elder* 20, 4–7, Symmachus, *Letters* 3, 20, Cicero, *Att.* 4.15,19, 6.1, Quintilian, *Inst.*

38 Pliny *NH*, 7.73. For more on estimating the age of children, see Hennig et al. (1877).

39 Varro reports that Scaevola (consul 95 B.C.) tells us that girls did not use their *praenomen* before they were married, and boys did not use it before they assumed the toga virilis (*Auctor de praenominibus*, para. 3.6 = Funaioli, *Grammaticae Romanae Fragmenta*, Leipzig (1907, 331). See Gardner and Wiedemann (1989, 109).

40 See Eyben (1981, 340).

41 Although betrothal could occur well before puberty, Paul indicates that most Roman girls did not marry before the age of twelve [*Opinions* 2.19.1]. See Gardner and Wiedemann (1991, 109).

42 Gaius, *Inst.* 1.144–5. For more information on Roman marriage and the guardianship of women, see Evans (1992, 7–49).

43 Female children, however, sometimes wear the toga, but women do not.

44 See Kleiner and Matheson (1996, cat. 75); see also Michaelis (1882), and Poulsen (1923).

45 See Ryberg (1955) and Wiedemann (1989).

46 See Wiedemann (1989, 32–3).

47 For definitions of the *famlia, domus,* and *patria potestas,* see Saller (1994, 74–132).

48 Wiedemann (1989, 32–3).

49 Cf. Bonfante Warren (1973, 584–614).

50 Wilson (1938, 131).

51 Macrob., *Sat.,* I.vi, 13, 14.

52 Wilson (1938, 132).

53 Bonfante Warren (1973, 605).

54 Bonfante Warren (1973, 605).

55 On Roman costumes, see Sebesta and Bonfante (1994), Bonfante Warren (1973), and Wilson (1938). Although it is believed that boys did not assume the toga until they reached puberty and that girls did not wear the toga at all, both male and female children are shown wearing the toga, indicating that they are Roman. While this may indicate that young children actually wore the toga, it may also be used in art as a shorthand symbol of their status. As a general rule, the costumes of Roman children followed those of Roman adults of the same gender Wilson (1938, 137).

56 It is important to note here the difference between the non-Roman child and the diminutive non-Roman adult. In accordance with the hierarchy of scale, diminutive non-Roman adults occasionally appear as symbols of a conquered territory, often under the foot of the emperor. I use the physical attributes outlined in the first section of this chapter to differentiate these figures from non-Roman children.

57 Sherwin-White (1939) holds that there is an "intangible sentiment" that the "peregrine provincial" was as much "Roman" as were the *cives Romani* living at Rome (p. 168). I, however, am not concerned with intangibles. In art, the primary indicators of status (costume, hairstyle, posture) are tangible. Sherwin-White does admit that the extension of "civic rights" to a "purely native community" was rare, at least during the early empire (p. 170). He also notes that in the third and fourth centuries, the term *Romanus* could apply both to a "provincial subject of Rome" and to "a foundation member of the Roman state" (p. 282). At this time, he says, the word *Romanus* was used to differentiate these people from "barbarian invaders" (p. 283). Again, I must rely primarily on costume in my identifications, despite possible discrepancies in

legal status. This seems the best default position to hold, because to argue that children in non-Roman costumes are actually Roman children dressed up as non-Romans is counterintuitive and a position that must be defended thoroughly and convincingly against all visual evidence to the contrary.

58 Because by law a person had to be thirty years of age before he or she could be formally manumitted, I cannot include freedpersons in my study. See Weaver (1991, 170). Manumission could take place at an earlier age only on the basis of a blood relationship. See also Gaius *Inst.* 1.16–19.

59 Bonfante Warren (1973) holds that Roman dress was used to distinguish age and gender, but only after a minimum age had been reached. Most children of both genders wore the tunic. Female children could wear the toga, but female adults did not. According to Wilson, male children of "noble" (patrician) families wore the *toga praetexta*, a toga with a purple border woven into the garment, but male adults wore the *toga pura*, a completely white garment (1938, 130). We may assume that children assumed adult costume after puberty, although neither Bonfante Warren nor Wilson finds evidence for a specific age at which the transition was made. Wilson holds that male children gave up their *bullae* at age sixteen, when they still would have been wearing the *toga praetexta* (1938, 132). According to Bonfante Warren, Romans had a variety of different mantles from which to chose, and they always wore a tunic and *calcei*, the generic term for "high, closed shoes" (1973, 585–6).

60 Bonfante Warren notes that the children of freedmen sometimes wore the leather *bulla* (1973, 605), although the material of the *bulla* is impossible to distinguish in sculpture.

61 Toynbee (1953, 84n.5) refers to Virgil, *Aen.* V.559, which contains the description of a Trojan youth wearing a *flexilis obtorti per collum circulus auri . . . pectore summo.*

62 Toynbee's assertion is based on the children on the Ara Pacis whom I (and others) identify as non-Roman. Thus, the fact that they wear torques does not support the argument that Roman children wore collars similar to torques.

63 The two categories, of course, are not mutually exclusive. Nonmythological children cannot always be distinguished from the mythological. Consequently, I address few "liminal" children in my study. Representations of mythological children can establish conventions of gesture or composition useful for examining nonmythological children. If we assume that some Roman conventions for depicting children have their roots in Hellenistic art, even representations of nonmythological children could be related to Hellenistic putti. Costume and artistic context are helpful in determining whether a child is mythological, but they are not always conclusive. In addition, when the identification of a child is problematic, it is impossible to know what conclusion a Roman viewer would have drawn. In fact, I feel that if a child's status seems impossible to determine, it might have been intended as indeterminate. The distinction between mythological and nonmythological might not have been important in every artistic context. Would a Roman viewer have made a distinction between a putto without wings and a nude, wingless child? A viewer's response to a work of art exists on many levels. Thus, categories "mythological" and "nonmythological" can interact, influencing one another and their audiences. While I generally limit the study to nonmythological children due to constraints of time and space, at times I must address mythological or liminal children.

64 See *P&M* III (1991, 814, Fig. 41).

65 A similar phenomenon can occur in depictions of non-Romans. Occasionally, a diminutive conquered non-Roman adult or youth will be depicted beneath or near the feet of a cuirassed Roman general/emperor, as in the portrait of Hadrian from Hierapytna. See Kleiner, Fig. 205. There is a similar pair in the Olympia Museum. See Vermeule (1959, Fig. 51). Because scholars disagree over the ages of many such diminutive figures, I exclude them from this study.

66 For more on *camilli/ae*, particularly illustrations of these forty scenes, see Ryberg (1955, 1967).

THREE. IMPERIAL LARGESSE

1 Although Roman children are represented in numerous freestanding portraits, it is nearly impossible to identify such portraits as official. The provenance and original context of these portraits are often unknown, and the individual identities of the children depicted can rarely be determined. Only when multiple portraits of a child survive can a portrait-type for that child be identified, and this is true primarily for portraits of imperial children, whom I do not address here. Similarly, although Roman children are also depicted in scenes of private religious experience and are occasionally immortalized in votive portraits found in sanctuaries, I do not consider these scenes official because of the types of spaces in which they were displayed and the fact that most were commissioned privately.

2 For further detail on the status implications of the *sella curulis* in particular, see Alfoldi (1935, 22–3) and Salomnson (1956, 75–7).

3 See, for example, scene XLIXa from the Column of Marcus Aurelius in which a non-Roman (also submissive) holds out his cloak, about to receive a distribution from the emperor. See Brilliant (1963, Fig. 3.113).

4 Kleiner (1992, 452) makes a similar observation in passing in her discussion of the Arch of Constantine. She compares the so-called *alimenta* relief from the Arch of Trajan with the *congiarium* relief from the Arch of Constantine and concludes that "there was . . . apparently a tradition for including such a theme [children] in scenes celebrating the emperor's distribution of money to the citizenry."

5 See *Res Gestae* 15. Hamberg holds that the term *congiarium* comes from *congius*, "a measure for liquids such as oil or wine" (1945, 33).

6 Pliny, *Pan.* 25–7.

7 Livy 25.2: *congii olei in vicos singulos dati quinquageni.*

8 Cassius Dio 41.16–17 (no specific mention of children).

9 Imperial donatives seem not to have been predicated on the financial need of recipients, as will be discussed later. In some scenes of imperial largesse togate Romans from the senatorial and equestrian orders as well as tunic-clad plebeians receive the distribution.

10 See van Berchem (1939), Hands (1968), and Kloft (1970).

11 A number of the legends to which I refer appear in the exergue.

12 Among the motifs, or scene-types, that scholars such as Brilliant, Hamberg, and Koeppel have enumerated in their examinations of Roman historical reliefs and coinage are the *congiarium*, the *alimenta*, the *liberalitas*, and the *adlocutio*, all named

primarily for the legends of the coins on which such scenes are found. These names have been applied to many scenes of public gathering in which Roman children appear. See Brilliant (1963, 76, 106–8, 133, 165–73, 203).

13 *BMC* I, 138; see Brilliant (1963), Hamberg (1945), and Sydenham (1920).

14 *BMC* 139, 140

15 See van Berchem (1939, 166–76), Hamberg (1945, 34–40). A similar device appears in the hands of the attendants of Constantine in the so-called *congiarium* panel from the Arch of Constantine (Fig. 14). On the panel of Constantine, see Kleiner (1992, 452).

16 *BMC* 87; *RIC* 56, 57.

17 Trajanic *congiarium* coins are nearly identical to those of Nerva and Nero discussed here, but Trajan usually appears in the upper right of the flan, and children are not present in his *congiarium* types. See Brilliant (1963, 108).

18 It has also been suggested, however, that the *alimenta* was initially intended to provide low interest loans to Italian landowners because the funds from which children were supported came from interest payments from landowners to the imperial *fiscus*. See Duncan-Jones (1964, 124).

19 *RIC* 93, 230; *BMC* III, 378, 379; see Belloni (1973), Brilliant (1963), Hammond (1953), and Strack I.

20 Brilliant (1963, 107) identifies Trajan's hand as "generously enlarged." Trajan's right hand is also shown enlarged in scene L from the Column of Trajan. In this case, the enlarged hand probably signals not largesse but *imperium*. See Brilliant (1963, 121–3 and Fig. 3.43).

21 See Kuttner (1995, pl. 41) and Mattingly and Sydenham (1926), respectively.

22 *RIC* 461; *BMC* III, 870–73; see Belloni (1973), Brilliant (1963), Hammond (1953), Kuttner (1995), and Strack I.

23 See Kuttner (1995, pl. 41).

24 *RIC* 243, 459–60, 604–6; *BMC* III, 404; see Belloni (1973), Brilliant (1963), Foss (1990, 103), Kuttner (1995), and Strack I.

25 *RIC* 105, 470–4.

26 See Strack I, 190.

27 *RIC* 156, 485.

28 Although the child is difficult to make out, the position of Roma's right hand confirms the identification. Galba produces similar restoration motifs without children. See Brilliant (1963, Fig. 2.84–5); *BMC* I, 258; and *RIC* I, 153. These show a similar figure of Libertas kneeling with left hand meeting the right hand of Galba and right hand at his knees. Compare the position of the goddesses' right hands in the images. Of *RIC* 156, in particular, Mattingly and Sydenham (1926) note that Cohen's readings are mistaken. See also Bernhart (1926, pl. 83.13).

29 *RIC* 92; see also Foss (1990, 96).

30 The *liberalitas* motif decreased in popularity during the third century. According to Brilliant, the *largitio* motif and legend replaced the *liberalitas* motif as a "generalized, unspecific offering" during the third century and continued into the fourth century. See Brilliant (1963, 170). I, however, include *largitio* under the general heading *congiarium-liberalitas*.

31 See Strack II, 59.

32 For example, see Brilliant (1963), figs. 3.68 (*BMC* III, 1136), 3.69 (*BMC* III, 1315), 3.114 (*BMC* IV, 216–19, 542–8, 1688–97).

33 *BMC* III, 1160–2; in 1162, the woman places her left foot on Hadrian's platform; see Brilliant (1963), Hammond (1953), and Strack II.

34 In defense of his theory, Strack (II, 60) quotes Pliny's *Panegyricus* 27, in which Pliny writes, *magnum quidem est educandi incitamentum tollere liberos in spem alimentorum, in spem congiariorum, maius tamen in spem libertatis, in spem securitatis.*

35 In fact, an inscription on a marble statue base from Tarracina that bears what appears to be an *alimenta* relief commemorates Trajan's *providentia*, or forethought. See Rawson (2001, 31) and Woolf (1990, 224).

36 As a result, Foss (1990, 75) speculates that the *ROMA RESTI*(tuta) coin commemorated Galba's establishment of a charity for children, but this need not be the case.

37 See Andreae (1977) and (1979), Brilliant (1963), Currie (1996), Hamberg (1945), Kleiner (1992), and Torelli (1997).

38 See Kleiner (1992, 224).

39 Brilliant has shown that in Greek art, the hand-on-head gesture is benign. See Brilliant (1963, Fig. 1.14).

40 See Bonfante Warren (1973, 610), who holds that the *paenula* was worn especially by the army but also for traveling. L&F identify the *paenula* as a traveling-cloak in particular, fastened with a brooch at the front and a hood behind.

41 See Torelli (1997, 145–78), and Kleiner (1992, 224–7).

42 Moreover, it is unclear whether Trajan instituted such a program at all. The few authors who mention an alimentary program not only are late but disagree as to its founder. Whereas the fourth-century *Historia Augusta* and Cassius Dio, who writes during the Severan period, first mention the *alimenta* in their accounts of Trajan's reign [HA *Had.* 7.8, *Pert.* 9.3; Cassius Dio 68.5.4], one of our few surviving literary references to the *alimenta* claims that Nerva implemented a program to provide financial assistance to children of impoverished (*egestosis*) parents in the towns of Italy [Pseudo-Aurelius Victor, *Epitome de Caesaribus* 12.4]. This account is the only one to attribute the founding of the *alimenta* to Nerva. With the exception of Trajanic coinage, our best evidence for the *alimenta* is epigraphic; however, although there are nearly one hundred inscriptions extant from forty-two towns throughout Italy that mention a *quaestor alimentarum* and document the children who received largesse and the sums of money they received, these inscriptions provide neither dates nor any other relevant information See Duncan-Jones (1964, 126) and *CIL* 4.1492, 9.1455, and 11.1147.

43 Woolf (1990, 227) points out that although we cannot know how recipients of the *alimenta* were chosen, all evidence suggests that they were "eligible by virtue of their privileged status, either as citizens and inhabitants of a privileged area – Italy – or . . . as members of a more elevated group within the Italian communities," rather than on the basis of their financial need. He bases his argument on comparisons with private alimentary schemes and on the epigraphic record.

44 In her interpretation of a relief from the Arco di Portogallo, Kleiner (1992, 254) identifies that panel as an *alimenta* scene, stating that "the young boy . . . must stand for impoverished Roman children who were the recipients of Hadrian's largesse." In his volume on Trajan, Bennett (1997, 81) claims that the *alimenta* was a "scheme

whereby private individuals and public corporations could assist poor families in bringing up their children."

45 Moreover, although the proximity of the emperor to recipients on *alimenta* coins may be an artistic innovation essential to the *alimenta* motif, it may also be the simple result of Trajan's and Hadrian's desire to be seen as accessible to the Roman people, a desire consistent with the ideology presented to the public by both emperors. Bennett (1997, 65) says that Trajan was a provincial, a man who conformed to the "plebeian concept of integrity . . . rustic simplicity, and valour." See Pliny, *Pan*. 49.5 and 82.9. Trajan presented himself as *primus inter pares* and was said by Pliny to rule by example, as one of the people [Pliny, *Pan*. 23–4]. Pliny also praised the new freedom to speak freely, even in criticism of the emperor, which Trajan restored to the Roman people after Domitian had taken it away. See Bennett (1997, 53 especially).

Hadrian took a similarly personal approach to governing the empire, and Boatwright (1987, 29) suggests that one of the motivations for Hadrian's work in the capital was emulation of Trajan. She holds that "Hadrian was directly and personally interested in the workings and welfare of the city of Rome" (p. 19). Moreover, Hadrian's biography claims that he had a great love for the plebs [*HA, Hadr*. 17.8: *fuit et plebis iactantissimus amator*], an attestation supported by his building programs, which provided work for many, and by his preservation of Rome's land for housing. See Boatwright (1987, especially 24). Hadrian was also particularly visible and accessible to the Roman people, and his biography reports that he often went into public, even bathing at public baths [*HA, Hadr*. 17.5]. Thus, the proximity of the emperors Trajan and Hadrian to the recipients of largesse in *alimenta* scenes on coins and monuments may simply be the result of the type of the public image they chose to present, rather than an aspect of the new *alimenta* motif.

In addition, the new proximity of the emperor to the people during the reigns of Trajan and Hadrian may simply indicate a change in the *congiarium-liberalitas* motif, the general motif of giving. Artistic motifs are dynamic; they change over time. The primary distinction of the *congiarium-liberalitas* motif from the *alimenta* motif is the proximity of the emperor to the recipients of the donative. Although the Hadrianic *LIBERTAS* coin provides something of an exception to the rule in that Hadrian sits on a high platform, he still distributes the donation himself. In *congiarium-liberalitas* scenes such as the first *congiarium* type of Nero, discussed earlier, the emperor is removed from the Roman citizens. In addition, he makes the distribution indirectly, through a Roman magistrate. The recipients must climb a ladder to receive the donative. In the later *alimenta* motif shown on coins, the emperor sits or stands alone. He makes the distribution personally, and he is often shown on the same level as the recipients. What appears to be a new and intentional development may simply be a change to the *congiarium-liberalitas* motif that occurred during their principates, and although this change certainly reflects something significant, there is no evidence that it reflects the *alimenta* specifically.

46 In fact, a coin type of Trajan from A.D. 99 commemorates one such donative. With the legend *COS II CONG P R*, the coin shows Trajan, an imperial official, Liberalitas, and a citizen. Children are absent from the scene. See Foss (1990, 99). Similar coins are found throughout the empire. Those minted before the reign of Hadrian use

the *congiarium* legend. Those minted during and after the reign of Hadrian use the *liberalitas* legend.

47 Brilliant (1963, 127–8) holds that Hadrian's presence in the right attic panel of both sides of the Arch of Trajan at Beneventum indicates that the arch may have been completed after Trajan's death. He goes so far as to suggest that Hadrian's appearance on the arch was intended to legitimize his succession.

48 See Hammond (1953), Helbig (1913, 1841–2), and Rawson (1997).

49 See Helbig (1972, 3234) for a detailed description.

50 See Helbig (1972, 3234) and Rawson (1997, 226).

51 See Helbig (1972, 3234) and Hammond (1953, 182), respectively.

52 See Rawson (1997, 226), who considers this likely.

53 See Helbig (1972, 199) and Hammond (1953, 182) [*HA, Pius* 8.1; *HA, Marcus Aurelius* 26.6; *ILS* 6065].

54 *RIC* 397–99, 1149; *BMC* 324–25. Rawson (1997, 225) claims that these scenes participate in the *FELICITAS TEMPORUM* and *FECUNDITAS* motifs common to coins commemorating women from the families of Hadrian and the Antonines.

55 Although Angelicoussis (1984), Hannestad (1988), Kleiner (1992), and Strong (1961) identify the emperor in this relief as Marcus Aurelius, Baharal (1996, 114, Fig. 20) identifies him as Hadrian.

56 See Angelicoussis (1984), Brilliant (1963), Kleiner (1992), Kuttner (1995), Ryberg (1955, 1967).

57 This gesture could also be seen as a sign of scolding, as it is in nineteenth- and twentieth-century Britain and America.

58 Kleiner (1992, 291) calls him a boy.

59 See Strong (1961, 53). Elsner's (2000) recent work on frontality in the Column of Marcus Aurelius can be helpful for understanding representations of the emperor in other contexts. Elsner cites Kleiner, who claims that the presentation of the emperor "as a hierarchically frontal . . . icon documents a major change in the Roman concept of emperorship" (Kleiner, 300).

60 See Angelicoussis (1984, 155). Based in part on evidence of reworking in the upper-right quadrant of the panel, she holds that Commodus sat beside the emperor in his own *sella curulis*. As she notes, Commodus shared two *congiaria* with his father but was later erased from public record. Angelicoussis dates this *congiarium* to A.D. 177. See also Koeppel (1986, 1–90).

61 See Cassius Dio 38.7.3, 43.25.2; Suet. *DJ* 20.3; Appian, *Civil Wars* 2.10. See Hands (1968, 104, n.122) and Bolkestein (1939, 364).

62 Cicero, *Pro Marcello* 23.

63 Livy, *Per.* 59.

64 See *ADA*, 166–98; Suet. *DA* 34; Tac. *Ann.* 3.25; Cassius Dio 54.16.1–2.

65 *Congiaria populo frequenter dedit . . . ac ne minores quidem pueros praeteriit, quamvis non nisi ab undecimo aetatis anno accipere consuesssent* [Suet. *DA* 41].

66 Duncan-Jones (1974, 297).

67 *ILS* 977; see Hands (1968, 184). Duncan-Jones (1974, 297) claims that the imperial *alimenta* were modeled on foundations for the support of children, such as this one, that already existed in Italy.

68 *Adventante congiarii die observare principis egressum in publicum, insidere vias examina infantium futurusque populus solebat. Labor parentibus erat ostentare parvulos impositosque cervicibus adulantia verba blandasque voces edocere* [Pliny, *Pan.* 26].

 Super omnia est tamen quod talis es, ut sub te liberos tollere libeat expediat. Nemo iam parens filio nisi fragilitatis humanae vices horret, nec inter insanabiles morbos principis ira numeratur. Magnum quidem est educandi incitamentum tollere liberos in spem alimentorum, in spem congiariorum; maius tamen in spem libertatis, in spem securitatis [Pliny, *Pan.* 27].

69 Parkin (1992, 117–8) has explored the sources for Augustus' *ius liberorum* to determine whether the right was granted to those with the required number of living children or just the required number of births. He finds that there were some instances in which it was the *"trying"* to have children that was rewarded, rather than the fact of actually having children [see Ulpian, *Epit.* 16.1a]. According to Parkin, other ancient accounts directly contradict one another. Some imply that living children are required to receive financial benefits, and others specifically state that the children do not have to be alive [Paul. *Sent.* 4.9.1, 9; *Dig.* 27.1.2.7, 27.1.2.8, 27.1.36.1, 50.4.3.6, 50.4.3.12].

FOUR. PUBLIC GATHERINGS

1 In depictions of sacrifices, Roman children play one of two distinct roles. First, they may simply observe a sacrifice as members of the audience. Second, Roman children may play an active role in sacrifices. As noted, I do not address *camilli/ae* here.
2 Lehmann-Hartleben (1926, 17) holds that the *adlocutio* coin-type follows a monumental composition. Not every *adlocutio* coin bears the *ADLOCUTIO* legend.
3 See Brilliant (1963, 67) and Aldrete (1999, 3–97).
4 *BMC* I, 33ff, 67–8.
5 *BMC* III, 827; *RIC* 553–5.
6 *BMC* III, 1309–11; *RIC* 639–41.
7 Legends do not identify the coins as *adlocutiones*. Trajan's legend is *SPQR OPTIMO PRINCIPI S C*, whereas Hadrian's is simply *COS III S C*.
8 See Aldrete (1999, 93), Brilliant (1963, 135), and Strack II, 114–7. The temple, along with the Rostra Julia, was centrally located in the Forum Romanum surrounded by the Temple of Castor and Pollux, the round Temple of Vesta, the Regia, and the Basilica Aemilia. For more on Roman topography, see Aicher (2004).
9 See Brilliant (1963, Fig. 2.70), Nero; 3.1, Nerva; 3.34–7, Trajan; and 3.64–5, Hadrian, for further examples of the *adlocutio* motif.
10 *RIC* 695. See also Cohen (1882, 1388–9), the former of which is in the Cabinet de France. The so-called coin may actually be a medallion.
11 See Foss (1990, 116).
12 *RIC* 648–9.
13 An Antonine date has also been proposed, although Kleiner (1992, 253) feels the reliefs are thoroughly Hadrianic. See also Arce (1988) and Boatwright (1987).
14 See Boatwright (1987, 224–35), Brilliant (1963, 132), Helbig (1966, 264ff), Kleiner (1992, 253–4), Strong (1961, 42–3), Stucchi (1949/50). The head of the emperor, in particular, is not original; a plaster cast, taken from another portrait of Hadrian, was added to the relief in 1921. See Kleiner (1992, 253).

15 Kleiner (1992, 253ff).

16 See Kleiner (1992, 309–11).

17 One exception to this rule is a depiction of two children who greet the emperor together on a Trajanic coin with the legend *ALIM ITAL* (Fig. 4), and in this case the emperor stands in for the parent. In scenes of largesse, however, no other child approaches the emperor without a parent or at least a fellow child.

18 There are two exceptions here: the *alimenta* coin of Trajan in which the emperor greets two children (Fig. 4) and the so-called *alimenta* relief from the Arch of Trajan (Fig. 9).

19 Aldrete (1999, 46–9) identifies the scene in question as an *adlocutio*.

20 See Ryberg (1967, Fig. 37Aa).

21 One must also remember that the limited space on a flan necessarily requires the use of artistic shorthand. Artists have more room for freedom and variety of expression in the space of a monumental relief.

22 Boatwright (1987, 234) holds that a relief of Sabina's apotheosis would have been unsuitable for an arch. It (and the *adlocutio* relief) may originally have "embellished an altar, [and] if so, probably it was in the northern reaches of the Campus Martius." Hannestad (1988, 208) identifies the reliefs as part of a sepulchral monument to Sabina. For other apotheoses in Roman art, see the Arch of Titus and the pedestal of the Column of Antoninus Pius, Kleiner (1992, Figs. 157 and 253, respectively).

23 See Kleiner (1992, 254).

24 See Strack II, 114–7.

25 The coin's legend does not illuminate the scene on its reverse, but Brilliant agrees with Strack's analysis of the image. See Brilliant (1963, 135).

26 Polybius 6.53 reports that it was inspirational for young men (*neos*) to attend the funerals of statesmen. Suet. *DA* 100.2 reports that it was suggested that children of both genders sing a dirge at the funeral of Augustus (*canentibus neniam principum liberis utriusque sexus*). In addition, Arce (1988, 35) compares the *funus imperatorum* to the *pompa triumphalis*, in which non-Roman children appeared and which Roman children probably would have watched.

27 On the Column of Trajan see Brilliant (1963), Currie (1996), Hamberg (1945), Hannestad (1988), Kleiner (1992), L&F (1988), Romanelli (1942), Rossi (1972), Settis (1988), Waelkens (1985).

28 In this and following discussions of the Column of Trajan, I follow Cichorius' numbering, as do L&F and Settis.

29 See Currie (1996, 159).

30 See Ryberg (1955, 121).

31 See Sebesta (1994, 48).

32 See Giacosa (1977, pl. XXIII, Marciana; XXIV, Matidia; and XXVII, Sabina).

33 See L&F pl. LXIII.

34 Ryberg (1955, 125) identifies the scene as a departure.

35 See Giacosa (1977, pl. XI, Messalina, and VII, Antonia the Younger). The style may mimic that of Sabina as seen on a sestertius minted at Rome between 117 and 138. See Giacosa (1977, pl. VIII–IX, Agrippina the Elder).

36 Domaszewski and Gauer, respectively; see L&F (1988, 133) for a summary of these arguments.

37 See L&F (1988, 136) for attribution and discussion.

38 See *PECS* (311, 718, 799, 843, 894) for status of cities.

39 Ryberg wisely notes that the effort to identify the towns on the Column of Trajan based on details rendered in the representations is misguided and not justified by the nature of the column itself. Ryberg cites the work of Lehmann-Hartleben, who holds that "the artists of the column were not attempting to depict a factual account of events, and that in the details of the relief they were guided primarily by artistic considerations rather than by factual accuracy." See Ryberg (1955, 122, n.7). See also Hamberg (1945, 105ff).

40 See Ryberg (1955, 122).

41 See L&F, 138.

42 Ryberg (1955, 124) agrees with this assessment, although she identifies the woman in question specifically as a grandmother.

43 Ryberg (1955, 124) holds that scene XCI is composed of Romans and Dacians. L&F (p. 138) identify the non-Romans in this scene as Greek.

44 See Chapter 9 for a discussion of the Ara Pacis frieze, which also includes children in Roman and non-Roman costume. The gestures and postures of the children on the Ara Pacis frieze, however, as well as the dearth of non-Roman adults on that frieze, lead me to draw very different conclusions from those drawn here.

45 Suet. *DA* 31.4.

46 In A.D. 47, 147, and 247. See Lewis and Reinhold II (1990, 519).

47 See Brilliant (1963, 99).

48 *RIC* 376; *BMC* II, 428.

49 *RIC* 379; *BMC* II, 426.

50 See Dennison (1903, 55). In fact, Dennison uses the coin as evidence that the *ludi saeculares* celebrated by Augustus may have included a procession.

51 *CIL* 6.32, 323.

52 See Mommsen (1891, 649).

53 See Dennison (1903, 50).

54 Zosimus *Hist.* 2.5.

55 See Dennison (1903, 53–4); Zosimus *Hist.* (16–22). Bib. nat., no. 7975 (gamma): *Incipit Carmen Saeculare, quod patrimi et matrimi cantarunt in choro puellarum et puerorum ad Apollinem et Dianam.* Porphyrio, ed. Holder, p. 180, 1–6: *Hoc Carmen Saeculare inscribitur. Cum enim Saeculares ludos Augustus celebraret, secundum ritum priscae religionis a virginibus puerisque praetextatis in Capitolio cantatum est.*

56 Livy 27.37; 37.3.

57 Dionysius 7.72; Appian, *Punica* 66.

58 Dennison (1903, 66).

59 Cohen (1882, 398, 325); Ryberg (1955, 148). See also Gnecchi (1912, pl. 46, 1, 2). See also Dressel (1903). Lewis and Reinhold II (1990, 519), however, identify games celebrated by Antoninus Pius as the *ludi saeculares*. The games celebrated by Antoninus Pius in A.D. 147 appear to coincide not with his tenth year in power but rather with the nine hundredth anniversary of Rome's founding, an event documented on numerous coins featuring scenes from Roman foundation myths. See Foss (1990, 128–9) (*RIC* 644, 608, 91, 722, 99, 603). Moreover, it was the *ludi saeculares* that were celebrated by Philip I on the anniversary of Rome's thousandth birthday one hundred years later.

60 Cassius Dio 53.16.

61 See Gnecchi (1912, vol. 2, 12, #30).

62 Ibid.

63 Ibid.

64 See Ryberg (1955, 148).

65 See Ryberg (1955, Fig. 48a).

66 See Ryberg (1955, 99–100); See also Paribeni (1932, 58–9).

67 Juvenal claims that the *pompa* of the *ludi* mimicked the triumphal procession [10.36–46].

68 Three seemingly similar coins contain images of children participating in the cult activities associated with the Vestal Virgins at Rome. A number of coin types from the reign of Caracalla commemorate the restoration of the temple of Vesta in the forum by Julia Domna in A.D. 214. See Foss (1990, 182). One, with the simple legend *VESTA*, includes four Vestals and two children sacrificing before the round Temple of Vesta. See Foss, p. 175. Others, with the legend *P M TR P XVII/I COS IIII P P*, show Caracalla with a group of priests, Vestals, children, and sometimes Julia Domna, sacrificing in front of the round temple. See Foss, p. 182. A similar coin type from A.D. 264, with legend *P M TR P IMP V COS III P P*, shows Postumus sacrificing at an altar with two Vestal Virgins, a citizen, and one child. See Foss, p. 232. Aulus Gellius reports that when girls were selected as Vestals between the ages of six and ten, they were taken immediately to the House of Vesta and handed over to the pontiffs [*Attic Nights* 1.12]. The female children shown on the coins here thus may be young initiates participating in cult activities. Tacitus, however, records that children of both genders participated in sacrifices performed by the Vestal Virgins. In his account of Vespasian's restoration of the Temple of Jupiter Optimus Maximus after the fire of A.D. 69, Tacitus says that Vestal Virgins, assisted by children with both parents living, sprinkled the temple precinct with water from springs and rivers [Tac. *Hist.* 4.53]. Thus, all the male (and perhaps some of the female) children shown on these coins probably perform similar functions. Although these coins are important evidence that Roman children took part in the sacrifices performed by the Vestal Virgins, the children depicted perform functions similar to those of *camilli/ae* and appear in contexts similar to those in which *camilli/ae* appear.

69 Ryberg (1955, 122) calls these arrival scenes, but L&F (1988, 133) identify them (after Cichorius) as departure scenes. The subsequent scenes depict a sacrifice with multiple altars and victims, toward which the procession in LXXXIII–IV may move, but such sacrificial items are absent from the scenes in question. L&F hold that the welcome depicted in the following scene awaits Trajan at his next destination.

70 One woman may be present at the very rear of the group, but it is difficult to confirm her gender because she stands with most of her body obscured; she appears, however, to wear the *stola* of a Roman matron. If this is indeed a woman, she is the only woman in the scene.

71 See Chapter 2.

72 *Caesar, ubi luxit, omnes senators senatorumque liberos, tribunos militum equitesque Romanos ad se produci iubet . . .* [B.Civ. 1.23].

73 *Exceptus est Caesaris adventus ab omnibus municipiis et coloniis incredibili honore atque amore. Tum primum enim veniebat ab illo universae Galliae bello. Nihil relinquebatur quod ad ornatum*

portarum, itinerum, locorum omnium qua Caesar iturus erat excogitari poterat. Cum liberis omnis multitudo obviam procedebat, hostiae omnibus locis immolabantur, tricliniis stratis fora templaque occupabantur, ut vel exspectatissimi triumphi laetitia praecipi posset [B. Gal. 8.51].

74 *Et promptiora quam promiserant inveniunt, obvias tribus, festo cultu senatum, coniugum ac liberorum agmina per sexum et aetatem disposita, exstructos, qua incederet, spectaculorum gradus, quo modo triumphi visuntur* [Ann. 14.13].

75 See n. 26

FIVE. ANAGLYPHA TRAIANI/HADRIANI

1 See Boatwright (1987, 182–3 and following discussion). See also Rüdiger (1972) and Torelli (1982).

2 See Boatwright (1987, 184).

3 Hammond (1953, 163) uses the representation of deified emperors on earlier coins, for example, a sestertius of Tiberius of 22/23, to show that the seated figure in the center group is the deified Trajan. See also Fig. 5.

4 See also Kuttner (1995) and Bartman (1992) on copies or versions of larger or monumental works of art on coins or in other miniature media.

5 See Boatwright (1987, 187) and Henzen (1897). See *BMC* III (184, nn. 870–2) and Hammond (1953, 155–76) for coin types with statuary groups.

6 Koeppel (1982, 514) demonstrates the distinction between what he calls "monumental" or "Grand Style" historical relief and relief from the "epic-documentary tradition," after Hamberg (1945). The compositional structure of epic-documentary relief is often "bird's-eye view," a flatter, less dynamic structure derived from triumphal painting. This does not apply to the Anaglypha Traiani/Hadriani, which is composed in the monumental-Grand Style, giving the impression that the scene takes place in actual space, "not only in the plane of the relief, but also . . . in and out of the background."

7 Aldrete (1999, 95–7) identifies this scene as an *adlocutio*.

8 For Hadrian's extension of the *alimenta* in 118, see *HA, Hadr.* 7.8. For modern arguments, see Bormann (1883), Seston (1927), Hirschfeld (1905), Carter (1910), Carcopino (1921), Hammond (1953), and Kuttner (1995).

9 Hammond (1953, 179) bases his conclusion not on the *adlocutio/alimenta* relief alone but on the *adlocutio/alimenta* panel in conjuction with the debt-burning relief. He feels that "the realism of the style, the coherence of their composition, and the continuity of the background in the historical reliefs demand that the two scenes [*adlocutio/alimenta* and debt-burning] be both actual and related." As he says, the "continuous background [of the *adlocutio/alimenta* panel and the debt-burning panel] suggests that they occurred at the same time." Hammond gives thematic unity to the Anaglypha by suggesting that both historical panels advertise the generosity of Trajanic and Hadrianic imperial policy.

10 The *adlocutio* panel from the Arch of Constantine is composed similarly.

11 See Torelli (1982, 91).

12 Torelli (1982, 90) takes issue with proposed Hadrianic dates on the grounds that *CIL* 6.967 (= *ILS* 309) and the *HA* (*Hadr.* 7) locate the Hadrianic debt-burning in the Forum Traianum, not the Forum Romanum. Furthermore, as he points out, the

location of the fig tree and the statue of Marsyas in the area of the Forum Romanum near the Column of Phocas is based on what he calls a "wrong interpretation" of a passage of Pliny [*N.H.* 15.78].

13 See Kleiner (1992, 224), Boatwright (1987, 187).

14 Kuttner (1995, 45) proposes that, if the relief is Trajanic, the emperor shown with the children is Augustus. Although this theory is intriguing, it does not acknowledge the blatant similarity of the group in question to groups on Trajanic and Hadrianic coinage.

15 Hammond (1953) has noted the similarity among these images.

16 Torelli (1982, 104–5) draws an interesting connection between Marsyas and the fig tree and Roman freedom. Citing a "fictitious connection of Marsyas with the old plebeian god of the Aventine, Liber" [Serv. *Aen.* 3.20; 4.58], Torelli sees Marsyas and the fig tree as "living symbols of *libertas*, the special version of the *libertas* of the Roman plebs, and at the same time a pawn of the *continuitas imperii*. Plebeian freedom meant above all freedom from want – the Marsyas – and the kind of freedom that allowed the reproduction – the fig tree – of the forces of the empire – the *continuitas imperii* – to which also the *alimenta* aimed. . . . But if we turn again to the *ficus Ruminalis* and read another passage of Festus, we understand very well the coupling of the fig tree . . . and the Marsyas statue. Festus, speaking of the *ficus Navia*, says:" [*Quod etiam responso haruspi*]*cum et divin* [*is ostentis confirmabatur, quamdiu ille ficus*] *viveret, libe* [*rtatem populi Romani incolumem man*] *suram* [Festus 286].

17 Brilliant (1963, 108) has also observed the combination of two motifs, the "[i]mperial donation and address," on this relief.

SIX. SUBMISSION

1 See Brilliant (1963, 15, 41).

2 Brilliant's bronze figurine of a non-Roman adult epitomizes the gesture (1963, Fig. 2.62). For additional scenes of adult supplication, see Brilliant (1963, 70–1, Figs. 2.53–57; 156–8, Figs. 1.130–1.133). See also Romanelli (1942, Fig. 80).

3 It has been suggested to me that the seemingly submissive gestures of children are simply naturalistic, because children "naturally" stretch out their hands to adults, asking to be picked up. Regardless of children's natural tendencies, which are themselves a matter of debate, we must remember that there existed a Roman visual language of submission in Roman republican and imperial art in which children's gestures participate. The intention of the children or their parents is not necessarily important if we consider the images within the context of a visual language in which so many similar images existed. All scenes in which the submissive gesture occurs would have conveyed a consistent message to Roman viewers. It is also worthwhile to note here that Roman children seldom perform this gesture, making its identification as naturalistic problematic.

4 See Brilliant (1963, Fig. 1.68).

5 Ibid., Fig. 2.54.

6 See Ostrowski (1990). Personifications of the provinces often show provinces kneeling and shaking hands with the emperor. While the relationship between the

emperor and provinces necessarily requires that provinces submit to the emperor, the relationship is more complex than one of simple submission. A mutual respect and partnership are implied by the handshake. On *dextrarum iunctio*, see also Brilliant (1963, 18–21), Reekmans (1958), and Treggiari (1988, 149–51, 164–5, especially n. 40), and the Appendix of this volume.

The submission is also clearly distinct from the *rex datus* motif, in which the emperor crowns a loyal foreign king not, as Brilliant (1963, 153) puts it, "as a matter of right but as an instance of Roman grace."

7 Aemilius Paulus Lepidus receives the captive Perseus and his sons similarly on a Republican bronze coin. See Brilliant (1963, 40, Fig. 1.67 = BMC Rep., 3373). Perseus' hands are bound, preventing him from making a gesture, and his sons before him do not gesture toward Lepidus; however, a trophy stands between the Macedonians and the Roman, and the non-Romans are "much smaller than the grand figure of their captor who rises, tall and magnificently at ease to dominate the motif."

8 The image appears on an *aureus* (RIC 200) and a *denarius* (RIC 281). See Foss (1990, 53). See also RIC 1984, 55 and BMC I, 492–95 and Brilliant (1963), Giard (1983), Kuttner, (1995), and Rose (1993).

9 It has been suggested that the adult is a personification of Germania. Kuttner (1995, 85) includes in her study an Augustan depiction of Germania, now lost, as a female in male Celtic dress.

10 See Héron de Villefosse (1899), Kuttner (1995), Rose (1993, 1997), and Zanker (1988).

11 See Zanker (1988, 228). Rose (1993, 60) holds that they are Celts, but Kuttner (1995, 117) identifies them as Gauls.

12 The second cycle survives on the Ara Pacis. Smith (1988, 50–77) suggests a third cycle.

13 See Kuttner (1995, 195–6). On miniature copies of larger original works of art, see also Bartman (1992).

14 Kuttner (1995, 94), while Brilliant, identifies the chair as the *sella castrensis* and holds that the combination of stool and dais signify a military tribunal.

15 Miclea (1971, 44) notes that Laberius Maximus, the governor of lower Moesia, is said to have taken Decebalus' sister as his captive. See Dio Cassius 68.9.4.

16 See Chapter 7.

17 For the parallel gesture, see Settis (1988, scene 91).

18 See L&F, 88.

19 It is interesting to note that whereas violent scenes usually show the destruction of the non-Roman family group, scenes of submission sometimes preserve its structure.

20 See Miclea and Florescu (1971, 54).

21 This scene may present a practical historical reality. Perhaps the *tarabostes* met with the emperor in their official capacity while the civilian Dacian throng remained outside the fort, as scholars have assumed; however, the compositional difference between this scene and other submission scenes is striking and therefore worth exploring. See Miclea and Florescu (1971, 54).

22 Trajan is not alone in his cool response to submissive non-Romans. A coin of Lucius Verus (Brilliant 1963, 149–50) shows an "aloof" emperor receiving Armenian submission. While the Armenian supplicates the emperor, he grasps the trophy and makes

no gesture toward his suppliant. Domitian receives a German submission similarly (*BMC* II, 299, 337, 379; *RIC* II, 285).

23 See Settis (1988, Fig. 160), who remarks that we see in scene XC *un gruppo di civili, vestiti con abiti in tutto simili a quella dei Deci* (p. 417).

24 Brilliant (1963, Fig. 1.13) here is speaking of Perseus in particular. The relief, dated to 400 B.C. and dedicated to Perseus at Cumae, now in Berlin, shows adults and children greeting Perseus, who is mounted on a horse.

25 Brilliant (1963, 17) identifies the waving gesture of the standing figures as one of adoration, and adoration is closely related to supplication. In scene XXXI from the Column of Marcus Aurelius, two non-Roman men make some type of agreement with the emperor. The man nearer to the emperor holds out two fingers. Caprino (1955, 94) says that the non-Romans are making a solemn promise or a pledge of loyalty to the Marcus Aurelius. Again, the gesture, while perhaps not explicitly submissive, maintains the power relationship between the emperor and his subordinates. It implies a responsibility on the part of the non-Romans to the emperor, and it is certainly not a gesture that the emperor would make toward non-Romans. Aldrete (1999, Fig. 8) presents a series of similar open-handed gestures as "denoting wonder," and Corbeill (1996) holds that the thumb (*pollex*) could be used to express good will.

26 See Chapter 8. In his examination of imperial coins, Bernhart (1926) compiles *adventus* types (Tafel 80), many of which depict the emperor's arrival on horseback. In none of his examples, however, does the emperor's horse appear to threaten those among whom he arrives.

27 See Brilliant (1963, Fig. 3.15) and a similar coin of Lucius Verus (ibid., Fig. 3.94).

28 See Brilliant (1963, Fig. 3.135) and Ryberg (1955, pl. LVIII.91).

29 See Andreae (1977), Kleiner (1992), and Strong (1961, Fig. 95).

30 There is a third sarcophagus from Frascati nearly identical to the two discussed here, but the child, presumably once there, is no longer visible on it. See Brilliant (1963, Fig. 3.136).

31 See Brilliant (1963, Fig. 3.132); see also Lasinio (1814, pl. CXIII) and Vermeule (*Berytus* 1959, 24, pl. XXI.65).

32 See Caprino et al. (1955), Hamberg (1945), Hannestad (1988), Kleiner (1992), Koeppel (1969), Petersen et al., (1896), and Zanker (2000).

33 See Zanker (2000, 168).

34 This posture is explored in depth in Chapter 8.

35 See Caprino et al. (1955, Fig. 71).

36 Strong (1907, 292) identifies the non-Romans in this scene as Sarmatians, holding that the scene corresponds to the Bellum Sarmaticum of 174–176 A.D.

37 Ryberg (1967, 61) suggests that the scroll may represent the treaty with the non-Romans and that the emperor may be reading from it in this scene.

38 See Kuttner (1995, Fig. 89).

39 This is the only scene of submission that lacks an overt military element.

40 For more on the importance of the father's authority to the Roman *familia*, see Saller (1991, 1994) and the conclusion of this chapter.

41 See Kleiner (1992, Fig. 105); see also Andreae (1977), Hamberg (1945), and Hannestad (1988).

42 See Kleiner and Matheson (1996, Fig. 162).

43 See Hannestad (1988), Kleiner (1992), Kuttner (1995), and Petermann (1975).

44 For a discussion of the tradition, see Kleiner.

45 Kuttner (1995, 168) identifies the costume of the non-Roman men in the foreground as Celtic but claims that the children are not in Celtic garb. She calls their dress "Greco-Roman . . . togalike." The children may be male and female because their garments are slightly different from one another.

46 See Chapter 5, n. 3. See also the figure of Augustus on the Grand Cameo of France (Brilliant 1963, Fig. 2.78) or on the Gemma Augustea (Brilliant 1963, Fig. 2.58). Later parallels occur on coins of Caracalla (Brilliant 1963, Fig. 4.68) and Elagabalus (Brilliant 1963, Fig. 4.113).

47 On the hierarchy of scale, see Kleiner (227), who claims that the hierarchy of scale in state art was an innovation of the Trajanic period but that it had been developed on coins and in reliefs of freedmen as early as the age of Augustus. Even in Augustan state reliefs, the emperor is never depicted as shorter than any person around him. The hierarchy of scale is most obvious in representations of slaves, who, though adults, may only appear childlike in height.

48 While the facial expressions and poses of the figures on the Boscoreale cup may differ slightly from those found in other works of art, the gestures of the children and the composition and context in which they occur are clearly similar. Moreover, the facial expressions of the figures on the cup are difficult to see, let alone to interpret. From some angles, two of the children appear to be smiling, but their fathers do not. Furthermore, because the cup has been lost, we must rely on the century-old photos of Héron de Villefosse as our primary visual record, making it impossible to judge the psychological state of the figures on the basis of the nuances of their poses or facial expressions. Finally, when children from established Roman provinces are depicted on the Column of Trajan they are shown either as Roman (or Romanized) children, in Roman costume, or as loyal non-Romans, behind the Romans in position and status, certainly, yet not at all submissive. As Bonfante Warren has demonstrated, the key proof of Romanization is costume, and none of the children on the Boscoreale cup wears a Roman costume.

49 Kuttner also states that in submission scenes, the emperor sits on a higher tribunal than that which is shown on the cup, although I have provided evidence that the tribunal and the height of the emperor in relation to the other figures on the cup is consistent with other scenes of non-Roman submission.

50 See Braund (1984, 10–11). [Jos. AJ 15.52–3, 17.20–21, 80; BJ 1.573, 602–3].

51 Strabo 6.4.2, 16.1.18.

52 As noted in Chapter 4, scene XCI from the Column of Trajan is our only extant exception to this rule, in which three non-Roman children stand at the rear of a group observing a sacrifice. The two non-Roman children from the south side of the Ara Pacis friezes may also seem to be exceptions, but I argue that they are not. I address them in detail in Chapter 9.

53 Even if we consider the possibility that non-Roman children in certain scenes of submission may have been handed over to the emperor for education at Rome, we cannot disregard the circumstances under which the education of non-Romans took place. While Augustus claims that Phraates sent his children willingly, [a]d me rex Parthorum Phrates Orodis filius filios suos nepotesque omnes misit in Italiam non bello superatus,

sed amicitiam nostram per liberorum suorum pignora petens [*Res Gestae* 32] he includes the incident in his own memoirs and within the context of kings who approached him as *supplices*. Both Tacitus and Strabo call such children hostages, *obses* and *therapeutikos*, respectively. [Tac. *Ann.* ii; Strabo 6.4.2]. Plutarch's *Life of Sertorius* recounts that the Roman general impressed the non-Romans by educating their children, but while he appeared simply to be educating them, Plutarch claims, he actually made captives of them [Plut. *Sert.* 14.2]. The local Spanish boys whom Sertorius educated no longer dressed as non-Romans; they donned the *togae* and *bullae* of Roman boys (ibid.). Similarly, Tacitus implies in the *Agricola* that education was a form of subjugation used by Roman generals, including it as one aspect of their mastery over non-Roman peoples [Tac. *Agric.* 21.2]. Agricola is said to have instructed the sons of the conquered chieftains *liberalibus artibus*, teaching them Latin and rhetoric and Roman *mores* [ibid.]. He distracted the sons of the chieftains from their own customs and the desire to fight against Rome by assimilating them into the Roman way of life. Thus, to be educated at Rome (or as a Roman) could be considered a form of subjugation. Even if eventually educated at Rome, non-Roman children in scenes of submission still function as a type of offering and still must submit to the emperor. For non-Romans under Roman imperialism, to offer one's children "willingly" means little, and the possibility that submissive children may have been educated does not make them less submissive.

54 See also Harris (1986). There has been extensive debate over the meaning of the father's *vitae necisque potestas*, and, as Saller notes, the evidence for this power is generally inconclusive. Saller (1994, 117) finds Thomas' (1984, 512, 545, 500) conclusions most satisfactory: "the *vitae necisque potestas*, mostly clearly attested in the adoption formula, rather than in practice, was not 'a daily reality,' 'not a fact of social history,' but 'an abstract definition of power,' 'a pure concept.'"

55 Saller (1991, 165) highlights the difference between a father's power over his own children and that held over his slaves: the "relationship between a master and slave was inherently one of exploitation . . . paternal authority was not fundamentally coercive in the way that the master's . . . was." As evidence, Saller recalls the philosophical distinction between coercive and noncoercive authority held by the Romans and recorded by Cicero [*De rep.* 3.37: *Sed et imperandi et serviendi sunt dissimilitudines cognoscendae. Nam ut animus corpori dicitur imperare, dicitur etiam libidini, sed corpori ut rex civibus suis aut parens liberis, libidini autem ut servis dominus, quod eam coercet et frangit*]. When non-Roman children are shown performing gestures of submission and supplication before the emperor, it may be this dual aspect of the emperor's *patria potestas* to which the depictions allude.

56 Harris uses the term "exposure," but, as he notes (1994, 1, n.1), Boswell (1988, 25) prefers to use the term "abandonment," claiming that the former "conveys a sense of risk or harm." As Harris points out, the effect of this behavior was often harmful to the child and very risky. Saller (1994, 117) claims that the father's right to expose a newborn is uncertain.

57 Saller (1994, 119–20) wisely points out the difference between the legal powers of the *paterfamilias* and his practical or socially acceptable powers. "These legal powers," he writes, "would seem to endow the *paterfamilias* with an overwhelming dominance in the family. Some legal historians point to an evolution in which *patria potestas* was gradually limited by the emperors and assumed a protective (rather than coercive)

quality. . . . But the development would not be overstated." He points to the "other aspects of law and social custom that softened the impact of [the father's] powers," such as the powers of the mother or other relatives (p. 131). Saller (p. 130) claims that "a survey of the non-legal evidence reveals that day-to-day behavior did not correspond to the abstract characterization of the Roman family as a paternal despotism," but the fact that the *paterfamilias* did not often carry out his powers to their fullest extent does not change the letter of the law or its psychological impact. Saller does not believe that Roman children would have been aware of the extent of their father's powers (p. 117), but adults surely would have. In fact, it was not until the time of Constantine that the killing of one's child was actually considered *parricidium* (p. 115). I believe it is Thomas' "pure concept" of *patria potestas* that is being invoked in these images.

58 Currie (1996, 153, 181) supports such analysis: "in the realm of public art Rome's dominion over its empire found a parallel in the dominion of adults over children. . . . While there was no simple identification of child with barbarian . . . the relationships of Roman Italy to its empire and adults to children were part of an integrated process of empire."

59 For such views, see Haverfield (1912), Brendel (1979), Millett (1990), Kuttner (1995), and Woolf (1998). Of the Boscoreale cups, in particular, Kuttner supports an interpretation that she calls "benevolent *imperium*," holding that all of the identifiable people depicted on the cups come from provinces already incorporated into the empire. While acknowledging that images of "pure dominance" existed as advertisements for the power of the empire, Kuttner (1995, 86) feels that this is not the only interpretation of the images found on the Boscoreale cups. She sees signs of grief, rather than subordination, as the most important signs of subjugation depicted on the cups. See the Conclusion of this study (Chapter 10) for further discussion of such interpretations.

SEVEN. TRIUMPH

1 Triumphal paintings were often carried in triumphal processions and displayed in public after the procession itself was complete. Although none of these paintings survives, Holliday (1997, 134) claims that the main purpose of such paintings in republican triumphs was didactic, "to advance the personal prestige of the *triumphator* by documenting those achievements that had led to his triumphal celebration. They were primarily propagandistic, often with political or electoral ends in mind."

2 Zonaras' *Epitome* 7.21 provides a general description of a Roman triumph.

3 See Payne (1962, 149). Zonaras notes that in the republican period, triumphs were voted to whole companies and legions, but during the empire, triumphs were reserved for the emperor and his family members only.

4 Kuttner (1995, 166) identifies the fragment as Julio-Claudian, comparing it with two small and poorly preserved cuirass fragments from the Julio-Claudian period, as well as a Neronian statue showing a naked infant at its father's feet. Ryberg (1955, 149, n. 27), however, identifies the fragment as Antonine based on the treatment of

the toga and of the bearded heads. Both identify the scene as a triumph. I follow Kuttner because she places this scene in the context of other Julio-Claudian scenes of conquered, non-Roman peoples, whereas Ryberg dates the scene on purely stylistic bases. See also Reinach (1909–12).

5 See Kuttner (1995), 263, n. 15.

6 See Chapter 8, n. 35, on frontality.

7 Younger (1991, 295) has used the phenomenon of "tabbing" (connecting separate slabs or groups in a frieze by using feet or other sculpted features to "tab," or connect, one compositional group to another) as evidence that sculptors or groups of sculptors worked from patterns. He has demonstrated that artists worked from preliminary sketches or pattern books that they used repetitively on the Parthenon frieze. On this frieze the right foot of the child tabs into the left of the woman behind him or her, whose right foot tabs into the left foot of the figure behind her. This phenomenon occurs in both compositional groups. For more on the use of patterns, see Stewart (1990) and Clairmont (1993).

8 See Andreae (1977), Baharal (1996), Hannestad (1988), and Kleiner.

9 See Andreae (1977, Fig. 558).

10 Zanker (2000, 168) calls them *der Barbarenfürst und seine Frau*.

11 The non-Roman woman on the bier has one breast exposed, like a number of non-Roman women in scenes of violent military activity discussed in Chapter 8. This type of exposure may evidence the sexualization of non-Roman women on imperial monuments.

12 These views are supported by Josephus' description of Vespasian's triumph in *BJ* 7, 5. Considering the relatively low literacy rate during the Roman Empire, which Harris (1989) estimates at 5 to 10 percent, public spectacles like triumphal processions and visual images were crucial vehicles for conveying information and propaganda to the populace.

13 Plut., *Aem.* 33 (*doula*).

14 In fact, all scenes in which non-Roman children appear must be seen against the backdrop of the dynastic system of the empire that necessarily informs them.

EIGHT. THE BATTLEGROUND

1 Although cognizant of the diverse ethnic reality of the Roman military machine, I cannot be concerned here with the ethnicity of the Roman troops, the ambiguities of soldiers-for-hire within the Roman ranks, mercenaries, and the like. Therefore, I call all those fighting on the side of the Romans "Roman soldiers."

2 In his recent study of women and children on the Column of Marcus Aurelius, Zanker (2000, 164) divides images into two categories: scenes of military activity, with which he includes scenes of conquest and flight, and scenes with prisoners of war. Because both categories result from violence (or at least the threat thereof) and because prisoners of war are certainly not exempt from violence, I have included all such scenes under the heading "military activity."

3 See Chapter 7 and Hannestad (1988, 36).

4 See Zanker (2000, 168).

5 Zanker's (2000, 164) *zurückgewandtem Kopf*.

6 See Rossi (1997, 474).

7 The Tropaeum Traiani was most probably dedicated by Trajan to Mars Ultor. See Rossi (1997, 473) and Florescu (1965).

8 Inv. Nr. 35. I follow Florescu's (1965) numbering here.

9 There is disagreement as to the precise ethnicity of the non-Romans on the metopes of the Tropaeum Traiani. See, for instance, Florescu (1965, 500–1) and Rossi (1997, 474).

10 See Florescu (1965, 501).

11 See Settis (1988, Fig. 36).

12 The gender of this child is impossible to determine unequivocally, but he appears to have short hair, and his clothing may mimic that of the male adults with whom he is shown. All wear capes.

13 Although this scene is adjacent to and thematically consistent with a submission that also includes non-Roman children (scene XXX), the scenes are distinct. A mountainous ground line separates the two. In addition, the three fleeing non-Romans look back at the scene they have left, while the women and children in the adjacent image look in the opposite direction, toward the emperor. Scene XXIX should be taken simply as a scene of violent military activity.

14 See Settis (1988, 311).

15 It has been suggested to me that there is a second child in this scene, held above the battle fray by the non-Roman man to the left of the lifeless child near the top of the scene. I have determined the image in question to be a combination of two crossed clubs held by Dacians.

16 Inv. Nr. 37; see Florescu (1965).

17 For the former view, see Cichorius; for the latter, Pollen (1874).

18 See, for example, Fig. 56. The posture of this child recalls the posture of the older child from the Arch of Septimius Severus at Lepcis Magna (Fig. 45).

19 L&F (p. 121) identify the buildings in the background as nonmilitary; they may be temples.

20 See Settis (1988, Fig. 271).

21 See L&F p. 176–7. The following scene shows a severed head displayed on a Roman shield.

22 According to L&F (p. 177), the "usual fate for such princelings was internment for life at some secure retreat, far from their native land and remote from political contacts, like Ravenna."

23 See L&F (p. CXII).

24 L&F (p. 183) ask whether these figures are Dacians or immigrant farmers, acknowledging the possibility that the hill depicted in the scene stands for the mountains bordering Transylvania; this, apparently, is a question that cannot be answered definitively, but a comparison of the scene with similar scenes from the Column of Trajan leads me to the conclusion that they are, indeed, Dacian refugees.

25 Kampen (1991, 235) recognizes a similar motif, that of the "pathetic conquered barbarian family," on the Column of Marcus Aurelius, holding that "the barbarian woman with babe in arms signals the depth of defeat suffered by her society, just as Livia, beneath her divine spouse and next to her ruling son [on the Grand Cameo of France], is the crucial link in the chain of enduring dynastic power."

26 Inv. Nr. 9; see Florescu (1965).

27 Vulpe (1938), Ferri (1933), Patsch (1937), and Frova (1961) all identify this as a scene of flight.

28 I assume here that Florescu's (1965) arrangement of the metopes is correct. If not, the context provided by a victory monument on which violence is enacted by Romans against non-Romans may be enough to sustain the argument concerning metope XLII.

29 Inv. Nr. 49; see Florescu (1965).

30 See Florescu (1965).

31 The exception is scene XCI, discussed in Chapter 4.

32 See Currie (1996, 159–62) for a brief discussion of the children depicted on the Column of Trajan.

33 I follow Petersen and colleagues (1896) numbering here.

34 Zanker identifies the long, unkempt (ungeordneten) hair of non-Roman women on the Column of Marcus Aurelius as one sign that the women are in perpetual mourning (die ewige Trauer) (2000, 170–1).

35 On frontality on the Column of Marcus Aurelius, see Elsner (2000).

36 See Caprino (1955, Fig. 86).

37 This gesture is probably comparable to the benign hand-on-head gesture seen in many depictions of child-adult pairs. See Chapters 3, 4, and 9 for examples.

38 Beard (2000) analyzes this scene in some depth. She explores Petersen and colleagues' (1896) identification of the scene as a "joke" and problematizes modern interpretations of the scene, calling into question our ability to derive meaning from gesture.

39 See Caprino (1955, Fig. 107).

40 A modern restoration of scene LXXIX shows a battle between Romans and non-Romans. In addition to male soldiers, the battle scene includes non-Roman women and children. The scene is divided into two levels to show depth, with men in the upper register and women in the lower. Among the women in the lower register is at least one male child, who is shown nude and nearly frontal. Another child appears to ride a horse at the far left of the scene. It seems that the group is being led away by Roman soldiers, but details of the scene are difficult to determine with certainty, and the restoration is odd. As Petersen and Caprino observe, it is likely that the missing scene looked something like this, but nothing of the original remains from which to confirm the restoration. See Petersen et al. (1896, 78–80) and Caprino (1955, 107, 123).

41 Too late for this study is a porphyry sarcophagus from A.D. 325–350 known as the Sarcophagus of Helena (mother of Constantine), which contains a group of scenes in which Roman soldiers defeat and capture a group of non-Romans. The battle is shown on all four sides of the sarcophagus. Non-Romans, some cut down in battle and some marching before mounted Roman soldiers, are bound about the wrists. Their heads hang in despair. Among the captives are young, shoeless children, all of whom appear to be male. On the adjacent side of the sarcophagus, adult male captives kneel, nude from the waist up, before a Roman general. They also appear to be barefooted. Although this detail may seem insignificant or inconsistent with other depictions of non-Romans, the well-preserved non-Roman child from north side of the Ara Pacis friezes is also barefoot (Fig. 61). The depiction of a figure without shoes

may indicate his or her non-Roman status. Moreover, the feet (bare or covered) are a detail often difficult to discern from poorly preserved representations, making their absence in other representations nonproblematic.

The scene on the Sarcophagus of Helena closely resembles scene LXI from the Column of Marcus Aurelius, in which Roman soldiers on horseback and on foot cut down bearded non-Roman men. The captives on the column have their hands bound behind their backs, and they walk in the same, stooped manner as the captive men on the sarcophagus. One of the captives on the column is even naked to the waist, and he wears the same pants with twisted waistband that some of the sarcophaghus captives wear. Other captives in both scenes wear belted tunics. Both scenes are divided into two registers to show depth. While no children appear in scene LXI, the similarities between it and the scene on the Sarcophagus of Helena are striking; perhaps both derive from a type-scene of Romans battling and capturing non-Romans. Most important, the compositional similarities between the two reinforce the legitimacy of the sarcophagus as a work of official art.

Unfortunately, conclusions drawn from this sarcophagus are controversial for many reasons and therefore must be tentative. First, although it is obvious that the Romans are fighting non-Romans, the entire sarcophagus was damaged by fire and subsequently heavily restored, making it impossible to identify the ethnicity of the non-Romans. Although engravings made before the restoration have been used to identify repairs made to the sarcophagus, the engravings differ from one another enough that they are not always conclusive. The date of the sarcophagus is also debated on stylistic grounds, but the composition and the subject of the reliefs are typical of the Constantinian period. The findspot of the sarcophagus, the possibility that the work pertains to the emperor's mother, and the use of porphyry as the medium also support a date in the second quarter of the fourth century. For a full discussion of these issues, see Kleiner (1992, 456–7). I find the assumption that the sarcophagus was commissioned by the imperial government justified. The sarcophagus tells us simply that the violent defeat and capture of non-Romans and their children by Romans was an artistic motif used by the Roman ruling elite at least into the fourth century.

42 See Brilliant (1963, Fig. 3.128), relevant bibliography includes Hamberg (1945, 176ff, pl. 40); S. Aurigemma (*The Baths of Diocletian* [Mus. E Mon. d'Italia 78, Rome 1947], 16, pl. XV); G. Picard (*Trophees rom.*, 445, pl. XXIII).

43 See Strong (1961, Fig. 96) and Andreae (1977).

44 In the Terme; see Brilliant (1963, Fig. 3.141); relevant bibliography includes S. Aurigemma (*The Baths of Diocletian* [Mus. E Mon. d'Italia 78, Rome 1947], 18, pl. XVIII); G. Picard (*Trophees rom.*, 449ff, pl. XXI).

45 The child's cape has a fantastic drapery quality similar to that of figures from the Balustrade of the Temple of Nike at Athens and the frieze from the Temple of Apollo at Bassae.

46 Similar to these images of non-Roman children on Antonine sarcophagi are three images of non-Roman children from cuirasses or cuirass fragments. The children exhibit postures and gestures nearly identical to those of Figures 58–59. See Vermeule (1980, Fig. 53) and Stemmer (1978, Fig. 14.3 and 56.6).

47 Kuttner's (1995) term.

48 And in most of these Roman soldiers do their best to separate family members from one another, as in metope XLIII from the Tropaeum Traiani (Fig. 46).

49 Currie (1996) has explored this possibility with respect to the Column of Trajan in particular. My analysis here will be addressed in greater detail in the Conclusion.

NINE. ARA PACIS

1 For an excellent overview of earlier scholarship on the Ara Pacis, see *RE* XVIII, 2 (1942, cols. 2082ff, H. Riemann). See especially Castriota (1995), Conlin (1997), Emanuela (1994), Holliday (1993), Kleiner (1993), Koeppel (1987), Kuttner (1995), La Rocca (1983), Pollini (1987), Rose (1993, 1997), Simon, (1967), Syme (1984), Torelli (1982), Toynbee (1953), Vermeule (1982), Weinstock (1960), and Zanker (1988).

2 See Bianchi (1994, 10–11) and Simon (1967, 22), respectively, for resumes of these arguments. On the use of stock elements in Roman state relief, particularly in processions, see Hannestad (1988, 361, n. 140) and Brilliant (1963).

3 For more on dynastic imagery in general, see Rose (1997) and Kuttner (1995).

4 See Ryberg (1955, 35, 57, 68, 77, 86).

5 See Conlin (1997, Fig. 60).

6 Ibid., Fig. 12.

7 Of course, the adult women on the friezes of the Ara Pacis do not wear *togae*.

8 See Pollini (1987) and Rose (1997).

9 Pollini's detailed examination of age-height ratios for children and adults has led him to conclude that the average two- to three-year-old boy is approximatly half the height of an adult male. This approximation is found in Pliny's *NH* 7.73 and remains constant in nineteenth-century and modern growth charts. See Pollini (1987, 22–3). See also Withee's findings, cited in Chapter 2. Lucius Antonius is described by Tacitus as *admodum adulescentulum* in 2 B.C. [*Ann.* 4.44]. Pollini (1987, 28) identifies the figures in front of and behind Lucius Antonius as his mother and father, respectively.

10 The only child close to the same age as Lucius at the time has been identified by Simon and Pollini as the young Gnaeus Domitius Ahenobarbus because of his intimate connection with and proximity to Antonia the Elder and L. Domitius Ahenobarbus, parents of the same.

11 Gaius Caesar is something of an exception. Dressed as a *camillus*, Gaius is present presumably as a participant in a religious ceremony, probably that depicted on the friezes. As the immediate heir to the principate, he plays a role in the administration of the state cult. As Rose (1997, 16) says, Gaius is *camillus* as Augustus is priest. Rose speculates that because Gaius would have attended Augustus specifically, as Iulus attended Aeneas in the scene on the west side of the enclosure wall, he need not be shown among other priests and religious figures, as are the other *camilli* on the Ara Pacis. Gaius, therefore, as a religious assistant to his adoptive father, Augustus, not only advertises the future strength of the dynasty, but also the piety and purity of the imperial family and its future leaders.

12 Domitius was to become the father of the future emperor Nero. See Simon (1969, 19).

13 Kleiner outlines well the controversy surrounding these two children. See especially (1993, 48, n. 15). See also Rose (1993).

14 For identification of the child as Roman, see Andreae (1977), Bianchi (1994), von Domaszewski (1942), Hannestad (1988), and Poulsen (1946).

15 See Zanker (1988, 217) and Bianchi (1994, 18). Crawford (1922, 313–15) suggests that the younger child on the north frieze is Drusus the Younger, son of Tiberius and Vipsania, but no one else has taken up his suggestion.

16 See Kleiner (1993, 48, n. 15). Toynbee (1953, 84, n. 5) claims that a torque would be "suitable to a child of imperial or patrician rank" because it recalls the *flexilis obtorti per collum circulus auri* worn by the Trojan boy described in *Aeneid* 5.559. Her evidence, however, could just as easily indicate that the children are non-Roman, as I believe is the case.

17 See Rose (1997) and Simon (1967).

18 For portrait types of Gaius and Lucius, see Pollini (1987), in which these children are identified not as the heirs to the principate, but as "barbarians." In addition to discrepancies between these children and portrait types of Gaius and Lucius, the ages of these figures may not correspond with the ages of Gaius and Lucius Caesar in 13 or 9 B.C. Gaius was born in 20 B.C., Lucius in 17 B.C. Thus, in 13 B.C. Gaius would have been seven and Lucius four. The children in question appear to be approximately seven and two years old, respectively. The argument is made stronger if one considers the possiblity that the children on the altar are depicted as they appeared in 10 or 9 B.C., closer to the time of the altar's completion. In 9 B.C. Gaius and Lucius would have been eleven and eight years, respectively. For more on the identification of the children of the Ara Pacis based on age, see Rose (1997).

19 The two mythological children in the so-called Tellus frieze are nude.

20 The bare feet of the younger child are particularly problematic to his identification as Lucius Caesar. Kleiner (1992, 67) notes that Augustus' bare feet in the Primaporta portrait have been thought to show that he was *divus* at the time the statue was carved. She also points out, however, that Augustus is shown with bare feet on coins dating ca. 31 B.C., and she predicts that the controversy over bare feet as a divine attribute (at least with respect to Augustus) may never be resolved. While bare feet may be used to indicate heroic or divine status, perhaps suggesting that this child is dead, Lucius Caesar lived until A.D. 2 and would have been shown in Roman costume, in any case.

21 Rose (1993, 55, 59).

22 Pollini (1987, 23).

23 Following de Bruyne (1943), Brilliant (1963, 17) identifies the "hand-on-head" gesture as a benign gesture of benediction or blessing.

24 This similarity, however, is difficult to prove because the heads of all the figures on the Julio-Claudian frieze have been restored. See Kuttner (1995, 263, n. 15).

25 As I have suggested, non-Roman children are usually depicted with their mothers, Roman children with their fathers. For an overview of the evidence, see the Conclusion (Chapter 10).

26 See Rose (1993, 56).

27 Rose (1997, 57) notes that the marriage of Polemon and Dynamis, as described by Cassius Dio, and of which Augustus approved, united the kingdoms of Pontus and

Bosporus and helped establish peace in the area of the Cimmerian Bosporus, an act with which Agrippa was credited in 14 B.C.

28 See Simon (1967, 18). *Ad me supplices confugerunt reges Parthorum Tiridates . . . Ad me rex Parthorum Phrates Orodis filius filios suos nepotesque omnes misit in Italiam non bello superatus, sed amicitiam nostram per liberorum suorum pignora petens. Plurimaeque aliae gentes expertae sunt p. R. fidem me principe quibus antea cum populo Romano nullum extiterat legationum et amicitiae commercium [Res Gestae 32].*

29 Smith (1988, 73) states that "it would not be cogent to argue that . . . conquered peoples would be inappropriate to an altar of peace. . . . They represented the peaceful incorporation of new conquests. New additions to the empire and the establishment of a peaceful order were quite consonant Augustan ideals." He refers here to a group of poorly preserved barbarian figures from the altar proper, identified as *gentes* by Kahler (1954).

30 See Simon (1967, 18). Simon speculates that the altar in the interior would have contained personifications of provinces and non-Romans.

31 Weinstock (1960, 44–58).

32 Weinstock (1960, 44).

33 Weinstock (1960, 44–9) holds that Pax depended on the Greek goddess Eirene. Unlike Eirene, who did not stand for a particular political philosophy, he claims, Pax stood for Roman imperialism from her very beginnings; in fact, the root of her name came from the verb *pacisci*, which originally meant a "pact" rather than "peace." Thus, the cult of Pax did not stand for an "idyllic peace." Weinstock argues that Caesar introduced the goddess Pax to support his political philosophy with a religious figure, citing, in particular, a *quinarius* of L. Aemilius Buca, ca. 44 B.C., with a female head and the legend *PAXS* on the obverse and a pair of clasped hands on the reverse.

34 Weinstock (1960, 44) notes that the caduceus of Pax is borrowed from Eirene.

35 See Weinstock 1960, 44. The location of the *Ara gentis Iuliae* in the time of Augustus is unknown.

36 See the discussion of *patria potestas* in Chapter 6.

37 Rose (1993, 61) suggests that "the Bosporan prince and queen on the south frieze served as an illustration of Agrippa's role in securing peace in Asia Minor. . . . The juxtaposition of East and West [see below] would accord well with the relief decoration of the inner altar of the Ara Pacis, which seems to have contained a relief with provincial personifications, and other Augustan monuments stress the same East-West theme."

38 We find later parallels for the indifference of the Roman official toward the non-Roman child here, for example, in scene XXXIX from the Column of Trajan (Fig. 33) and in the submission panel of Marcus Aurelius (Fig. 38).

39 The torque of the north frieze child was restored from a drawing in the Codex Ursinianus in the Vatican. Kleiner (1993, 48, n. 15) addresses the question of the restoration, noting that the torque was usually associated with non-Romans. See also n. 14.

40 Ryberg (1967, 64) cites scene LXXV from the Column of Trajan and the relief panel of Marcus Aurelius (Fig. 38) in which the emperor receives the submission of non-Romans with indifference. I suggest that these scenes are parallels for the indifference of the Roman official to the non-Roman child on the north frieze of the Ara Pacis.

TEN. A NARRATIVE OF IDENTITY

1 Of the children on the Column of Marcus Aurelius and the Arch of Septimius Severus at Lepcis Magna, in particular, Zanker (2000, 169) says, *Die Tatsache, daß Kinder in der gleichzeitigen römischen Staatkunst als Garanten der Zukunft eine so grosse Rolle spielen und in Gestalt von Eroten und Jahreszeiten eine Fülle positiver Konnatationen haben, muß im Kontrast dei Aussage der Bilder über die Barbarenkinder noch verstärkt haben.*

2 Ellul (1973, 75).

3 See Zanker (2000, 171–3) on non-Roman women, in particular, as representative of subjugated peoples.

4 Kuttner (1995) identifies the children on the Boscoreale cup, as well as those on the Ara Pacis, in this middle ground as well; in these cases she sees not submissive hostages, humiliated before the Roman ruling elite but rather foreign children cherished by the Roman ruling elite, about to be educated by the emperor. Perhaps, however, these are both very early examples, and I have shown that in gesture and composition, the children in these images parallel children from scenes of submission and triumph, respectively.

5 On the importance of the *familia*, see Rawson (1986) and Saller (1994).

6 Translated by Gardner and Wiedemann (1991, 2).

7 As noted in Chapter 4, one woman may stand at the very end of the procession in scene LXXXIII, but it is impossible to identify the gender of the figure unequivocally.

8 For specific information on the legal restrictions placed on women during the republic and empire, see Evans (1992, 7–49) on marriage and guardianship. On women in Roman succession, see Rawson (1986, 58–82); on women's political rights, see Bauman (1992, 1–12 and 99–129). Bauman (p. 1) cites L. Valerius, Cato, and Ulpian on the fact that women were barred from "all civil and public functions," including public office, priesthoods, magistracies, and jury duty.

9 *Tu ne rogari quidem sustinuisti et quamquam laetissimum oculis tuis esset conspectu Romanae sobolis impleri, omnes tamen ante quam te viderent adirentve, recipi incidi iussisti.* "You, however, did not endure to be asked, and although it might be for you the most joyful experience to have your eyes filled with the sight of the Roman progeny, nevertheless you ordered everyone to be registered and recorded before they might see or approach you" [Pliny, *Pan.* 26].

10 *CIL* 11.1147.

11 *Liberalitatem omnibus ordinibus per occasiones frequenter exhibuit.* "Given the opportunity, he frequently offered donations to people of all orders" [Suet. *DA*, 41]; Cf. *Res Gestae* 15.

12 See n. 10.

13 D'Ambra (1996, 221) contrasts Venus' controlled and productive sexuality with that of Aphrodite, in particular. Whereas Aphrodite's sexuality is often shown to be a threat to the patriarchal structure, Venus' sexuality works within and for the Roman imperial patriarchy.

14 Some scenes of submission do depict a non-Roman woman offering a child to a Roman general. See Figs. 40 and 41 in particular.

15 I include in this total neither children of the imperial family from the Ara Pacis nor children considered for the sake of comparison only.

16 I have excluded images of imperial children from this study, but my research shows that there is a correlation in official imperial art between the frequency with which Roman and non-Roman children are depicted and the frequency with which imperial children are depicted. Augustan and Julio-Claudian imperial children were frequently shown on official monuments and coins and in imperial portrait groups. Coinage from the Julio-Claudian period included Roman children in scenes of imperial largesse. At the same time, non-Roman children appeared on the Ara Pacis and on works of art such as the Boscoreale cups, which commemorated the conquest of non-Roman territories.

Whereas only six coin types from the Flavian dynasty include representations of children from any status group, the Antonine dynasty saw a dramatic increase in the number of children depicted in official art. The children of Marcus Aurelius and Faustina the Younger appeared on numerous coin types from the reigns of Antoninus Pius and Marcus Aurelius. Earlier, Roman children were depicted on coins advertising the *alimenta*, and Roman children were frequently incorporated into Trajanic and Hadrianic monuments such as the Arch of Trajan at Beneventum, the Column of Trajan, the Anaglypha Traiani/Hadriani, and the Arco di Portogallo reliefs. Furthermore, non-Roman children were shown on the Columns of Trajan and Marcus Aurelius and on the Arch of Trajan at Beneventum.

After the Antonine dynasty the correlation is not as clear. Numerous Severan portraits and coins immortalized the children of the imperial family, but with the exception of the non-Roman children from the Arch of Septimius Severus at Lepcis Magna, I know of no representations of non-Roman or Roman children from the Severan period. In light of the information on *ludi* presented in Chapter 4 and the fact that Roman children appeared on Domitian's and Antoninus Pius' *ludi* coins, it seems likely that children would have appeared on coins commemorating Septimius Severus' *ludi saeculares* in A.D. 204. If such coins ever existed, however, they are no longer extant. Similarly, with the exception of the Arch of Constantine, on which Roman children appear at an *adlocutio* and a donative, imperial children are shown on only two coins from Constantine's reign. I know of no representations of non-Roman children from the reign of Constantine, and there are few extant images of children from any status group between the end of the Severan dynasty and the reign of Constantine. For details, see Uzzi (1998).

17 As early as A.D. 196, at ten or twelve years of age, Caracalla was named Caesar and *princeps iuventutis*. Just two years later Caracalla was named Augustus, and Geta, who was only nine years of age at the time, was declared Caesar and *princeps iuventutis*. In A.D. 217, Diadumenianus, known as the child- or boy-emperor, became *princeps iuventutis* at age nine; at ten he was proclaimed Augustus, and he ruled with his father, Macrinus, as co-emperor from ages ten to eleven, when he was killed in battle. The practice of bestowing imperial power on ever younger children during the late second and early third centuries clearly contrasts with the norms of the Julio-Claudian period, in which the average age of a *princeps iuventutis* was fourteen, and the typical age of the emperor was between forty and fifty years. While Gaius Caesar's first official activity was his introduction to the troops in Gaul at the age of twelve in 8 B.C., Gaius and Lucius Caesar were not made *princeps iuventutis* until they reached age of fourteen. Furthermore, it was not until 1 B.C., at the age of nineteen, that Gaius set out on a

military campaign, and not until two years after that that he entered the consulate in Syria. At nearly the same ages, Caracalla and Geta were ruling as co-emperors. For further details and coin types commemorating titles adopted by younger and younger children see Foss (1990, 54, 176, 184, 189). According to Rose (1997, 13), the name Caesar, given to Gaius and Lucius, documented their adoption into the Julian family; it should not be seen as a political title in the same way that it was for Caracalla and Geta.

APPENDIX. COMPARANDA: CHILDREN IN PRIVATE AND
FUNERARY ART

1 Such images are private (or nonofficial) in terms of funding. Private images may also be domestic (of domestic provenance).
2 Louvre 659; see Huskinson (1996, 22), Berzcelley (1978, 61, pl. 76), and Amedick (1993, 144); see also *CIL* 14.4875.
3 The youth reclines on *kline* at a banquet; see Huskinson (1996, 13, 22, cat. no. 1.24).
4 British Museum inv. no. GR 1805. 7–3. 144; see Huskinson (1996, 21).
5 See Huskinson (1996, 1.37; see also 1.8, 1.19, 1.21, 1.27, 1.44, and 1.45).
6 Vatican Museums, inv. 1304; see Huskinson (1996, 16–17, cat. no. 1.37).
7 British Museum 649; see Walker (1985, 45).
8 Mus. inv. 29739; see Goette (1989, 459–60, Fig. 8), Wrede (1981, 179–80, cat. no. 222, pl. 32.3), and Museo Nazionale Romano, *Le sculture* I.7.1 (1984, 50–51, no. 2.33; *CIL* 6.25572).
9 See Goette (1989, 459, Fig. 7) and Wrede (1981, 254–5, cat. no. 161 and pl. 33.2).
10 *CIL* 6.23032.
11 Ostia Museum, inv. 1375; *CIL* 14.4899; see Rawson (1991, pl. 3).
12 Ostia Museum, inv. 308–9; see Rawson (1991, cover and frontispiece, pl. XVIII); see also Becatti (1968, 345) and Kleiner (1981, 512–44).
13 Vatican Museo Gregoriano Profano, section vii, inv. 9837; see Rawson (1991, pl. 6); *CIL* 6.2365.
14 House I. ix.3
15 *CIL* IV.992a; see Jashemski (1979, 102; 1993, 44).
16 The male adult in the *dextrarum iunctio* relief also holds a coin purse (Fig. 65).
17 In addition to its painted child portrait, the House of Puer Successus contained a marble sculpture of a small boy, found in its north portico (Pompeii inv. no. 20395). The boy holds a dove in his left hand, as does the *puer*, and he is nude with the exception of a cape. In fact, he bears a striking resemblance to the painting of *puer Successus*. This figure, however, served as a table base. See Jashemski (1993, 44, Fig. 47).
18 She notes in addition that references to children are frequent in Pompeian inscriptions. See Kepartová (1984).
19 Museo Archeologico Nazionale di Napoli inv. 120620a and b; see *P&M* III.
20 An inscription from the tomb tells us that Sulpicius Maximus, who died at age eleven, was the winner of the third Capitoline contest under Domitian in A.D. 94 for the recitation of Greek poetry. See Nash (1962, 371–3).

21 Deutsches Archäologische Institut 31.1757, 1780, 1781; see *P&M* V.

22 De Caro (1987, 92–3, Figs. 10a–b) identifies this as the "Crowned head of the child Dionysus."

23 Noting the absence of other imperial portraits at Oplontis, De Caro (1987, 90) concludes that "the boy represented here is not a prince; he is probably just an anonymous private individual interpreted according to the dominant style of dynastic representation."

24 Pompeii inv. no. 20455.

25 Oplontis inv. no. 3299; see Jashemski (1993, 300–1), who identifies this piece as a portrait. See also De Caro (1987, 112–13).

26 See Maiuri.

27 Maiuri (p. 107) places these paintings within the context of the "traditions and curriculum of the Attic *ephebia*," which he claims Pompeii continued with the institution of the "Juventus."

28 Gazda's recent (2000) publication provides the following concise overview of the discussion: "The cycle depicts women engaged in activities that have often been connected with the initiation of one or more young women into the mysteries of the cult of Dionysus, or Bacchus, in preparation for marriage" (p. 1). The cycle may also depict "episodes from myth, events from the life of Bacchus, or theatrical performances" (p. 12, n. 2).

29 See Maiuri, pp. 50–65.

30 Ibid. p. 63.

31 Ibid.

32 Huskinson's sarcophagus 6.30, the lid of which bears an apparently unfinished *kline* portrait of a girl, depicts two pairs of cupids at cock fights on its front. See Huskinson (1996, 49).

33 See Dwyer (1982, 62).

34 See Warsher (1951, Fig. 255).

35 See Jashemski (1993, 148), who provides a drawing (Fig. 161) of the figure.

36 See Von Rhoden (1880, 21–2, 45–6).

37 See Chapter 2.

38 See Wallace-Hadrill (1994) for an excellent discussion of the division of the Roman home into its public and private components.

BIBLIOGRAPHY

Aicher, Peter J. *Rome Alive*. Vols. I + II. Wauconda, IL: Bolchazy-Carduci, 2004.

Aldrete, Gregory S. *Gestures and Acclamations in Ancient Rome*. Baltimore: Johns Hopkins University Press, 1999.

Alfoldi, A. "Insignien und Tracht der römischen Kaiser." *RM* 50 (1935): 1–171.

Amedick, Rita. "Die Kinder des Kaisers Claudius." *RM* 98 (1991): 373–95.

"Zur Ikonographie der Sarkophage mit Darstellungen aus der Vita Privata und dem Curriculum Vitae eines Kindes." In *Grabeskunst der römischen Kaiserzeit*. Mainz am Rhein: P. von Zabem, 1993.

Anderson, Benedict. *Imagined Communities*. London: Verso, 1991.

Andreae, Bernard. *The Art of Rome*. New York: Harry N. Abrams, 1977.

"Zum Triumph-fries des Trajansbogens von Benevent." *RM* 86 (1979): 325–9.

Angelicoussis, Elizabeth. "The Panel Reliefs of Marcus Aurelius." *RM* 91 (1984): 141–205.

Arce, Javier. *Funus Imperatorum: Los funerales de los emperadores romanos*. Madrid: Alianza Editorial, 1988.

Ariès, Philippe. *L'Enfant et la vie familiale sous l'ancien régime*. Paris: Plon, 1960.

Baradez, Jean. "Tropaeum Traiani" In *Provincialia-Festschrift fur Rudolf Laur-Belart*, edited by L. Berger, P. Bürgin, and E. Schmid, 201–13. Schwabe: Basel, 1968.

Baharal, Drora. *Victory of Propaganda*. Oxford: Tempus Reparatum, 1996.

Bartman, Elizabeth. *Ancient Sculptural Copies in Miniature*. Leiden: E. J. Brill, 1992.

Bauman, Richard A. *Women and Politics in Ancient Rome*. London; New York: Routledge, 1992.

Beard, Mary. " The Spectator and the Column: Reading and Writing the Language of Gesture." In *Autour de la Colonne Aurélienne*, edited by J. Scheidt and V. Huet, 265–79. Turnhout: Brepols, 2000.

Beauvoir, Simone de. *The Second Sex*. New York, Vintage Books, 1989.

Becatti, Giovanni. *The Art of Ancient Greece and Rome*, From the Rise of Greece to the Fall of Rome. New York, H.N. Abrams, 1967.

Belloni, Gian Guido. *Le Monete di Traiano*. Milan: Museo Archeologico di Milano, 1973.

Bennett, Julian. *Trajan*. Bloomington: Indiana University Press, 1997.

Berchem, Denis van. *Les distribuions de blé et d'argent à la plèbe romaine sous l'empire*. Geneva: Georg & cie s. a., 1939.

Nourrir la plèbe. Kassel: Friedrich Reinhard, 1991.

Berczelly, L. "A Sephulchral Monument from Via Portuense and the Origin of the Roman Biographical Cycle." *Acta ad Archaeologiam et Atrium Historiam Pertinentia* 8 (1978): 49ff.

Bernhart, Max. *Handbuch zur Münzkunde der römischen Kaiserzeit,* Vol. 2. Halle (Saale): A. Reichmann & co., 1926.

Bianchi, Emanuela. *Ara Pacis Augustae.* Rome: Fratelli Palombi, 1994.

Boardman, John. *The Parthenon and Its Sculptures.* Austin: University of Texas Press, 1985.

Boatwright, Mary T. *Hadrian and the City of Rome.* Princeton: Princeton University Press, 1987.

"The Imperial Women of the Early Second Century A.C." *AJP* 112 (1991): 513–40.

Bolkestein, H. *Wohltätigkeit und Armenpflege im vorchristlichen Altertum; ein Beiträg zum Problem "Moral und Gesellschaft."* Utrecht: A. Oosthoek, 1939.

Bonfante Warren, Larissa. "Roman Costumes." In *ANRW* I, no. 4 (1973): 584–614.

Bormann, Eugen. *Varias observationes de antiquitate romana praemisit.* Marburg: Typis academicis Roberti Friedrich, 1883.

Boswell, J. *The Kindness of Strangers.* New York: Pantheon Books, 1988.

Bradley, Keith. "Wet Nursing at Rome: A Study in Social Relations." In *The Family in Ancient Rome,* edited by Beryl Rawson, 201–29. Ithaca, NY: Cornell University Press, 1986.

"Writing the History of the Roman Family." *CP* 88 (1993): 237–50.

Braund, David. *Rome and the Friendly King: The Character of Client Kingship.* London: Croom Helm, 1984.

Bremen, Riet van. "Women and Wealth." In *Images of Women in Antiquity,* edited by A. Cameron and A. Kuhrt, 223–42. Detroit: Wayne State University Press, 1983.

Brendel, O. *Prolegomena to the Study of Roman Art.* New Haven: Yale University Press, 1979.

Brilliant, Richard. *Gesture and Rank in Roman Art.* New Haven: Connecticut Academy of Arts and Sciences, 1963.

Visual Narratives: Storytelling in Etruscan and Roman Art. Ithaca: Cornell University Press, 1984.

Caprino, C., et al. *La Colonna di Marco Aurelio.* Rome: Bretschneider, 1955.

Carcopino, J. "La table de Velleia et son importance historique." *REA.* 23 (1921): 302ff.

Carp, Teresa C. "*Puer Senex* in Roman and Medieval Thought." *Latomus* 39 (1980): 726–39.

Carter, J. B. "The So-Called Balustrades of Trajan." *AJA* 14 (1910): 310ff.

Castriota, David. *The Ara Pacis Augustae and the Imagery of Abundance in Later Greek and Early Roman Imperial Art.* Princeton: Princeton University Press, 1995.

Chatsworth, M. P. "The Refusal of Divine Honors, an Augustan Formula." *PBSR* 15 (1939): 1–10.

Cichorius, Conrad. *Die Reliefs der Traianssäule.* Vols. II and III. Berlin: G. Reimer, 1896 and 1900.

Clairmont, C. W. *Classical Attic Tombstones.* Kilchberg, Switzerland: Akanthus, 1993.

Cohen, Henry. *Description historique des médailles frappées sous l'Empire romain.* Tome II. Paris: Rollin and Feuardent, 1882.

Coleman, K. M. "Fatal Charades: Roman Executions Staged as Mythological Enactments." *JRS* 80 (1990): 44–73.

Conlin, Diane Atnally. *The Artists of the Ara Pacis.* Chapel Hill: University of North Carolina Press, 1997.

Corbeill, Anthony. "Thumbs in Ancient Rome." *AJA* 101 (1996): 114.

Coulon, Gérard. *L'enfant en gaule romaine*. Paris: Editions Errance, 1994.

Crawford, J. R. "A Child Portrait of Drusus Junior on the Ara Pacis." *AJA* 26 (1922): 313–15.

Currie, Sarah. "The Empire of Adults: The Representation of Children on Trajan's Arch at Beneventum." In *Art and Text in Roman Culture*, edited by J. Elsner, 153–81. Cambridge: Cambridge University Press, 1996.

D'Ambra, Eve. "The Calculus of Venus: Nude Portraits of Roman Matrons." In *Sexuality in Ancient Art*, edited by Natalie Boymel Kampen, 219–32. Cambridge: Cambridge University Press, 1996.

de Bruyne, L. "L'Imposition des mains dans l'art chrétien ancien." *RACrist* 20 (1943): 113ff.

De Caro, Stefano. "The Sculptures of the Villa of Poppaea at Oplontis: A Preliminary Report." In *Ancient Roman Villa Gardens*, edited by Elisabeth Blair MacDougall, 77–133. Washington D.C.: Dumbarton Oaks, 1987.

Dennison, Walter. "The Movements of the Chorus Chanting the Carmen Saeculare in Horace." In *Roman Historical Sources and Institutions*, edited by Henry A. Sanders, 48–66. New York: Macmillan, 1903.

Dixon, Suzanne. *The Roman Mother*. Norman: University of Oklahoma, 1988.

Domaszewski, A. von. "Die Dakerkriege Traians auf dem Reliefs der Saule." *Philologus* 45 (1906): 321ff.

Dressel, E. "Ludi decennales auf einem Medaillon des Pius in Beitrage zur alten Geschichte." In *Festschrift zu Otto Hirschfelder 60. Geburtstag*, 280–95. Berlin, 1903.

Duncan-Jones, Richard. "The Purpose and Organization of the Alimenta." *PBSR* 32 (1964): 123–48.

The Economy of the Roman Empire. Cambridge: Cambridge University Press, 1974.

Dwyer, Eugene. *Pompeian Domestic Sculpture*. Rome: Bretschneider, 1982.

Edwards, Catharine. "Unspeakable Professions: Public Performance and Prostitution in Ancient Rome." In *Roman Sexualities*, edited by Judith A. Hallett and Marilyn B. Skinner, 66–95. Princeton: Princeton University Press, 1997.

Elder, C. D, and R. W. Cobb. *The Political Uses of Symbols*. New York: Longman, 1983.

Eley, Geoff, and Suny Grigor. *Becoming National: A Reader*. New York: Oxford University Press, 1996.

Ellul, Jacques. *Propaganda: The Formation of Men's Attitudes*. New York: Vintage Books, 1973.

Elsner, Jas, ed. *Art and Text in Roman Culture*. Cambridge: Cambridge University Press, 1996.

"Frontality in the Column of Marcus Aurelius." In *Autour de la Colonne Aurélienne*, edited by J. Scheidt and V. Huet, 265–79. Turnhout: Brepols, 2000.

Emanuela, *Ara Pacis Augustae*. Rome: Fratelli Palombi, 1994.

Evans, Jane De Rose. *The Art of Persuasion: Political Propaganda from Aeneas to Brutus*. Ann Arbor: University of Michigan Press, 1992.

Evans, John K. *War, Women, and Children in Ancient Rome*, London: New York: Routledge, 1991.

Eyben, Emil. "Was the Roman 'Youth' an 'Adult' Socially?" *L'Antiquite classique* 50 (1981): 328–50.

Ferri, Silvio. *Arte romana sul Danubio*. Milan: Tip. "Popolo d'Italia," 1933.

Ferris, Iain. "Insignificant Others; Images of Barbarians on Military Art from Roman Britain." In *TRAC 94: Proceedings of the Fourth Annual Theoretical Roman Archaeology Conference*, edited by Sally Cottam et al., 24–31. Oxford: Oxbow Books, 1994.

"The Enemy Without, the Enemy Within: More Thoughts on Images of Barbarians in Greek and Roman Art." In *TRAC 96: Proceedings of the Sixth Annual Theoretical Roman Archaeology Conference*, edited by Karen Meadows et al., 22–8. Oxford: Oxbow Books, 1996.

Fittschen, Klaus. "Das Bildprogramm des Trajansbogens zu Benevent (Sitzung am 22. Juni 1971)." *AA* (1972): 742–89.

Die Bildnistypen der Faustina Minor und die Fecunditas Augustae. Gottingen: Vandenhoeck and Ruprecht, 1982.

"Mädchen, Nicht Knaben." *RM* 99 (1992): 301–5.

Florescu, F. B. *Das Siegesdenkmal von Adamklissi, Tropaeum Traiani*. Bukarest and Bonn: Verlag, 1965.

Foss, Clive. *Roman Historical Coins*. London: Seaby, 1990.

Foucault, Michel. *The Use of Pleasure*. Vol. 2. of *The History of Sexuality*. New York: Pantheon Books, 1985.

Freedburg, David. *The Power of Images*. Chicago: University of Chicago Press, 1989.

Frova, Antonio. *L'Arte di Roma e del mondo romano*. Torino: UTET, 1961.

Galinsky, Karl. *Augustan Culture*. Princeton: Princeton University Press, 1996.

Gardner, Jane, and Thomas Wiedemann. *The Roman Household: A Sourcebook*. London: Routledge, 1991.

Garzetti, A. *L'Impero da Tibero agli Antonini*. Bologna: La Cappelli, 1960.

Gauer, Werner. *Untersuchungen zur Traianssäule*, vol. I., *Darstellungsprogramm und künstlerischer Entwurf*. Berlin: Mann, 1977.

Gazda, Elaine, K, ed. *The Villa of the Mysteries in Pompeii: Ancient Ritual, Modern Muse*. Ann Arbor: University of Michigan and the Kelsey Museum, 2000.

Giacosa, Giorgio. *Women of the Caesars*. New York: Edizione Arte e Moneta, 1977.

Giard, Jean-Baptiste. *Le monnayage de l'atelier de Lyon: des origines au regne de Caligula*. Wetteren Belgique: Editions Numismatique Romaine, 1983.

Gnecchi, F. *I Medaglioni romani*. Milan: Ulrico Hoepli, 1912.

Goette, H. R. "Die Bulla." *BJ* CLXXXVI (1986): 133–65.

"Beobachtungen zu römischen Kinderportraits." *AA* (1989): 453ff.

Golden, Mark. *Children and Childhood in Classical Athens*. Baltimore: Johns Hopkins University Press, 1990.

"Change or Continuity? Children and Childhood in Hellenistic Historiography" In *Inventing Ancient Culture: Historicism, Periodization, and the Ancient World*, edited by M. Golden and P. Toohey, pp. 176–91. London: Routledge, 1997.

Gregory, Andrew P. "'Powerful Images': Responses to Portraits and the Political Uses of Images in Rome." *JRA* 7 (1994): 80–99.

Gruen, Erich S. *Culture and National Identity in Republican Rome*. Ithaca, NY: Cornell University Press, 1992.

Hamberg, Per Gustav. *Studies in Roman Imperial Art*. Copenhagen: Ejnar Munksgaard, 1945.

Hammond, Mason. "A Statue of Trajan Represented on the 'Anaglypha Traiani'." *MAAR* 21 (1953): 129–83.

Hands, A. R. *Charities and Social Aid in Greece and Rome*. Ithaca, NY: Cornell University Press, 1968.

Hannestad, Niels. *Roman Art and Imperial Policy*. Aarhus: Aarhus University Press, 1988.

Harris, W. V. "The Roman Father's Power of Life and Death." *Studies in Roman Law in Memory of A. Arthur Schiller* (1986): 81–95.

Harris, W. V. *Ancient Literacy*. Cambridge, MA: Harvard University Press, 1989.

"Child-Exposure in the Roman Empire." *JRS* 84 (1994): 1–22.

Hatcher, Evelyn Payne. *Art as Culture*. Lanham: University Press of America, 1985.

Haverfield, Francis. *The Romanization of Roman Britain*. Oxford: Clarendon Press, 1912.

Helbig, Wolfgang. *Führer durch die öffentlichen Sammlungen klassischer Altertümer in Rom II*. Leipzig: Druck und Verlag von B. G. Teubner, 1913.

Führer durch die öffentlichen Sammlungen klassischer Altertümer in Rom IV. Tübingen: E. Wasmuth, 1963–1972.

Hennig, C., et al., *Handbuch der Kinderkrankenheiten*. Tübingen: Laupp, 1877.

Henzen, W. "Rilevi di marmo scoporti sul firo romano." *Bull Inst* (1872): 274–81.

Héron de Villefosse, A. *Le trésor de Boscoreale. Monuments Eugène Piot 5*, 1899.

Hingley, Richard. *Rural Settlement in Roman Britain*. London: Seaby, 1989.

"The 'legacy' of Rome: The Rise, Decline, and Fall of the Theory of Romanization." In *Roman Imperialism: Post-Colonial Perspectives*, edited by Jane Webster and Nicholas J. Cooper, 35–48. Leicester: University of Leicester, 1996.

Hill, Philip V. *The Monuments of Ancient Rome as Coin Types*. London: Seaby, 1989.

Hirschfeld, Otto. *Die kaiserlichen Verwaltungsbeamten bis auf Diokletian*. Berlin: Weidmann, 1905.

Holliday, Peter J., ed. *Narrative and Event in Ancient Art*. Cambridge: Cambridge University Press, 1993.

"Roman Triumphal Painting: Its Function, Development, and Reception." *Art Bulletin 79*, no. 1 (1997): 130–47.

Huskinson, Janet. *Roman Children's Sarcophagi*. Oxford: Clarendon Press, 1996.

Jashemski, Wilhelmina. *The Gardens of Pompeii*. 2 vols. New Rochelle, NY: Caratzas Bros., 1979 and 1993.

Kampen, Natalie. *Image and Status: Roman Working Women in Ostia*. Berlin: Gbr. Mann Verlag, 1981.

"Between Public and Private: Women as Historical Subjects in Roman Art." In *Women's History and Ancient History*, edited by Sarah Pomeroy, 218–48. Chapel Hill: University of North Carolina Press, 1991.

"Looking at Gender: The Column of Trajan and Roman Historical Relief." In *Feminisms in the Academy: Thinking Through the Disciplines*, edited by D. Stanton and A. Stewart, 46–73. Ann Arbor, MI, 1995.

Kepartová, J. "Kinder in Pompeji: Eine epigraphische Untersuchung." *Klio* 66 (1984): 192–209.

Kleiner, Diana E. E. "Second-Century Mythological Portraiture: Mars and Venus." *Latomus* (1981): 512–44.

Roman Imperial Funerary Altars with Portraits. Rome: Bretschneider, 1987.

Roman Sculpture. New Haven: Yale University Press, 1992.

"The Great Friezes of the Ara Pacis Augustae. Greek Sources, Roman Derivatives, and Augustan Social Policy." In *Roman Art in Context*, edited by Eve D'Ambra 27–52. Englewood Cliffs, NJ: Prentice-Hall, 1993.

Kleiner, Diana E. E., and Susan B. Matheson. *I Claudia: Women in Ancient Rome*. New Haven: Yale University Press, 1996.

Kleiner, Fred S. *The Arch of Nero in Rome*. Rome: Giorgio Bretschneider, 1985.

"The Study of Roman Triumphal and Honorary Arches 50 Years After Kaehler." *JRA* 2 (1989): 195–206.

"An Extraordinary Posthumous Honor for Livia." *Athenaeum* 68 (1990): 508–14.

Kloft, Hans. *Liberalitas principis; Herkunft und Bedeutung*. Köln: Bohlau, 1970.

Koeppel, Gerhard M. "Profectio und Adventus." *BJb* 169 (1969): 130–74.

"The grand pictorial tradition of Roman historical representation during the early empire." *ANRW* II, Künste 12.1 (1982): 507–35.

"Die historischen Reliefs der römischen Kaiserzeit IV." *BJb* 186 (1986): 1–90.

"Die historischen Reliefs der römischen Kaiserzeit V Ara Pacis Augustae I." *BJb* 187 (1987): 101–57.

"Die historischen Reliefs der römischen Kaiserzeit V Ara Pacis Augustae II." *BJb* 188 (1988): 97–106.

Kuttner, Ann. *Dynasty and Empire in the Age of Augustus: The Case of the Boscoreale Cups*. Berkeley: University of California Press, 1995.

Lacey, W. K. *The Family in Classical Greece*. London: Thames and Hudson, 1968.

La Rocca, Eugenio. *Ara Pacis Augustae*. Rome: Bretschneider, 1983.

Lasinio, Giovanni P. *Raccolta di sarcophagi, urne e altri monumenti di scultura del Campo Santo di Pisa*. Pisa: Didot, 1814.

Lehmann-Hartleben, Karl. *Die Traianssäule; ein römisches Kunstwerk zu Beginn der Spätantike*. Berlin: Leipzig, W. de Gruytert & Co., 1926.

Lepper, Frank, and Sheppard Frere. *Trajan's Column*. Gloucester: Alan Sutton, 1988.

Levi, A. C. *Barbarians on Roman Imperial Coins and Sculpture*. American Numismatic Society, Numismatic Notes and Monographs 123 (1952).

Lewis, Naphtali, and Meyer Reinhold. *Roman Civilization*. Vols. I and II. New York: Columbia University Press, 1990.

Lintott, Andrew. *Imperium Romanum*. London: Routledge, 1993.

Locke, John. *The Second Treatise of Government*, edited by Thomas P. Pearson. New York: Macmillan, 1987.

MacDonald, William Lloyd. *The Architecture of the Roman Empire*. New Haven: Yale University Press, 1982.

Maiuri, Amedeo. *Roman Painting*. Geneva: Skira, 1953.

Manson, Michel. "The Emergence of the Small Child in Rome (Third Century BC–First Century AD)." *History of Education* 12 (1983): 149–59.

Mattingly, H., and Sydenham, E. A. *The Roman Imperial Coinage*. London: Spink, 1923–1981.

McCormick, Michael. *Eternal Victory: Triumphal Rulership in Late Antiquity, Byzantium, and the Early Medieval West*. Cambridge: Cambridge University Press, 1986.

McCrum, M., and Woodhead, A. G. *Select Documents of the Principates of the Flavian Emperors*. Cambridge: Cambridge University Press, 1961.

Michaelis, A. *Ancient Marbles in Great Britain*. Cambridge: Cambridge University Press, 1882.

Miclea, Ion, and Radu Florescu. *Columna*. Cluj: Pub. House Dacia, 1971.

Millar, F. "Emperors at Work." *JRS* 57 (1967): 9–19.

Millett, Martin. *The Romanization of Britain: An Essay in Archaeological Interpretation*. Cambridge: Cambridge University Press, 1990.

Mommsen, Theodor. *Mon. Ant. della Reale Acad. de'Lincei* 1 (1891).

Museo Nazionale Romano. *Le sculture*. Rome, 1981.

Nash, E. *Pictorial Dictionary of Ancient Rome*, 2nd ed. Vol. II. New York: Frederick A. Praeger, 1962.

Néraudau, Jean-Pierre. *Être enfant à Rome*. Paris: Collection Realia, Les belles lettres, 1984.

Oliver, James H. *The Ruling Power: A Study of the Roman Empire in the Second Century after Christ through the Roman Oration of Aelius Aristides*. Philadelphia: American Philosophical Society, 1953.

 Greek Constitutions of the Early Roman Emperors from Inscriptions and Papyri. Philadelphia: American Philosophical Society, 1989.

Ostrowski, Janus. *Les personnifications des provinces dans l'art romain*. Varsovie: Comer, 1990.

Paribeni, R. *Le Terme di Diocleziano e il Museo Nazionale Romano*. Rome: La Libreria dello Stato, 1928.

Parkin, Tim. *Demography and Roman Society*. Baltimore: Johns Hopkins University Press, 1992.

Patsch, Carl. *Der Kampf um den Donauraum unter Domitian und Trajan*, 1937.

Patterson, J. R. "Crisis: What Crisis? Rural Change and Urban Development in Imperial Appennine Italy." *PBSR* 55 (1987): 115–46.

Payne, Robert. *The Roman Triumph*. London: Robert Hale Limited, 1962.

Petermann, R. "Zur Restaurierung des Deckelreliefs vom ludovisischen Schlachten-sarkophag." *Jahrbuch Zeitschrift Museum Mainz.* 22 (1975): 218–20.

Petersen, E., von Domaszewski, A., and Calderini, G. *Die Marcussäule auf Piazza Colonna in Rom*. Munich: F. Bruckmann a.g., 1896.

Pighi, Ioannes Baptista. *De Ludis Saecularibus*. Amsterdam: Verlag P. Schippers N. V., 1965.

Plecket, H. W. "Licht uit Leuven over de romeinse jeugd?" *Lampas* 12 (1979): 173–92.

Pollen, J. H. *A Description of the Trajan Column*. London: G. E. Eyre and W. Spittiswoode, 1874.

Pollini, John. *The Portraiture of Gaius and Lucius Caesar*. New York: Fordham University Press, 1987.

Pollitt. J. J. *Art in the Hellenistic Age*. Cambridge: Cambridge University Press, 1986.

Poulsen, F. *Greek and Roman Portraits in English Country Houses*. Oxford: Oxford University Press, 1923.

Pugliese Caratelli, Giovanni. *Pompei: Pitturi e Mosaici*. 5 vols. Rome, 1990–4.

Rawson, Beryl, ed. *The Family in Ancient Rome*. Ithaca, NY: Cornell University Press, 1986.
 Marriage, Divorce, and Children in Ancient Rome. Canberra: Humanities Research Centre, 1991.

 "The Iconography of Childhood." In *The Roman Family in Italy: Status, Sentiment, Space*, edited by Beryl Rawson and Paul Weaver, 205–32. Canberra: Humanities Research Centre, 1997.

 "Children as Cultural Symbols." In *Childhood, Class, and Kin in the Roman World*, edited by Suzanne Dixon, 21–42. London: Routledge, 2001.

 Children and Childhood in Roman Italy. Oxford: Oxford University Press, 2003.

Reekmans, L. "La 'dextrarum iunctio' dans l'iconographie romaine et paleochrétienne." *Bulletin de l'Institut historique belge de Rome* 31 (1958): 23–95.

Reinach, S. *Répertoire de reliefs grecs et romains*. Paris: E. Leroux, 1909–12.

Richardson, L. *Pompeii: An Architectural History*. Baltimore: Johns Hopkins University Press, 1988.

Richter, Gisela. *Roman Portraits*. New York: Metropolitan Museum of Art, 1948.

Romanelli, Pietro. *La Colonna Antonina*. Rome: Carlo Colombo, 1942.

 La Colonna Traiana. Rome: Carlo Colombo, 1942.

Rose, Charles Brian. "Princes and Barbarians on the Ara Pacis." In *Roman Art in Context*, edited by Eve D'Ambra, 53–74. Englewood Cliffs, NJ: Prentice-Hall, 1993.

 Dynastic Commemoration and Imperial Portraiture in the Julio-Claudian Period. Cambridge: Cambridge University Press, 1997.

Rossi, Lino. *Trajan's Column and the Dacian Wars*. Ithaca, NY: Cornell University Press, 1971.

 "A Synoptic Outlook of Adamklissi Meopes and Trajan's Column Frieze: Factual and Fanciful Topics Revisited." *Athenaeum* 85, no. 2 (1997): 471–86.

Rüdiger, U. "Die Anaglypha Hadriani." *Antike Plastik* 12 (1973): 161ff.

Rühfel, Hilde. *Kinderleben im Klassichen Athen*. Mainz am Rhein: P. von Zabern, 1984.

 Das Kind in der Greichischen Kunst. Mainz am Rhein: P. von Zabern, 1984.

Ryberg, Inez Scott. *Rites of the State Religion in Roman Art*. Rome: American Academy in Rome, 1955.

 Panel Reliefs of Marcus Aurelius. New York: Archaeological Institute of America, 1967.

Saller, Richard. "Corporal Punishment, Authority, and Obedience in the Roman Household." In *Marriage, Divorce, and Children in Ancient Rome*, edited by Beryl Rawson, 144–65. Canberra: Humanities Research Centre, 1991.

 Patriarchy, Property, and Death in the Roman Family. Cambridge: Cambridge University Press, 1994.

Salomonson, J. W. *Chair, Scepter, and Wreath. Historical Aspects of Their Representation on Some Roman Sepulchral Monuments*. Amsterdam: E. Harms, 1956.

Sebesta, Judith. "Symbolism in the Costume of the Roman Woman." In *The World of Roman Costume*, edited by J. Sebesta and L. Bonfante, 46–53. Madison: University of Wisconsin Press, 1994.

Sebesta, Judith, and Larissa Bonfante. *The World of Roman Costume*. Madison: University of Wisconsin Press, 1994.

Seston, W. "Les 'Anaglypha Traiani' du Forum romain et la politique d'Hadrian en 118." *Mél. Ec. Fr. Rome* 44 (1927): 15ff.

Settis, S., et al. *La Colonna Traiana*. Torino: Giulio Einaudi, 1988.

Sherwin-White, A. N. *The Roman Citizenship*. Oxford: Clarendon Press, 1939.

Simon, Erika. *Ara Pacis Augustae*. Greenwich: New York Graphic Society, 1967.

Smith, R. R. R. "Similacra gentium: The *Ethne* from the Sebasteion at Aphrodisias." *JRS* (1988): 50–77.

Stemmer, Klaus. *Untersuchungen zur Typolgie, Chronologie und Ikonographie der Panzerstatuen*. Berlin: Gebr. Mann Verlag, 1978.

Stewart, Andrew. *Greek Sculpture: An Exploration*. Vols. 1 and 2. New Haven: Yale University Press, 1990.

Strack, P. L. *Untersuchungen sur römischen Reichsprägung des zweiten Jahrhunderts*. I: *Die Reichsprägung zur Zeit des Traian*. Stuttgart: W. Kohlhammer, 1931.

 Untersuchungen sur römischen Reichsprägung des zweiten Jahrhunderts. II: *Die Reichsprägung zur Zeit des Hadrian*. Stuttgart: W. Kohlhammer, 1933.

Strocka, V. M. *Häuser in Pompeji* (VI 8–10), Bd. 4. Tübingen: E. Wasmuth, 1984.

Strong, D. E. *Roman Imperial Sculpture*. London: A. Tiranti, 1961.

Strong, Eugénie. *Roman Sculpture from Augustus to Constantine*. London: Duckworth, 1907.

Stucchi, S. "L'arco detto 'di Portogallo' sulla via Flaminia." *BullComm* 73 (1949/50): 101–22.

Sutherland, C. H. V. *Art in Coinage*. New York: Philosophical Library, 1956.

Sydenham, E. A. *The Coinage of Nero*. London, 1920.

Syme, Ronald. "Neglected Children on the Ara Pacis." *AJA* 88 (1984): 583–9.

Thomas, Y. P. "*Vitae necisque potestas*: le père, la cité, la mort." In *Du châtiment dans la cité: supplices corporels et peine de mort dans le monde antique*, 499–548. Rome: L'Ecole, 1984.

Torelli, Mario. *Typology and Structure of Roman Historical Reliefs*. Ann Arbor: University of Michigan Press, 1982.

"'Ex his castra, ex his tribus replebuntur': The Marble Panegyric on the Arch of Trajan at Beneventum." In *Interpretations of Architectural Sculpture in Greece and Rome*, edited by Diana Buitron-Oliver, 145–178. Washington, DC: National Gallery of Art, 1997.

Toynbee, Jocelyn M. C. "The Ara Pacis Reconsidered and Historical Art in Roman Italy." *Proceedings of the British Academy* (1953): 67–95.

Treggiari, Susan. *Roman Marriage: Iusti Coniuges from the Time of Cicero to the Time of Ulpian*. Oxford: Oxford University Press, 1988.

Uzzi, Jeannine Diddle. *The Representation of Children in the Official Art of the Roman Empire from Augustus to Constantine*. Ph.D. diss., 1998.

Vermeule, C. C. *The Goddess Roma in the Art of the Roman Empire*. Cambridge, MA: Sold by Spink, London, 1959.

"Hellenistic and Roman Cuirassed Statues." *Berytus* XIII (1959): 1–82.

Roman Imperial Art in Greece and Asia Minor. Cambridge: Harvard University Press, 1968.

Hellenistic and Roman Cuirassed Statues. Boston: Museum of Fine Arts, 1980.

"The Ara Pacis and the Child Nero: Julio-Claudian Commemorative Reliefs in Italy and Elsewhere." *AJA* 86 (1982): 242–4.

Veyne, Paul. "Les honneurs posthumes de Flavia Domitilla et les dédicaces grecques et latines." *Latomus* 21 (1962): 49–98.

Von Rhoden, Hermann. *Die Terrakotten von Pompeji*. Stuttgart, 1880.

Vulpe, Radu. *Histoire ancienne de la Dobroudja*. Bukarest, 1938.

Waelkens, M. "From a Phrygian Quarry; The Provenance of the Statues of the Dacian Prisoners on the Column of Trajan." *AJA* 89 (1985): 641–53.

Walker, Susan. *Memorials to the Roman Dead*. London: British Museum, 1985.

Wallace-Hadrill, Andrew. "Image and Authority in the Coinage of Augustus." *JRS* 76 (1986): 66–87.

Houses and Society in Pompeii and Herculaneum. Princeton: Princeton University Press, 1994.

Ward-Perkins, J. B. *Roman Architecture*. New York: Electa/Rizzoli, 1988.

Warsher, T. *Codex Topographicus Pompeianus*, part VI. Rome, 1951.

Watson, Alan. *The State, Law and Religion*. Athens: University of Georgia Press, 1992.

Weaver, P. R. C. "Children of Freedmen (and Freedwomen)." In *Marriage, Divorce, and Children in Ancient Rome*, edited by Beryl Rawson. Canberra: Humanities Research Center, 1991.

Weber, W. *Die Darstellungen einer Wagenfahrt auf römischen Sarkophagdeckeln und Loculusplatten des 3 und 4 Jahrhunderts n. Chr.* Rome: Bretschneider, 1978.

Weidemann, Thomas E. J. *Adults and Children in the Roman Empire*. London: Routledge, 1989.

Weinstock, Stefan. "Pax and the Ara Pacis." *JRS* 50 (1960): 44–58.

Wilson, Lillian M. *The Clothing of the Ancient Romans.* Baltimore: Johns Hopkins University Press, 1938.

Withee, Diana. *AJA Abstracts* 96.2 (1992): 336.

Woolf, Gregory. "Food, Poverty and Patronage: The Significance of the Epigraphy of the Roman Alimentary Schemes in Early Imperial Italy." *PBSR* 58 (1990): 197–228.

"The Unity and Diversity of Romanisation." *JRA* 5 (1992): 349–52.

Becoming Roman: The Origins of Provincial Civilization in Gaul. Cambridge: Cambridge University Press, 1998.

Yavetz, Zvi. *Julius Caesar and his Public Image.* Ithaca, NY: Cornell University Press, 1983.

Younger, John. *AJA Abstracts* 95.2 (1991): 295.

Zanker, Paul. *The Power of Images in the Age of Augustus.* Ann Arbor: University of Michigan Press, 1988.

"Die Frauen und Kinder der Barbaren auf der Markussäule." In *Autour de la Colonne Aurélienne,* edited by J. Scheidt and V. Huet, 163–74. Turnhout: Brepols, 2000.

Žižek, Slavoj. *Tarrying with the Negative: Kant, Hegel, and the Critique of Ideology.* Durham, NC: Duke University Press, 1993.

INDEX

Boldface page numbers refer to illustrations.